Jay Diamond & Ellen Diamond

Contemporary
Visual Merchandising and Environmental Design

Fifth Edition

Prentice Hall
Boston Columbus Indianapolis New York San Francisco Upper Saddle River
Amsterdam Cape Town Dubai London Madrid Milan Munich Paris Montreal Toronto
Delhi Mexico City Sao Pa l Singapore Taipei Tokyo

Editor in Chief: Vernon Anthony
Editorial Assistant: Doug Greive
Director of Marketing: David Gesell
Senior Marketing Coordinator: Alicia Wozniak
Marketing Manager: Kara Clark
Associate Managing Editor: Alexandrina Benedicto Wolf
Inhouse Production Liason: Alicia Ritchey
Operations Specialist: Deidra Skahill
Text Designer: Kathy Mrozek

Cover Designer: Ali Mohrman
Cover Art: SuperStock
Lead Media Project Manager: Karen Bretz
Full-Service Project Management: S4Carlisle Publishing Services
Composition: S4Carlisle Publishing Services
Printer/Binder: Edwards Brothers
Cover Printer: Lehigh-Phoenix Color
Text Font: 45 Helvetica Light

Credits and acknowledgments for materials borrowed from other sources and reproduced, with permission, in this textbook appear on appropriate page within text.

Library of Congress Cataloging-in-Publication Data
Diamond, Jay.
　Contemporary visual merchandising and environmental design/
Jay Diamond, Ellen Diamond.—5th ed.
　　p. cm.
Includes index.
ISBN-13: 978-0-13-500761-7
ISBN-10: 0-13-500761-5
1.　Display of merchandise.　I. Diamond, Ellen.　II. Title.
HF5845.D46 2010
659.1′5—dc22
　　　　　　　　　　　　　　　　　　　　　2009053038

10 9 8 7 6 5 4 3 2 1

Prentice Hall
is an imprint of

ISBN 10:　　0-13-500761-5
ISBN 13: 978-0-13-500761-7

www.pearsonhighered.com

brief contents

contents

Lighting: Dramatizing the Selling Floor and Display Areas | 160

Themes and Settings for Windows and Interiors | 180

Energizing the Specialty Boutique | 200

Signage: The Tool That Tells a Story | 216

14 Graphics in the Retail Environment | 232

15 Point-of-Purchase Display | 248

16 Display Windows as Settings for "Consumer Theater"* | 264

17 Execution of a Visual Presentation | 278

preface

At this time, merchants find themselves facing challenges as never before. The economic downturn in 2008 and 2009 together with the ever-increasing popularity of off-site ventures, an increased growth in minority consumer demographics, and an awareness of the need to make their in-store premises "green" or environmentally appropriate makes the manner in which business is conducted extremely difficult. Motivating shoppers to come to the stores to satisfy their needs instead of relying upon the Internet, catalogs, and home shopping networks has become a necessity for bricks-and-mortar establishments. Whether it is advertising and promotional endeavors that bring the people to the store or just their own curiosity to see what is available for sale, it is the visual merchandiser's responsibility, to some extent, to make certain that there will be sufficient excitement to capture their attention and turn browsers into purchasers.

Visual merchandisers' tasks become even more complicated given the severe budgetary constraints imposed upon many of them by management. They are called upon to deliver visual presentations intended to capture the shopper's attention at minimal expense. It is the creativity and ingenuity of the visual merchandising team that make the in-store environments places where sales will be generated.

In addition to the task of creating window and interior displays, visual merchandisers must consider that the "one-size-fits-all" presentation is no longer acceptable. With multicultural consumer markets growing, the standard displays of yesterday will no longer fit the bill. These extremely important market segments must be considered when visual tools are utilized. A new chapter, **Addressing Multicultural Consumer Needs through Visual Merchandising,** has been added to show how these markets are targeted by visual merchandisers.

The need to make environments "friendlier" has also been a goal of retailers. Not only has management begun to employ a host of new ways in which to achieve needed environmental changes, but in many cases, visual merchandisers have been asked to help make consumers aware of "green" initiatives. In another new chapter, **Environment Design Direction: Going Green,** the retailing industry's commitment to improving the environment is explored.

In addition, each chapter has been updated to reflect industrial changes. Along with textual changes, new artwork has also been provided. The full-color art has been expanded from sixteen to twenty-four pages.

Also featured is a wealth of pedagogical tools that will help the reader master the materials that have been presented. These include:

- Key points at the end of each chapter.
- Discussion questions that will challenge the reader.
- Cases that will require problem-solving skills.
- Exercises and projects that require individual research.

A PowerPoint presentation is also available (ISBN: 0132358727).

Instructor's Resource Center To access supplementary materials online, instructors need to request an instructor access code. Go to www.pearsonhighered.com/irc, where you can register for an instructor access code. Within 48 hours after registering, you will receive a confirming e-mail, including an instructor access code. Once you have received your code, go to the site and log on for full instructions on downloading the materials you wish to use.

acknowledgments

We wish to thank the following people and organizations for their contributions to *Contemporary Visual Merchandising and Environmental Design:* Elliott Brodsky, The Elliott Group; Raymond Graj, Simon Graj, Eric Gustavsen and Stee Goodman, Graj + *Gustavsen*; Michael Stewart, Adel Rootstein; Michael Hewitt, Philips Lighting Company; Kelly Moror, Bloomingdale's; Lavelle Olexa and Manoel Renha, Creative Directors, New York Windows, Visual Merchandising Department, Lord & Taylor; Marcy Goldstein, JGA, Inc.; Carl Cohen, Juno Lighting, Inc.; Ryan Lester, Clearr Corporation, Display Division; Tim Wisgerhof, Window Director, Saks Fifth Avenue; Amy Meadows, Visual Marketing Manager, Marshall Field's; Sheri Litt, Florida Community College, Jacksonville; Greg McMillian and Donna Lombardo, Belk Department Stores; Mindy Greenberg; and Allan Ellinger, Marketing Management Group.

We would also like to thank the following individuals for their input: Rita Campo Griggs, Palomar College; Lisa Mahajan Cusack, College of St. Elizabeth; Carolyn L. Worms, University of Memphis. We also thank our reviewers: Ann Paulins, Ohio University; George Gannage, West Central Technical College; Leigh Southward; Tennessee Tech University Cookville; Celia Stall-Meadows, Northeastern State University; Marilyn Van Court, Mississippi Gulf Coast Community College Jefferson; Laverne Tilley, Gwinnett Tech College; and Cheryl Zuhn-Moulder, Mesa Community College.

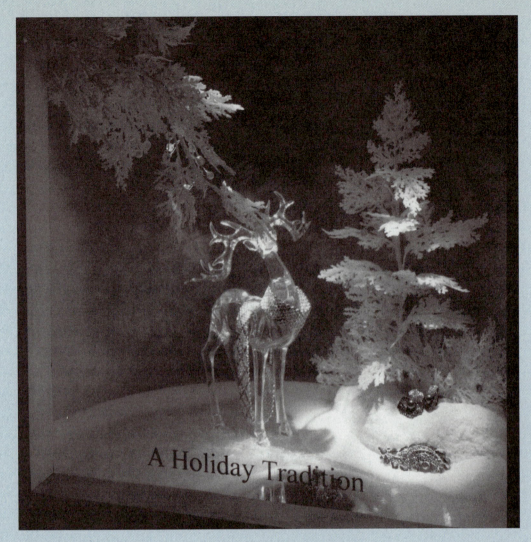

A Holiday Tradition

the visual concept in a environ

Objectives

After completing this chapter, the student should be able to:

... Discuss the various aspects of visual merchandising that are important to creating and installing modern visual presentations.

... Describe the different environments in which visual merchandisers operate and the different demands of each.

... List the different categories in the visual merchandiser's budget.

... Explain the importance of safety in the installation of visual presentations and the precautions necessary to avoid mishaps.

... Describe the elements that contribute to the success of window and interior displays.

... Contrast the emphasis placed on mannequin design today with that of years past.

... Briefly discuss the lighting changes that have taken place in the industry.

... Tell about the various types of careers available to someone pursuing entry into the field of visual merchandising.

... Discuss the trends that are currently becoming part of the visual merchandising scene.

merchandising contemporary ment

Introduction

In the world of visual merchandising as we know it today, artistic talents play a major role in creating an atmosphere that motivates shoppers to become customers. Unlike the fine artist whose creativity is a statement of feelings, or yesterday's **window trimmer** whose goal was just to produce a pretty display, today's visual merchandiser must create displays with an eye on function and artistic expression that ultimately increase the store's profitability. In today's retail environment, the practice of concentrating a store's display budget on windows replete with costly props and backgrounds is the exception rather than the rule. While some flagship stores such as Macy's Herald Square in New York City and Neiman Marcus in Dallas still feature exciting, costly displays—especially at times like Christmas—their branch stores are often in windowless structures or buildings with few display windows. In shopping malls, the major retail venues in the United States, the traditional windows have been replaced with wide-open entryways through which shoppers can view a large portion of the main selling floor. In these environments, the store itself is the display, and it must be effectively enhanced to attract shoppers and stimulate sales.

With the emphasis on the whole store rather than on just the windows, display people have become visual merchandisers—part of a team that specializes in the entire store's visual appearance. When one enters a Disney store, for example, the experience is unique. The **total environment** or **theme concept** immediately captivates shoppers, in particular children, who are quickly motivated to buy a variety of tempting items. With the animated figures that encircle the store, the giant screen that features Disney videos available for sale, and the mounds of stuffed animals heaped in an inviting fashion, a magical moment in shopping is achieved.

Many retailers are using this concept, which was initiated by Banana Republic. In its original stores, merchandise emphasis was on safari-inspired clothing, and the interiors were designed to reflect that image. Until the company changed its image and merchandising philosophy, the stores were replete with netting, jeeps, palm trees, bamboo, and anything that gave the impression of a trip to the wild. Today, companies like Nike in its Niketowns, Warner Bros. in its retail outlets, and OshKosh B'Gosh have followed the early Banana Republic lead and subscribe to this thematic approach to visual presentation.

Another departure from traditional store design and merchandise presentation is a concept introduced by Ralph Lauren. In his New York City flagship store on Madison Avenue, antique and reproduction fixtures transform the environment into a homelike setting. Merchandise is featured in armoires and on tables that one would find in elegantly designed residences. Enhanced by fine art and beautiful home accessories, the magic begins as the doors open into the stores. Shoppers are made to feel that they are in a comfortable home rather than in a conventional store.

Borrowing from the retailers, restaurants have successfully adopted the thematic approach. The Hard Rock Cafe, Motown, Planet Hollywood, and Rain Forest Cafe created environments reminiscent of an exciting setting. The latest and perhaps most visually exciting of these eating establishments is the Rain Forest Cafe, with branches throughout the country. As customers enter, the lush vegetation immediately sets the mood to whet their appetites. In addition to the food they serve, most of these dining emporiums feature boutiques offering a host of products bearing their logos, a marketing technique that adds to the bottom line.

Williams-Sonoma with its enticing cooking utensils displayed creatively, Crate & Barrel with its brilliant settings that make shopping an adventure, and Pottery Barn with its wealth of contemporary home furnishings each add their own touches to make them distinguishable from other stores. At the department store level, the lavish windows of the downtown flagships still generate a great deal of excitement. Particularly near Christmas, stores like Lord & Taylor and Saks Fifth Avenue in New York City still impress critics and customers with their imaginative window displays (Figure 1–1). Lines of would-be customers congregate to view the extravaganzas set forth by the visual merchandisers.

Figure 1–1 A stylized fantasy display at Christmas.

(Courtesy of Marshall Field's, now a Macy's company.)

Each year the presentations seem more elaborate than those of the previous year. While these approaches are an exciting part of today's visual environments, they do not encompass all of the design directions taken by the retail community. The challenge to visual merchandisers is to continually develop ideas that will present the entire store in its best possible light every day, to make certain that their companies get a fair share of the consumer market.

Those wishing to enter the field of visual merchandising must develop the knowledge necessary to create and install presentations of merit. Throughout this text, concepts and theories as well as host of display techniques and innovative projects are carefully presented to assist the reader in learning how to develop ideas and tackle the everyday problems associated with visual presentation.

Capturing the Consumer's Attention

Before any considerations can be made regarding a retailer's approach to visual merchandising endeavors, it is a necessity to carefully study its customer base and any potentially new markets that it wishes to target. While the basics of visual merchandising remain constant for most merchants, there are variations on presentation that should be addressed before establishing a visual program. Whether it is the department store that often spends more than any other retailing classification on visual merchandising, the specialty chain that often stretches from coast to coast with hundreds of stores, or the small retailer who has just one or a few outlets, planning in terms of how to attract shoppers is of paramount importance.

Not too long ago, retailers used a one-size-fits-all approach when planning presentations. That is, no matter what the makeup of the consumer base, the approach was to try to motivate all shoppers with the same types of display—no matter what their ethnic makeup. It was assumed that all customers would be attracted to "standard" displays, without consideration of their cultural backgrounds. Today, this concept is beginning to change. An editorial in *Advertising Age* (July 14, 2008) best summed up the situation by stating, the "*general market* is no longer synonymous with the *white market*."

Markets are made up of different ethnicities, with each needing special attention to make them feel part of the shopping experience. Multiculturalism is the key to such in a retailer's promotional endeavors, with visual merchandising an important element. The significant growth in the African-American, Hispanic, and Asian populations signals that

retailers can no longer use "standard" display practices in their visual planning, but must embark upon programs that address all of these diverse populations.

In Chapter 2, Addressing Multicultural Consumer Needs through Visual Merchandising, attention will focus on how the retailer is making changes in visual programs to capture the attention of these different ethnicities.

The Visual Merchandiser's World

Visual merchandising, briefly defined, is the presentation of a store and its merchandise in ways that will attract the attention of potential customers and motivate them to make purchases. The role of the visual merchandiser in this effort is to carry out the merchandising concepts as formulated by management. These merchandising plans include what items are to be featured and in which locations they should be housed. The visual merchandiser, guided by these decisions and using all of his or her creative talents, sets out to present the best possible visual effects.

A position as visual merchandiser involves a combination of skills, including creativity (Figure 1–2); a sense of order; dedication to design principles; and the discipline to follow directions, stay within budgets, and complete paperwork. It involves artistic talent and training and also knowledge of tools, lighting, construction of backgrounds and props, and a complete understanding of store design. Other important skills include the ability to create signs (both hand-lettered and computerized), write copy, and create and choose appropriate graphics. On any day, the demands of the job could involve many other abilities.

The specific duties depend on the arena in which the visual merchandiser works and at what level he or she is involved. Some positions require expertise in only one aspect of visual merchandising, such as sign preparation or window installations, whereas others require a broader base so that all of the functions can be satisfactorily accomplished by one person. In major stores, visual merchandising roles tend to be specialized because there is often a large staff that carries out each project. When Macy's Herald Square, for example, plans and installs its famous annual Flower Show (Figure 1–3), scores of individuals with different talents undertake the task. On the other hand, a freelancer who creates backgrounds and props, installs the displays, and prepares copy must be a jack-of-all-trades. Somewhere in between is the person who works for a small chain and, along with an assistant, is responsible for more than one aspect of visual merchandising.

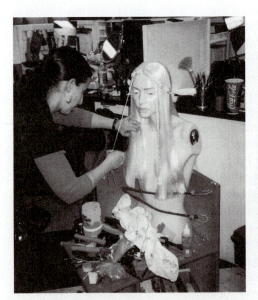

Figure 1–2 Trimmer creating a hair design that will be appropriate for the display's theme.
(Photograph by Ellen Diamond.)

Figure 1–3 The Flower Show signals the arrival of spring, a time for shopping for the new season.
(Courtesy of Marshall Field's, now a Macy's company.)

Whatever the level of participation, each individual should understand the job and what his or her role is in developing the entire visual merchandising picture. Basically, there are three areas in which people in the field are employed: department stores, specialty chains, and freelancing.

Department Stores

The major full-line department stores such as Macy's and Bloomingdale's and the specialized department stores such as Saks Fifth Avenue employ in-house staffs to visually merchandise their premises. Key individuals generally operate from the company's **flagship stores** and are responsible for the direction of the visual merchandising philosophy and the creation of the concepts for the entire company. Since the role of visual merchandise director has become so complex, the position has been elevated in most stores to vice president and in some cases, senior vice president. In addition to being the central figure in planning window and interior presentations, the visual merchandise manager has assumed numerous other responsibilities, such as store design, layout, fixture design and selection, graphics development and procurement, signage direction, and lighting usage.

Other members of the visual merchandising team may specialize in one or more areas. They include sign making, graphics, prop and background construction, and trimming. Generally, each member of the team has a narrow responsibility and contributes some particular expertise to the overall challenges conceived by the head of visual merchandising. Although visual merchandising is typically a subdivision of the promotional division in most large department stores, each company uses a structure that best suits its needs.

Specialty Chains

Unlike the department store that generally locates management in the company's flagship store, the visual merchandising manager in chain organizations usually operates from central headquarters where all other top managers are based. The responsibility at this level is to conceive a visual concept with what is generally a small staff of designers, who disseminate the ideas to those responsible for the individual stores' installations (Figure 1–4). The plans are carried out either by trimmers who travel within a particular region of the stores

Figure 1–4 A display that was created at the chain's headquarters to be replicated at the company's individual outlets.
(Courtesy of iStockphoto/Sapsiwai.)

or by the individual store managers who faithfully install the preplanned displays from photographs and corporate directives. In more and more companies, specific plans are set out in **mock windows** and interior settings in the company's headquarters and are photographed for copying by the stores. A more detailed presentation of this centralized approach appears in Chapter 3.

Freelancers

Individuals who operate their own visual merchandising businesses and provide their services to clients for a fee are called **freelancers**. Generally, they concentrate on window presentations for independent retailers and sometimes involve themselves in interior presentation if the store requests it.

Creating Effective Visual Presentations

The visual merchandiser is largely concerned with the creative presentation of the store's merchandise in settings that will maximize sales. The job involves the coordination of all the components needed to produce window and interior displays that will enhance the store's image and set it apart from the competition. To achieve this goal of creating an inviting environment for shoppers, a number of tasks must be performed, such as selecting the appropriate props and mannequins to enhance the merchandise. Once these ingredients have been determined, the visual merchandiser must consider design, color, lighting that both illuminates and creates dramatic effects, and signage. The finished product should be one that attracts shoppers' attention and transforms them into customers.

The Components of Visual Merchandising and Facilities Design

In order to effectively differentiate one retail facility from another, and bring the retail premises to its highest level of visual appeal, a variety of different components must be successfully coordinated. Visual merchandisers must be constantly aware of what's taking place in each of these visual segments and must be prepared to make any necessary changes. The following sections represent an overview of the various components, which will be explored in greater depth in the upcoming chapters.

Store Design

There is no longer a typical store design. Merchants employ the services of architects and designers who, along with visual merchandisers, create environments that are both unique and functional. The space that was once allocated to store windows has been minimized and replaced with more selling-floor space. In place of the traditional windows, large panes of glass are used to allow shoppers to see a large portion of the store. The interiors range from natural settings using stone and handhewn woods to elegant environments with atriums, majestic staircases, marble flooring, and other touches of grandeur (Figure 1–5). Many of the major department stores are reducing the appearance of vast selling floors with the construction of individual shops or boutiques to house their special designer collections. This approach gives the customer the feeling of shopping in smaller stores rather than the cold feeling of the large department store.

Food stores are abandoning the sterile looks long associated with them in favor of surroundings that feature espresso and juice bars, preparation areas that allow shoppers to see how the products are prepared, areas that offer "prepared meals," and a host of kiosk

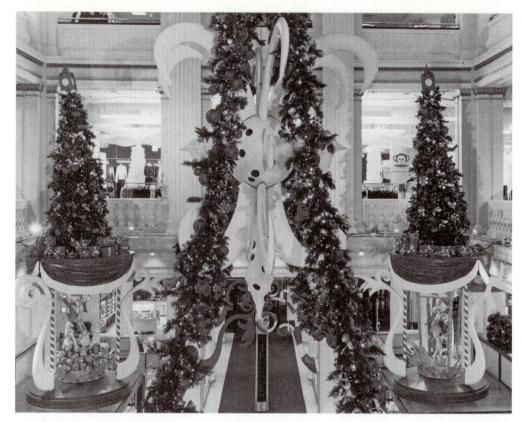

Figure 1–5 The store's basic environmental design is enhanced at Christmas with a wealth of holiday trim. *(Courtesy of Marshall Field's, now a Macy's company.)*

fixtures scattered throughout the store. Chains like Whole Foods, Fresh Market, and Harris Teeter are leaders in innovative visual merchandising that transforms their stores into exciting food-shopping venues.

Mannequins

While traditional mannequins are still often featured, many stores have replaced them with, to name a few, wire mannequins, soft sculptured types, stylized forms, and motorized models (Figure 1–6). With the increasing cost of traditional mannequins, many merchants have opted for forms that represent mannequins and are created by visual merchandisers. The creation of these **representational mannequins** is fully explored in Chapter 6 including step-by-step instructions on how to build them.

Props and Materials

The list of materials and props used by today's visual merchandisers seems to be endless. Although conventional store-bought props are available at various resource centers, more and more retailers are making use of things found in nature (such as tree branches, rocks, and sand) and found objects once reserved for the junk pile (such as old chairs, worn picture frames, and rusty farm tools) (Figure 1–7). With fresh coats of paint and new finishes, **found display objects** can be used dramatically in displays. Not only do they provide for effective visual presentations, they also enable budgets to go further. Antiques and antique reproductions are also being used extensively, a trend started by Ralph Lauren. Of course, near Christmas, animated displays and glittery props are still of paramount importance.

Figure 1–6 Realistic mannequins are the mainstays of most major department stores' visual merchandising programs.
(Courtesy of Adel Rootstein. Photograph by Ellen Diamond.)

Figure 1–7 Old picture frames and chairs that have been refurbished enhance window displays at minimum cost.
(Photograph by Ellen Diamond.)

Shoppers line up along the major department store windows to enjoy the creative offerings of companies like Spaeth Design that specialize in unique, animated presentations. (See Chapter 17 for a Profile on Spaeth Design.)

Lighting

Although fluorescents are still used by retailers like supermarkets and warehouse clubs for general illumination, this form of lighting is no longer in great prominence in most retail stores. Today, halogen and quartz lighting and high-intensity discharge lamps are the products of choice. They not only serve the functional needs of illumination but can be used to achieve dramatic effects. Numerous types of cans or holders are being used to house these lightbulbs, supplying a variety of looks to augment the many types of store fixtures.

Graphics and Signage

Although traditional two-dimensional signs are still used abundantly, signage and **graphics** have taken on new looks (Figure 1–8). Airbrushed murals celebrating local landmarks, multilevel murals featuring a variety of montages, animated cartoon characters that move throughout the signage, **backlit transparencies**, light walls, prismatic displays, and digitally produced huge photographic blowups that rival outdoor billboards are just a few of the exciting approaches now used in retail environments.

Electronics continue to pervade retailers' premises. Fashion designer Norma Kamali began featuring each season's collections on numerous television screens in her New York City store windows. Today, the trend continues with major retailers all over the country— such as Bloomingdale's and Macy's—using television monitors throughout their stores to

Figure 1–8 Photographs and signage are combined in one visual presentation to capture the shopper's attention.
(Courtesy of Saks Fifth Avenue.)

show vendor collections. In addition to in-store video, retailers are using other electronic formats to capture shoppers' attention. For example, *Voila!*, a system by Advanced Interactive Video, Inc. of Columbus, Ohio, is an interactive directory used in shopping malls. The system highlights store sales and promotions and gives previews of upcoming events. It also automatically dispenses individual retailer coupons. *Instant Imagery* by R. D. Button Associates, Inc. of Randolph, New Jersey, is a computerized system that enables customers to see how they look in clothing without trying it on. The customer inputs his or her size and selects an outfit, which is then displayed on the person's image on a computerized screen.

Point of Purchase

In addition to the signage that abounds in retail establishments, there are point-of-purchase programs developed by manufacturers for retailer use. The **Point of Purchase Advertising International (POPAI)** reports that it now represents a $12 billion industry! Its president defines **point-of-purchase** merchandising as "displays, signs, structures and devices that are used to identify, advertise and/or merchandise an outlet, service or product and which serve as an aid to retail selling" (Figure 1–9). Industry reports revealed that whenever these programs were in evidence for specific brands, sales increased significantly. Examples of how the industry has gone from one that merely used signage to one that develops full programs are included in Chapter 15.

Sound Usage

Sound is not a visual element, but it is being used to enhance visual presentation. Professionals in the field agree that shoppers can turn away form visual elements, but sound is inescapable. The first early venture into sound for visual enhancement was made by Disney. In its Main Street environment in Disneyland, Disney determined that the attractions alone were not sufficiently stimulating. The incorporation of sound made them come to life. Sound is being used abundantly by retailers today to set moods and give shoppers news. At Warner Bros. stores, for example, Bugs Bunny's voice is used for the store directory. More and more retailers are

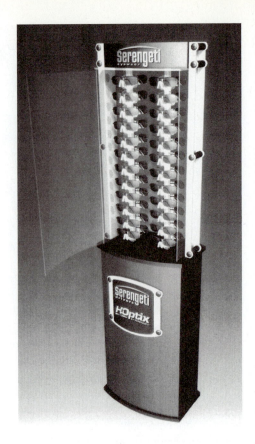

Figure 1–9 This Serengeti point-of-purchase display rack motivates the shoppers to help themselves to glasses. *(Courtesy of The Elliott Group.)*

using music to put shoppers in a buying frame of mind. Walk through many junior departments, for example, and you can hear a rock beat permeating the selling floor.

In order to keep up-to-date with the comings and goings of the visual industry and store design, it is imperative that those responsible for such endeavors read all of the periodicals that touch upon these subjects and attend the trade expositions that feature the latest in the field. One of the ways in which to learn about new trends, product offerings, and other pertinent news is by reading the trade periodical *Visual Merchandising and Store Design*, whose profile follows.

Visual Merchandising and Store Design Websites

One of the fastest ways in which to explore the visual merchandising and store design industry is by accessing **online resources** through the websites of individual businesses, trade organizations, and associations. At these websites, visual merchandisers and store designers are able to browse and learn about product offerings, innovations in design, industrial expositions and meeting places, company resources, directions for every visual component, and the like. Once the appropriate sites of interest have been selected, further investigation may be accomplished by e-mailing them or making in-person visits to get better acquainted with the products and services they provide for those involved in visual merchandising and store design.

The chart on page 13 offers selected websites that serve a multitude of needs. The list is by no means complete in terms of what is available on the Internet, but merely serves the purpose of introducing readers to the materials in the field and the organizations that benefit the industry's professionals.

SELECTED WEBSITES FOR VISUAL MERCHANDISERS AND STORE DESIGNERS

Organization Name	Website Address	Offerings
Institute of Store Planners	www.ispo.org	Information on store design
International Association of Lighting Designers	www.iald.org	Lighting information and products
International Council of Shopping Centers	www.icsc.org	Latest innovations in shopping centers
The Planning and Visual Education Partnership	www.visualstore.com/PAVE	An alliance of the major organizations dedicated to visual merchandising and store design
Clear Corp	www.clearrcorp.com	Major supplier of graphics
Pam International	www.pamint.com	Store equipment
Carol Barnhart Inc.	www.carolbarnhart.com	Mannequins, forms, decoratives, etc.
Point of Purchase Advertising International	www.popai.com	Marketing research regarding point-of-purchase
Visualstore	www.visualstore.com	Complete retail design and visual merchandising resource
Adel Rootstein	www.rootstein.com	Premier manufacturer of upscale mannequins
VM + SD	www.stmediagroup.com	Monthly magazine on visual merchandising and store design
Lightsearch.com	www.lightsearch.com	The source for lighting specifiers and buyers
The National Retail Federation	www.nrf.com	Major resource for information on retail industry
American Center for Design	www.ac4d.org	Primary source for design information
Color Marketing Group	www.colormarketing.org	Premier international association for color and design professionals

PROFILE: A Contemporary Visual Merchandising and Environmental Design Profile: *VM + SD*

The periodical "bible" of the visual industry is undoubtedly *Visual Merchandising and Store Design (VM + SD)*. Not only does it provide pertinent information to visual merchandisers and store designers about the field, it also enables others in every retail capacity to learn about innovative ideas that will help them to become better merchants. Its history as a visual publication dates back to the early part of the twentieth century when it was called *Display World.* At that time it concentrated primarily on store windows. When the term *display* was inadequate to describe the overall aspects of visual programs, its title was changed to *Visual Merchandising.* Another title change to *VM + SD* took place when it was obvious that these two components of design were compatible with each other and provided for overall premises excellence.

Produced monthly, *VM + SD* presents a wide range of materials, including innovations of retailers around the world and articles that address everything from signage and graphics to mannequins and lighting and the various resources from which they may be purchased. Once a year, a special issue, *Buyer's Guide*, provides store designers, visual merchandisers, construction services firms, photographers, and the retail industry association with a complete guide to resources needed to help them carry out their roles. Monthly announcements of conferences, exhibits, competitions, and events keep the industry aware of what is happening and where it is taking place. Articles written by the publication's editorial staff and industry experts who specialize in certain segments of the field appear in every edition.

The wealth of excellent photographs of innovative store designs and visual presentations enables readers to see, firsthand, what is happening that is newsworthy and, perhaps, how they can capitalize on it for their own use. Rounding out the magazine's offerings are advertisements of major companies that supply the visual merchandising and store design industries. Each ad clearly depicts the company's products and helps potential purchasers to learn about what is available to them.

In addition to the monthly publication, *VM + SD's* website, *www.visualstore.com,* offers the latest happenings in the industry and serves as a place where professionals can log on for information other than what is featured in the periodical.

Other Factors in Visual Merchandising

There are other factors that visual merchandisers consider on a day-to-day basis, primarily budgets and safety.

Budgeting

Retailers of all sizes must grapple with how much of the budget to allocate for their visual merchandising. No matter how much is earmarked to accomplish the store's goals, it never seems to be enough. Budgets are established in many ways, with the major department store organization using the most structured formats. The small, independent merchant, on the other hand, tends to be less disciplined about budgeting, particularly where visual presentations are concerned. This may be because the staff does not include visual professionals who can lobby for reasonable allocations or because these merchants view visual merchandising as something to be achieved with whatever resources are left over after stock purchasing, human resource costs, and advertising. Generally, there are three aspects to visual merchandise budgets, no matter how large or small the organization: display fixturing, materials and props, and labor costs.

Display Fixturing
Equipment of a more permanent nature, such as stands, platforms, pedestals, merchandise forms, and mannequins, is generally used for a long time (Figure 1–10). Except for the major department stores where specialized forms and mannequins are set aside for specific purposes (such as the mechanical ones often used at Christmas), this type of equipment is generally used for all presentations. Since the materials from which these forms are made are long-lasting, expenditures for this classification of display pieces are made infrequently, perhaps once a year or less often. Repairs to such equipment, such as mannequin restoration, often come out of a contingency budget.

Figure 1–10 Platforms and other fixtures must be considered in display budgets to give the visual merchandiser a wealth of items to use on the selling floor.
(Photograph by Ellen Diamond.)

More and more retailers are setting their sights on less costly mannequins, such as unisex types made of wire or other materials that can be used for many purposes. Creative visual merchandisers are even producing their own mannequin substitutes to feature merchandise. These forms are often very exciting and can be made inexpensively. Using a variety of basic materials, the trimmer comes up with forms that serve the retailer's purposes. We discuss how to build these original forms in Chapter 6.

Materials and Props The settings that we see in store windows or inside stores that set the scene for a display are changed frequently. Sometimes these backgrounds are painted or adapted for repeated use, saving the retailer a great deal of expense. For specific seasons such as Christmas, when glittery fabrics, imaginative mechanical devices, and other materials indicate a specific setting, it is difficult to use the same fabrics that worked well the rest of the year. The transformation of a store at this holiday period is costly. However, because it is a time when most retailers generate a major portion of their annual sales, budget cuts are not usually made at this time. The majority of retailers overexpend themselves at this time of the year and, if necessary, cut back on the moneys used for visual presentations for the remainder of the year. By borrowing props such as chairs, ladders, bicycles, and musical instruments from other businesses or from their own merchandise departments, retailers can stretch budgets (Figure 1–11). It is the creative visual merchandiser who can develop effective presentations when costs have been greatly reduced.

Labor Costs A look at any major store's organizational chart for the visual merchandising department indicates that a significant amount is spent on the staff who create, construct, and install the store's visual presentations. In special situations such as storewide promotions, the labor cost is further increased by overtime pay for the staff and by hiring temporary employees to complete the project. In small stores where freelancers are generally used, expenses increase when higher prices are charged by the freelancers.

Many chains have reduced their labor costs by turning to a variety of graphics instead of the traditionally used displays. Companies like The Gap, Banana Republic, The Limited, Abercrombie & Fitch, and Ann Taylor have taken the graphics route to curtail labor costs associated with traditional visual merchandising. In order to cut labor costs, some small retailers create their own displays or at least make some changes in merchandise presentation themselves between freelancer visits. By using **seasonless props** that are easy to change,

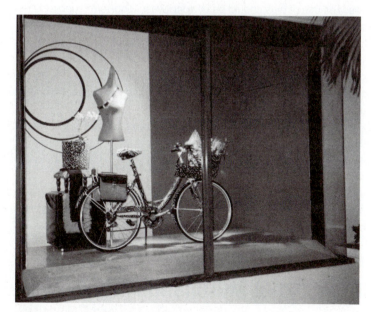

Figure 1–11 Bicycles are excellent props in displays and may be borrowed from other retailers without cost.
(Photograph by Ellen Diamond.)

retailers can reduce the labor cost of trimming. Although the expense for visual presentations may be considerable, most retailers agree that the visual impression is very important in attracting shoppers and that any investment in creative display pays off in the end-of-the-year bottom line.

The Safety Factor

Visual merchandise design is based on such elements as lighting, merchandise selection, and the principles of display employed to ensure success. In executing designs, the installers must always make certain that the presentation is safely produced. Most retailers are reluctant to discuss careless display work that resulted in injuries and lawsuits. An electrical wire that extends past the interior display area, an overhead sign that falls, or an unsecured mannequin that topples when a customer touches it are typical of the safety problems associated with display.

Safety is an important consideration on the job, for the well-being of the visual merchandising staff as well as the customers. The potential exists for someone to be burned by hot lights, shocked by faulty electrical equipment, or tripped by poorly placed wires. In order to prevent these accidents, the following precautions should be taken when working on an installation:

- When signs or graphics are suspended from the ceiling, a sufficient amount of space must be left for shoppers to walk under them. The signs must also be out of the shoppers' reach.
- Ceiling grills or grids should be used to suspend items. The use of screw eyes directly in a ceiling might not guarantee good support. If there is any doubt about the holding ability of screws, toggle bolts should be used for plaster or plasterboard ceilings.
- All parts of a mannequin should be secured, with special attention to the base plate and rod that attaches to the buttock or ankle. The support rods should be tightened to prevent toppling. Even when mannequins are used in enclosed windows and out of the reach of shoppers, automobile and pedestrian traffic could cause them to tip over. If base plates are not used, the mannequin should be wired to the floor by a process called **striking a mannequin**.
- Heavy-duty nails or screws should be used to secure merchandise or props to walls. The use of pins should be avoided when long-term support is needed.
- Three-dimensional letters should be attached with bonding materials such as hot glue, double-face foam tape, or headless nails called *brads*. Vibration or heat from light fixtures could cause letters to fall if they are not well attached.
- Lighting fixtures should be placed out of the customers' reach. Unprotected floor spotlights should not be used in interior installations where someone could get burned by touching one.
- Extreme caution should be exercised when using hot glue guns, spray paint, or any other tool that could cause damage or injury.
- Electrical wiring should be examined regularly to make certain there is no damaged wire that could start a fire.
- Suspending wire that is strong enough for its task should be used. Although nylon filament and number 30 (invisible) wire are common choices, they do have limitations. The supports should be tested before the display is completed.

Careers in Visual Merchandising

Whether you will be employed by a major department store, starting as an apprentice and rising through the ranks, work for a chain to trim the windows of several units, or go into business as a freelancer, a career in visual merchandising will require particular skills and

abilities. Some people have a natural color sense; others might be sufficiently talented to construct backgrounds that generate excitement. The challenge is to develop both what comes naturally and what can be learned from books and experience.

In order to prepare for a career in visual merchandising, several practical courses are beneficial. Courses in color, design, lighting, lettering, photography, advertising layout, prop construction, and general display techniques can give the prospective visual merchandiser the background necessary for success. Schools, colleges, and technical institutes across the country offer such courses either in degree programs or on a course-by-course basis.

Once the preliminary tasks have been mastered, you should prepare a resume. It should be about one page in length and should briefly describe professional training, educational accomplishments, and related experiences. A good resume is needed to compete with all of the others that companies receive from candidates. Booklets from the U.S. Department of Labor, online resources, computerized programs, and books on resume writing are available. You can also employ a professional resume writer to carry out the task. An appropriate cover letter should accompany the resume, outlining your interest in the position you are seeking. In addition to the resume, you should develop a **portfolio** of your visual merchandising projects. It should include samples of any work created either in class or on the job.

When seeking employment, there are several places to look. Trade periodicals such as *VM + SD*, *Women's Wear Daily*, and *DNR* feature classified ads, and consumer newspapers do the same. Contacting employment agencies and attending trade shows such as Shop East, Global Shop, Visual New York, and the Exhibitor Show in Las Vegas can turn up important leads. Once a prospective employer shows interest by granting you an interview, it is important to appear with a prepared portfolio of work and to present a professional and enthusiastic manner.

Proper attention to the details of a job search will ultimately match you with a suitable employer. Once you are hired, an exciting world filled with opportunity awaits you.

Trends in Visual Merchandising

As is evident in every aspect of retailing, companies are undertaking changes in visual programs and directions to maintain their places in this highly competitive business arena. With visual budgets sometimes strained, visual merchandisers have, by necessity, come up with new approaches to planning. Others without the constraints of limited funds have also embarked upon new approaches to their programs that they hope will generate excitement and transform "lookers" into customers. By all accounts, there are many trends, no matter what the budget, that are making headlines in the area of visual merchandising and environmental design. Some of the major trends in the field are listed here and will be given greater attention in the subsequent chapters in the book.

- *The increased use of graphics.* In just about every retailing venue, and in the stores that house them, the use of *graphics* is reaching new heights. Everything from the digitally produced "billboards" to graphics that feature motion is being utilized to capture the attention of the shopper.
- *Opulence in store design.* Throughout the country, upscale retailers are investing in store designs that are more extravagant than ever before. Companies such as Cartier and Ferragamo have taken facilities design to new heights in their New York City emporiums with extravagant fixturing, lighting, and other amenities to capture the upper-class market. The various trade papers indicate this is only the beginning and that retailers will be likely to continue these design endeavors for the foreseeable future.
- *The resurgence of mannequins.* In the past few years, many retailers have opted for less costly, more practical mannequins on which to display their merchandise.

Today, however, and for the foreseeable future, companies like Bloomingdale's and Nordstrom in the United States, and David Jones in Australia are following the trend of relying upon unique mannequins to enhance their facilities in place of the less costly "torso" and "headless" types that made their way into visual merchandising during the close of the twentieth century.

- *Innovative lighting.* A wealth of new ideas is now vastly improving lighting for interiors and visual presentations. Included are advances in color kinetics, new lensing systems that give a smoother appearance to the light beam, new lighting control systems, and greater energy efficiency in white-light LEDs.
- *Directional signage.* Studies show that the average customer spends only nine minutes in a store, so it has become essential for retailers to create **directional signage** that quickly directs the customer to the right place to find the desired products. To achieve this there is a trend toward greater use of hanging and framing systems. Companies like Rose Displays and APCO are addressing retailer needs with a wealth of new signage products that will more than likely become part of the interior landscape of the vast majority of large retail spaces.

It should be noted that these are only some of the trends that have been reported in trade periodicals such as *VM + SD*. Others will be addressed throughout the various chapters.

chapter review
key points in the chapter

1. The world of display has been expanded from a concentration on eye-catching windows to a concept of storewide visual merchandising that includes not only window and interior displays but how to present any and all merchandise for customer inspection, and create total, exciting environments. This includes the choice and use of functional and unusual lighting throughout the premises and signage and graphics that differentiate one part of the store from the others.

2. Merchandise presentation must be creative as well as functional so that customers can make purchases easily.

3. Borrowing from retailers, restaurants have successfully adopted the thematic approach and have transformed dining establishments into unusual environments.

4. By using the environmental or thematic approach to visual merchandising, merchants present the same setting throughout the year, without the need to change for seasons and holidays.

5. Visual merchandisers perform their duties for many different types of retailers, with each requiring the same basic preparation for success.

6. All retailers are confronted with the question of how to allocate dollars for their visual presentations. Included in their budgeting considerations are display fixturing, materials and props, and labor costs.

7. Safety plays an important role in visual merchandising. Carelessness in installation could result in injuries to store employees as well as shoppers.

8. The creation of effective presentations involves the appropriate mix of various components, such as color, lighting, fixturing, and signage selection and usage.

9. In order to keep abreast of the times, today's visual merchandisers must be aware of trends in the field. Contemporary trends include:
 - an increase in the use of graphics
 - opulence in store design
 - the resurgence in the use of mannequins, props, and materials that do not require purchasing
 - innovative lighting that is both functional and exciting
 - directional signage that reduces the amount of time needed to find particular departments and merchandise
 - interactive point-of-purchase devices
 - the use of sound as an attracting tool

10. A career in visual merchandising requires skill in a number of areas, each of which can be learned through formal instruction and on-the-job training.

terms of the trade

internet exercises

1. Log on to three department or specialty store websites for the purpose of learning about career opportunities in visual merchandising. If you do not know their specific websites, you can use any search engine, such as www.google.com, to discover them.

 Once you have settled on three choices, you should determine if any one provides an opportunity for employment. If the necessary information that you are seeking is unavailable on the websites, you should contact a human resources individual by e-mail, telephone, or fax, all of which are generally provided on the site, to learn more about potential visual employment. Once you have completed the task, write a brief summary of the jobs available in visual merchandising at each of the three companies.

2. Professionals in visual merchandising most often use the website www.visualstore.com when they are researching a problem related to visual presentation and store design. Pretending that you are a visual merchandiser, log on to this website and choose from the many areas of information, such as the retail designer list, associations, and *VM + SD* magazine, to determine what they provide in the way of current information to the professional in the field. Once you have chosen a particular area of interest, write a paper summarizing what you have learned about it.

discussion questions

1. How does the display person's job in today's retail environment differ from what it was in years past?
2. Define the term *visual merchandising*.
3. Define the *total environment concept* as used by some of today's retailers and restaurateurs.
4. In what way does the department store visual merchandiser's task differ from that of the freelancer?
5. What are some of the categories covered by the visual merchandising departments of most large department stores?
6. In what way can a store that utilizes mannequins reduce its outlay for such forms while still capturing the shopper's attention?
7. By what means can a visual merchandiser cut costs for materials and props?
8. Why must the visual merchandiser pay strict attention to safety when creating presentations?
9. What are some of the safety points that should be considered when planning and installing a display?
10. What are some of the types of illumination that provide both functional and dramatic effects?
11. What is meant by the term *point-of-purchase?*
12. What types of knowledge must the visual merchandiser possess in order to develop a career?
13. Discuss some of the major trends of visual merchandising in the new millennium.

Case Problems

Case 1

Faced with imminent human resources cuts in just about every division and reductions in budgeted expenditures for materials and supplies for the forthcoming year, the divisional managers at P. J. Marin, a midwestern department store, are preparing their recommendations for the new budget. The company had been a dominant force in retailing but has fallen on hard times. The board of directors has instructed management to cut expenses until profits improve.

The company's visual merchandising manager believes that the way to become more profitable is through promotion, with visual merchandising playing a key role. Mr. McCarthy, who heads visuals, has tried to convince management of the dangers of curtailing his budget at this time, saying that an increase would be in order to help alleviate the problem. Though he advocated a visual plan that would require an increase in spending, or at least remain at the current budgetary level, the powers at the top still directed a cut.

The budget for the visual area is divided into three parts: display fixturing, materials and props, and labor. It was suggested by the assistant visual manager that several trimmers be terminated and department managers be responsible for making interior changes. Another suggestion was to reuse last year's materials and props. Still another suggestion was to cancel the order for action mannequins earmarked for the active sportswear department.

The time has arrived when Mr. McCarthy must deliver a revised budget that not only will reflect dollar reductions but will still make P. J. Marin a force in visual presentation.

QUESTIONS

1. Do you agree with the company's plan to cut the visual budget? Defend your answer with sound reasoning.
2. Which, if any, of the suggestions are feasible?
3. What approach would you suggest to cut the budget and still make P. J. Marin a visually appealing store?

Case 2

Jane Livingston is a recent graduate of a prestigious art school. Her aspirations of becoming a fine artist have diminished with each art gallery's rejection of her paintings. She would someday like to break into the world of fine art with her creations, but, with funds at an all-time low, she is considering a career alternative.

Prodded by her friends, Jane is considering a field related to art—visual merchandising. Everyone feels she can easily make the transition from painting landscapes to creating attractive visual presentations because of her excellent background in design principles and color. Although she possesses the art background, she has never taken a professional course in display or visual merchandising and doesn't know where or how to begin.

One of her former professors suggested that a department store would be a perfect beginning for Jane. As an apprentice she would learn to apply her theoretical knowledge to on-the-job situations. Another acquaintance feels the chain store would be a wiser choice. Working for a major specialty chain with several hundred stores would offer a broad base of experience, he says. Finally, a relative is trying to convince her to take the freelance route. "Being your own boss would give you freedom that the other two approaches wouldn't offer," she says.

Jane has assembled a portfolio of her artwork to help break into the field of visual merchandising. She still hasn't decided, though, which route to take.

QUESTIONS

1. Does Jane have the qualifications necessary for a visual merchandising career?
2. Which route do you feel would be best for her to follow? Why?

exercises and projects

1. Visit a department store or specialty store to evaluate its window and interiors in terms of safety. Use the Evaluation Survey form that follows as a guide in your evaluation and prepare a report on your findings.
2. Make an appointment to interview someone in visual merchandising and prepare an oral report that includes the following information: career opportunities, salary potential, typical workday, academic preparation, and technical expertise needed for employment. The interviewee may be someone employed by a company or working as a freelancer.
3. Using this chapter as a guide, prepare a resume for a hypothetical job in visual merchandising for a department store, for a chain organization, or as a freelancer.
4. Put together a portfolio of work for use in securing a visual merchandising position. Make certain that all samples of your work (photos of displays, lettering, layouts, etc.) are carefully mounted on presentation board or in a binder.

NAME: _____ **DATE:** _____

EVALUATION SURVEY

Store Name _____ Store Classification _____

Mannequin placement _____

Hanging signs _____

Light fixtures _____

Interior prop placement _____

Accessible display merchandise _____

(PhotoEdit Inc.)

addressing
consumer
visual mer

Objectives

After completing this chapter, the student should be able to:

... Discuss the importance of multicultural demographics to visual merchandising efforts.

... List the order in which the major minority ethnicities are ranked.

... Explain the cultural differences among the major minority groups.

... Describe the new approach to mannequin design that helps make a greater impact on African-American consumers.

... Discuss how signage helps make Hispanic shoppers feel more welcome in retail shopping environments.

... Describe the wealth of graphics used by many merchants in an attempt to encourage minority purchasing.

multicultural needs through chandising

Introduction

As we learned in Chapter 1, The Visual Merchandising Concept in a Contemporary Environment, ethnic diversity warrants specific attention from the retailer in terms of visual merchandising approaches. Where historically all cultural market segments were treated as one, a time for change has been on the horizon for the past few years. With the African-American and Hispanic populations, most notably, steadily gaining in numbers, and the Asian-American population to a lesser extent, many retailers have taken steps to make them more comfortable when shopping in their stores. One of the ways that merchants have started to attract more minorities into their stores is through visual presentation. More and more retailers have, for example, begun to use a wealth of graphics that feature minority images, signage that is in Spanish for the Latino market, and mannequins that depict African-American or Asian-American models instead of Caucasians.

Before an exploration of the ways in which merchants can attract ethnic minorities into their stores through visual presentation, there should be a measurement of the potential for such patronage—the numbers that each ethnicity occupies in the overall population, their spending habits, and other considerations—termed **multicultural demographics**.

The Demographics of the Multicultural Population

Although American Caucasians still outnumber any of the other ethnicities, African Americans, Hispanics, and Asian Americans are beginning to close the gap. They are the major minorities that retailers interface with in most parts of the country, especially in the major cities across the nation. Whether it is fashion merchandise, food products, cosmetics, or many other product categories, the need to assess their desires and the manner in which visual merchandise can attract them to the store's offerings is of paramount importance.

Considered to be important are population figures, buying power, and household mean income, as discussed next.

Population Figures

The most recent population figures available from the U.S. Census Bureau estimate that minorities are closing the gap with Caucasians. African Americans experienced some growth, but recent figures indicate that the Latino population is growing faster than any other minority in the United States. Lagging behind are Asian Americans, but their growth in particular areas signals significant increase.

The figure on page 25, provided by the U.S. Census Bureau, shows the U.S. population by race. It clearly indicates that the Hispanic or Latino population is enjoying the biggest increase.

Also noteworthy for those retailers who have significant numbers of Hispanics in their trading areas—such as Los Angeles, New York, Miami, Houston, and Chicago, the five leaders in the country—is the projected U.S. Hispanic population from 2010 to 2050.

Buying Power

Although the **buying power** of the minority ethnicities pales in comparison with that of Caucasians, their numbers also indicate significant retail purchasing potential. African Americans lead the way, with Latinos second and Asian Americans third. Together, according to the Selig Center for Economic Growth in Athens, Georgia, spending of these groups will reach $3 trillion by 2011. This projection is making companies like Kohl's, Wal-Mart, Sears, and others step up their visual programs to attract these ethnicities.

U.S. POPULATION BY RACE AND HISPANIC ORIGIN

For 45.5 million Hispanics in the U.S. in 2007

	2007	2006	CHANGE	% CHG
Total population	301,621,157	299,398,484	2,222,673	0.7
White	241,166,890	239,746,254	1,420,636	0.6
Black or African-American	38,756,452	38,342,549	413,903	1.1
American Indian/Alaska Native	2,938,436	2,902,851	35,585	1.2
Asian	13,366,154	13,159,343	206,811	1.6
Native Hawaiian/Pacific Islander	537,089	528,818	8,271	1.6
Two or more races	4,856,136	4,718,669	137,467	2.9
Hispanic or Latino	45,504,311	44,321,038	1,183,273	2.7
Not Hispanic (of any race)	256,116,846	255,077,446	1,039,400	0.4

SOURCE: *U.S. Census Bureau, annual estimates of the population by age, sex, race, and Hispanic origin; and estimates of the number of housing units. The 2007 population estimates start with a base population for April 1, 2000, and calculate population estimates for July 1 for years 2000 to 2007, released May 1, 2008.*

PROJECTED U.S. HISPANIC POPULATION

Versus total U.S. population

TOTAL POPULATION	2000	2010	2020	2030	2040	2050
Total U.S.	282,125	308,936	335,805	363,584	391,946	419,854
Hispanic (of any race)	35,622	47,756	59,756	73,055	87,585	102,560
NUMERICAL CHANGE	'00-'50	'00-'10	'10-'20	'20-'30	'30-'40	'40-'50
Total U.S.	137,729	26,811	26,869	27,779	28,362	27,908
Hispanic (of any race)	66,938	12,134	12,000	13,299	14,530	14,975
PERCENT CHANGE	'00-'50	'00-'10	'10-'20	'20-'30	'30-'40	'40-'50
Total U.S.	49	10	9	8	8	7
Hispanic (of any race)	188	34	25	22	20	17
PERCENT OF TOTAL POPULATION	2000	2010	2020	2030	2040	2050
Total U.S.	100	100	100	100	100	100
Hispanic (of any race)	13	15	18	20	22	24

SOURCE: *U.S. Census Bureau. Population in thousands.*

Household Mean Income

After Caucasians, Hispanics are next in greatest **household mean income**, followed by African Americans, then Asians. It should be noted that the African-American and Hispanic populations are very close in mean income.

Figure 2–1 Ethnic minorities are now the focus of many retail organizations.

Figure 2–2 The Latino population has now surpassed the African-American population.

Trends indicate the following for retailers to consider:

1. For the first time, the Hispanic population has surpassed the African-American population. In fact, by 2050, one in four workers in the United States will be Latino (Figure 2–2).
2. By 2010, it is expected that minorities will comprise about one-third of the general population, thus making it necessary to plan visual presentations that will address this population shift.
3. The buying power of blacks, Latinos, and Asian Americans continues to increase, making them excellent consumer groups to be targeted by retailers. Most notable is the Hispanic population's buying power, estimated to be about $1 trillion by 2010.

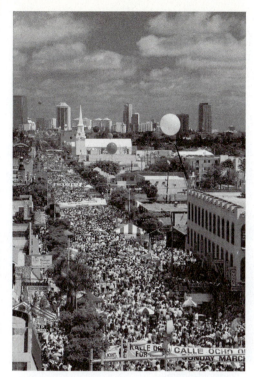

Figure 2–3 Many American cities are achieving significant minority growth.

Figure 2–4 African Americans continue to be major purchasers of fashion products.

4. Between now and 2020, the three major ethnic populations are expected to grow at six times the rate as the nonethnic population. In terms of percentages, the ethnic population will grow by 36 percent and the nonethnic by only 6 percent.

5. Cities in the United States that are achieving such major growth include Miami, Los Angeles, New York, Houston, San Francisco, Dallas, Washington, Chicago, Atlanta, and Philadelphia, making them especially ripe for increased visual merchandising efforts (Figure 2–3).

6. African Americans continue to make clothing and accessories purchases the single most important expenditure after they have satisfied their basic needs (Figure 2–4).

7. Cosmetics, fragrances, and beauty aids continue to capture the attention of African-American women.

8. With many Hispanic designers and celebrities coming to the forefront in fashion merchandise and cosmetics, the attention paid to them by Latina women is increasing.

9. Although they rank third behind African Americans and Latinos, Asian Americans are especially favored by retailers because they account for the highest mean household income (Figure 2–5).

Cultural Differences within Minority Groups

Although Hispanics and Asian Americans are usually grouped as individual classifications, there are cultural differences within these groups that need separate attention from the retailer's visual merchandising offerings. For example, the Hispanic population is comprised of Cubans, Mexicans, South Americans, Central Americans, and so forth. Each group should be addressed in a manner that best serves their needs. A visual presentation should concentrate on one of these minorities with displays that are most likely to gain their attention.

Similarly, the Asian-American market includes more than fifteen ethnic groups and origins, such as Chinese, Japanese, Korean, Vietnamese, and so forth. Each has its own needs and should be adequately addressed in visual merchandising.

Figure 2–5 Asian Americans account for the highest mean household income.

To make certain which of these need specific attention, organizations such as Florida-based Market Segment Research should be contacted. For further clarification, the U.S. Census Bureau is an efficient resource.

Relying on an overall classification, such as Hispanic, does not really provide sufficient information.

Reaching Ethnic Groups through Visual Merchandising

Walking through the aisles of many retail establishments will quickly underscore that merchants are putting forth significant effort to make minorities feel comfortable in the retail surroundings, and are attempting to motivate them to buy. Where signage was once solely spelled out in English, Spanish is now often used. Graphics, a leading attention-getter in many stores, are now using more and more blacks, Hispanics, and Asians in their presentations, or at least showing these ethnicities along with Caucasians. Even more dominant in window and interior displays is the use of ethnic mannequins along with caucasian.

Mannequins

In an industry that once primarily used Caucasian mannequins as its mainstay, the trend has been for the incorporation of **ethnic mannequins** in the window and interior displays. More and more merchants, at all levels of retailing, are expanding their mannequin inventories to include African-American, Hispanic, and Asian models (Figure 2–6). The styles range from the upscale, traditional designs of Adel Rootstein, considered to be the epitome of mannequin creativity, to more stylized versions that emphasize ethnicity. In the Rootstein collections, in particular, a wealth of high-fashion ethnic mannequins has captured the essence of minority cultures. One of the mannequin companies that has embraced ethnically designed mannequins is Pucci. Long a leader in high-fashion mannequin production, the company now features complete lines of African-American and Hispanic models. Instead of using the traditional runway models as their inspirations, Pucci has used the figures of such celebrities as Jennifer Lopez and Beyonce to sculpt its ethnic collections. Most noteworthy of these designs are their

Figure 2–6 Many retailers are expanding their ethnic mannequin inventories.

curvaceous dimensions: They average about 2½ inches greater in curviness than the traditional offerings, to better emulate the typical figures of minority women.

In the world of sexy high fashion, evidence of the ethnic mannequin is on display at Victoria's Secret. A mix of these ethnic mannequins is now being regularly used along with the traditional Caucasian types. It is important in areas that serve a mix of ethnicities to make certain that those represented in the trading area are represented in mannequin form. It is only necessary to restrict mannequin usage to one culture if the theme of the display is directed to that consumer. For example, if the theme is Black History Month, the mannequins should all be African American.

The depth and breadth of ethnic mannequins are in evidence by the large numbers being produced by a variety of manufacturers. The following table identifies some of the more prominent in the field.

Company	Location	Telephone
Rox Studio	East Brunswick, NJ	732-246-7058
Trio Display	San Diego, CA	800-454-4844
Mannequinexpert.com	Commack, NY	631-367-2005
Mondo Mannequins	New York, NY	212-255-2117
Rootstein	New York, NY	212-645-2020
Goldsmith	New York, NY	212-366-9040
Ralph Pucci	New York, NY	212-633-0452
Greneker	Los Angeles, CA	323-263-9000
Patina-V	City of Industry, CA	626-961-2471
Mannequin Madness	Oakland, CA	510-444-0650

Signage

With signage a major part of today's visual merchandising picture, it is important for the messages to be appropriately displayed—whether it is merely a greeting to shoppers, a sign that accompanies a particular window presentation, or an in-store visual offering.

In cases where there is a preponderance of one or more ethnicities, it is imperative that the different visitors to the store feel that they have been recognized. Where traditional signage

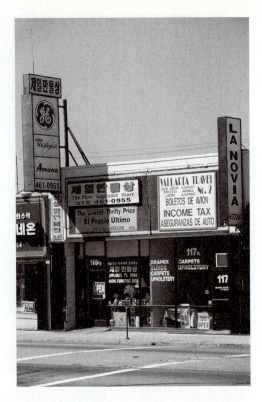

Figure 2–7 Much signage is in Spanish to attract the ever-growing Hispanic population.

that was spelled out in English was once considered sufficient for all shoppers, this is no longer appropriate. It is especially important for the messages to be in Spanish for the Latino customer, the largest of the multicultural market (Figure 2–7).

Some of the signage guidelines are as follows:

- *Installation of **multilingual signage***. This gives immediate recognition to consumers who are of different cultures and indicates that all are welcome as shoppers.
- *Placement of a welcome sign in a community's dominant tongue*. While many Latinos, for example, read English, significant numbers are only fluent in Spanish. This signage immediately informs shoppers that there is an awareness of the minority's needs.
- *Use of phrases and terms that have meaning to the shopper*. While English is spoken by African Americans, there are some words and expressions to which some may better relate. Using a straightforward, common-language approach will not always be as effective. This is particularly true when the market is comprised of teens and young adults. The same holds true for the Hispanic audience.

Some of the major "do-it-yourself" retailers have recognized the importance of the Hispanic community to their success. Many of their stores located in heavily populated Hispanic areas feature **bilingual signage**. This not only helps those with limited or little English language usage to learn about the stores' products but also makes those who do understand English feel that they are welcome in the stores.

In order to develop signage and other display materials that have multicultural appeal, it is beneficial to contract with an agency that specializes in ethnic marketing techniques. One of these agencies is BLH Consulting, an Atlanta, Georgia–based organization that specializes in the African-American and Hispanic markets. Another that targets the Latino market is San Antonio, Texas–based Garcia 360.

Graphics

One of the less expensive ways for visual merchandisers to attract the attention of their customers who are ready to shop or browsers who visit their stores to assess their inventories is with the use of **multicultural graphics**. More and more retailers are using these devices to attract attention without spending significant sums.

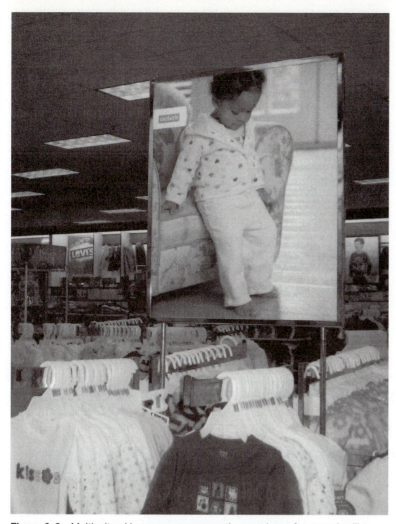

Figure 2–8 Multicultural imagery now graces the premises of companies like The Gap, Target, and Kohl's.
(Photograph by Ellen Diamond.)

It is with these visual pieces that come in a variety of sizes that multicultural images may be projected (Figure 2–8). Companies like The Gap, Target, Kohl's, and numerous department stores utilize these visuals both in their store windows and interior premises. Photographs of minority designers as well as typical shoppers from every ethnicity can be seen gracing these premises. The consumers depicted range from the very young to more mature representatives and are found in departments that feature the appropriate merchandise for these age groups (Figure 2–9).

A Profile of Kohl's shows how the retailer utilizes graphics to make its premises more inviting to multicultural shoppers.

Some of the offerings feature a mix of ethnicities while others focus on one particular culture. No matter which format is used, the basic principle is to make multicultural shoppers feel a sense of belonging. The actual enlargements run the gamut from those that are solely images of people to those that combine the visuals with pertinent copy.

Interior placement varies from store to store. Some graphics are used near store entrances to give the immediate impression that all ethnicities are considered as equal in terms of satisfying shopping needs. Others are prominently displayed on department walls, in floor stands, and on easels. Still others "fly overhead" so that they can be seen from high-traffic areas.

For those retailers who do not have access to in-store visual experts, there are excellent suggestions available regarding the use and availability of graphic blowups from www.photographyblog.com. It is a free website that answers questions regarding graphics usage. Other websites of interest are www.dreamstime.com and www.istockphoto.com,

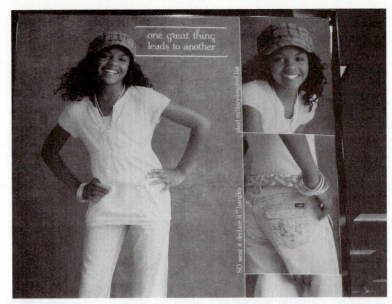

Figure 2–9 Ethnic mannequins are used in signage at many retail operations. *(Photograph by Ellen Diamond.)*

which offers images at very low cost to the retailer. For hanging graphics, an excellent source is www.begardenchic.com.

Of course, for individual preferences, the major retailers create their own graphics specific to their needs.

Institutional Display Presentations with Multicultural Appeal

Retailers are increasingly expanding their appeal to multicultural audiences with window displays that acknowledge ethnic minority endeavors. Many are using **institutional display presentations** to capture the attention of these audiences. Much as advertising and promotional endeavors are used to underscore the presence of ethnic diversity to their shoppers, visual merchandising, most notably in store windows, is doing the same.

The themes of such displays range from single displays to full-scale presentations. The focus might be on Black History Month, a salute to African-American designers, Asian designers that have achieved fashion stardom, or anything that might acknowledge local or national multicultural topics or groups.

It is the creativity of the visual team that can address themes that appeal to minority groups and motivate them to become part of the retailer's consumer base.

Kohl's Corporation is "a family-focused, value-oriented specialty department store." Founded in 1962, its merchandise mix includes apparel, footwear, bedding, furniture, fashion accessories, beauty products, electronics, and housewares. Based in Menomonee Falls, Wisconsin, it operates more than one thousand stores in forty-eight states. In a time when the American economy was in the midst of a meltdown in 2008, Kohl's took the unusual step of opening forty-six stores on a single day in nineteen states. While others were downsizing or curtailing their operations, the company moved ahead with its mission to become "the leading value-oriented, family-focused specialty department store" in the United States.

In addition to savvy merchandising and its commitment to adhering to the U.S. Green Building Council's LEED standards for environmentally friendly structures, it has embraced a multicultural audience with its significant use of in-store graphics.

Upon entering the stores, shoppers are immediately greeted with graphics that depict cultural diversity. Whether it is large blowups of ethnic designers whose creations are exclusively sold at the store—such as Hispanic personality Cristina Saralegui's Casa Cristina collection, Asian American Vera Wang's Simply Vera Wang offerings, or Latina celebrity and actress Daisy Fuentes, whose apparel has become nationally known—or the multitude of graphics featuring African Americans, Hispanics, and Asian Americans of all ages, the store quickly makes shopping there a welcoming experience for people of all cultures.

A look at the visual merchandising approach used by Kohl's suggests that the way to go is with the significant use of these oversized graphics that appear everywhere in the stores.

chapter review

key points in the chapter

1. Many retailers have taken significant steps to make minority consumers feel more comfortable in their stores.
2. The demographics of the minority populations indicate that there will be more and more growth, making them excellent targets for retailers.
3. African Americans, at this time, are the most important segment of the minority population in terms of buying power.
4. By 2050, it is expected that one in four workers in the United States will be Latino, making this group an important prospect for retailers to target.
5. Many mannequin producers are manufacturing ethnic mannequins to meet the needs of retailers who are using them to appeal to minority consumers.
6. Multilingual signage is becoming a permanent part of many retailers' environments.
7. Many retailers are utilizing the services of agencies that specialize in ethnic marketing techniques to improve their capture of minority consumers.
8. Graphics featuring minority designers and consumers are being used by retailers to motivate more purchasing from multicultural bases.

terms of the trade

bilingual signage 30
buying power 24
ethnic mannequins 28

household mean income 25
institutional display presentations 32
multicultural demographics 24

multicultural graphics 30
multilingual signage 30

internet exercises

1. Using any search engine, such as www.google.com, locate an agency that specializes in signage with multicultural appeal. From the information gathered, describe how the company targets African-American, Hispanic, and Asian-American markets with appropriate signage.

2. Research five mannequin manufacturers and discuss the types of mannequins they have available to target multicultural consumers.

1. Why are merchants becoming more aggressive in using visual merchandising to attract minority purchasers to their stores?
2. What is the order of buying power for the three major ethnic population segments?
3. What are some of the major trends in the population explosion that have ignited retailer interest in minority consumers?
4. Why can't retailers treat all of the Asian-American market as one?

5. How have mannequin producers helped merchants motivate minority shoppers to feel comfortable in their environments?
6. How are the measurements of African-American and Latina mannequins different from those of Caucasian forms?
7. In what ways is signage being used to appeal to Hispanic shoppers?
8. What types of graphics are being used in retail environments to appeal to minority shoppers?

Case Problems

Case 1

In the retail business for thirty-five years, Caroline and Company has catered to women with a complete assortment of apparel, shoes, fashion jewelry, handbags, and other accessories. The company originally started as a single operation but has grown into a small chain with ten units within a one-hundred-mile radius. Its clientele has remained the same in terms of disposable income, lifestyle, and fashion enthusiasm. The majority of its customers range in age from twenty to sixty, with some on either side of those age classifications. In the group are singles, married women with children, single moms, empty-nesters, and others.

The only change that has taken place in all of its units is the ethnic makeup of the customers. Over the years, the clientele that was once predominantly Caucasian is now of mixed ethnicities. More and more African Americans and Latinas have moved into its trading areas and have become regular customers of the stores. Their shopping needs and habits are primarily the same as those of their earlier, almost totally Caucasian patrons.

With significant numbers of people from different cultures visiting its stores, management has decided it would be beneficial to make some changes to encourage the now multicultural clientele to feel at home while shopping. In addition to employing many African Americans and Hispanics to work for the company, management also would like to make the visual environment multiculturally-friendly.

QUESTION

1. With little monetary expenditures, what visual merchandising could the company employ to make the sales floors more appealing to the ethnicities that shop there?

Case 2

The Clothing Shack is a small chain of eight stores that specializes in trendy fashion merchandise. Its target market is the teenage to mid-twenties segment. When The Clothing Shack established the company fifteen years ago, its clientele was typically Caucasian. Over the years, however, its stores have witnessed an increase in traffic from a more diverse population, with African Americans and Hispanics in particular becoming more and more visible. Although the Caucasian population is still predominant in its trading areas, there has been a population shift that signals more and more minorities are making their homes near Clothing Shack stores. Being ahead of the curve in terms of merchandising changes and other practices has made the business extremely profitable.

At this point in time, with the potential for a shift in the makeup of its customer base, The Clothing Shack wants to make certain that its new customer mix will be properly addressed in the coming years. Management plans to use a variety of visual merchandising approaches that would make the shops more "minority-friendly." However, with this goal in mind, management wants to make certain that its efforts are appropriate for the population shifts that are to come.

QUESTIONS

1. Without considerable expense, how might the business learn more about the predicted future minority population shifts in its trading areas?
2. Is it advisable to immediately adjust The Clothing Shack's visual merchandising practices to include new mannequins, signage, and graphics?

exercises and projects

1. Visit any large department store to assess its use of ethnic mannequins. Ask permission to take pictures of them and place them on a foam board for use in a class presentation in which you will describe the styles of each and how they differ from the standard, traditional types. Also make an assessment as to their numbers in relation to the overall number of mannequins in the store.

2. Make a trip to a large chain such as Target, Wal-Mart, or Kohl's to assess their use of graphic blowups that feature minority images. Describe to the class whether the images are of consumers, ethnic designers, or a combination of both.

planning and
visual pre

(Photograph by Ellen Diamond.)

developing
sentations

Introduction

Consumers examine store windows and interiors to seek out the merchandise that will satisfy their needs. Few ever realize the planning that went into creating the presentations that whet their appetites and tempt them to purchase. Although the conception and mechanics of most displays are secondary in importance to the merchandise being offered, it is often true that the shopper would not act on a desire for merchandise if its presentation were not so striking. The lone exception is the institutional display, which will be explored later.

Only students of retailing, or more specifically visual merchandising, can really appreciate the trials and tribulations associated with creative visual presentations. The shopper may admire a display but is seldom inquisitive about how it was put together. For students of retailing, an understanding of the various approaches to the planning, development, and execution of visual installations is essential. How are the visual concepts born? Who creates the formats? Who installs the displays? These are just some of the questions that must be answered to fully comprehend the work that goes into visual presentations.

Generally, there are three approaches to achieving satisfactory displays and visual merchandising formats, depending on the size and organizational structure of the retailing operations. Traditionally, department stores expend the major effort in terms of dollars and involvement in visual merchandising. One need only observe the window and interior presentations to immediately understand the complexity of the department store's visual program. A careful study of the dramatic Christmas windows by such retailing giants as Lord & Taylor, Macy's, and Saks Fifth Avenue shows that these are major undertakings. Chain stores usually take a different route. Many chains have centralized visual facilities at corporate headquarters where the ideas for visual presentations are born and then disseminated to individual branches for installation by a store manager, or sometimes a trimmer who works in one of the company's regions. Finally, the smaller merchant who recognizes the value of professional visual installations but doesn't have the staff to deal with the creative complexities of visual merchandising takes yet a different approach, employing the services of a **freelancer**.

This chapter focuses on the approaches used by department stores, chain organizations, and independent retailers to achieve visual presentations that will turn shoppers into customers.

Department Store In-House Visual Departments

Every major department store organization—whether it be of the full-line variety such as Macy's and Bloomingdale's that carries an assortment of hard goods and soft goods or the specialized types such as Saks Fifth Avenue and Bergdorf Goodman—has its own **in-house visual merchandising department** (Figure 3–1). These departments are so important to the giant retailers that their directors often carry the title of vice president. Where a store formerly had a display department with major emphasis on windows, today it has a full-blown visual merchandising department or division with responsibility for everything in the store that has a visual orientation. With the enormous growth and expansion into branch stores, the visual presentations that are planned for the flagship store must be applicable to these units as well. There must be a unity of presentation in both the fixturing and the themes.

The effectiveness of seasonal merchandise promotions depends on several components of the visual staff's management plan, such as (1) overall comprehension of the plan, (2) the ability to set and meet target dates, (3) implementation of the promotion, and (4) interdepartmental coordination. Too often store plans go astray because the specialized areas work independently, as if their responsibilities and roles do not require cooperation from

the other areas. For example, an advertising campaign will only prove successful if the visual merchandise presentations complement what is highlighted in the advertisements. If the bright colors and lively theme emphasized in the advertisements are not part of the store's display, the shopper who was motivated by advertising to enter the store may lose interest, once inside. If the shopper fails to see any tie-in to the advertised theme, he or she may quickly leave the store.

Without question, extensive planning is a key element in the success of any retailer's visual presentation. Generally, major stores begin this planning process at least six months in advance. This allows enough time to purchase props and supplies, make any needed alterations to the existing displays, and coordinate efforts with other sales promotion departments, such as advertising. Most major department stores use window schedules to carefully spell out the events that will take place in the store on particular dates.

Note in the featured Lord & Taylor example in Figure 3–2 that each window bears a number for easy identification and a brief description of which merchandise will be featured. In order to accomplish the difficult task of guaranteeing a unified approach to the store's promotion emphasis, some major stores have a **kick-off seminar** for employees who have some relationship to merchandising and its promotion, including advertising, special events, publicity, and visual merchandising. In addition to those involved in promotion, the audience generally includes buyers, merchandise managers, store managers, group managers, and department managers, all of whom are involved in merchandise selection and placement and whose input might help direct the store's merchandise promotions.

Figure 3–1 In-house window display director at work planning a visual presentation.

UPDATED WINDOW SCHEDULE					
WINDOWS 15 & 14 38TH ST CORNER	**WINDOWS 13, 12, 8, 7 5TH AVENUE**	**WINDOWS 7D, 6D, 5D, 4D DREICER BLDG 5TH AVENUE**	**WINDOWS 11 & 9 FRONT ENTRANCE 5TH AVENUE**	**SMALL WINDOWS & SHADOW BOXES**	**SUNDAY ADS IN CONJUNCTION WITH WINDOWS**
INSTALL TUESDAY	**INSTALL TUESDAY**	**INSTALL WEDNESDAY**	**INSTALL THURSDAY**		
JULY 30 Continued	**JULY 30** Continued	**JULY 31** incl. Windows 7, 8 DKNY Color TBC	**AUGUST 1** Continued		**AUGUST 4**
AUGUST 6 A-Line	**AUGUST 6** A-Line Lime/Purple with mailer	**AUGUST 7** Continued	**AUGUST 8** Yeohlee Purple Velvet 2 figures		**AUGUST 11** Nautica NYT 5 × 21
AUGUST 13 Continued	**AUGUST 13** Continued	**AUGUST 14** Nautica Women's	**AUGUST 15** Continued		**AUGUST 18** Polo Jeans NYT 5 × 21
AUGUST 20 Lauren Ralph Lauren	**AUGUST 20** Lauren Ralph Lauren	**AUGUST 21** Continued	**AUGUST 22** Polo Jeans Men's/Women's		**AUGUST 25** Lauren by Ralph Lauren NYT 12 × 21

Figure 3–2 An excerpt from a Lord & Taylor window schedule spells out displays to be installed and corresponding ads. *(Courtesy of Lord & Taylor.)*

```
                         VALENTINE'S DAY
                     PRESENTATION GUIDELINES
                       TABLE OF CONTENTS

OVERVIEW                                                    1

PART I:
MERCHANDISE PRESENTATION GUIDELINES
         WOMEN'S AND MEN'S FRAGRANCES SELLING              2
         WOMEN'S FRAGRANCES                                3–7
         MEN'S FRAGRANCES                                  8–12
         COSMETIC ACCESSORIES                              13–15
         JEWELRY                                           17–20
         ACCESSORIES                                       21–24
         INTIMATE APPAREL                                  25–28
         MEN'S FURNISHINGS                                 29–32
         GIFTS                                             33–38
         FINE JEWELRY                                      39

PART II:
VISUAL MERCHANDISING GUIDELINES                            1–28
```

Figure 3–3 A Presentation Guidelines Table of Contents.
(Courtesy of Lord & Taylor.)

The Lord & Taylor Approach

Most companies publish a visual merchandising directions book similar to the one used by
Lord & Taylor that features merchandise presentation guidelines (Figures 3–3 through 3–6).
These books are carefully detailed so that nothing is left to chance. For holidays and special
events throughout the year, detailed presentation guidelines cover everything from schedules
to special needs and presentation techniques. To show how detailed these planning books
are, we include a number of illustrations from a typical Lord & Taylor Merchandise Presenta-
tion Guidelines book. Although such books have a wealth of charts and graphs directed to-
ward merchandise managers and buyers, in addition to visual merchandisers, the examples
chosen deal specifically with the visual staff and its role in the Valentine's Day presentations.
This format is used for every event in the store.

 The Guidelines tell the trimmers (those people who install the displays) exactly which
props to use for the upcoming holiday event. Additional instructions are listed under Special
Notes to make certain that every detail is properly followed. The instructions also include a
summary called "Steps to a Successful Seasonal Presentation." This guarantees that if faith-
fully followed, the end result will be perfect.

 In order to make certain that the actual displays are executed as planned, drawings
for specific presentations accompany the written instructions. The example drawing in
Figure 3–7 shows how a plexi promotional bag riser should be trimmed for Lord & Taylor's
Valentine's Day promotion.

 An important part of the fragrance displays for the featured Lord & Taylor Valentine's
Day promotion requires the use of in-house-produced hat boxes. Detailed steps for the con-
struction of the boxes, and how they should be stacked for the finished display, are illustrated
in Figures 3–8 and 3–9. The step-by-step construction of the hat boxes eliminates the need
to produce and ship the props from the flagship store to the branches, which saves the
company packing and shipping costs.

 Rounding out the Merchandise Presentation Guidelines package are a wealth of
other ideas and instructions for the trimmers in the branches to use, from how to use
streamers to stacking gift boxes in a display. If the trimmers carefully follow all of the out-
lined procedures, the stores will have uniform visual merchandising presentations for the
Valentine's Day holiday.

VALENTINE'S DAY
PRESENTATION GUIDELINES OVERVIEW

KEY DATES

TUESDAY, JANUARY 15	VISUAL SET-UP COMPLETE
TUESDAY, JANUARY 23	SIGNS IN-STORE
WEDNESDAY, FEBRUARY 14	VALENTINE'S DAY
THURSDAY, FEBRUARY 15	VISUAL TAKE-DOWN

SIGNING

11×17 GENERIC: TO BE USED IN CONJUNCTION WITH THE VISUAL PRESENTATION
22×28 GENERIC: USE THROUGHOUT THE STORE, ESPECIALLY AT KEY ENTRANCES
"WHAT A PERFECT PRESENT": COSMETICS, JEWELRY, INTIMATE APPAREL, MEN'S FURNISHINGS

ITEM PRESENTATIONS
— ALL VALENTINE'S MOTIF MERCHANDISE SHOULD BE PROJECTED FORWARD AS A SINGULAR PRESENTATION WITHIN ITS PARENT DEPARTMENT.

SPECIAL NEEDS
FRAGRANCES:
— MERCHANDISE ONE FRAGRANCE PER TABLE WHERE POSSIBLE.
— STORES CAN FEATURE FRAGRANCE GIFT SETS WITH KEY ITEMS SKUS ON ROUND TABLES WHERE POSSIBLE.
— ALL OPEN SELL SKUS MUST BE TICKETED.
— HATBOXES: L&T SIGNATURE HATBOXES CONTINUE TO BE IMPORTANT NOT ONLY FOR VALENTINE'S DAY BUT THROUGHOUT THE YEAR.
— STORES MUST REFER TO EITHER THE ENCLOSED GUIDELINES OR THE HATBOX VIDEO WHEN CREATING FRAGRANCE HATBOX GIFTS USING EXISTING STOCK OF HATBOXES.
SMALL BOXED MERCHANDISE:
— USE ROUND TABLES WITH PLEXI LIPS AND BUILD-UP ON RISERS.

PRESENTATION
— CONCENTRATE ALL KEY ITEMS IN ONE AREA WITHIN THE PARENT DEPARTMENT TO CREATE A GIFT-GIVING ENVIRONMENT.
— BY FEBRUARY 1ST, ALL RED AND PINK MERCHANDISE SHOULD BE PROJECTED FORWARD WITHIN ITS PARENT DEPARTMENT TO ENHANCE THE VISUAL PRESENCE THROUGHOUT THE STORE.

FIXTURING
— STORES SHOULD UTILIZE ALPHA TOWER AND ROUND TABLE CONFIGURATIONS TO CREATE A VALENTINE'S DAY ENVIRONMENT WHEREVER POSSIBLE (CONCENTRATE FIXTURE CONFIGURATIONS IN COSMETICS, GOURMET/GODIVA, ACCESSORIES, MEN'S FURNISHINGS).

MEN'S FURNISHINGS
— UTILIZE ROUND TABLE WITH PLEXI LIP BUILD-UPS. MERCHANDISE ALL VALENTINE'S MOTIF IN ONE LOCATION (HOSIERY, BANDED BOXERS, NECKWEAR). THIS CONFIGURATION SHOULD BE MERCHANDISED ADJACENT TO DOUBLE/TRIPLE HUNG VALENTINE'S DAY MOTIF BOXERS.

VISUAL MERCHANDISING PRESENTATION
TABLECLOTHS:
— USE RED BENGALINE TABLESKIRTS WITH VALENTINE'S DAY OVERLAYS (RED LOGO ON WHITE). BE SENSITIVE TO PLACEMENT, 30" - 36" AISLE (REFER TO GUIDELINE).
— STORES MAY UTILIZE ROUND ITEM TABLES OR RECTANGULAR ITEM TABLES (FOR MERCHANDISE REQUIRING CAPACITY FIXTURING).
THE FOLLOWING PAGES DETAIL TABLE CONFIGATIONS AND HIGHLIGHT THE APPROVED SCENARIOS WITHIN EACH VALENTINE'S DAY ZONE, 30" - 36" AISLE.
PADDED WALLS:
— ALL RED WALL PROJECTIONS FROM CHRISTMAS ARE TO BE REMOVED AND CHANGED TO THEIR EVERYDAY COLOR.
WRAPPING PAPER:
— ALL STORES WILL BE RECEIVING THE VALENTINE'S DAY COSMETIC WRAPPING PAPER.
— THE PRE-WRAP BOX STACKS ARE TO HAVE THE TOP AND BOTTOM BOXES WRAPPED IN THE RED PAPER AND THE MIDDLE BOX WRAPPED IN THE WHITE PAPER.
FRAGRANCES:
— TOP OF COUNTER, OPEN SELL FRAGRANCE UNITS ARE TO BE PRE-WRAPPED WITH RIBBON AND STICKER, EVERY OTHER FACING.
— CUSTOMER COURTESY WRAPPING WILL ALSO BE OFFERED FOR VALENTINE'S DAY.
— VISUAL MANAGERS SHOULD AFFIX A PRE-WRAPPED #25 SIZE BOX TOP ONTO THE 14x22 SIGN.
— REFER TO VISUAL MERCHANDISING SECTION INCLUDED IN THIS GUIDELINE FOR DIRECTION ON VISUAL SET-UPS IN STORES.
— PROPER AND ORDERLY HANDLING OF SEASONAL TRIM AND STORAGE. SEASONAL ASSETS MUST BE SAVED.

Figure 3–4 A Presentation Guidelines Overview for Valentine's Day.
(Courtesy of Lord & Taylor.)

VISUAL MERCHANDISING SEASONAL DIRECTIVE
EVENT: VALENTINE'S DAY

	YES	NO	DETAILS
ROUND ITEM TABLES	X		Specifics and Sketches Attached
RECTANGULAR ITEMS TABLE	X		As Needed - Red Bengaline
TABLESKIRT	X		Red Bengaline
OVERLAY	X		Red Logo on White - Quantities Owned Attached
GIFT WRAP	X		Red w/White Logo & White on Silver Logo
RIBBON	X		Red Background w/Hearts
BOX STACKS	X		Round & Heart Combinations 1995 - Use From Last Year See Attached
PAPER STREAMERS - WIRED	X		See Attached - As Per Guideline
RED, SILVER FORM COVERS	X		Use as per Sketch - See Attached
GILT FRAMES	X		Silver as per Sketch
FABRIC	X		Use as per Sketch - See Attached

SPECIAL NOTES: • KEEP BOX STACKS TALL AND GRAPHIC ON LEDGES. NO DITZ
• GODIVA/SCENT SHOPS - ALPHA TABLES, BOX STACKS. SIGNING
• BENGALINE RED CHRISTMAS WALLS MUST BE REMOVED.
• USE ALL STREAMERS.

Figure 3–5 A prop list to be used by trimmers for Valentine's Day.
(Courtesy of Lord & Taylor.)

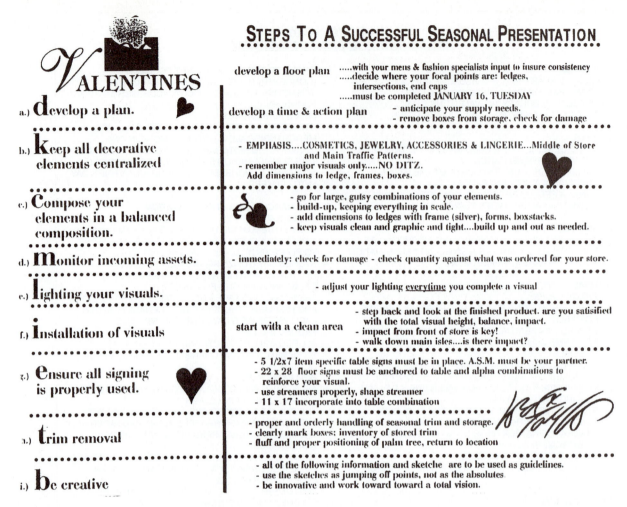

VALENTINES

a.) **develop a plan.**

develop a floor planwith your mens & fashion specialists input to insure consistency
.....decide where your focal points are: ledges, intersections, end caps
.....must be completed JANUARY 16, TUESDAY

develop a time & action plan
- anticipate your supply needs.
- remove boxes from storage, check for damage

b.) **Keep all decorative elements centralized**

- EMPHASIS....COSMETICS, JEWELRY, ACCESSORIES & LINGERIE...Middle of Store and Main Traffic Patterns.
- remember major visuals only.....NO DITZ. Add dimensions to ledge, frames, boxes.

c.) **Compose your elements in a balanced composition.**

- go for large, gutsy combinations of your elements.
- build-up, keeping everything in scale.
- add dimensions to ledges with frame (silver), forms, boxstacks.
- keep visuals clean and graphic and tight....build up and out as needed.

d.) **Monitor incoming assets.**

- immediately: check for damage - check quantity against what was ordered for your store.

e.) **lighting your visuals.**

- adjust your lighting everytime you complete a visual

f.) **Installation of visuals**

start with a clean area
- step back and look at the finished product. are you satisfied with the total visual height, balance, impact.
- impact from front of store is key!
- walk down main isles....is there impact?

g.) **ensure all signing is properly used.**

- 5 1/2x7 item specific table signs must be in place. A.S.M. must be your partner.
- 22 x 28 floor signs must be anchored to table and alpha combinations to reinforce your visual.
- use streamers properly, shape streamer
- 11 x 17 incorporate into table combination

h.) **trim removal**

- proper and orderly handling of seasonal trim and storage.
- clearly mark boxes; inventory of stored trim
- fluff and proper positioning of palm tree, return to location

i.) **be creative**

- all of the following information and sketche are to be used as guidelines.
- use the sketches as jumping off points, not as the absolutes.
- be innovative and work toward toward a total vision.

Figure 3–6 A summary of trimmer instructions for creating a successful presentation.
(Courtesy of Lord & Taylor.)

VALENTINES

SHOWN BELOW IS A SUGGESTED USE OF THE PLEXI PROMOTIONAL BAG RISER WITH VALENTINE'S DAY HEART BAG TISSUE ON FRAGRANCE LEDGE.

PLEXI PROMOTIONAL BAG RISER

WHITE BAG w/HEART LOGO

Figure 3–7 Suggested use to trimmers of a plexi promotional bag riser.
(Courtesy of Lord & Taylor.)

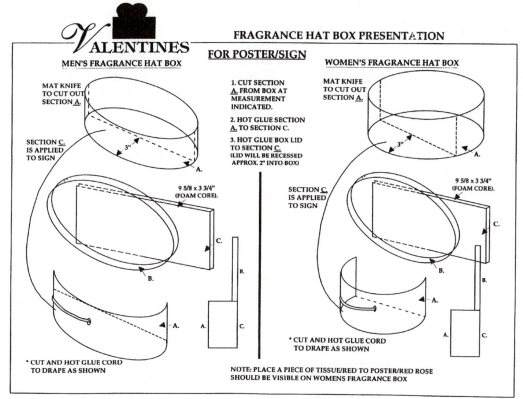

Figure 3–8 Detailed steps in the construction of hat boxes.
(Courtesy of Lord & Taylor.)

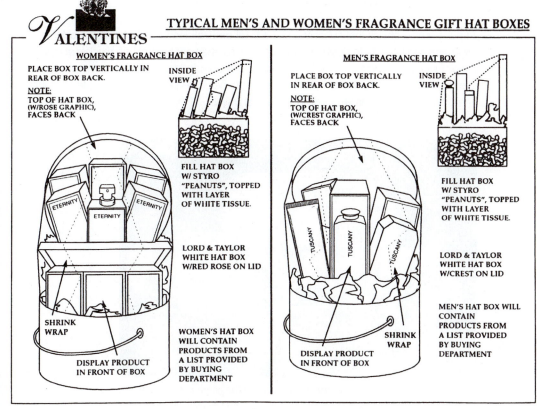

Figure 3–9 Finished hat boxes produced following the steps of construction in Figure 3–8.
(Courtesy of Lord & Taylor.)

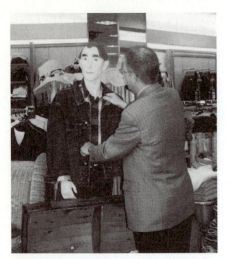

Figure 3–10 A daily walk-through by a trimmer assures that the interior displays will retain their original freshness.

(Photograph by Ellen Diamond.)

Ongoing Visual Tasks

As noted, the visual team is involved with much more than just the installation of new windows and interior displays. An important function that is performed each day throughout the store is called the **daily walk-through** (Figure 3–10). At the end of the day, just about every display inside the store has been handled by shoppers. Shirts on counter displays have been picked up and haphazardly replaced. The outfits on mannequins have been pulled and distorted, leaving a less-than-perfectly-dressed form. To return the merchandise displays to their original state, trimmers conduct these daily walk-throughs and freshen what the shoppers have mishandled. In this way, the display's appearance begins each day with a clean look. If this is not attended to, the store will take on a shabby appearance and the visual presentations will not attract as much attention from shoppers as planned.

Centralized Visual Merchandising

As you have just learned, most department stores have in-house staffs that visually merchandise the flagship stores as well as the branches. In the chain organizations, with some numbering more than one thousand units, this arrangement would be impractical. Stores like The Gap, Victoria's Secret, The Limited, Eddie Bauer, and Williams-Sonoma do not use professional trimmers to install the displays in their stores. Instead, they use a **centralized visual merchandising** program to better serve their needs. Still others, like Crate & Barrel, use a combination of a centralized visual program and an in-store trimmer. The centralized visual plans are extensions of the organization's overall philosophy. Just as the merchandise is centrally purchased by buyers at corporate headquarters and the policies are centrally developed by top management, the concept of visual merchandising also is centrally planned.

The Total Centralized Visual Plan

To put it simply, chains that subscribe to the **total centralized visual plan** use **model windows** and interiors to design their presentations, then photograph the models and send the pictures to the various stores for reproduction (Figure 3–11). In addition to the photographs, specific written directions and drawings are sent to help the visual installer complete the job. These detailed directions are needed in the vast majority of the chain organizations because

Figure 3–11 Photograph of a display produced in the company's central headquarters that is copied by the managers of the various units in the chain.

(Courtesy of iStockphoto/Vasiliki Varvaki)

the displays are installed by a store manager or assistant and not a trained, professional visual merchandiser. Among the many companies that subscribe to this type of centralized visual merchandising is Williams-Sonoma. It sends **display presentation kits** to the various units that contain some of the following items:

- An actual photograph of the display. Along with the photograph is a signage checklist.
- A graphic presentation that depicts each item in the display along with numbers on the drawing that correspond to the provided list of items. In this way, if the photograph isn't totally clear to the installer, the graphic plan will take any of the guesswork out of the presentation.
- The actual signage that is featured in the display.
- Any materials that are not sold in the store but are used for display purposes.
- Price tags, if used, are also sent to the store.

The Williams-Sonoma product line easily lends itself to duplication. In stores that feature soft goods, however, where pinning and draping of goods is often required, the results are often less satisfying. The display kits nevertheless satisfy the store's needs and save the company the funds that would be needed to have professional installers in each store.

Nowadays, with the trend away from traditional window structures in favor of wide-open fronts and plain glass walls separating the outside from the inside of the store, this centralized approach to visual merchandising has become a little easier.

Alternate Central Visual Merchandising Plans

Some companies like the concept of centralized visual merchandising in order to guarantee a uniformity of display in all of their units. However, they believe that their stores and clientele are better served if an on-staff trimmer is available to prepare the presentations.

A walk through any Crate & Barrel store, a subscriber to an alternate method of visual merchandising that is used by others in retailing, immediately reveals a commitment to excellence in visual presentation. Instead of a complete reliance on a central team to develop its visual concepts, each store has at least one full-time designer. In addition, Crate & Barrel has several regional designers. The result is excitingly displayed merchandise that quickly draws the shopper to it. Using color as a motivational device, each and every product classification is prominently displayed. A brief overview of the history of Crate & Barrel, along with its display approach, is presented in the following Profile.

In some chains where the organization is divided into regions, the companies often use one or two trimmers to service all of the stores in the region. Although there is no single individual present at all times in a particular store, this method does afford the chain professional visual installations approximately every two weeks.

Freelance Arrangements

A mall or a downtown shopping area gives shoppers the impression that retailing is dominated by the major department stores and specialty chains. This is actually the case, but there are numerous stores throughout the United States that are single-unit operations or are parts of small chain organizations with just a few units. Like their larger store counterparts, they are interested in maximizing profits, and they realize that effective visual merchandising is essential to their goal. Short on the expertise necessary to install their own visual presentations, and equally short on the funds to employ a full-time display professional, many small companies use the services of a freelancer.

Freelancers work in a number of ways (Figure 3–12). Some charge an hourly fee for their time and charge for the props and materials they install in the client's interiors and windows. Others charge a flat fee per trim, while others contract for a certain number of changes throughout the year. Just as there are artists with different styles and designers

Figure 3–12 A freelancer dressing the mannequins in a window display.
(Photograph by Ellen Diamond.)

PROFILE: A Contemporary Visual Merchandising and Environmental Design Profile: Crate & Barrel

When Gordon and Carol Segal opened their first store in Chicago's Old Town in 1962, few would have guessed that it would be the beginning of one of the country's most successful home furnishing chains. Oddly, the concept for the company began in the couple's kitchen, where they had the idea that others would enjoy the dishes they were washing that were brought back from one of their many travels to foreign shores. The dinnerware and other products obtained on their trips were unique and generally unavailable elsewhere in the United States. Although their thoughts were credible, they didn't have the funds necessary to open an elaborate business. Instead, they opted to renovate a 1,700-square-foot space in Chicago's Old Town, using "crates and barrels" to display items rather than expensive fixturing. Their instinct and business approach were right, and they quickly began to attract shoppers to their premises. With great prices and

unique merchandise, they were soon established as a viable home furnishings player in the Chicago area. It wouldn't be long before they opened other units, began a catalog division, and launched a website to make it a multichannel retailer. Expanding on the product mix to include furniture and a wide assortment of accessories for the home, Crate & Barrel eventually became an important chain, operating stores in many major U.S. markets.

Key to the success of Crate & Barrel was the development of the now widely imitated method of creating vignettes with merchandise to convey affordability and usability. Their approach to the visual process begins with the vice president of corporate design, who is involved in store design, working with buyers to learn about the different types of merchandise that are on order, and reporting all of this information to the design and visual people. With this information in hand, the centralized design team

is ready to prepare guidelines for the store's visual program. Each store has at least one full-time design and display individual, with larger stores such as the Chicago flagship and the New York City Fifth Avenue unit having as many as six. The company also employs six regional designers who are responsible for bringing the desired display guidelines to the stores' trimmers. In addition to the chain of command that verbally brings the ideas of top management to the store level, photographs and written directives are used to get the concept across.

Today, in more than 170 stores in markets that span major trading areas nationwide and in Canada, the company's unique product mix continues to capture the attention of the consuming public. Most industry professionals agree that while Crate & Barrel's product mix is primarily responsible for its success, it is the attention to visual presentation that sets it apart from the others in the field.

known for achieving a special look, most visual merchandisers and trimmers have distinctive styles and approaches.

Bearing in mind that store windows are the silent sellers of retailing and the impression they make is vital to the store's success, the retailer should carefully select the freelancer. Such factors as cost, prop utilization, and scheduling should be discussed before entering into an agreement. If an actual **freelance contract** is drawn, these details are usually spelled out. In less formal arrangements, the retailer would be wise to discuss each point to make certain that both sides understand the deal.

Unlike the larger organizations where teams of professionals carry out a prescribed plan of visual merchandising, the freelancers and the retailers who employ them develop the concepts and plans together from a mutual understanding of the format, style, and direction that the presentations will have. The freelancer has several ways of showing a prospective employer his or her methods and style of work.

First, most freelancers prepare slide or **photographic portfolios** that show examples of displays they have completed. Some even develop video presentations that can be distributed to prospective clients. By examining any of these visual presentations, the retailer can immediately discern whether or not the freelancer uses an approach appropriate for his or her store. A second route is to provide a list of stores for the retailer to visit so that the displays can be observed in person. This also enables the potential client to discuss the trimmer's work with other retailers. Finally, a route taken by many freelancers who are just beginning their careers and do not yet have track records is to offer to do a display without cost to the retailer. This is an investment in time, but it could result in a regular professional relationship.

It should be noted that emphasis in this discussion of freelancers and small stores has been on window installations. Most independent retailers trim their interiors themselves or call upon freelancers for advice concerning merchandise arrangements and fixtures. The dollars

they expend are generally for the store's face or entrance, and they do the balance of the store's visual merchandising themselves.

Needless to say, all of the planning and developing of the visual presentations include such areas as proper use of the store's window structures and fixtures; appropriate usage of mannequins, props, and materials; proper design; color and lighting choice; and the use of appropriate copy and signs—all of which must be presented in eye-catching themes and settings. All of these aspects are fully explored in subsequent chapters. In Chapter 17, we focus on how all of these aspects are coordinated in the step-by-step installation of a display.

chapter review

key points in the chapter

1. In order to make the best use of visual merchandisers, many large department stores prepare planning books that emphasize each department's role in visual presentations.

2. The three major visual merchandising categories of retailers are those who have in-store visual departments, those who use centralized display staffs that set the tone for all units to follow, and those who employ freelancers to trim the windows.

3. The centralized plans are generally either totally centralized operations whereby model windows are installed, photographed, and sent to stores for reproduction or an alternate plan whereby the creative aspects are accomplished centrally and the individual units have in-store trimmers to follow the plans.

4. To emphasize the next season's visual approach, many large retailers hold planning seminars for key personnel in both the flagship and branch stores.

5. Visual presentations should coordinate with advertising and other sales promotional devices for maximum sales effectiveness.

6. The visual merchandiser's efforts are based on the merchandise and directions initiated by the merchandise managers and buyers.

7. Most chains, especially those of significant size, use store personnel, rather than trained visual merchandisers, to dress their windows and interiors using company-provided guidelines. Some chains use traveling trimmers to visually merchandise the stores.

8. Freelancers are employed by small chains and independent retailers to execute displays. These trimmers are paid either on a per-window basis or by annual contracts.

9. Freelancers promote their services to retailers through the use of portfolios that feature their work or videos that show them in action.

terms of the trade

centralized visual merchandising 44

daily walk-through 44

display presentation kits 45

freelance contract 46

freelancer 38

in-house visual merchandising department 38

kick-off seminar 39

model windows 44

photographic portfolio 46

total centralized visual plan 44

internet exercises

Select a major department store and chain organization and log on to their websites for the purpose of learning more about their tables of organization. If this information isn't available, contact the companies either by telephone, fax, or e-mail, which are generally listed on the website, to learn about their structures and specifically the direction they take for designing and installing their visual presentations.

A one-page, typed, double-spaced paper should include:

1. The title of the person in charge of visuals.

2. The direction taken to get the information to each of the units in the organization.

3. The use of a "direction book."

4. The individuals in each store responsible for installations.

Case Problems

Case 1

Since the opening of its first unit, which is still the company's flagship, Avidon's has expanded into one of the largest department store organizations in the Midwest. Over the last twenty years, the store's emphasis has been away from the downtown or main street shopping center in favor of opening units in major malls. Unlike the traditional format of the parallel-to-sidewalk window configuration used in the flagship, the newer stores have employed the "windowless window" concept, so the store itself is the visual presentation. The cost of mall space has mandated that traditional windows are a luxury and that the space is better used as selling areas.

In order to modernize the older units in the organization, Avidon's has decided to adopt the windowless window concept in all of the units except the flagship store. This will give the stores a fresh appearance and additional selling space. While Avidon's has always prided itself on its visual presentations, management recognizes that it is impractical to continue to use such a large staff when windows are no longer available for trimming except at its main location. Cutting expenses will be a benefit of the new concept, but the company believes it must still visually present merchandise in a manner that will motivate shoppers to purchase.

The visual staff firmly believes that it will still play a vital role in dressing the store even though physical changes have taken place. The visual director would like to see her people assigned to the various units to arrange the inventory attractively and set up interior displays. However, the general merchandise manager believes in putting less emphasis on formal display and more on merchandise arrangement on the floor, which would better serve the store's needs and could be accomplished by department employees.

QUESTIONS

1. Do you agree with the store's movement away from the conventional approach to visual merchandising?
2. Should it sacrifice the windows for more selling space in all of the stores?
3. How could regular department personnel learn to visually merchandise their areas satisfactorily?

Case 2

Perry Wilson's window installations have attracted attention for the ten years since he graduated from college and started his own freelance company. By chance, his first assignment was for a men's clothing store, and he has remained a specialist in visual presentation for menswear. He has received a great deal of recognition for his work but hasn't been totally satisfied with the limitations of planning and developing visual presentations only for menswear. His unhappiness is based on two factors.

First, menswear stores traditionally make fewer changes than do women's stores. Menswear is a two-season business while womenswear is a five-season operation. In order to make a living, Perry must sell his services to many men's outlets because they require little attention over the year. Second, and even more frustrating for Perry, is the fact that men's shops are less given to the artistic and sometimes flamboyant approaches used for the windows in women's shops. Although menswear has come a long way from the conservative image of yesteryear, the window concepts generally remain quite conventional.

Perry would like to break into women's visual presentations. Although he believes he has the talent and ability required for such display work, he hasn't been able to convince any women's retailers to use his services. Without photographs of women's windows or recommendations from satisfied clients of womenswear, he hasn't been able to show off his expertise. He even offered to do some displays at no cost, but still he hasn't any takers.

QUESTION

1. How might Perry arm himself with ammunition to overcome retailers' doubts?

discussion questions

1. Which classification of retail organization expends the most dollars for visual merchandising?
2. What are the three most common approaches used to achieve satisfactory visual presentations?
3. How do branch stores emulate the flagship store's visual format if different personnel perform the installation function at each store?
4. Through what means does Lord & Taylor make its visual presentation known to the entire company?
5. Discuss the various elements used by Lord & Taylor in its Valentine's Day Merchandise Presentation Guidelines.
6. Who provides the visual team with the information necessary to carry out appropriate visual presentation?
7. Is it necessary for the store's advertising campaigns to match its visual presentations? Why?
8. How far in advance of a season should the visual team begin its preparations for the following major presentation?
9. What are the major elements indicated in a store's planning booklet?
10. In addition to detailed, written procedures, what other devices are used to make certain that new visual displays are constructed as desired?
11. How have chain organizations with numerous units instructed their store personnel to visually merchandise their premises?
12. Why do many chains use nonprofessional personnel to trim windows?
13. Which retailer classification makes the most use of freelancers?
14. How can a freelancer tempt a retailer to use his or her services?

exercises and projects

1. Prepare a Special Events calendar for a full-line department store for the month of February, indicating the dates, names of the events, and visual merchandising participation for each promotion. Put your data on the form provided on the next page.

2. Visit a unit of a major chain organization (the malls are filled with them) and learn from the manager about how visual presentations are accomplished. Prepare a written or oral report to include the following questions:

 a. Does the home office give any visual direction?

 b. Is there a formal plan or presentation provided by the home office?

 c. Who installs the actual presentation?

 d. Is merchandise selection for displays left to the store manager's discretion, or does central management make the decision?

 e. How often are the visual presentations changed?

 f. Who provides the signs and other copy for visual merchandising?

NAME: _____ DATE: _____

EXERCISE 1 SPECIAL EVENTS CALENDAR

Date	Promotional Event	Visual Merchandising Participation

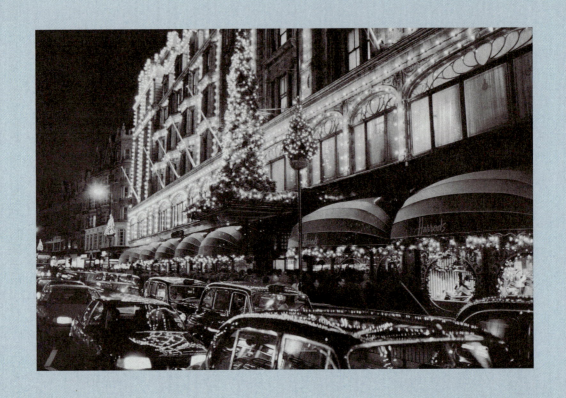

facilities exteriors, and fix

After completing this chapter, the student should be able to:

... Understand the importance of a facility's design to the success of its operation.

... Describe some of the exteriors that the restaurant segment of retailing is using today to attract attention.

... Describe five types of window structures that are found in retailing.

... Differentiate between open-back windows and windowless windows.

... Explain the uses of shadow box windows.

... Discuss the circumstances for using vitrines instead of open-type pedestals.

... Describe the environmental concept for interiors.

... List six types of fixtures that are commonly used in store interiors to display merchandise.

... Describe an architect's plans for a company and tell why they are important.

... Discuss the purpose of the artist's rendering of a facility's design.

design: interiors, turing

Introduction

Essential to the success of every operation that deals with consumers is the ability to motivate potential customers to come inside. Advertisers spend their professional lives whetting the public's appetite with artwork and copy that will hopefully result in a trip to the store or restaurant. While it is true that many consumers visit their favorite companies after reading a specific advertisement or set out for a specific store or restaurant for a specific item or special meal, there is a vast market of people who enjoy a visit to a mall or downtown area without a destination in mind. These consumers could be tempted by an operation that has the right appeal.

What racing car enthusiast could encounter the NASCAR Thunder store entrance in the Gwinnett Mall in Atlanta without wanting to go inside to see the merchandise offered for sale?

It is refreshing to see how many businesses in malls and other busy shopping locations are beginning to embrace unique facility designs over the mundane variety. In years past, the basic design of a new store or restaurant was generally left to a team of individuals that included store planners, interior designers, and architects. The visual merchandiser was not typically involved in such early decision making. His or her role was to set up merchandise in the windows, counters, shelves, and other interior locations as designed by other people. In the restaurant industry, the visual merchandiser was completely absent. Today, a look at many retail operations and restaurants shows that visual merchandisers are present in the initial planning. No one is better qualified to make judgments about the design of the environment. For example, Raymond Anderson of Crate & Barrel spent four years in visual display work for the company before being named vice president of corporate design. He not only designs the company's complete facilities but regularly involves the visual merchandisers in their creation. His visual merchandising background has given him an understanding of how a facility would best serve the merchandise offered for sale (Figure 4–1).

Other important players in facilities design are the merchandise vendors themselves. In the very showrooms to which retailers come to shop the lines, the vendors are designing their facilities to give ideas to the retailers that can be used in their shops. Bass Shoes, for example, designed its showroom as an environment that immediately raised its product line to a new level. Not only were the shoes there for purchasing, but so was an exciting facility that could easily be translated into retail environments. Many other vendors producing merchandise that ranges from computers to fashion are leaving behind their mundane showrooms and creating newer, fresher environments that epitomize their product lines and help the retailers borrow from these concepts. This is especially helpful to the smaller retail operation who hasn't the available in-house professional staff or the funds necessary to

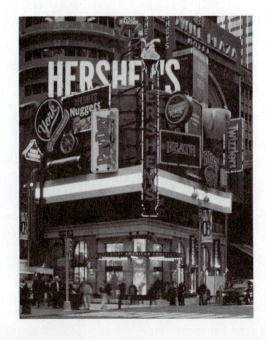

Figure 4–1 The Hershey's entrance motivates shoppers to enter the store in Times Square, New York City.
(Courtesy of JGA, Laszlo Regos Photograpy.)

employ outside help. When specific plans are laid out for them, even the smallest shopkeepers can bring excitement to their stores.

This chapter focuses on the overall design of store and restaurant facilities, including exteriors, window structures, interiors, and fixturing.

Imperative to any successful store design is the selection of the right company to carry out the entire creative process. One of the more important companies that continually performs this design magic is JGA, as noted in the following Profile.

Exteriors

When Banana Republic first came onto the retail scene many years ago, it initiated its environmental concept and made certain that the theme would be carried right to the front of its stores. Jeeps crashing through windows into the stores' entranceways motivated shoppers to come inside to see what was happening. The excitement generated by Banana Republic in its storefronts led the way for many other businesses to put their best foot forward right at the entranceway. Others such as the NBA store in New York City, the Disney stores, and Tommy Bahama followed Banana Republic's thematic lead and made the exteriors places that would motivate shoppers to enter their stores (Figure 4–2). Of course, not every company uses the approach initiated by Banana Republic, but all pay strict attention to their exteriors to make certain that they each have an individual uniqueness.

The ultimate change in its merchandising philosophy led Banana Republic to a more sophisticated facilities design that would better enhance its now very successful product direction. Today, it is a sleek, contemporary design that augments its inventories.

On a trip to a mall, a downtown shopping area, or any place where retailers and restaurants are located, you will see that each business has a different design. Some are contemporary with giant walls and lots of steel, while others feature polished brass and rich woods. Still others decorate their facades with a wealth of materials such as brick and mortar. Each company uses the exterior to develop an image and convey a message to the public. The Rain Forest Cafe, a business that combines both retail space and a restaurant facility, does an outstanding job in attracting attention. Located in shopping centers along with

Figure 4–2 The Tommy Bahama stores use the thematic environmental approach.
(Photograph by Ellen Diamond.)

Since 1971, JGA has evolved to become one of the nation's leading retail design, brand strategy, and architectural firms. The company gained its reputation by helping retailers realize their visual marketing potential and attain leadership within their niche. Its goal is to bring a creative idea into reality. Achieving success, it believes, requires the integration of strategic clarity, competitive and market awareness, conceptual motivation, and a strong business sense, each of which it helps clients to address.

As strategists and designers, JGA's services are extensive. A team approach offers significant value over conventional firms. As part of the client's project team, JGA motivates the creative process through strategic design, scheduling, budgets, and implementation, resulting in increases in customer interaction and satisfaction.

With a staff of fifty associates, JGA offers a diverse menu of services, including:

- market and design strategy
- conceptual positioning
- visual communication design
- logo/brand identity
- design and architectural development and implementation
- retail tenant coordination
- construction administration
- fixturing/furniture/materials procurement

Company designs have been recognized internationally and published by the industry's leading magazines, among them *Chain Store Age*, *Visual Merchandising and Store Design (VM + SD)*, *Display & Design Ideas*, and *Shopping Center World*, trade papers such as *Women's Wear Daily*, and consumer newspapers such as the *New York Times*. Recent award-winning environmental and graphic design projects include Ripley's Cargo Hold, Disney, Fossil, NASCAR Thunder, Nature's Northwest, Perfumania, American Museum of Natural History, Planetarium Shop at the Rose Center for Earth and Space, Dickson Cyber Express, and General Nutrition Centers.

scores of stores and other restaurants, the Rain Forest Cafe features a junglelike atmosphere at its entrance. With lush foliage filling the exterior, replete with replicas of animals found in the wild, a live animal trainer with a live parrot in hand hawks the crowd. The trainer's appearance generally draws large crowds to see the performance. Ultimately, many of the spectators come inside the facility either to purchase the goods offered for sale, to eat a meal, or both. It is a visual presentation that, at this time, has little competition.

Kellogg's Cereal City in Battle Creek, Michigan, set out to attract shoppers with an outstanding physical facility. A huge multilevel glass face surrounded by several attached buildings makes it a striking contrast to other retail operations, often motivating the shopper to be drawn inside for closer inspection. This glass facade certainly gives the store an image of its own.

While the use of specific materials is important to the aesthetic quality of the design and the general impression that it leaves in the consumer's mind, function must play a vital role in the form used. Eye appeal is certainly a factor, but the design must be functional in order to properly feature what the company is trying to sell.

Traditional Storefronts and Window Structures

In retailing, there are several traditional categories of window structures and storefronts. They are conceived and developed by designers and visual merchandisers. Each is designed with a specific purpose in mind, and they run the gamut from the typical downtown retailer's flagship and its parallel-to-sidewalk configuration to the popular no-window fronts found in many shopping malls. It should be understood that these are basic designs that allow for many variations (Figure 4–3).

Parallel-to-Sidewalk Windows

Department stores that have the advantage of a very large frontage on a main street often choose to build storefront windows that run parallel to the sidewalk and are generally **back-closed window structures** to separate them from the rest of the store. **Parallel-to-sidewalk windows** are preferred by many visual merchandisers because they only need to concern themselves with the merchandise being displayed in the window. There is no interference of

Figure 4–3 The multilevel glass facade provides a highly visible introduction to the Hershey's store.
(Courtesy of JGA, Laszlo Regos Photography.)

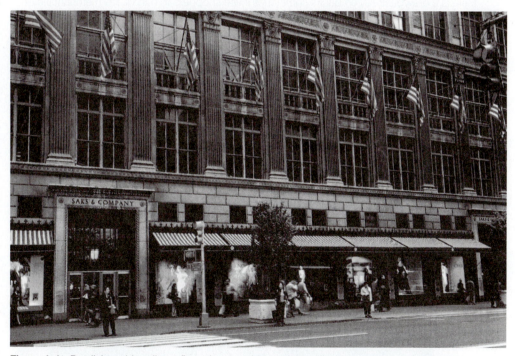

Figure 4–4 Parallel-to-sidewalk configurations provide maximum display exposure to pedestrians.
(Photograph by Ellen Diamond.)

interiors as occurs in open-back designs. In stores that employ this format, such as Saks Fifth Avenue in New York City and Neiman Marcus in Dallas, there are usually multiple windows in the storefront, with the entrance to the selling floor in the center of the building (Figure 4–4). It should be noted that these windows are the ones on which retailers expend the most dollars for displays. The stagelike settings they offer are perfect for extravagant displays at Christmas and other times when the store is looking to promote something special.

It should be understood, however, that the vast majority of window structures utilize other designs because of the lack of space and the need to make the "lots" more usable for selling.

Corner Windows

When a retailer has the good fortune to occupy a corner location, the design should take advantage of the fact that passersby will be converging on the store from two directions. Stores in large shopping malls vie for such locations and generally pay a premium rental for them. Given practically identical circumstances, architects, store designers, and visual merchandisers use corner locations very differently. The differences are often based upon the type of merchandise that the store will feature in the windows and the number of entrances needed to maximize shopper traffic.

In some corner designs, there is a **corner window** with entrances on either side of it. In others, the entrance is in the center, with two windows flanking it. In still others, the traditional windows are deemphasized for display, with just glass separating the interior from the exterior. Using this format, the entire store is presented as a visual merchandising package.

When traditional windows are the choice, a variety of styles are used. Some may be the traditional types that usually run from 8 to 10 feet high; others are the 3- to 4-foot raised showcase variety displaying small items that can be closely inspected by shoppers.

Open-Back Windows

Retailers who believe that the entire store should be visible to the consumer from the outside, yet feel the need to feature conventional window displays, often choose the **open-back window** structure (Figure 4–5). Although this format does give the retailer these two features, there is a drawback. Open backs sometimes invite shoppers to handle the merchandise on display, so the display can become unkempt. On occasion merchants have found children romping through such windows, knocking over merchandise and causing damage.

Angled Windows

In order to give more exposure to the viewer, some visual merchandisers and architects design **angled windows** that are similar to the parallel-to-sidewalk type but can feature more displays in less space. By angling the windows, they can be elongated to form a vestibule that leads the shopper to the store's entrance.

Figure 4–5 The open-back window provides for in-store visibility.
(Courtesy of JGA, Laszlo Regos Photography.)

Arcades

When a store has minimum frontage on the street or in a mall but has ample depth, the **arcade** front is often constructed. The arcade configuration requires setting the store's entrance back from the building line and extending the size of the display windows. Stores with limited frontage whose merchandising philosophy requires more window display space benefit from such a design.

Islands

Deep vestibules and wide frontage result in an excessive amount of space at the store's entrance. In this ample exterior space the typical arcade configuration is often used. Some stores wishing to better use the lobby area and gain additional display space build **islands** in the center of the vestibule. The island design enables the shopper to view merchandise from all angles. In today's economy, however, with high rent and space limitations, this structure has generally disappeared from the retail scene. Some retailers, however, make use of the **island window** inside the store. These islands extend the sales effort by enabling the shopper to walk around the store and view the merchandise from all angles while waiting for an available salesperson. Stores that have display island windows often find that shoppers are more likely to know exactly what they would like to purchase, thus cutting down on the time it takes for the sales associate to suggest merchandise.

Windowless Windows

In most malls, many of the exteriors feature **windowless windows.** Retailers in these locations often choose to construct their stores without one of the conventional window designs. The consensus among these retailers is that with ample open frontage the shopper can get an impression of the store's merchandise and will enter the premises without being enticed by a window (Figure 4–6). Windowless windows, or the **no-window concept,** requires a great deal of attention to proper visual merchandising of the store's interior, with merchandise clearly visible from outside the store. The only apparent drawback to this arrangement is the security of the merchandise. Stores that use this open design must make considerable efforts to secure their goods. Some use security guards at these entrances as a cautionary measure. When stores of this nature are closed, a security gate blocks off the entire entranceway but still permits consumers to see inside.

Figure 4–6 Windowless windows provide for easy pedestrian access.
(Courtesy of JGA, Kevin Brusie Photography.)

Figure 4–7 Shadow box windows allow small items to be better displayed. *(Courtesy of Lord & Taylor.)*

Circular Windows

In order to individualize their images, some companies develop window structures that are quite different from the traditional ones. Although they do not give the retailers additional space in which to display goods, they do take the store's image out of the ordinary. The Crate & Barrel flagship on Chicago's North Michigan Avenue is an example of a giant **circular window** that immediately separates that structure from all of its neighbors.

Shadow Box Windows

Stores that feature small items such as fashion accessories require window structures that enable close inspection of the merchandise without requiring the shopper to crouch on the floor. Windows of this nature are elevated so that comfortable, clear viewing is possible (Figure 4–7). Some retailers, such as jewelers who deal in expensive, one-of-a-kind precious gems, sell directly from these **shadow box window cases.** They have easy access from the back for the items' removal. In this way, the jeweler can display wares and make them easily accessible for closer inspection and an ultimate sale. At the end of each business day the merchandise is removed and placed in secured storage for safekeeping. Other shadow box usage is for displays that change every week or so. These items include sunglasses, fashion jewelry, handbags, scarves, and other small items. Since there is no substantial value to these items, they remain in the shadow boxes, as is the case with other display windows.

Architecturally Unique Entranceways

The traditional approaches, as discussed in the preceding section, are perfectly suitable, but some retail operations take a different route to distinguish themselves from the competition and attract attention. Today's environmental designers continue to create entranceways that utilize a wealth of materials that in the past would never have been considered (Figures 4–8 and 4–9).

Two entries that have received a great deal of attention are Dickson Cyber Express in Kowloon Station, Hong Kong, and Hot Topic in Laguna Hills, California. In the Dickson Cyber Express, the unique design uses steel beams and global icons at the point of entry. In Kowloon Station, where 2.2 million people use Hong Kong's Metropolitan Transit daily, the

Figure 4–8 The unusual use of steel beams makes for an exciting entranceway to the store.
(Courtesy of JGA, Laszlo Regos Photography.)

Figure 4–9 An architecturally unique entranceway provides for visual excitement.

(Courtesy of JGA, Laszlo Regos Photography.)

store that is just one of hundreds located in six shopping zones needed a departure from the traditional to make it distinguishable. The "tunnel" entrance of faux rusted curved steel beams sitting on aged concretelike footers at Hot Topic signals that what lies ahead is quite different from other retailers. It helps to create a dramatic transition from the mall's common area in which it is located.

Interiors

Although the actual interior design of any store is generally the work of an architect and a designer, the visual merchandiser is often involved. This team sets out to create an environment

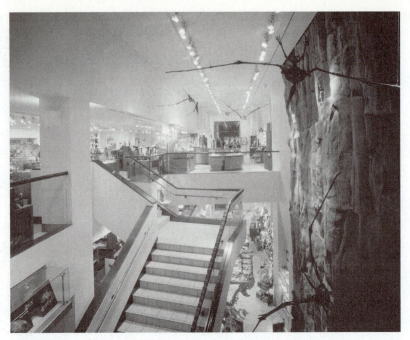

Figure 4–10 The "floating" staircase is an imposing addition to the store's environment.

(Courtesy of JGA, Laszlo Regos Photography.)

that is both pleasing for the shopper to experience and, at the same time, functional. They must carefully assess where fixtures will be stationed, the design and color scheme of the arrangement, the flow of traffic, the assignment of space to the particular selling departments and how they best interface with their neighboring departments, the lighting that will best illuminate the store, and other issues such as flooring, signage, and graphics (Figure 4–10).

By walking through any store that has been built in the last ten years, one will notice that greater attention than ever before has been given to individuality of design. The typical, traditional layouts and fixturing of the past no longer meet the challenges of competition. Retailers select their designs as carefully as they choose the merchandise that will fill the selling floors. A distinct image is the goal, so that shoppers will immediately recognize the differences.

The remainder of this chapter focuses on the fixturing used in today's retail environments. Color is explored fully in Chapter 9, lighting in Chapter 10, signage in Chapter 13, and graphics in Chapter 14.

Fixturing

Fixtures come in a vast array of materials and designs. They are chosen with the store image in mind and their suitability for the merchandise that they will house. By examining the many fixture offerings in periodicals like *Visual Merchandising and Store Design*, *Chain Store Age*, and *Display & Design Ideas* and making trips to the vendors who specialize in store fixtures, one can evaluate the various styles. The designs run the gamut from high-tech to wooden antique types. Within the many different styles there is a wide range of floor cases, wall cases, island display cases, shadow boxes, vitrines (closed display pedestals), open pedestals, slatwall, and show-and-sell fixtures.

Floor Cases

One type of fixture that combines the functions of storage and display is the **floor case.** Located away from the walls of the store, a floor case enables individuals to view the merchandise at close range and provides the sales associate with a counter on which to show merchandise. This type

Color Plates 1–7 The "going green" concept is used in these displays to convey the message of protecting the environment.

Color Plate 2

Color Plate 3

Color Plate 4

Color Plate 5

Color Plate 6

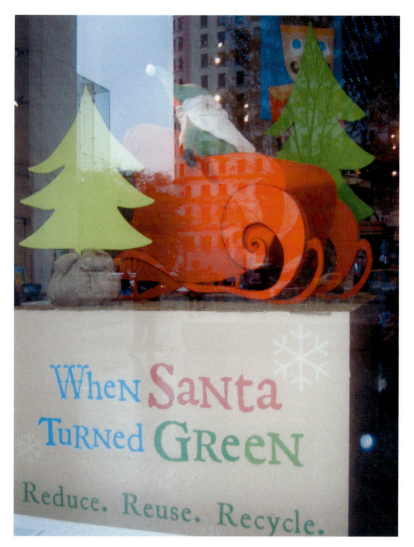

Color Plate 7

Color Plate 8 The abundance of the muppet characters is meant to emphasize the "green" concept and also show the importance of the item to the retailer.

of fixture is a must for jewelry, glasses, watches, expensive handbags, and other items that should not be handled by the shopper. Once arranged in a specific pattern, they not only present an aesthetic picture but they can also direct the shopper through the store. As evidenced by many retailers' premises, the newer entries are as visually exciting as they are functional.

Wall Cases

The basic element in almost any retail establishment's layout is the **wall case.** Whether it is a case filled with shelves for stackables such as sweaters, shirts, bottles, towels, dinnerware, glassware, shoe boxes, or table linens or is fitted with rods for hanging merchandise, it is the mainstay of the department's fixtures. It is the visual merchandiser's task to make certain that a wall case is not boring. Merely hanging merchandise on the rods or placing the folded items haphazardly will not entice shoppers to purchase. If arranged tastefully and artistically, these cases will help turn shoppers into customers. Like window displays, wall cases are often referred to as silent sellers.

Multipurpose Merchandise Systems

In addition to the wall cases that are permanently installed, many retailers are availing themselves of **multipurpose merchandise systems** that offer a great deal of flexibility (Figure 4–11). These systems can be configured easily to adapt to most retailer's needs. Some utilize a pegboard with a variety of brackets that can house either shelves or hanging rods. Others use **slatwall,** a system that uses grooved panels into which fittings may be inserted for shelving or hanging items. Still others employ **slot walls** that enable the user to create a combination of shelves that can be changed quickly to meet most merchandise needs.

Island Display Cases and Tables

Island display cases and tables encourage self-service. They come in a variety of designs, some with storage areas below and others merely serving as places to display items. Customers are visually encouraged to choose a piece of merchandise from a counter and purchase it without salesperson assistance (Figure 4–12).

Figure 4–11 Modular display systems allow for ease in fixture movement. *(Courtesy of JGA, Laszlo Regos Photography.)*

Figure 4–12 Open cases enable shoppers to make their own selections. *(Courtesy of JGA.)*

Shadow Boxes

When a store wishes to catch the attention of the shopper who is waiting for assistance, it might feature merchandise in a **shadow box.** These display environments are generally fitted with lights and are placed in strategic locations with the merchandise directly at eye level. They are often grouped in clusters of two or three to have a greater impact. To make certain that the trimmer's artistic arrangements are not tampered with, these boxes are usually fitted with glass windows. If the shadow boxes are without glass protection, they are placed out of customer reach, but within customer view.

Vitrines

Still another display fixture option is the **vitrine.** It is a glass-enclosed display pedestal that enables the shopper to see the merchandise from all sides. It is built high enough to permit comfortable viewing. Small items such as jewelry, belts, sunglasses, and evening bags are displayed in these fixtures.

Show-and-Sell Fixtures

Many retailers have difficulty attracting a sufficient number of sales associates to their companies. Without people who are capable of selling, the store often finds that shoppers who are motivated to shop leave disgruntled because their needs were not satisfied by a capable salesperson. In order to overcome this very serious problem, many retailers are using fixtures that are neither cases nor pedestals but further promote customer self-service and add variety to the merchant's display options. Generally known as **show-and-sell fixturing,** these racks and stands are a better choice for some merchandise that may get lost inside counters or on shelves (Figure 4–13). These fixtures often feature the latest merchandise arrivals and are generally placed at the entrance to a department. If the featured collection has several components, each is given space on the fixture. Often a mannequin dressed in an ensemble of the merchandise is featured next to the fixture. In this way the shopper can see the merchandise and how it looks on a figure and then can proceed to select the pieces that are appropriate for his or her needs.

In some companies, such as The Gap and Williams-Sonoma, visual merchandisers send directives to the selling departments about the placement of these fixtures to attract the

Figure 4–13 Kitchen cabinetry serve as excellent show-and-sell fixtures for dinnerware.
(Photograph by Ellen Diamond.)

most attention. For multipurpose use, some retailers are using systems that can be quickly assembled and reassembled to fit specific needs. Instead of using fixed show-and-sell fixtures, they use adjustable ones such as grid systems that can serve many purposes.

The abundance of fixturing on the market today is overwhelming. Almost daily, newer and more exciting fixtures become available to meet every retailer's need. The visual merchandiser keeps up with trends through catalogs, showroom visits, trade expositions, and trade periodicals such as *Visual Merchandising and Store Design* and *Identity*.

The Complete Layout

The storefronts, window structures, interiors, and fixturing discussed thus far are chosen by teams in such companies as FRCH Worldwide, JGA, Inc., MBH Architects, and Retail Planning Associates who are employed to design each store. Each visual element is conceived and executed to have aesthetic quality as well as to perform a particular function. In the past, small retailers and restaurateurs visited storefront companies and fixture showrooms for their overall design ideas. Very often, these consultants didn't consider the whole project, but only their end of the layout. Today, even the smallest organization understands the need for a total, unified retail premises package. Coordinating the complete layout is a must if the desired company image is to be achieved (Figure 4–14).

Architects who specialize in retail establishments and restaurants design entrances, window structures, and interiors for even the smallest of spaces. In fact, the smaller the square footage, the more important it is to ensure the best use of the space. More and more vendors are addressing the retailer's needs for store design by designing their showroom facilities in ways that can easily be translated into retail space. Not only does this take the guesswork out of store design but it saves the retailer the expense of having plans drawn for his or her premises.

If a retailer prefers a more individualized look, using an architect is the best approach. The architect usually shows the retailer a rendering of the anticipated design created with a computer program along with a list of materials suggested for use in construction. The rendering is a realistic picture of the project. It shows the exact colors that will be used; simulated merchandise on racks and in shelves, showcases, and windows; and detailed wall and floor coverings. Samples of flooring, wall coverings, fixture materials, lighting, and so on

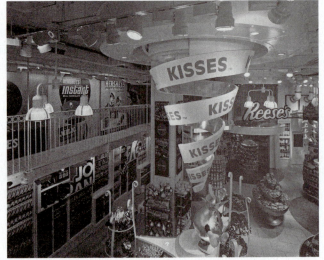

Figure 4–14 Unique fixturing coupled with company storage provides for an interior that is conducive to shopper purchasing.
(Courtesy of JGA, Laszlo Regos Photography.)

accompany the rendering; nothing is left to chance. This enables the merchant to study the next best thing to a photograph of the proposed store or restaurant. Since the project is still in the planning stages, this is as close to reality as possible. Large companies generally involve their visual merchandisers at this point and throughout the construction phase to make certain that the plan will be suitable for maximum merchandise exposure.

Once the company is satisfied with the plans, the architect prepares detailed architectural drawings to use during construction. Drawn to exact scale, these plans give specific sizes and elevations and show the location of every fixture, illuminated areas, and other details on which the construction will be based. It is only through careful planning that the end result will satisfy the needs of the company.

chapter review

key points in the chapter

1. Visual merchandisers play an important role in a company's facilities design.
2. The visual merchandising director is involved in the planning of exteriors, window structures, interiors, and fixturing.
3. In addition to playing an important role in visual merchandising for stores, many professionals in the industry are now involved in designing environmental settings for restaurants and creating displays for vendor showrooms.
4. More and more attention is being focused on interiors so that they will project images different from the competition's.
5. Unusual window structures and exterior designs, such as the silolike exterior used in Crate & Barrel's Chicago flagship, help make a retailer appear immediately different from neighboring businesses.
6. Parallel-to-sidewalk windows are generally the choice for stores with wide street frontage.
7. In an effort to maximize shopper awareness, stores that are located on a corner often plan windows and entrances on both streets.
8. Open-back windows provide display space as well as a view of the store interior from the outside.
9. Arcade fronts form vestibules, some of which are sufficiently large to house island windows and increase display space.
10. The windowless window increases selling space by eliminating conventional windows and giving the shopper a view of the interior.
11. Store and restaurant facilities are taking on new, individualized designs to help make a lasting impression of the shopping experience.
12. Floor cases and wall cases not only house the merchandise but, if properly placed, can become traffic-stopping displays.
13. Vitrines enable the shopper to examine merchandise from all sides.
14. Show-and-sell fixturing enables the customer to examine the merchandise closely and often to select it without salesperson assistance.
15. Multipurpose merchandise systems offer a great deal of flexibility on the selling floor.
16. Slatwall is a system that uses grooved panels into which fittings can be inserted for shelving or hanging items.
17. An artist's rendering of a proposed facilities design permits the retailer to visualize the finished product.
18. Architects' plans are drawn to scale, indicating every aspect of the design.

terms of the trade

internet exercises

1. One of the more complete websites that concentrates on retail facilities design is www.ispo.org. The agency, the Institute of Store Planners, is comprised of more than one thousand design companies, each of whom specializes in individual approaches to design. After logging on to the website, you will be able to report about the organization and the reasons for its existence. Write a two-page report on the institute, telling how it serves the needs of the design industry.
2. Using the websites of the design firms mentioned in the chapter, or any other that you may find through contact with the *www.ispo.org* website, select two to use in an oral presentation about these companies.

Case Problems

Case 1

Jolie Couture is a high-fashion retailer specializing in clothing for the sophisticated female. Typical of its clientele is the customer who spends freely on original designs and appreciates pampering and special service. The company was established thirty-five years ago with its first shop in Palm Beach, Florida, and has grown to an organization of ten salons in places such as Dallas, Texas, and Beverly Hills, California.

The company is about to embark on a new venture. It plans to open a series of stores under the name Jolie Couture II that will be a separate division of the company. These stores will be upscale, high-fashion shops but will be different from the original store's concept. While Jolie Couture specializes in original designs from all over the world as well as custom-made, in-house styles, the new stores will concentrate on designer labels, with little emphasis on custom design. They expect to attract a larger market since the merchandise assortment will be more readily accessible to more women.

The concept has been enthusiastically received by the various levels of management, but there is still one problem that hasn't been resolved. Peter Gordon, director of visual merchandising for the company, has presented his concept of the physical structure of the new stores. His ideas are in contrast to those in evidence at the original Jolie Couture shops. In the original locations, the storefronts have windows that do not allow observation of the interior. Each unit in the chain features a pair of parallel-to-sidewalk windows framed in marble. The style suggests elegance and has proven to be a successful showcase for the store's custom merchandise.

Peter's recommendation for the new shops is quite different. He wants to use the entire store, elegantly furbished, as a window. He suggests a floor-to-ceiling glass front that would enable passersby to see into the store. The glass front would be dramatically illuminated from the outside.

Martha Peabody, vice president for merchandising, is not in total agreement and feels strongly that the concept will take away from the exclusivity now enjoyed by the company. The management team is divided in its feelings, half agreeing with Peter and half with Martha.

QUESTIONS

1. With whom do you agree? Defend your answer.
2. How could both parties be accommodated? Suggest a design that could satisfy each group.

Case 2

In each of the first five years in business, Caryn-Sheri Unlimited has enjoyed a significant increase in sales. So successful is the shop that the partners are embarking on an expansion program. They plan to open two new units within the next five years and additional shops if they continue to be profitable.

Caryn-Sheri Unlimited specializes in active sportswear for women at a price point that appeals to those in the $35,000 to $60,000 income bracket. The stores were designed to resemble a workout or exercise facility. The decor uses various types of equipment found in a gymnasium to display the merchandise.

While both partners are enthusiastic about expansion, they are in complete disagreement over the focus of the store design for their new venture. Caryn, the more practical partner, believes the new stores should duplicate the first in all aspects. The interior and the window design have proved to be beneficial. Why mess with success? Sheri, the more creative partner, believes that although they are successful, they are limiting their market to those interested in the merchandise only for use in physical exercise. She favors a design that would minimize the gymnasium atmosphere and develop an environment showing the merchandise in other uses. Her rationale is that much more could be sold if the message were that active sportswear is equally suitable for streetwear. Caryn counters that a chain organization should have all of its units similar to each other. She believes that a different design might take away from the appeal that has contributed to their success.

QUESTIONS

1. Is it necessary for all stores in a company to have a uniform appearance?
2. With which partner do you agree? Why?
3. Can a plan be developed to satisfy the beliefs of both partners? Describe such a plan.

discussion questions

1. What role does a visual merchandiser of a large company play in designing a store?
2. Why do retailers desire a different look for their stores?
3. How are many restaurants now distinguishing themselves from others in their facilities design?
4. Why are some merchandise vendors redesigning their showrooms?
5. How does the Rain Forest Cafe attract passersby to stop and take a closer look?
6. Describe the typical window structure of a department store's downtown flagship store. Why is this design used?
7. What advantage does the corner window configuration give to the retailer?

8. Although the open-back storefront affords some advantages, describe some shortcomings of this design.

9. How can narrow frontage be transformed into more window space?

10. Why do merchants, particularly in malls, often subscribe to the windowless window concept?

11. What purpose does a circular window serve?

12. Why are store interior designs being given more attention by retailers than ever before?

13. What are the two major types of merchandise fixtures that retailers use?

14. Discuss the advantages of multipurpose merchandise systems.

15. Describe show-and-sell fixturing.

16. What is a vitrine?

17. How does the artist's rendering help the retailer?

exercises and projects

1. Visit a shopping center and evaluate six stores in terms of their window structures and interiors. Make sure you select six different types of windows, as outlined in this chapter, and complete the information requested on the form provided on page 70.

2. Select a merchandise classification such as home furnishings or men's clothing and develop a plan for a store that would visually merchandise the offerings to their best advantage. The store will be located in a mall and occupy a 15-foot front and a depth of 100 feet. The structure is just open space now. Use the form provided on page 71 to complete a design plan for the store. Make sure you complete all of the categories in developing your design.

EXERCISE 1 WINDOW AND INTERIOR EVALUATION

Store Name	Window Type	Interior Decor	Effectiveness of Visuals

EXERCISE 2 DEVELOPING A STORE PLAN

MERCHANDISE CLASSIFICATION:

Category **Justification**

Storefront/Windows

General Decor

Interior Display Fixtures

environment
direction:

(Courtesy of Lord & Taylor.)

objectives

After completing this chapter, the student should be able to:

... Discuss whether retailers are involved in sustainable design as a marketing ploy or a social responsibility.

... Explain why going green is advantageous to retailers.

... Discuss the meaning of LEED certification and what it takes to achieve this status.

... Explain how REI made its flagship in Portland, Oregon, "green."

... Describe which energy alternatives retailers are using to become more energy-efficient.

... Offer suggestions concerning the use of alternative paints rather than the conventional, solvent-based variety.

... Explain why bamboo is considered environmentally sound.

... Discuss how recycled glass is being used for floor covering.

design
going green

Introduction

As we have just learned in the preceding chapter, retailers are paying stricter attention than ever before to their facilities designs. While much of the environmental design continues to focus on storefronts and window structures, fixturing, and departmental layout, retailers are taking their planning a step further. Many are addressing the problems of protecting the environment with **sustainable design**, also sometimes referred to as **green design**, **eco-design**, or **design for the environment**. The concept includes building entire facilities such as stores, redesigning parts of existing environments, using **eco-friendly** fixtures such as those used in lighting systems, and using sustainable products in flooring.

Proponents of sustainable design cite numerous reasons for joining the ever-growing bandwagon. These include eliminating the environmental crises that are affecting human population, slowing the depletion of natural resources, and just doing the right thing while maintaining a satisfactory standard of life. In optimizing environmental designs that could have a positive effect on the quality of life, retailers are engaging in the use of nontoxic materials, incorporating **energy-efficient** systems in their stores and warehouses, utilizing longer-lasting **sustainable products** that need less frequent replacement and do not deplete natural resources making use of **reprocessed materials** for their environments, and moving toward premises that are not harmful to the health of the employees who inhabit them and consumers who frequent their premises.

Also very important in the practice of improving the environment, in which more and more retailers are engaged, is the use of recycled raw materials. With supplies such as shopping bags, printed graphics, direct mail pieces, and so forth generally an important part of the retail landscape, turning to recycled paper and **low-VOC inks** (inks low in volatile organic compounds), for example, offers yet another route to protecting the environment.

Through careful design construction that optimally incorporates green design in their structures, some merchants have earned an LEED (Leadership in Energy and Environmental Design) rating. The **LEED certification** system awards points for the satisfaction of each environmental concept initiated by the retailer that translates into a Bronze, Silver, Gold, or Platinum rating. REI, an outdoor gear and clothing retailer, and Giant Eagle, a supermarket chain, are two merchants that have achieved LEED status.

Of course, with retailers always concerned about the "bottom line," the involvement in green design often increases their expenses in both building the premises and using eco-friendly materials and systems. Having said this, more and more are joining the bandwagon to do their part in creating totally green environments, refurbishing parts of their structures, or simply adding components that make their premises more eco-friendly.

This chapter focuses on total green environments, the benefits that are driving the retail sector to become more "green," the ways in which the store's environment can become more energy efficient, the benefits of using recycled materials for interiors and sustainable products for fixturing, and so forth.

Is It Marketing or Social Responsibility?

While many retailers speak of their need to become proactive in the country's quest to save our environment and do the right thing to make the world a better place in which to live, there is an undercurrent of opinions that say participation is just a marketing ploy. The cynical comments that insist this is a way for some merchants to improve their images come from people who don't buy the social responsibility argument.

Although there might be some publicity benefits for those who have embraced sustainable design or green design, no matter what the motive, it is the American people who benefit in the long run from their participation.

Retailers such as REI have long advocated their concerns about the environment even before it was chic to say so. Their commitment seemed to be sincere. As we will see later in the chapter, the investment in "design for the environment" is costing retailers more dollars than if they continued to utilize the equipment that simply served their needs without environmental considerations.

Totally Green Environments

Although the trend is ever-increasing for businesses to develop and implement plans for the construction of totally green environments, the retail arena has been one of the slower groups to embrace the concept. In existing retail locations, complete renovation is out of the question, but as we will learn later in the chapter, when replacement systems and materials are in order, the direction is going the green route. In larger companies where expansion to new locations is a company's goal, sustainable design is becoming a reality.

The major issue for an all-green retail structure is cost. While the initial costs for such construction are higher than those of traditional building, the ultimate savings in the long run are significant. Given these initial costs, however, there are acknowledged benefits for retailers who pursue *eco-design* for their premises. Among the factors that are driving many merchants in this direction are:

- *Tax incentives.* Many local governments are offering tax credits for the installation of systems that are environmentally sound. The incentives vary for partial installations to those that are totally considered sustainable design. LEED certification, which will be addressed later in the chapter, generally brings the major tax incentive.
- *Consumer awareness.* The wealth of advertising in the media and the actions of governmental and environmental agencies has spread the news about environmental concerns to consumers all across the nation. Whether it is the use of the fear factors that stir the emotions or the concept of doing the right thing, there is a growing outcry from society for businesses to do all they can to protect the environment. The reactions have been a demand for retailers to take green initiatives.
- *High energy costs.* If there is little else to motivate retailers to get on the green bandwagon, it is the ever-increasing cost of energy. Lighting and ventilation costs have motivated many retailers to take a look at alternative methods for illuminating their premises and heating and cooling the interior. Solar systems, when employed, generally bring incentives on the federal, state, and local levels. Even without these incentives, the use of environmentally friendly bulbs can bring significant savings.
- *Positive public relations.* In addition to the real savings attributed to green commitments, businesses, with retailers among them, are deriving positive accolades from the press that often translate into increased shopper traffic. Some retailers are handling their green initiatives in the same manner they would their marketing strategies. Thus, the benefits of sustainable design not only address environmental concerns, but also may bring positive responses from the clientele.
- *Safety of staff and shoppers.* Given the advantages to the retailer of going green such as tax incentives, cost savings on energy, and so forth, safety concerns of people in a company's employ as well as customers have become a factor.

LEED Certification

While the product mix offered by retailers is generally the primary consideration that motivates shoppers to visit a retail operation, with price a close second, more and more consumers are considering a store's green initiatives when considering where to shop. The target for more and more merchants is to achieve LEED certification for their environments. The U.S. Green Building Council (USGBC) introduced a rating system in 1998 that has set new standards for design, construction, and operation of sustainable buildings. Both new construction and existing spaces that are renovated to meet environmental standards may qualify for the Leadership in Energy and Environmental Design (LEED) recognition and certification.

Although some of the initiatives undertaken by retailers in pursuit of certification are typical, such as the use of solar energy and the installation of larger windows, as in the case of some Wal-Mart stores, other concepts are less known. For example, a Chipotle store in Ridgedale, Minnesota, has installed a 6-kilowatt wind turbine to offset 7 to 10 percent of the unit's energy needs.

Well known as a national outdoor retail operation devoted to inspiring, educating, and outfitting its clientele, REI, founded in 1938 by a group of Pacific Northwest mountaineers, also addresses the problems that the environment now faces. Specifically, in its desire to help preserve the environment, REI has initiated several steps within its retail units and distribution centers.

For its retail operations, the company has made many changes to the typically designed environments using many green principles. The goal to go green was achieved in its Portland, Oregon, flagship. Its design was recognized by the USGBC with the earning of a Gold LEED rating, the first retail organization to achieve this designation.

In addition to moving its stores in the direction of environmentally sound designs, the company has been one of the first to construct a warehouse and distribution facility that was awarded Silver certification. Among its features include:

- The use of twelve additional acres to create a natural wetland for local wildlife
- The installation of more than 360 windows and skylights to allow natural daylight throughout the building, helping to reduce its reliance on energy use by 33 percent
- The provision of thirty preferred parking spaces to those who carpool and drive fuel-efficient vehicles, and twenty bike stalls—all transportation methods that save fuel

- The reduction of water use with the installation of dual-flush toilets and waterless urinals
- Positioning the building to take advantage of sun and wind direction during warm summer months and icy winter months
- Reducing construction carbon emissions through heavy-construction equipment vehicles powered by B20 biodiesel
- Contracting with a private recycling vendor to recycle glass, plastic bottles, and shrink wrap

In addition to designing new structures that fit the sustainable design concept, REI has also upgraded numerous components in its existing locations.

In keeping up with sustainable design, Gensler, a design company, designs numerous LEED-certified buildings. One of the more active retail participants utilizing Gensler is REI, or Recreational Equipment Inc. Many of REI's units have been designated as Gold-certified. Recognizing its dedication to environment preservation, REI received Chain Store Age's 2007 Retail Store of the Year award.

A Profile of REI examines its commitment to protecting the environment. LEED-certified buildings hold the promise to:

- Lower operating costs and increase asset value
- Reduce waste sent to landfills
- Conserve energy and water
- Provide healthier environments for occupants
- Reduce harmful greenhouse emissions
- Qualify for tax rebates and zoning allowances

For the retailing industry in particular, the USGBC has created many options to achieve LEED certification. There are four levels of the designation: standard certification, Silver, Gold, and Platinum. The awards are based on a points system awarded for the inclusion of the many energy-saving components that a company uses in its premises construction. Platinum-rated projects, the highest achievement, requires 70 points, and standard certification, the lowest, needs a minimum of 26 points. Points are awarded for the offering of preferred parking for employees that use fuel-efficient automobiles, incentives for employees that use public transportation, efficient energy-saving ventilation systems, lighting systems that use components such as Solatubes and light monitors, and so forth.

Components of Sustainable Design

Whether the environment in which retailers operate their stores or warehouses are complete eco-friendly premises or ones that utilize just some of the elements in their venues, there are specific installations, systems, and materials that are considered to be "sustainable." They include such items as heating and cooling systems, illumination devices, flooring, water purification systems, fixturing, and so forth. The use of each is just one more step in "**going green**."

Solar Energy

With soaring energy costs and a goal to reduce dependence on fuel, some retailers are focusing their attention on **solar energy**. Various technologies have been developed to take advantage of this energy alternative. The harnessing of the sun's heat and light, the basic principle behind the concept, is achieved in a number of different ways. These include full solar power systems, passive solar heating and daylighting, and space heating and cooling (Figure 5–1). The energy coming from heat and light are in such abundant amounts that, if so desired, retailers can sell their excess to utility companies. Though this is not the intent, it is addressed to show the availability of solar energy.

The power systems used are determined by "load profile" and potential sun hours. The number of panels used is determined by a calculation called the *Solar Matrix System.*

Natural Illumination

The use of oversized windows and skylights to illuminate store premises, workrooms, distribution centers, and warehouses has enabled merchants to reduce their total reliance on light fixturing (Figures 5–2, 5–3). Wal-Mart, for one, has begun to utilize a variety of these natural

Figure 5–1 Solar panels provide an abundance of solar energy.

Figure 5–2 Oversized windows enable merchants to reduce their reliance on light.

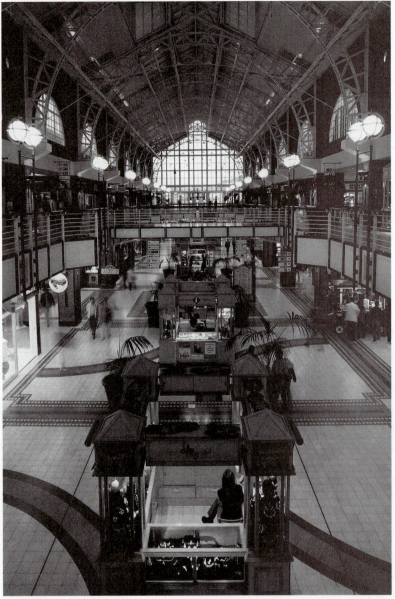

Figure 5–3 Natural light that comes through massives windows as seen her contributes to energy-saving.

light windows and has reported that sales within the stores have increased since their installations.

Wind Power

Although the use of wind power is still lagging behind the other heating and cooling concepts, it is getting some attention from retailers (Figure 5–4). Chipotle, in its Ridgedale, Minnesota, outlet, has installed a 6-kilowatt wind turbine to capture the winds that come off the nearby Lake Michigan. The company reports that the result has been a 7 to 10 percent saving in energy use.

Paint Products

The smell in a freshly painted room usually indicates that a conventional solvent-based paint has been used (Figure 5–5). Its contents often include as much as 60 percent volatile organic compounds (VOCs), such as formaldehyde, benzene, and acetone, each of which can have

serious effects on the body. These include dizziness, respiratory complications, and allergic reactions. Also, the VOCs are considered to contribute as much as 9 percent of the atmospheric pollution and are a detriment to the ozone layer.

With such negative connotations, retailers are turning to alternative paints that have been developed by such giants as Benjamin Moore and Glidden. They are water-based acrylics that are low-odor and near-zero VOC. Bioshield, a German company, has paint products that meet the green requirements. In an array of colors, products such as thinners, glazes, paints, and so forth can be used over existing painted walls as well as newly painted surfaces. The results are durable surfaces that stand the test of time and serve to fill the need for **eco-minded** merchants.

Flooring

One of a retailer's areas that have become increasingly more green is its floors. While the vast majority of merchants continue to base their flooring needs on aesthetics and durability, more and more are considering other factors when installing floor coverings. Carpet, wood, linoleum, and recycled glass are choices that efficiently address environmental concerns. Whether the use is for renovations or for new premises, the choices are many.

Carpet

In upscale stores, where carpet is often the choice for covering floors, especially in areas that need "luxury definition," merchants have choices that not only satisfy the green factor but comfort and durability as well. The list of environmentally sound products continues to grow. Mohawk, in particular, has introduced a variety of carpets that meet the needs of retailers seeking eco-friendly environments and aesthetically pleasing results. SmartStrand with DuPont Sorona contains ingredients made from sugar, a 37 percent **renewable resource**. These renewably sourced ingredients replace ingredients that are traditionally derived from

Figure 5–4 Wind power is getting some attention from retailers.

Figure 5–5 Conventional solvent-based paint adds to pollution.

petroleum, which has severe price implications and supply limitations. For every 7 yards of SmartStrand, the renewably sourced polymer, the energy equivalent of 1 gallon of gasoline is saved. The good news is that performance is not compromised and its environmental impact is positive. Durability is also a plus with SmartStrand. It is extremely durable and has the added feature of stain resistance, as well as incredible softness. Another Mohawk entry is EverStrand. Made from discarded plastic beverage bottles, the fiber produced is far superior to the lower-grade synthetic fibers used in many carpets. With Mohawk recycling more than three billion plastic bottles each year, the fibers produced provide exceptional stain resistance and excellent color clarity.

Linoleum

A good choice for high-traffic areas in outlet stores and other high-volume establishments is natural linoleum. It is made from natural raw materials that include linseed oil, resins, and wood flour. These materials offer a healthy environmental alternative to the retailer. During production, it has no adverse health issues, making it eco-friendly. It is anti-static and reduces the potential for electric shock. It is easy to clean since dust and dirt particles do not stick to its surface. In addition to use on the selling floor, it is perfect for back-room operations as well as fitting rooms.

Wood

With the potential for using our wood resources in a manner that might quickly deplete our forests, environmentalists are fearful that the supply could eventually erode. One classification of wood products (although technically a grass) that is favored because of its ability to rejuvenate in a matter of a few years is bamboo (Figure 5–6). With its natural beauty and little impact on the environment, it is often called one of nature's gifts to humankind. Instead of using traditional wood flooring, retail store designers are opting for bamboo. With the help of recent technological advances, the flooring can be made as flat as any other hardwood or laminate floor while keeping within environmental guidelines. Bamboo floors are available in a wide range of colors in either planks or tiles. Easy to install, the wood is tough and durable and can withstand the heavy traffic that retail environments generate.

Another eco-friendly choice is the use of **reclaimed wood** flooring (Figure 5–7). There is an abundance of wood that was previously used, ranging from antique heart pine to reclaimed Australian chestnut. Both of these are excellent choices when character is desired. For use in special retail settings such as boutiques and designer areas in major stores, these woods are outstanding. Reclaimed wood is the most eco-friendly option as long as chemical strippers and sealants aren't used in the process.

Recycled Glass

Although it has thus far been limited in use, **recycled glass** is becoming a choice for flooring. Glass is in itself environmentally "correct," and when it is recycled from discarded bottles, it is especially "green." The glass bottles are crushed and then mixed with epoxy. The mixture is then poured to fill the necessary spaces. The result is an attractive, durable terrazzo-like surface.

Figure 5–6 Bamboo is an excellent product since it quickly rejuvenates.

Figure 5–7 Reclaimed wood is an eco-friendly choice.

Fixturing

Also significant in the area of environmental design is the choice of fixtures that are used in a store's premises. Display fixtures that are used to house the retailer's merchandise are generally chosen with aesthetics in mind as well as the functions they serve. A good display case, for example, must be sufficiently attractive to enhance the surroundings in which it sits, and functional in terms of its purpose (Figure 5–8).

Today, some merchants go one step further in choosing their fixtures by making certain that the materials used in their production meet environmental standards. More and more fixture suppliers are addressing ecological concerns by offering display bins, shelving, gridwalls, shelving, and other products that are made from materials that are sustainably developed.

By using such raw materials as bamboo, plantation cedar wood, and recycled wine barrels (Figure 5–9) in their fixtures, retailers help lessen the environmental impact of their fixture needs. The construction utilized includes low-emitting strong adhesives that have little adverse effect on the environment.

Companies like GreenStore Inc., whose motto is "Saving the world one business at a time," offer numerous types of fixtures that are eco-friendly. With reliance on sustainable materials and renewable resources, such companies offer quality products that comply with the latest demands of environmentalism (Figure 5–10).

Supplies

Retailers who specialize in fashion merchandise use an abundance of hangers in their stores. Most are made from plastics that do not meet eco-friendly standards. Today, some companies are producing hangers that are 100 percent recyclable. Made from recycled post-consumer waste, the pulp is converted into durable corrugated board, and the final product is customized to fit the needs of the merchant. The hangers may be impregnated with a store's name or logo, for example, or decorated in any manner that is desired. Unlike plastic and metal hangers, these are recyclable.

Figure 5–8 Fixtures must be attractive as well as functional.

Figure 5–9 Recycled wine barrels help reduce the impact of fixture needs.

Figure 5–10 Eco-friendly containers are used to recycle materials.

With more and more articles, editorials, and advertisements, along with increased industry awareness, the green movement is certain to gain momentum. Buzz words and terms like *sustainable design, eco-friendly, eco-design,* and others seem to be catching on and making consumers and merchants ready to embrace the concept of environmental protection.

5 chapter review

key points in the chapter

1. Retailers are paying closer attention than ever before to making their environments eco-friendly.

2. Sustainable design is becoming more widely used to avoid depletion of natural resources and help eliminate environmental crises.

3. Recycling of raw materials is being stressed in the production of such items as shopping bags, printed graphics, direct mail pieces, and so forth.

4. Some merchants who have incorporated green design in their premises have earned LEED status.

5. The awarding of tax incentives has motivated some merchants to join the environmentally sound movement.

6. Consumer awareness has prompted many retailers to "do the right thing" in terms of environmental protection.

7. High energy costs have prompted some retail operations to install solar systems and environmentally friendly light bulbs on their premises.

8. REI, a company founded by a group of mountaineers, has led the way for green initiatives in retailing.

9. LEED-certified buildings lower operating costs, reduce landfill waste, conserve energy, reduce harmful greenhouse emissions, and qualify for tax rebates.

10. Solar energy needs are determined by a calculation called the *Solar Matrix System.*

11. Some retailers are using oversized windows and skylights to take advantage of natural illumination and reduce energy costs.

12. A new breed of paint products has been introduced to make retail environments "green."

13. New types of carpet have significantly contributed to eco-friendly environments.

14. Bamboo has started to replace traditional wood flooring because it is a more sustainable resource.

15. Recycled glass is obtained from discarded wine bottles and other containers that are processed into mixtures and then used for durable flooring.

terms of the trade

internet exercises

1. LEED certification has become a goal for retailers to achieve to make their environments eco-friendly. Although this status is a goal for many retailers, there is more than one level of certification. Using the search engine www.google.com, or any other, investigate the different levels of LEED status, describing the requirements of each, which stores have achieved the different levels, and what components are necessary for the awarding of this designation.

2. Using an Internet search engine, explore some of the different manufacturers that offer "green" products for the retailer's premises. Select three and describe the different products that can be incorporated in a store's environment. Make certain that each producer is in a different field than the others.

Case Problems

Case 1

Abigail and Sophia, friends for many years, operate a successful small fashion boutique. In business for twelve years, they have established themselves as a company that caters to women who are fashion-savvy and aware of the style trends that are popular.

The boutique has always maintained solid relationships with its clientele, and has built a loyal customer base. With the majority of the customers being relatively affluent, price is not very often a concern. First and foremost, the shopper's needs are satisfied with fashions from domestic and global suppliers. By utilizing some direct mail advertising to announce the arrival of new collections and sales events, Abigail and Sophia have significantly increased traffic in the store.

Characteristically, the majority of those who patronize the store are well educated and have concerns for the environment. With all the news concerning environmentalism, sustainable design, eco-friendliness, and so forth, customers have started inquiring about the store's attempt to join the "going green" movement.

Being a small company, Abigail and Sophia don't have sufficient capital to undertake major changes such as adding solar power for energy needs, refurbishing with eco-friendly carpet, and so forth. While they would like to participate in some efforts to help improve the environment, they don't see how they could become involved without high costs.

QUESTIONS

1. From the information provided, what are some ways in which the boutique could become eco-friendly?

2. Would the involvement in pursuing environmentally correct solutions be a good marketing scheme, or a means of addressing social responsibility?

Case 2

Michael Alexander is a small chain that specializes in outdoor merchandise such as gas barbeques, lawn and patio furniture, hot tubs, pool supplies, and so forth. It has been in business since 1993 and has grown from a one-store operation to a company that numbers twelve units. Based in Oregon, it has enjoyed considerable success in all of its units.

Unlike most stores in this type of retail classification, the environments are especially eye-appealing. Small waterfalls, backyard settings, and other visually attractive components make the environments particularly striking. The merchandise that is

offered for sale is separated into different sections according to classification.

A new outdoor mall, or town center, is being developed within the company's trading area. The clientele that is expected to patronize the new venue is comprised of young families, many of whom are "naturalists." They enjoy the outdoors and are, for the most part, concerned with protecting the environment. They are specifically interested in *sustainable*

design, green initiatives, and *eco-friendly* safeguards.

The company, wishing to address the environmental concerns of prospective customers, has hired an architect to draw preliminary plans for the newest store. Although the expected budget is greater than what the company has usually spent on other locations, management believes that the costs will eventually bring positive results to the bottom line. The company

would also like to apply for LEED certification, which could give the new store positive exposure with the expected clientele.

QUESTIONS

1. What might some of the benefits be from such an undertaking?
2. What are some of the areas that must be addressed to qualify for LEED certification?

discussion questions

1. Define *sustainable design* and discuss its importance to retailers.
2. How are retailers making use of recycled raw materials in their everyday undertakings?
3. Is *going green* a marketing tactic or a retailer's social responsibility?
4. Are tax incentives a reality for those merchants using eco-friendly devices for their stores?
5. Do retailers benefit from positive public relations when they employ green approaches to their companies?
6. What is LEED certification?
7. How has REI achieved LEED certification?
8. What is meant by *Solar Matrix Systems*?
9. Is it plausible for retailers to use natural illumination as a replacement for some of their traditional lighting?
10. Why are many retailers switching from the use of conventional solvent-based paints to alternative paints for their painting needs?
11. How have some manufacturers provided retailers with carpet for their interiors that satisfies the "green factor"?
12. Why is linoleum flooring considered to be an environmentally friendly alternative to other flooring?
13. Which wood flooring is a favorite for eco-minded merchants? Why?
14. How has recycled glass been used in flooring for retail establishments?
15. What materials go into the production of eco-friendly clothing hangers?

exercises and projects

1. Visit a major retailer in your trading area for the purpose of determining if it is investing in sustainable design for its premises. Make an appointment with someone in management to help you assess the retailer's involvement and any future plans to address eco-friendliness. Construct a chart with those practices already in place and one that lists future endeavors planned by the company.

2. Make a trip to a carpet company that offers commercial carpeting. Ask to see the different carpets that are considered environmentally sound. Compare these with other products that are made from traditional fibers. Prepare a list of the names of the environmentally safe flooring options, and describe the benefits that each offers in terms of sustainable design.

mannequins
human

objectives

After completing this chapter, the student should be able to:

... Describe four classifications of mannequins found in stores.

... Differentiate between the traditional human forms and those that are stylized.

... Discuss a major innovation in the use of representational mannequin forms.

... List and describe four reasons for the manufacture of human form mannequins as component parts.

... Identify the component parts of a mannequin.

... Explain the reasons for the different types of base-to-leg attachments found on mannequins.

... Describe the stages of dressing a mannequin.

... Discuss the advantages of fibers such as Kanekalon and Luraflex in wig construction.

... Compare the advantages and disadvantages of permanent mannequin makeup to the makeupless variety.

... Explain why human forms other than full mannequins are used in display.

... Compile a checklist for use in purchasing mannequins and other human forms.

... Create mannequins to be used in place of those produced by the mannequin industry.

and other forms

Introduction

Of all the component parts of a display, the one that is often the focal point is the mannequin (Figure 6–1). **Mannequins** have always been the mainstay of the visual merchandiser's bag of tricks, but they have taken on new excitement (Figure 6–2). In the past, the forms were lackluster replicas of people, and not much attention was given to carefully adorning and posing them to convey a fashion image or to enhance a theme. A quickly dressed mannequin was itself the goal, rather than being one element in a total display design, as is the case today.

In order to generate excitement, some visual merchandisers cluster several mannequins together. Not only does this eliminate the need for other props but it presents a striking appearance. If the mannequins used are particularly unusual, it adds even more to the presentation.

Visual merchandisers have come to recognize the mannequin's value in terms of sales and now choose them as carefully as the buyer does the store's merchandise. The selection of a mannequin is a precise and time-demanding process. Visual merchandisers, especially those with sophisticated retail operations, will travel far and spend huge sums to bring back the best available mannequin. Production and purchasing were once accomplished exclusively in the United States, and usually close to the store's base of operation, but today's quest for the perfect mannequin is often an international adventure. New John Nissen mannequins, Belgium; Adel Rootstein, London (Figure 6–3); and Poil Kyoya, Tokya, are just some of the foreign companies that do business with American visual merchandisers. Of course, American mannequin companies such as Patina V and Greneker are also major resources.

In addition to the mannequins available from manufacturers, many trimmers are using creations that they construct themselves. These creations and the various types of professionally produced mannequins are discussed later in this chapter.

Along with full-form mannequins, there are models such as three-fourths torsos, **hosiery legs**, and **shoulder** and **head forms**. As the full-form figures have changed in design and materials, so have these display devices.

This chapter focuses on the different aspects of mannequins, including:

- Component parts and their workings
- How to dress a mannequin
- Types and forms of mannequins

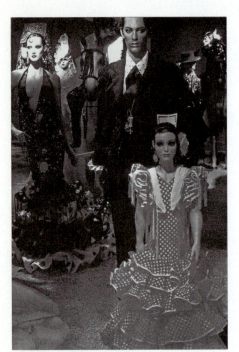

Figure 6–1 Adel Rootstein mannequins represent the "Rolls-Royce" of the industry. *(Courtesy of Adel Rootstein.)*

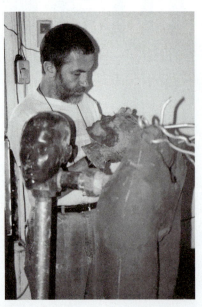

Figure 6–2 The creation of mannequins requires a great deal of attention. *(Photograph by Ellen Diamond.)*

Figure 6–3 Traditional mannequins are equally adaptable to sophisticated, formal, or casual attire. *(Courtesy of Adel Rootstein.)*

- Proper care and maintenance
- Wig selection and makeup
- A checklist for selecting mannequins and other human forms
- Step-by-step instructions for the creation of one's own mannequin

Types of Mannequins

A visit to any visual merchandising trade show, such as NADI's (National Association of Display Industry) GlobalShop, underscores the variety of mannequins from realistic to avant garde available to the retailer. Following are some of the types of mannequins available today and their potential uses.

Traditional Human Forms

Although abstract or stylized mannequins provide excitement in windows and interiors, their use is somewhat limited. Stores with restricted budgets and conventional merchandise offerings must rely upon models that typify their images. This is not to imply that image must be limited to dowdy because only ordinary mannequins are available. Today's **traditional human form** mannequin can be sophisticated yet serviceable for different types of attire. It is equally appropriate wearing a business suit or sportswear. It affords the retailer the advantages of adaptability and versatility. Through the use of different wigs, makeup, and arm and leg positions, a mannequin can be transformed to create many different impressions. Although stores such as Lord & Taylor, Macy's, Saks Fifth Avenue, and Bloomingdale's use the **fashion-forward mannequin**, their visual merchandising departments are also heavily stocked with traditional mannequins.

One of the leaders in the design and manufacture of traditionally realistic mannequins is Adel Rootstein, the subject of the following Profile.

Ethnic Mannequins

Throughout the United States, more and more retailers are using **ethnic mannequins**, as discussed in Chapter 2, in their visual presentations. The vast majority of these forms feature models that are either Hispanic, Asian-inspired, or African American (Figure 6–4). It should be noted that retailers are not just using these ethnic mannequins in areas that are predominantly of a particular ethnicity; they are part of most major department stores.

Stylized Human Forms

For the store seeking an image that will separate it from the rest of the pack, but still wishing to remain sophisticated, there are many **stylized human forms** of mannequins that follow traditional lines but offer a change of pace (Figure 6–5). Their figures might feature a skin tone finish other than human flesh color, a brushstroke body surface akin to a fine artist's brushstroke, or hair that is sculpted to give a claylike feeling and sleek appearance. What remains the same in this group of mannequins as in the traditional variety is the reality of the pose, the retention of the human features, and the versatility to effectively display a wide variety of merchandise. The major retailers in this country and abroad rarely use this type of mannequin as their display mainstay but use them instead for specific departments in the store.

Futuristic Human Forms

A retailer may seek to depart totally from the realistic look of a traditional mannequin, or even the slightly exaggerated look of a stylized form, but still wish to rely on some version of the

Figure 6–4 Ethnic mannequins help retailers show their commitment to diverse consumer markets.

(Courtesy of Adel Rootstein.)

PROFILE: A Contemporary Visual Merchandising and Environmental Design Profile: Adel Rootstein

At the beginning of the 1960s, when Britain was starting to influence fashion all over the world, designers such as Mary Quant and Jean Muir became symbols of the new movement; the personality cult was in full swing. It wouldn't be long before London replaced Paris as the world's fashion leader. One of the only deterrents for retailers during this time was the lack of mannequins suited to the new wave of fashion. The typical mannequins were of the stilted variety, stylized and very old hat; rigid and lifeless, they simply looked like the "dummies" they were often called. It was Adel Rootstein, the contemporary mannequin pioneer from London, who would change all of that. She captured the aura of the sixties fashion scene in England and began a totally innovative look that would make her mannequins world-famous.

The form starts life as a sculpture based upon the chosen model, often someone in some sector of the fashion or theatrical worlds. Some of Rootstein's earlier subjects included Twiggy, Joan Collins, and Dianne Brill. A plaster cast is made from the sculpture, which is then used to produce the final mold. The final form is created with fiberglass and shipped to every fashion center of the globe. Rootstein's choices did not come by chance, but rather from studying the world of fashion eighteen months before the new collections would be readied for retail buyers, just as the fashion forecasters have done for years. To this day, the same approach is used before any new addition to the mannequin collection is made.

Unique to the mannequin presentations at the Rootstein showrooms is the manner in which the forms are displayed. The figures are grouped in interesting arrangements as they would be in an upscale retail emporium and clothed in ensembles that may be compared to the offerings found in many couture collections. Each clothing design is created in-house for their exclusive use on the mannequins. A walk through the showrooms immediately reveals an air of excitement and is the stimulus for purchasing. Makeup artists, hair designers, and "skin" colorists add the final touches to each form, making them distinctly individualistic.

With headquarters in London and New York City, and regional showrooms in France, Greece, Italy, Singapore, Spain, Belgium, and numerous other global venues, the Rootstein mannequin continues to dominate the field as the "Rolls-Royce" of the mannequin industry.

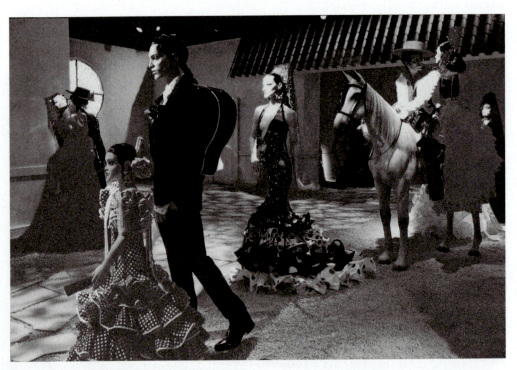

Figure 6–5 Stylized human forms, in unique poses, help separate a retailer's image from the competition. *(Courtesy of Adel Rootstein.)*

human form. The emphasis in **futuristic human forms** may be on unique coloration or accents, such as the hair, that depict unconventional shapes such as cones. Other futuristic mannequins may be unusually tall or finished with shiny surfaces, each designed to attract attention.

Representational Forms

With shrinking budgets, many retailers are resorting to the use of less expensive forms that fulfill the same purpose as traditional or stylized mannequins. A fine traditional mannequin may cost more than $1,000; these **representational forms** are quite inexpensive. With shrinking budgets, *forms seem to fit the bill.* Made of a variety of materials such as steel tubing, wooden dowels, brass, and PVC piping, the forms are actually **display hangers** on which merchandise may be satisfactorily displayed (Figure 6–6). These simple devices are easy to trim and may be used for both men's and women's clothing. They are particularly useful in the branches of many chains where professional visual merchandisers are not available to make mannequin changes. The simplicity of these structures makes it easy for a salesperson to make the needed adjustments (Figure 6–7).

Trimmer-Constructed Mannequins

When money for mannequins is severely limited, more and more trimmers are creating their own. **Trimmer-constructed mannequins** are similar to the manufacturer-made representational forms but are made of inexpensive materials at a fraction of the cost of any other mannequin (Figure 6–8).

Later in this chapter, a step-by-step illustration is provided to show how these invaluable display pieces can be constructed quickly and inexpensively.

Component Parts of Mannequins

Mannequins come in a wealth of styles, shapes, and materials. Some are made as self-contained units, as is the case with many of the representational forms. There are no separate parts to

Figure 6–6 Simple representational forms help the merchant to defray the cost of traditional mannequins.

(Courtesy of Saks Fifth Avenue.)

Figure 6–7 Dressmaker forms, when creatively used, are excellent alternatives to the traditional forms. *(Courtesy of Saks Fifth Avenue.)*

maneuver or adjust. Most other mannequins are constructed as a package of pieces, which, when assembled, constitute the full human form. The reasons for the components are:

1. *Ease in changing garments.* Since mannequins, unlike humans, cannot bend or change position to accommodate trying on a garment, parts such as the arms and legs must be removable for dressing.

2. *Flexibility.* If mannequins were capable of only one position, visual merchandisers would need many more for variety in their presentations. With the interchangeable legs, arms, torsos, and wigs, a mannequin can be adjusted to serve many purposes. Just a change of the leg portion can transform a stander to a sitter.

3. *Storage.* It is often easier to store the mannequin in parts. Arms and wigs, for example, require very little space and could be stored easily on shelves.

4. *Care.* No matter how careful the handlers are, mannequins are bound to suffer chips, scratches, and breaks. If the figure were a one-piece assemblage, refinishing to repair the damaged parts would require that the full figure be shipped to the mannequin repair company. It is certainly easier and less expensive to transport only the damaged part rather than the full form.

Figure 6–8 The use of large Styrofoam balls, used as heads, make this trimmer-created mannequin both eye-appealing and functional.

(Photograph by Ellen Diamond.)

There are several component parts of the mannequin and of the devices that enable them to be attached to form the full figure, as shown in Figures 6–9 through 6–14. The model illustrated is a female figure, but the male and children's counterparts are produced in the same manner.

The leg structure is usually a one-piece construction. In some cases, for maneuverability when displaying pants, one leg is detachable. At the top of the leg portion there is a wide, dowel-like fitting that attaches to the torso and secures the two principal parts of the body. At the base of the torso is a hole to receive the dowel-like fitting. While the leg portion may be adjusted slightly in a particular direction, the torso is stationary.

Figure 6–9 The standard leg structure is usually a one-piece construction.

Figure 6–10 The torso is a one-piece construction that features "armholes" into which the arms are inserted.

Figure 6–11 The standard base attachment is used to "steady" the mannequin.

Figure 6–12 An alternative base attachment is used when pants are featured.

Figure 6–13 The mannequin's arms are fitted with special devices that are inserted into the torso "armholes."

Figure 6–14 The hands have devices that lock into the arms' "receiving" holes.

Most mannequins are secured by a removable steel rod that extends from a weighted glass or metal base to the uppermost back portion of the leg. When secured at both the bottom (base) and top (leg of mannequin), the figure is in a steady position. An alternative method of securing mannequins is to wire them to the floor. Using this method, neither the steel rod nor the base is necessary for securing purposes.

Often mannequins are used to display pants. For that purpose, some forms are equipped with short steel rods that extend from below the leg calf. This short rod can easily be concealed under the pant leg. The long steel rod attachment can be a problem in pant dressing, so the shorter version is used. If either of the rods gets in the way of the pant leg, as might be the case when the pant is very tapered at the bottom, a seam in the garment may have to be opened to complete the mannequin's dressing.

The arms of the mannequin have metal devices that fit into **receiving holes** on the upper sides of the torso. The fitting is designed to permit the arms to rotate and stop at different intervals for varied positioning. Hands are fitted with devices that lock into receiving holes in the mannequin's arms. When both parts lock, the arm and the hand make a perfect fit.

When fully assembled, the components yield a full mannequin on which any type of clothing can be displayed. As already mentioned, the beauty of modern mannequin construction is that the upright figure may be changed to a sitter with a simple change of the leg structure (Figure 6–15).

Dressing the Mannequin

If the proper attention is paid to assembling and disassembling a mannequin as it is being dressed and undressed, the figure will retain its freshness and usefulness for a long time. The accompanying illustrations show the technique and steps used in dressing a mannequin. The order is simply reversed for undressing.

To dress the assembled mannequin, first remove the legs from the steel rod and base. Then turn the legs upside down to receive the skirt or pants. If the mannequin is to wear hosiery, it should be added before placement of the outer garment. With the legs upright in the proper position, it is time to add the shoes. Then reattach the legs to the rod and base. The trimmer must select the leg component carefully, making certain that it is appropriate for the garment to be displayed. For example, in the case of pants, the best choice is a leg base that attaches to the steel rod (Figures 6–16 and 6–17). If this is not used, it could be difficult to reinsert the steel rod. The longer steel rods would bind the pant leg and prevent insertion back into the base. Some companies manufacture a mannequin without the traditional attachment rods and instead use a device that connects the base under the mannequin's foot. A disadvantage of this design is that if hosiery and shoes are to be used, both items must have holes cut in them. While some stores do damage the shoes and hosiery, these items obviously cannot then be sold.

If a dress is being featured, it is possible, after the hosiery and shoes have been placed, to then attach the torso to the leg portion and slip the dress over the head of the mannequin onto the body. Hands-on experience provides the trimmer with a sense of the best way to place each garment on the mannequin. The novice will require a good deal of trial-and-error experimentation before mastering the task.

In the case of separates, next place the torso onto the leg component just described and then put on the shirt, sweater, or blouse. If the design buttons down the front or back, it is easy to insert the arms later. Mannequins are dressed in much the same way as humans put clothes on. Sweaters other than cardigans must be pulled over the head. At this stage, the blouse should be left unbuttoned with pullover sweaters hanging loosely. This is important because sometimes it is difficult to attach the arms to the torso. Leaving the clothing loose makes it easier for the trimmer to slip the arms in place (Figures 6–18 and 6–19).

At this point, attach the hands to the arms by lining up the two related devices, one found at the base of the arm, the other at the wrist portion of the hand. Once related properly, they will lock into place. Then slip the arms into the garment's sleeves and attach them to the torso, again rotating until locked into place. If the sleeve opening is too small to receive the hands in this manner, it might be necessary to detach the hands from the arms, insert the arms through the blouse or under the sweater, lock the arms in place, and then attach the hands. Again, experience is the best teacher.

Add the wig after the garments are in place and adjusted with pins, if necessary. If pins are needed, they must be applied to the back of the garment, out of the shopper's sight.

Wigs and Makeup

Too often a display features the latest fashion, yet the mannequin does not have a totally fresh look. The hair style might be out of sync with the clothing or the hair might be damaged or discolored, like human hair that has been neglected. Another basic problem could be the mannequin's makeup. The wrong color emphasis, discoloration of pigment, lackluster

Figure 6–15 The fully assembled mannequin is the sum of its component parts.

Figure 6–16 A skirt is easily placed on the standard base attachment.

Figure 6–17 Pants require the alternative type of base attachment that features a short steel rod.

Figure 6–18 When dressing the mannequin, if a shirt is used, it should be left open so that the arms may be easily attached.

Figure 6–19 The hands are attached to the arms, which in turn are attached to the torso, making the dressing complete.

application, and nicks and scratches all detract from the featured merchandise. Whether for humans or mannequins, to give the impression of perfection, the whole presentation must be carefully developed.

Wigs

In order to present the latest fashions successfully, a number of wig styles should be available from which to choose. A mannequin can be immediately transformed from a casual, sporty look to one of sophistication and elegance with a different wig. Fashion has so many influences and changes so rapidly and radically that different hairstyles are essential to capture the mood of each trend. One season the hair is long and ironed straight; the next, short and

Figure 6–20 The use of soft fibers enables the wig designer to create hairstyles that are appropriate to the featured apparel.

(Photograph by Ellen Diamond.)

curly. A blonde might be more suitable for a particular outfit, but a redhead might better complement an emerald-green ball gown. The keys to appropriate wig use are variety, flexibility, and adaptability (Figure 6–20). When a style is in vogue, the display person should be able to respond immediately without making a trip to the supplier. If the visual merchandising department has a variety of wig types, hair lengths, and fibers in stock, the task is easier.

The **horsehair**, lacquered **wigs** that were once dominant in the display world are outdated. Although the material made possible the creation of the most elaborate coiffures, once they were lacquered into place, the styles were permanent. Very few stores still use these wigs. They are easily detected. Shiny and stiff when new, they quickly fall into disarray and soon have separate clumps of hair that no longer form to the head's contour.

Just as hair has taken on a more natural, relaxed look, so have the wigs used on mannequins. The demise of horsehair has given way to fibers such as **Kanekalon**, **Elura**, and **Luraflex**. Each is soft and closely resembles human hair. Kanekalon has the advantage of being inexpensive, but it cannot be restyled from one shape to another without being washed each time. Elura can be reset, but its shortcoming is a slightly artificial look. Luraflex is extremely versatile for wig use. It is natural in appearance and can be restyled as often as necessary to complement the changes dictated by fashion.

Novelty fibers are much in evidence in today's windows and interiors. For that special promotion, the store that is fortunate enough to have a large visual merchandising budget often invests in unusual wigs. Raffia, lamé, and wool have been used to project specific fashion looks. They are not the mainstay of a store's wig collection, but they can be seen in fashion-forward stores throughout the world.

Care is vital if a wig is to remain attractive and useful. To lengthen the life of a wig: (1) store in individual containers, (2) wash regularly to get rid of hairspray, and (3) use care when setting and combing the wig. Of course, many visual merchandisers are using stylized mannequins that feature molded wigs made from the same materials as the mannequins. They cannot be changed or adapted to a specific need. However, some retailers prefer these forms because the hairstyles are always in place and need not be fussed with. With these mannequins, the problems associated with wig refurbishment are eliminated.

Makeup

Most retailers, except for the fashion-forward department stores, order mannequins complete with total, permanent makeup. Chain stores and independent retailers generally choose makeup that is acceptable for just about any style that is to be fitted on the mannequins. Although this is not best in terms of complete coordination with the garments to be displayed, it provides the least difficulty for the store: no smudging or smearing, no makeup on clothing, and no need for a specially trained person to design or apply makeup for each display change.

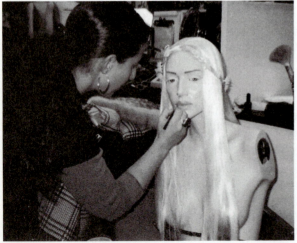

Figure 6–21 Specialized makeup is applied to enhance the displayed outfit.

(Photograph by Ellen Diamond.)

In an organization that considers specialized makeup imperative to each individual visual presentation, artistic creativity is needed (Figure 6–21). These stores simply order mannequins with no makeup or with very light makeup that can be strengthened as necessary. The selection of makeup at such a store's cosmetic counters is generally sufficient to meet this need. Because care should be taken to choose makeup that is appropriate to the mannequin's skin color, it is best to consult the cosmetic department specialist about color and application procedures. Sometimes, when a couture collection is being featured in the store's windows, the designer creates specific makeup colors and styles to accompany the designs. In these cases, the designer or a company representative should be contacted for instructions.

The following are some basic rules for mannequin makeup:

1. Make sure the face is cleaned often whether the mannequin's makeup is permanent or fresh. Correct any damage to the skin as necessary.
2. Makeup is used to highlight and complement the merchandise. Unless the display is a tie-in with a cosmetics company or a high-fashion clothing

designer, the makeup should be used only as an enhancer. It shouldn't stand out or compete with the purpose of the display.

3. The fashion pages of *Harper's Bazaar, Vogue, Women's Wear Daily, W,* and so on should be examined for cosmetic trends.

Other Human Forms

The full human form, whether realistic, stylized, or representational, is certainly central to many clothing displays in windows and interiors. Complete mannequins, however, do not meet all of the visual merchandiser's needs. Those who design and install displays make significant use of other human forms in conjunction with mannequins or alone. Some windows or interior spaces are too small to house a full form, or the merchandise might be best featured on another type of display form (Figure 6–22). As mannequins come in a variety of materials and images, so do other forms. Some of those found in visual installations are:

Figure 6–22 This torso form features arms that can hold a golf club and provide the visual installation with "movement."
(Photograph by Ellen Diamond.)

- **Women's torso** or three-fourths forms for swimsuits, blazers, and ensembles
- Male **suit forms** that are actually more popular than the full figures for men's clothing
- Shoulder and head forms for scarves, millinery, and accessories
- **Blouse forms**
- Hands, hosiery legs, and **shoe forms**

Purchasing Mannequins and Other Human Forms

Rarely is the display budget so plentiful that the visual merchandiser can select mannequins and other human forms without considering cost. Since a top-of-the-line mannequin may cost at least $1,000, mannequin purchases require careful planning.

By examining such periodicals as *Visual Merchandising and Store Design,* published in the United States, and *Retail Attraction,* published in Great Britain, one can assess the variety of mannequins and forms available, their producers, and their approximate cost. Most companies have showrooms for inspection of their lines and often have representatives who travel to the stores. They may provide photographs for those who cannot take advantage of the personal contact. Of course, a trip to the showroom or a trade exposition is best. Visual merchandisers should visit vendors much the same as store buyers do in shopping the lines of merchandise. This is a purchase that lasts a long time; it should not be done haphazardly.

Creating a Mannequin

Many trimmers create their own mannequins for the retailers they service. The benefits are versatility and extremely low cost—often the materials used in these constructions cost only a few dollars! This is quite a saving when compared to forms that are purchased from manufacturers. Professional trimmers are using these mannequin forms, but it should be noted that the retailers themselves can, after learning some of the techniques, create their own mannequins and cut their visual merchandising costs considerably. Manufacturers and wholesalers can also make use of these forms. At trade expositions, in particular, they can be quickly and cost-efficiently assembled to display their hottest numbers. Instead of calling upon the services of a professional, they too can satisfy their own display needs.

The following information and accompanying photographs illustrate the manner in which children's, men's, and women's forms are created and dressed.

Children's Mannequin

The supplies for this construction are easily obtained from a crafts store: a Styrofoam base, a wooden dowel, a Styrofoam ball, a wooden crosspiece, and wire (number 24 is perfect for this task). Follow these steps for perfect results:

1. Place the dowel (length to be determined by the desired height of the child) into the Styrofoam base. Make sure it is centered so that it will not topple.
2. Wire the crosspiece of wood (also a dowel that may be cut from the upright piece) to the dowel implanted into the Styrofoam.
3. The mannequin is ready to be dressed. First, place the top pieces such as shirts and sweaters over the arm dowel. Next, put pants on a hanger, as shown in Figure 6–23, and drop the hanger on the wire from the arm's crosspiece. Make certain that the wire is securely tied to the crosspiece.
4. Pin the end of one sleeve to the garment.
5. For fullness, stuff the arms, pant legs, and so on with tissue paper.
6. Attach the Styrofoam ball, which serves as the head, to the top of the upright dowel.
7. Pin a hat to the top of the head, or try something whimsical such as using many short lengths of ribbon for hair on the head. Another material to use for hair is jute. A bandanna might be used on top of the hair. The face might then be painted to give the mannequin a fun look. The creativity of the trimmer can add many elements to make this a unique mannequin.
8. The mannequin should then be placed in a setting to depict a theme or simply placed against a wall.

Men's Mannequin

For a full-form male mannequin the following supplies will be needed: one 6-foot piece of 2 × 4 lumber, a 1 × 12 square for the base, a 1 × 2 to anchor the 2 × 4 to the base, and two hangers, one a suit type and the other with clips. A drill and screws for assembly will also be needed. The following steps complete the project (Figure 6–24):

1. Assemble all of the pieces of wood as shown in the appropriate photograph.
2. Place a screw at about 8 inches from the top of the 2 × 4 from which the clothing will be hung on the hanger.
3. Put the clothing on the suit hanger. A shirt with a sweater over it looks very attractive.
4. Add a length of wire to the bottom hanger on which the pants will be clipped. Hang this wired hanger from the screw in the 2 × 4 and let the pants drop to the desired length.
5. Pin the arms of the shirt to suggest motion and place one sleeve in a pant pocket.
6. Arrange a bulky sweater over the shirt.
7. Cover the neck that shows at the top of the hanger with a pair of gloves.
8. Add a hat.
9. Place shoes at the base of the form, one over the other.
10. Place the completed form against a solid wall or within a theme setting.

Women's Mannequin

The materials needed for this presentation are one or two hangers, depending upon the design, wire, and branches. The following steps will produce the finished display (Figure 6–25):

1. Use a clothing rack to assemble merchandise.
2. Hang the clothing on the hanger. For pants, an additional hanger may be used.
3. Place upper pieces on hanger. Cut a piece of wire from which pants on the bottom hanger can be suspended from the neck of the top hanger.
4. Layer clothing to achieve interest.
5. Sleeves should be placed in pockets or pinned in an interesting manner.

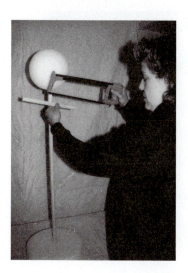

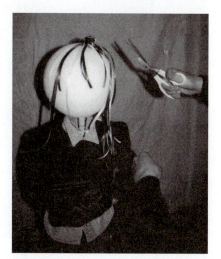

Figure 6–23 The various stages of construction that utilize a Styrofoam ball for the head, dowels for the "torso" and "crossbar," a wooden base, and wire and ribbons for the hair.

(Photographs by Ellen Diamond.)

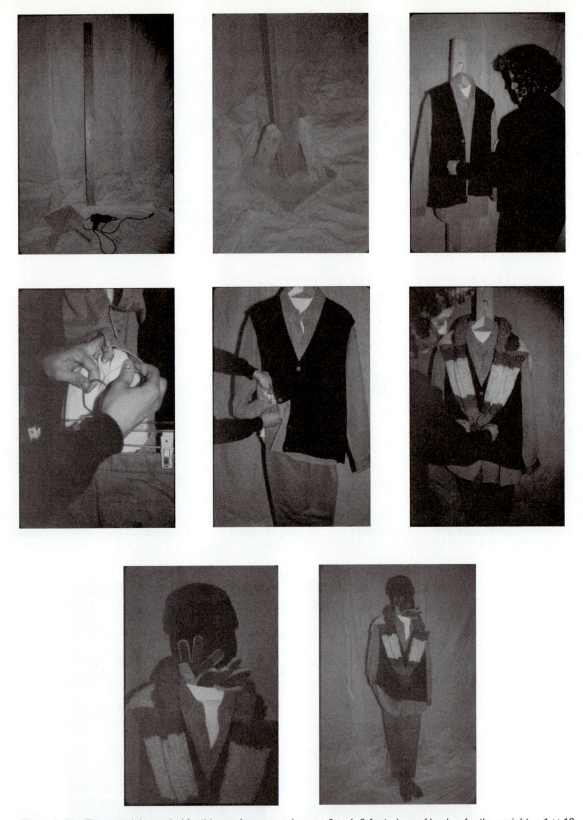

Figure 6–24 The materials needed for this men's mannequin are a 2 × 4, 6-foot piece of lumber for the upright, a 1 × 12 piece of wood for the base, a suit hanger that hangs from a nail on the uppermost portion of the 2 × 4, a hanger with clips from which pants may be suspended, and screws and wire for assembly. The outfit is then fitted onto the form.

(Photographs by Ellen Diamond.)

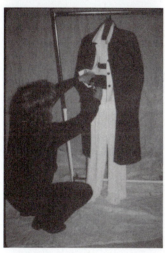

Figure 6–25 The materials required are one or two hangers, depending upon the outfit and wire. The mannequin is dressed and suspended from a prop such as a branch.

(Photographs by Ellen Diamond.)

6. Attach branches to the ceiling grid of the window or directly to the ceiling.
7. Hang the finished garment display from the branches.
8. Place a coordinating scarf at the neckline to conceal the exposed hanger.

These illustrations are merely some examples of how trimmer-made mannequins can be created. The guidelines can easily be altered. The professional, creative trimmer will come up with dozens of alternative techniques. The novice who is willing to spend some time mastering the techniques will also be able to create the mannequins. Experience will lead to new ideas.

review

chapter review

key points in the chapter

1. Today's mannequins bear little resemblance to the lackluster variety that was once popular.
2. The number and variety of mannequins have significantly increased, with manufacturing resources around the world.
3. Mannequins are available in many forms, from the traditional variety to the avant garde.
4. A stylized mannequin is used by the retailer whose clientele is sophisticated and desires fashion-forward concepts.
5. Representational forms are so versatile that they can be used to feature either male or female clothing.
6. Today, many trimmers are creating their own mannequins that are both inexpensive and serviceable.

7. Component construction of mannequins affords ease in dressing, flexibility, more convenient storage, and easier care.

8. Using component parts, the mannequin can be transformed from one look to another.

9. In dressing a mannequin, it is essential to follow a prescribed plan so that the garments are more easily handled.

10. To ensure a total look, it is important for the wig to be compatible with the merchandise.

11. Wigs are available in many fibers, each having specific advantages when compared with the horsehair variety.

12. Many of today's mannequins feature hair that is made of the same material as the mannequin and is permanent.

13. Makeup should complement the garment featured, not overpower it.

14. Where there are space limitations, other human forms are used in place of full mannequins.

15. These other human forms—such as the torso, head, and shoulder unit, hands, legs, and so on—also give variety to visual installations.

16. When purchasing mannequins and other human forms, it is important to consider durability, style, versatility, store image, wigs, makeup, and variety of poses.

terms of the trade

blouse forms 97

display hangers 91

Elura 96

ethnic mannequins 89

fashion-forward mannequin 89

futuristic human forms 90

head forms 88

horsehair wigs 96

hosiery legs 88

Kanekalon 96

Luraflex 96

mannequins 88

receiving holes 93

representational forms 91

shoe forms 97

shoulder forms 88

stylized human forms 89

suit forms 97

traditional human forms 89

trimmer-constructed mannequins 91

women's torso 97

internet exercises

1. When a high-fashion retailer is shopping for mannequins, oftentimes the first stop in the pursuit of the right selections is at Adel Rootstein. A presentation of its latest offerings is available on this company's website, www.rootstein.com. After viewing the website, make copies of the various mannequins, and briefly describe them in a paper that is no more than two typed pages.

2. Log on to the website of the National Retail Federation, www.nrf.com. Click on *Stores Magazine* and go to back issues, looking for any articles on mannequins. Once an article has been retrieved, write a summary of it for oral presentation to the class.

Case Problems

Case 1

Litt Clothiers, Inc. has been in business for ten years. It began as a small specialty shop that catered to middle-income women. Specializing in apparel and accessories, the store built a solid reputation and has maintained a profitable position with its conventional image. The store's interior was designed to complement the merchandise assortment that featured fashion as well as basic or staple clothing, with an occasional and usually successful attempt at some fashion-forward items. In keeping with the decor, the mannequins in the window and interior installations were traditionally oriented. They were of high quality, yet they did not lend themselves to pizzazz or innovation.

About five years ago, the company expanded into the adjacent building, nearly doubling the store's total square footage. The menswear division, a new part of the business, did well in this new addition. Now the company has discovered a new market, the teenage children of its customers. After considerable research, the company decided to convert its lower level into a sales floor aimed at the younger set. Among the problems to be dealt with is how to visually merchandise the new department in order to differentiate it from Litt's traditional, upstairs selling floors. Since the concept is new, past practice cannot guide the decisions.

Of considerable importance is the selection of mannequins. Since the new department will feature youthful male and female clothing, there seems to be a need for many mannequins, but only a modest

budget is available. Some planners feel that seven female and three male mannequins, stylized to give a contemporary look, would be a workable number. The menswear buyer feels that the new youthful menswear would be shortchanged, that not enough of the new clothing could be shown to make an impact. With the opening set for ninety days from today, the dilemma remains.

QUESTION

1. How could the mannequin problem be solved to the satisfaction of all concerned? Bear in mind the store's budgetary restraints. Your answer should be backed by specific examples.

Case 2

Five years ago, Amanda's opened its doors for business and began a most profitable venture in junior clothing retailing. The merchandise assortment featured just about everything the customer would need to complete her wardrobe. Clothing appropriate for the junior executive at work, active sportswear, and evening wear were the classifications that dominated the selling floor.

The company's success has enabled it to refurbish the store. New flooring, lighting, fixtures, and wall coverings have been selected and work is about to begin in the store. Management would like to expand its existing selling floor, but the acquisition of new space is impossible. With the boom that has taken place in the area, there is virtually nothing for the company to acquire.

In an attempt to capitalize on the space they have, Amanda's has decided to minimize sales support space and expand sales areas. Among the areas affected by the reallocation of space is visual merchandising. Although a significant sum has been earmarked for new mannequins, the visual merchandising department's manager has been informed to limit plans for the refurbished store to ten mannequins instead of the fifteen they presently use. While it is true that some of the mannequins rested in storage while others were on display, the new edict raises doubts about the ability to visually merchandise active sportswear, for example, on the same mannequins used for displaying evening wear. Still, the storage space, now limited in size, couldn't handle storing any mannequins until they were needed. The new mannequins must be able to accommodate all types of merchandise effectively. Already cut to the bone in storage space, the new mannequin purchase has yet to be resolved.

QUESTION

1. Given the space limitations and the limit of ten mannequins, how could the visual merchandiser solve the problem? Remember that the same merchandise assortment will fill the newly refurbished store.

discussion questions

1. Contrast the mannequins of the past with those used in visual merchandising today.
2. What does the term *silent seller* mean in terms of mannequin usage?
3. Describe the differences between traditional and stylized mannequin forms.
4. How does the futuristic human form differ from other mannequins used by retailers?
5. Representational mannequins are said to be more versatile than the other types. What accounts for their versatility?
6. Discuss the four major advantages of constructing mannequins in component parts.
7. What are two major types of base attachments used to secure mannequins? Why must both types be available?
8. Describe the first step in dressing a mannequin.
9. How does the trimmer overcome the difficulty associated with inserting the arm component into the torso while putting on the garment?
10. Is the horsehair wig used much today by the visual merchandiser? Why?
11. What are the disadvantages of Kanekalon and Elura?
12. Name the fiber that has the best properties for wigs, and discuss the advantages to the hair stylist.
13. Most mannequins in use have permanent makeup. What are the advantages and disadvantages of permanency?
14. Discuss two rules of makeup usage for mannequins.
15. For what reasons are some retailers resorting to creating their own mannequins for displays?
16. What are some of the resources for the materials used in making one's own mannequins?
17. Why do visual merchandisers use other human forms in their presentations besides mannequins?
18. List five human forms other than mannequins, and describe their functions.
19. With so many different mannequin types available, how does the retailer know which variety to purchase?
20. What factors should be considered in the purchase of mannequins and other human forms?

exercises and projects

1. Contact a large department store's visual merchandising manager or assistant manager and conduct an interview on the store's policy, endeavors, and considerations in the purchase of mannequins and other human forms. A list of questions should be prepared in advance, such as:

 a. From whom are the store's mannequins purchased?

 b. What is the price range of the mannequins used by the company?

 c. Is permanent makeup preferred or does a cosmetics expert apply what is needed?

 Be prepared to ask other questions and outline the information received for presentation to the class.

2. Visit two major stores in your area and closely observe the mannequins in the windows and interiors. Evaluate each store's mannequins in terms of the items listed on the form on page 105. Get permission to photograph several of each company's mannequins and affix the pictures, labeled with the store's name, to the form. Include complete information for each category. If the windows are on the street, it is best to photograph them at night using a high-quality digital camera with a minimum of 3.2 pixels. This also works best for interior photographs. (Keep this in mind for all of the photographic exercises in this text.)

3. Write to several of the manufacturers featured in such periodicals as *Visual Merchandising and Store Design*, requesting photographs, drawings, and information on the latest mannequins.

NAME: _____ DATE: _____

EXERCISE 2 MANNEQUIN EVALUATION

Name of Store: _____ **Name of Store:** _____

Mannequin classification	
Skin tone	
Wig types	
Makeup types	
Uniqueness of design, if any	
Overall evaluation Sample photographs (Affix to additional sheets of paper as necessary; label photographs clearly)	

materials, and tools of

(Courtesy of Saks Fifth Avenue.)

Objectives

After completing this chapter, the student should be able to:

... Discuss the trend in visual merchandising toward installing eye-catching windows without vendor-produced props.

... Compare the characteristics of masonite, Homasote, and plywood.

... Describe the many uses of foamboards.

... Contrast the use of fabric for backgrounds with the use of display paper.

... List the various commercial sources for props, and discuss the advantage of each source.

... Define the term *found objects*, and relate their value to visual merchandisers.

... Identify five items sold in many stores that double as display props.

... Explain the various methods by which retailers can acquire display props.

... Compile a list of essential tools needed by trimmers to accomplish most display installations.

... Discuss the difference between tools of the trade and accessories of the trade.

props,
the trade

Introduction

The dramatic nature of a display and the impact that it makes on a shopper very often are attributed to the elements in the display rather than to the merchandise. Although the most important feature of a visual presentation is the merchandise, the background is necessary to enhance what the store is trying to sell. Visual merchandisers are the first to admit that the major ingredient is the merchandise, no matter how exciting the presentation might be.

Materials and props might be compared to cosmetics. The right makeup choice and application will improve one's appearance but the facial structure stays the same. A black velvet backdrop, enhanced by dramatic lighting, will present a ball gown in a sensational setting and perhaps lend elegance to the gown's design, but it is the gown itself that will appeal to the shopper and encourage her to try on the item.

Often a display overwhelms the observer with too many devices. Windows and interior presentations of this nature may confuse the shopper. So overwhelming is the visual effect that the purpose of the display, selling the product, is not realized. Today's professional visual presenters are more aware than ever that functional display is the proper way to motivate purchasing. Except for some elaborate settings during the Christmas season and major store events for which institutional (image-building) emphasis is placed on windows and interiors, display people are concentrating more on the development of themes that require fewer background props and materials.

Although display settings and props are still being produced and sold, an inspection of many windows and interior presentations shows the widespread use of props that are not from visual merchandising environments. The use of window shutters through which items such as belts may be woven or ladders displaying different items on their steps are just two examples of such props. By resorting to these practical props, you can present effective displays within a limited visual merchandising budget. With the trend toward cutting costs for visual presentation, these objects are perfect props.

Another consideration is to use green products such as certain paints, woods, and recycled glass to keep the environment safe, all of which were discussed in Chapter 5.

This chapter focuses on the various props and materials featured in displays and the tools that trimmers use to install displays.

Materials

When consumers want to redecorate their homes, they have many alternatives available to them. A fresh coat of paint might be enough to create a new appearance. Paint can be used to create different effects, such as marbleizing, brushed suede, mottling, striating, and raised surfaces, making painting a wonderful, inexpensive method. Decorative wallpaper of fabrics might be used to create a special look. Visual merchandisers have the same tasks to perform, but the redecorating is frequent. The end result in home decorating lasts for many years. In visual merchandising, display installers are called upon as often as once a week to transform display areas from one theme or setting to something that is totally new and different. The home owner is often willing to spend a large sum on materials because of the long-lasting nature of the installation, but wallpaper at $50 per roll is simply out of the question when a display window may be timely for only one week.

Having considered the cost, versatility, and function of the material, the visual merchandiser is ready to make selections. The choice of materials is often expanded by the display person's own creative instincts, but there is a wide assortment readily available at costs to serve even the most limited budgets.

Construction Boards

Many types of **construction boards** are found in displays. Their uses are numerous, with each having certain characteristics that enable the visual merchandiser to achieve special effects.

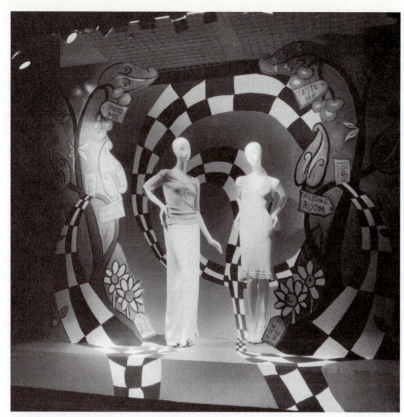

Figure 7–1 Foamboard is extremely versatile and can be used to create many different background props such as the one depicted.
(Courtesy of Marshall Field's, now a Macy's store.)

Foamboards This lightweight, paper-covered Styrofoam board is the mainstay of most display departments. It is produced by many companies (Figure 7–1). Fome-Core by Monsanto is a common one; another of the more widely used **foamboards** is Sintra, which is a thick variety that is long-lasting. It can be quickly cut into any shape, scored to create columns or rectangular forms, covered with fabric by using glue or staples, and even painted with excellent results. Available in several thicknesses, it is easy to cut with a **utility** or **X-acto knife**. Many trimmers prefer to use foamboard for irregularly shaped pads to fit into oddly shaped places. Unlike other boards, its flexibility enables it to be bent slightly for curved effects. A disadvantage of the product is its tendency to fray or bend at the edges. If carefully handled, however, it can be used again and again to create the most unusual forms.

Oaktag This is a sturdy, paper composition material with a shiny surface. It is very inexpensive, is available in many colors, and can be cut quickly into any desired shape. It can also be painted. Visual merchandisers often use **oaktag** to cut such shapes as hearts for Valentine's Day displays, artists' palettes to feature paint installations, and stylized faces for cosmetic presentations.

Masonite A composition board that comes in thicknesses of ⅛ inch to ½ inch and sizes up to 4 × 8 feet, **masonite** is used extensively in the display area. It has a longer life than foamboard but is much heavier to handle. It can take more bending than foamboard and is therefore often the choice when curved walls are needed. It is an excellent surface for painting background scenery. A disadvantage, however, is that it is difficult to staple and so is usually avoided when making pads.

Homasote Made of compressed cardboard, this product is a favorite for pads. **Homasote** is durable, comes in 4 × 8-foot sheets ranging in thicknesses of ⅝ inch to ¾ inch, and is lightweight.

Plywood When a solid, stiff construction is required, most people use plywood. In thicknesses that range from ⅛ inch to 1 inch, plywood comes in three grades: unfinished, one side finished, or both sides finished. When used as panels covered in fabric, the unfinished, least expensive variety is acceptable. If painting is required and only one side is to be viewed, then the better grade should be used. If both sides must be finished, then the top grade is the choice.

Miscellaneous Types Other types of boards used include **chipboard**, a wood-chip composition board; **upson**, heavyweight cardboard; and **gatorboard**, a thick Styrofoam panel. A trimmer should not depend on a type of construction board to perform a certain way until he or she has sampled the abilities and limitations of the board. Once the trimmer has sufficient hands-on experience, the choice of materials becomes second nature.

Fabric

Available in a variety of colors and patterns, fabric adds richness and quality to a display. Color is easily achieved through paint, but fabric applications are quicker (no need to allow time for drying) and richer in texture. Versatility and durability are fabric's assets. Although the initial cost is considerably greater than paper, fabric can be used over and over again if properly handled. Many trimmers rely heavily on felt, especially if a wide surface needs covering. Its unusual width of 72 inches generally eliminates seaming, and its elasticity enables it to be stretched to remove wrinkles and creases. The color selection is such that it offers a color range as wide as an artist's palette.

The durability of bengaline and moiré and their richness make them ideal for extensive use. Very often, pads are covered in one of these two materials. Burlap, also available in a wide color range as well as in the neutral burlap color, is another favorite. Its coarse fiber and open-weave construction provide a textured surface, popular in many rustic displays. It, too, is used to wrap pads, but it can also be featured as a draped material. Satin is a standard for draping. In displays that require drapery walls, satin is the most popular. Its lustrous sheen projects an aura of elegance. Most satins used for display purposes are rayon-based because of their inexpensive cost, but they crease easily. Wrinkle removal is most easily accomplished with a commercial steamer after the fabric has been applied to the walls. Velvets, lamés, mylars, brocades, and jacquards are other fabrics used when the trimmer desires opulence. Unlike their counterparts used in clothing construction, these fabrics are made of inexpensive fibers, which considerably lowers their cost. Like satin, they also drape well and give the trimmer the ability to create a rich environment.

Paper

The most widely used display paper is seamless paper. Available in widths up to 14 feet, with 8 feet being the most popular width, **seamless paper** is available in a wide color range at a very low price. It affords the trimmer an excellent material without the trouble of hiding seams. It can be used as it comes off the role or painted to depict a theme. Often, the trimmer tears the edges of the paper to give it an artistic look. The one disadvantage of paper is its short life. Unlike fabric, which is durable and can be reused, paper rarely has more than one life. It lacks strength, but it does have the advantage of low cost.

Occasionally, regular household wallpaper is used in installations. Its infinite variety, at various prices, makes it perfect for numerous themes. Many trimmers are known to scout the wall covering closeout stores for such papers at bargain prices. Other commonly used papers include the embossed type for a dimensional feeling, patterns, wet looks, cellophane, foil, string, and grasscloth. Each gives a different effect at minimal cost.

Paint

Most visual merchandisers use latex-based paint because it dries quickly and requires just soap and water to clean spills and brushes. A visit to today's paint shop shows the extensive range of available colors and the tools available to create a wealth of surfaces and finishes. From the

smoothest satin surfaces to the most textured varieties, the results are quickly achieved with an assortment of rollers that are easy to use. Paint has a long life and is used in areas where relative permanence is needed. Many are now using "environmentally correct" types to reduce odor and atmospheric pollution, such as those produced by Benjamin Moore and Glidden.

Carpet

Some stores desire in display areas a permanent floor covering that has rich textural and visual qualities and will complement many types of merchandise presentations. Carpet provides such a base. It is available in many colors and surfaces. Added to the large variety of velvets and plushes is the new range of sisals and berbers that give a dimensional look. They are available in many colors, are relatively inexpensive when the life of the product is considered, and can be cleaned easily. Environmentally sound carpets that satisfy the green factor, such as SmartStrand by Mohawk, are replacing the traditionally produced varieties.

Wood

Many stores, particularly smaller specialty shops, use finished wooden floors in their windows, with other materials reserved for interior use. Parquet and geometric designs are extensively used as permanent bases. Many woods come prefinished with polyurethane coatings for a lustrous finish. The only disadvantage of wood is that it can be scratched during setups. However, this can be avoided if the trimmer uses felt-based pedestals and other props whose sharp edges are protected. Bamboo, a quick-rejuvenating wood, is often replacing other woods to promote green concepts.

Other Materials

Ceramic and vinyl tile, netting, grass mats, straw rugs, rope, and many other materials are used in display. Visual merchandisers are always seeking different materials to achieve specific effects. It is not unusual to see real hay, sand, pebbles, or imitation snow covering a display floor. It is left to the ingenuity of the trimmer to come up with materials that were not earmarked for display but would make interesting enhancements to visual installations.

Props

Try to visualize the characters in a play or a movie speaking their lines in an environment devoid of props. It would be difficult to understand the production's time frame or setting. Set decoration quickly establishes a mood or theme, whether for the theater or for anything that requires a visual orientation.

In the world of visual presentation, considerable attention is given to securing props that will help present merchandise effectively. Visual merchandisers take several routes in acquiring these props. Some have the advantage of in-store shops to create many of the items required. Others rely on display houses for their needs. In addition to these two sources, many display people use found objects: items that were produced for other purposes, such as pieces of furniture, ladders, and picture frames.

Found Objects

To stretch limited budgets, creative displays are often built with **found objects** that were truly pulled from the junk pile and refurbished in addition to items that were manufactured for other uses but serve as wonderful props for window and interior settings. By using these props, visual merchandising directors can often stretch limited display budgets. The diligent

display person can find some visual merchandising treasures on the trash heap, if he or she possesses sufficient creative talent. Discarded crates that were used to ship produce, flower pots, empty soda bottles, garden equipment such as rakes and hoses, picture frames, barrels, and old photographs make wonderful props. With a little sandpaper, paint, and cleaning compounds, the shabbiest of these can be transformed into priceless display gems. These found objects are not only cost-saving, but also are considered to be "green."

Furniture

Many pieces of household furniture make wonderful display props (Figure 7–2). Stores like Victoria's Secret, for example, use a variety of settees, loveseats, benches, and boudoir chairs. Regular dining tables found in the home also make excellent props to feature the stacking of merchandise for interior display presentations. Chairs (Figure 7–3), lamps, pedestals, and other furniture items are being used for display (Figure 7–4). Large department stores have these items in stock for sale and can borrow them for display purposes. Other retailers wishing to use furniture often arrange for its use with stores in the area. If credit is given in the display for the furniture source, the lender is generally happy with the accommodation (Figure 7–5).

Merchandise Used as Props

Screens, shutters, window shades, ladders, antiques, vases, urns, musical instruments, and garden tools all make excellent props. In full-line department stores, many of these items are on the selling floor and, as in the case of furniture pieces, can be borrowed. For limited-line stores, where only one type of merchandise, such as apparel, is offered for sale, these props are acquired from different sources. In the case of musical instruments, for example, a music shop could be contacted for temporary use of the items. Offering to install a sign reading, for example, "Instruments available for purchase at Acme Music Company," will usually seal the deal.

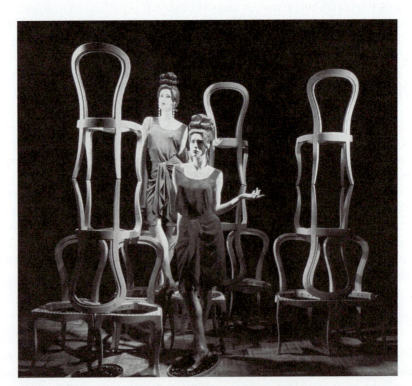

Figure 7–2 Chair frames, used in abundance, make for excellent props.
(Courtesy of Marshall Field's, now a Macy's store.)

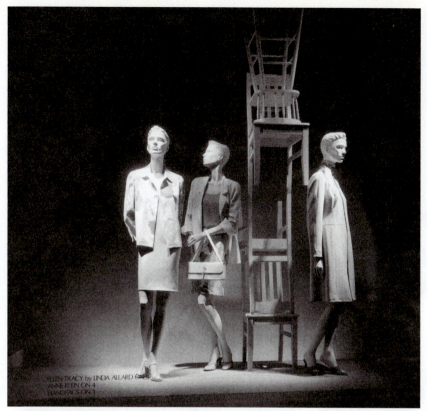

Figure 7–3 Old wooden chairs that were once used as functional pieces may be spray painted to give them new life.

(Courtesy of Saks Fifth Avenue.)

Figure 7–4 A park bench serves as an excellent prop for a wide variety of products.

(Photograph by Ellen Diamond.)

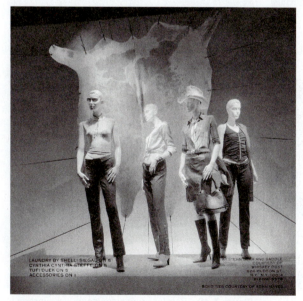

Figure 7–5 Borrowed props, such as the pelt, are often obtainable from other sources if credit is given to the supplier, as shown on the window signage.

(Courtesy of Saks Fifth Avenue.)

Figure 7–6 Ordinary pencils in a wheelbarrow make this display unique.

(Photograph by Ellen Diamond.)

Freelancers often purchase inexpensive items and sell them or loan them to their clients. Some borrow them from other stores, promising window credit, as discussed earlier. An antiques dealer would be an excellent source for merchandise to be used as props. If enough thought goes into merchandise prop procurement, the sources of supply are numerous (Figures 7–6 through 7–10).

Figure 7–7 A ladder is an excellent prop on which a mannequin may be elevated.

(Courtesy of Saks Fifth Avenue.)

Figure 7–8 Beach chairs and pails are easy to obtain and provide an interesting way in which to display various items.

(Photograph by Ellen Diamond.)

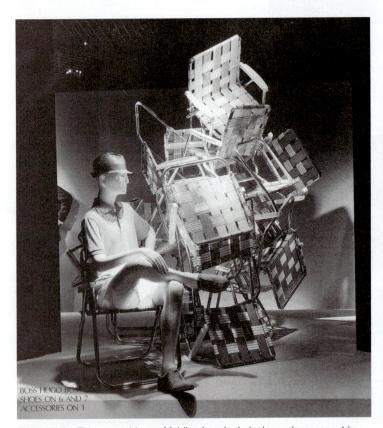

Figure 7–9 This assemblage of folding beach chairs is a unique accent in this window.

(Courtesy of Saks Fifth Avenue.)

Figure 7–10 Bamboo poles are inexpensive props that provide geometric dimensions to displays.

(Courtesy of Lord & Taylor.)

Display House Props

By visiting a display house, the visual merchandiser can acquire a vast assortment of professionally produced props as well as ideas for future presentations. Most vendors change their showrooms to coincide with the seasons. The seasons, however, do not coordinate with the actual calendar. For example, Christmas installations appear in the display houses during the summer so that visual

Figure 7–11 Props such as these are designed and produced by display houses for easy installation. *(Courtesy of Marshall Field's, now a Macy's store.)*

merchandisers can plan their Christmas presentations early enough for an appropriate delivery date. Purchases may range from individual pieces to complete installations (Figure 7–11).

Visiting all of the vendors in their showrooms can be a tedious and time-consuming task, especially for stores that are far from their suppliers. To make the task easier, vendor display products may be seen at trade shows. Major shows are held each year under the sponsorship of the National Association of Display Industries (**NADI**), which sponsors Global-Shop held in major cities such as Las Vegas each year.

Of course, the most important trade show for anyone involved in store design and in-store visual merchandising is GlobalShop, the subject of the following Profile, and StoreExpo in New York City.

Another time-saving approach in the procurement of props is to examine the monthly "Product Showcase" section of *VM + SD* magazine in which some of the industry's newest entries are featured, or to make regular visits to the *VM + SD* website, www.visualstore.com, where a host of items are featured.

The props bought at the display houses are very often refreshed and used again and again. They become part of the store's prop collection. Common to the prop collections of most major stores are items such as urns constructed from fiberglass or Styrofoam and finished to resemble more expensive materials; bamboo poles in a variety of lengths; artificial flowers and leaves, both stylized and realistic; columns of varying heights; and garlands, banners, artificial trees, rope, and PVC piping used to create different shapes. Some of the display house materials are featured in accompanying display photographs (Figure 7–12).

In addition to the display house props, a visit to major hardware stores such as Home Depot and to craft stores can provide ideas and materials that can be used for interesting displays.

Figure 7–12 This intricately stylized house is the product of an outside display company. *(Courtesy of Marshall Field's, now a Macy's store.)*

In-House Construction

Many major department stores have **display warehouses** in which they store their props, assemble display house purchases, or refinish items that were previously used in windows and interiors. The more fortunate visual merchandising staff also has an in-store construction shop equipped to build props (Figure 7–13). This display team can have almost anything built to specification in a short time. Equipped with the various tools of the trade, discussed in the next section, the shops can produce even the most intricate designs. These shops are usually found at the department store level, but some industrious freelancers maintain construction facilities in which they produce their own props for use at their clients' locations. Although most freelancers purchase their props, the do-it-yourself approach enables them to develop unique items and make a profit on the background as well as the time it takes to install a display.

Tools and Accessories

The tools used to execute a display vary from one project to another. If the props are purchased from a display house, all that might be necessary to complete a display is a **staple gun** to apply fabric to **pads** or paper to a wall, a screwdriver to assemble parts, if necessary, and to secure mannequins, a **hot glue gun** for adhering purposes, a pair of scissors, wire, pins, a hammer, and nails. If the job involves construction of props as well as installations, then other tools may be needed, some of which are unfamiliar to the layperson and might be used only occasionally by the trimmer. One such item is the **cutawl**, a type of electric jigsaw that can cut around any desired shape.

Large store organizations often have the largest assortment of tools, because they are involved in every aspect of visual merchandising, ranging

Figure 7–13 With the proper tools, props such as these stylized birds may be produced in-house.
(Courtesy of Saks Fifth Avenue.)

Anyone with an interest in any aspect of visual merchandising will find that Global-Shop is the consummate trade exposition in the field. It is an annual event that draws crowds from nations all over the world to a selected major city, such as Las Vegas or New York City. In 2006, the location was the Orange County Convention Center in Orlando, Florida. With more than 1,000 companies exhibiting their products and 15,000 retailers jamming the arena to learn about the industry's latest innovations, it is the epitome of the world of visual marketing.

The expo is comprised of five different pavilions, with each concentrating on specific components of the industry. They are The Store Fixturing Show, The Visual Merchandising Show, Retail Operations and Construction Expo, Interactive Ideas Show, and POP Marketplace. For visual merchandisers in particular, each segment gives them an overview of what is readily available to them from the various manufacturers and what they can do in their own workshops to create installations that would be unique to their own retail premises.

Representatives from the major American stores such as Neiman Marcus, Bloomingdale's, Macy's, Target, Disney, and Home Depot, and those who travel from global retail headquarters such as Australia, Asia, Africa, South America, and Europe, make this a truly international venture.

Whether it is merely to learn about trends or to purchase a vast variety of props, fabrics, flooring, graphics, signage, mannequins, point-of-purchase displays, and the like, it is here where all of the visual merchandiser's needs may be satisfied under one roof. It helps to get the juices flowing and enables the attendees to get on the right track for their future visual endeavors.

from a simple mannequin change to total refurbishing of a department. The majority of the items never leave the shop, however; the trimmer takes only a few tools to the job, the bulk of which will fit easily into a toolbox.

The tools discussed in this chapter and shown in Tables 7–1 through 7–3 include the minimum tools of the trade, the extra tools for display use, and the accessories of the trade that are musts for the toolbox and construction shop.

table 7–1 Minimum Tools of the Trade

Tools	Uses
Claw hammer	to hammer nails as well as remove nails and other fasteners
Tack hammer	small hammer for driving pins into solid structures
Flat screwdriver set	various sizes used for regular screws
Phillips-head screwdriver set	various sizes for use on Phillips-head screws
Staple gun	to attach fabrics, paper, wire, and props to walls, floors, ceilings, and pads
Staple remover	to remove staples left over from previous installations
Awl	to mark and set a hole to be drilled
Pliers	to turn metal screw eyes, to open and close chain links, remove nails, etc.
Scissors	to cut fabric and paper
Mat knife	to cut paper, oaktag, construction board, foamboard
Wirecutter	to cut wire and some chain
Hacksaw	to cut metal
Wood handsaw	to cut wood, masonite, Homasote, paneling, dowels, etc.
Wrench	to turn nuts and bolts
T-square	to measure perfect right angles
Steel rule—36″	to measure lines and to use as cutting edge with mat knife
Metal tape—12′	to measure widths and lengths longer than a 36″ steel rule
Drill	to drill holes

table 7–2 Extra Tools for Display Use

Tools	Uses
Cutawl	to cut intricate designs or patterns in wood (electric saw)
Saber saw	to quickly cut straight or curved lines (handheld saw with various blades)
Table saw	to quickly make straight or mitred cuts
Electric sander	to quickly sand rough, wooden surfaces
Set of wrenches	to loosen and tighten any size nuts and bolts
Drill press	to electrically set a hole
Jeweler's saw	for fine cutting of metal objects
Hot glue gun	to melt wax pellets into a form that may be used to bond two surfaces (has heating element and trigger mechanism)

table 7–3 Accessories of the Trade

Accessories	Uses	Accessories	Uses
Steel pins	headless pins used primarily with garments	Glues	hot glue for bonding most surfaces, epoxy for glass, Elmer's for paper and wood, and rubber cement for short-lived use of paper
T-pins	to pin heavier objects	Nuts and bolts	to join two pieces of wood or metal
Staples	to tack paper and fabric; available in lightweight or heavy-duty	**Molly screws**	to use in soft surfaces where studs aren't present
Screws	used when nails are not strong enough; easier to remove than nails	Wire	to "fly" merchandise; type No. 30 is nearly invisible
Screw eyes	to attach the wire used to hang signs, props, and merchandise	**Monofilament fish line**	to invisibly suspend merchandise from the ceiling or to secure baseless mannequins
Masking tape	to "mask" painted edges and to tape elements of short-lived displays; available in 1/4" to 2" widths	**S-clips**	to hang merchandise from ceiling grills
Double-stick tape	to bond two surfaces	Nails	used in prop construction, securing props, hanging signs, etc.; available in common and finishing (headless) types, sizes 4-penny to 16-penny
Cellophane tape	to affix paper signs and twine because it is invisible to the consumer		

New tools and accessories that will make the visual merchandiser's task easier or pave the way to more exciting visual effects are constantly appearing in vendor's catalogs. Every trimmer develops favorite tools and display accessories, but it is important to remain open to new ways of doing the job.

chapter review

key points in the chapter

1. Background props and materials should enhance a display but not overpower the merchandise available for sale.
2. Except for elaborate holiday displays such as for Christmas, many visual merchandisers favor functional display.
3. Using found objects and merchandise originally intended for other purposes as props, the display team is able to accomplish exciting presentations without severely taxing the budget.
4. Of all the construction boards used in visual merchandising installations, foamboard heads the list in most departments.
5. Fabric affords the trimmer the advantage of reusing the material.
6. Felt is a versatile fabric used in display because of its ability to be stretched, its wide color range, and its unusual 72-inch width.
7. Props are available from display houses, but equally effective and professional-looking props can be created by the visual merchandiser.
8. Major department stores often have in-house construction areas that produce props and revitalize old ones.
9. A trimmer should have a basic assortment of tools that fit easily into a toolbox for use at the actual display site.
10. Trimmer accessories are items such as pins, nails, staples, wire, and so on, which need constant stock replenishment.

terms of the trade

awl 117
cellophane tape 118
chipboard 110
claw hammer 117
construction boards 108
cutawl 116
display warehouses 116
double-stick tape 118
drill press 118
flat screwdriver 117
foamboards 109
found objects 111

gatorboard 110
Homasote 109
hot glue gun 116
jeweler's saw 118
masonite 109
mat knife 117
molly screws 118
monofilament fish line 118
NADI 115
oaktag 109
pads 116
Phillips-head screwdriver 117

S-clips 118
saber saw 118
seamless paper 110
staple gun 116
T-pins 118
table saw 118
tack hammer 117
upson 110
utility knife 109
wirecutter 117
X-acto knife 109

internet exercises

1. Log on to the website www.visualstore.com to learn about the particulars of the upcoming visual merchandising trade shows in the United States and abroad. By clicking on the calendar section of the website, the information needed to complete the project will be presented. Using this information, complete the accompanying form (on page 122), for a six-month period, choosing one exposition for each month.
2. Using the *VM + SD Magazine Buyer's Guide* that is published every January to locate the websites of materials or props manufacturers, prepare a chart for ten companies that features one product classification. For example, you might choose props producers, paper suppliers, wood products, and so on. In the section headed "Suppliers," examine the various company offerings, and choose those that specialize in your choice of props or materials. By logging on to their websites, you should be able to complete the chart provided for you on page 123.

Case Problems

Case 1

Unlike the giant department stores that have a wealth of display space in windows and interiors, Sheri's Boutique is a small, single-store operation that thrives in very limited quarters. In approximately 900 square feet the store manages to bring an excellent profit to its owner.

Located on the main shopping street of La Jolla, California, it faces stiff competition from four unique shops. Although each has a distinct personality and image, all of the stores appeal to the same market. Too small to advertise significantly, Sheri's Boutique believes that creative window displays will entice the most discriminating shoppers to enter the store.

For the past two years, the store has employed Caryn Joy to trim the small, closed-back window. Her displays receive favorable attention and have built up business. Caryn recently moved away and Sheri has been unable to hire anyone who could match Caryn's talent. Without creative windows, the store's business will suffer.

Sheri has watched Caryn for the past two years and has assisted her with each trim. Sheri never did a display herself, but she is being encouraged by her husband, Marc, to try it. While both believe the goal of effective display could be achieved without relying on a freelancer, they recognize the challenge of their present window structure. It requires a good deal of time for background changes. There is also the issue of props, which had always been on loan from Caryn. Now the store will have to purchase and store its own. Sheri and Marc would consider redesigning the window structure if display would be easier to accomplish and prop costs could be cut.

QUESTIONS

1. What type of window structure would you suggest?
2. How could prop and material use be minimized?

Case 2

Elements, Inc., a department store with six branches, has fallen on hard times. It continues to show a profit, but the past year was not as good as earlier years. Changes are underway.

The company hired a consultant to research the situation and make suggestions about reorganization and different operating methods. He found the overall problem to be one of rising costs without a comparable increase in sales, and he made several suggestions to improve the financial position.

At the meeting to cut costs in accordance with his suggestions, top management zeroed in on the visual merchandising department. Close inspection of that area's expenses indicated a steady increase in purchases for display presentations as well as a significant cost increase in the operation of the in-house construction facility. Creative work that will motivate shoppers to purchase is still considered a necessity, but management is determined to cut visual merchandising costs.

Mr. Mitchell, the company's senior vice president, is in favor of eliminating the in-house construction area. This would significantly cut the store's overall payroll. Opponents of the plan believe the move would result in less effective visual presentations. Although it seems to be a drastic step, the company must cut costs to remain a profitable enterprise.

So far, all of the store's departments have made recommendations for cost-cutting measures except for visual merchandising.

QUESTIONS

1. If the in-house construction shop is eliminated, can the store still have creative displays? How?
2. Could the shop be maintained while cutting the overall expenses of the visual merchandising department?
3. How can the store provide interesting visual presentations while cutting costs?

discussion questions

1. What is the most important element of a visual presentation?
2. Why do visual merchandisers often shy away from dazzling backgrounds?
3. How can a display's cost be minimized at the same time its effectiveness is maximized?
4. Describe foamboard and its uses in visual merchandising.
5. Discuss the advantages and disadvantages of masonite for displays.
6. Why is felt used extensively by individuals who create displays?
7. Which textured fabric is a favorite of the display world?
8. How can a trimmer achieve a colorful background without fabric or paint?
9. How can the visual merchandiser acquire display items that are both interesting and cost-efficient other than from display houses?
10. Define the term *found object*.
11. List five in-store merchandise items that can be used as display props.
12. In terms of actually building a display, what advantages does the visual merchandiser of a large department store have over a freelancer?
13. Which tools are considered necessities for the trimmer's toolbox?
14. Describe the difference between a wood saw and a hacksaw.
15. How do display accessories differ from the tools of the trade?

exercises and projects

1. Visit a mall or any major shopping center and examine all of the store windows. After studying each display, choose three different ones that feature the following props in their installations:
 - found objects
 - store merchandise used as props
 - commercially produced props

 Photograph your three choices and mount the pictures on the form provided on page 124. Be sure the information about each photograph is complete.

2. Make arrangements to visit a display company that sells tools and accessories of the trade to visual merchandisers. If a visit is difficult to accomplish, write to request information on the tools and accessories a company offers for sale to the professional display person. In both situations, try to obtain photographs, brochures, pamphlets, and so on that describe the items sold by the company. Companies that offer such tools are easily found in such periodicals as *Visual Merchandising and Store Design* and *Chain Store Age* and in local Yellow Pages directories.

 Once you have obtained the information, prepare a catalog on the tools and accessories of the display trade, indicating which are necessities and which are the extras. Drawings and/or photographs of each item will make the catalog a more meaningful publication from which tools and accessories can be selected.

EXERCISE 1: CALENDAR OF VISUAL MERCHANDISING TRADE SHOWS

Exposition	Location	Event Dates

EXERCISE 2: SUPPLIERS OF _____

Company Name	Website	Product Offerings

EXERCISES AND PROJECTS: DISPLAY PROPS

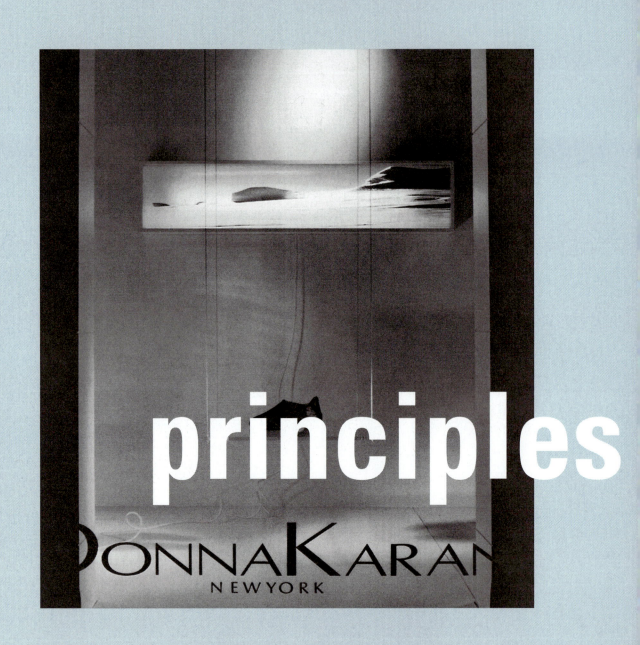

principles

DonnaKaran
NEW YORK

(Courtesy of Marshall Field's, now a Macy's store.)

Objectives

After completing this chapter, the student should be able to:

... List the five principles of design that may be found in visual presentations.

... Differentiate between symmetrical and asymmetrical balance, and tell how each is accomplished by the trimmer.

... Explain the numerous techniques employed to achieve emphasis in a window.

... Describe the importance of proportion in a display.

... Discuss rhythm and how the trimmer accomplishes it in an installation.

... Distinguish between rhythmic repetition and continuous line.

... Identify the use of rhythmic radiation in a display.

... Explain how to achieve harmony in the execution of a visual presentation.

... Justify the use of contrasting elements in a display design.

... Relate five methods for achieving contrast in a display.

of design

Introduction

Fortified with both exciting and functional fixtures, materials, and mannequins, the visual team is one step closer to installing merchandise displays that will capture shoppers' attention. In doing this, the visual merchandiser must always keep the principles of design in mind and carefully use them from the time the theme's concept is born until it is finally executed.

We have all heard or been involved in discussions about good or bad design as seen in a room, a building, a piece of furniture, or apparel. Good design should not be confused with taste, which involves personal choice or preference. The merit of any design is judged on a set of principles that includes balance, emphasis, proportion, rhythm, and harmony. These same principles may be applied to works of fine art, architecture, or any creative endeavor. In the case of visual presentations, when the principles are properly executed and professionally blended with other elements such as color, lighting, and signage, they result in a presentation that achieves its goals.

When these artistic principles are applied in the field of visual merchandising, they must be considered along with the store's merchandising concept, image, type of customers, geographic location, and other factors that make up the company's business philosophy. The design principles are the same, but the settings in which they are applied affect how emphasis or rhythm is carried out.

This chapter illustrates all of the design principles in photographs of actual presentations coupled with analytical drawings to make them more easily understood. You will notice that a trimmer generally employs more than one principle in a given display.

Balance

The word **balance** describes an equality of weight, something distributed evenly on two sides. When we think of a scale, we understand it to be balanced if both sides are at the same level, with each supporting a similar object. Figure 8–1 illustrates two objects identical

Figure 8–1 A balanced scale supports equal weights on both sides.

in size and weight. The centerline of the scale is the exact middle, with each side representing equal weight or importance.

When the principle is carried over to visual designs in a window or interior presentation, it is not adhered to as scientifically or mathematically. In order to give equal importance to objects in the display, they should be placed with care on either side of an imaginary line. Figure 8–2 shows two shapes in perfect balance. The broken line is imaginary, as the trimmer would envision it, and shows that both sides are equal or in balance.

Symmetrical Balance

Perfect balance may be fine for some displays, but the majority of presentations would be monotonous without other design possibilities. In the photograph and analytical drawing of the **symmetrically balanced** display shown in Figure 8–3, the trimmer has resorted to formal balance. Such a scheme guarantees the assignment of equal weight to each half of the design, but its effectiveness is limited. Novice interior designers often fall into the trap of formally balancing a room. They place a sofa in the center of a wall, end tables on either side with identical lamps adorning them, and a rectangular cocktail table in front of the sofa. Each side is a mirror image of the other. Although considered correct in terms of balance, this arrangement could be uninteresting if not carefully executed. Formal balance gains effectiveness if the merchandise is appealing, the colors are rich, and the two halves of the display, while

Figure 8–2 An imaginary line shows the balance between two geometric forms.

Figure 8–3 Perfect formal balance is achieved in this display. *(Photograph and illustration by Ellen Diamond.)*

formal in balance, do not feature identical items. The formality of the design is in the shapes employed rather than in duplication of designs and colors.

Asymmetrical Balance

Asymmetrical or informal balance is more relaxed and allows better use of the trimmer's creative talents. In this arrangement, the total weight on each side of the imaginary centerline is about equal, but the shapes used to balance each other could be different, such as two smaller pieces balancing a larger object. In the drawing depicting **asymmetrical balance** shown in Figure 8–4, an imaginary line divides the display in half. The large circle on the right side of the figure is balanced by the three smaller circles on the left. Each side achieves a sense of balance, though using different objects.

The visual merchandiser uses this simple concept in complex ways. Although governed by the fundamental principles of balance, imagination, creativity, and originality also come into play when asymmetrical balance is used. When the actual photograph of the Williams-Sonoma window is analyzed in Figure 8–5, the sense of balance can be understood. It should be noted that the bottles and steamers on the right are carefully offset by the woks and garlic on the left. Each half of the design represents an equal mass and comes across to the observer as having good balance.

Emphasis

Every visual presentation should be built around something of particular interest, often referred to as the focal point. The focal point is the dominant or central point of a display, with everything else playing a secondary or subordinate role. It may be a piece of merchandise, a prop, a concept, or a feature. In a model room setting, for example, the designer might use a famous painting, carefully illuminated, as its **focal point** or **emphasis**. You want the viewer to notice it immediately as the central **focus** and then to retain the image as a motivation to purchase. If a presentation has too many focal points, the result can be confusion rather than emphasis.

Emphasis can be achieved through a variety of techniques, the most common of which are size, **repetition**, **contrast**, and **unique placement**.

Size

When you walk into a room crowded with unfamiliar people, the first person you notice is usually the tallest one—for example, the basketball player among people of average height. Similarly, in the design of a visual presentation, dominance is easy to achieve

Figure 8–4 In asymmetrical balance, the halves may carry different shapes but have equal weight.

Figure 8–5 An analysis of asymmetrical balance using the display and a drawing to represent the shapes. *(Courtesy of iStock/Eliza Snow.)*

with something large. Many visual merchandisers use very large graphics in conjunction with traditionally scaled merchandise to draw attention (Figure 8–6).

Repetition

Repetition of a color, shape, pattern, or texture allows dominance to emerge. The eye quickly focuses on the repetitive element, and the abundance of these similar elements underscores their importance to the customer (Figure 8–7).

Contrast

Another means of portraying dominance or emphasis is with a color, texture, or concept that is in complete contrast to the other elements of the display. For example, in an arrangement where all of the geometric prop shapes are round, the circular shapes' surface appear as the dominant image, in contrast to the merchandise forms. You will understand this concept better after examining the shapes in Figure 8–8. Certain concepts are frequently employed to achieve contrast in design, the most common of which use size, lights and darks, shapes, textures, and directions.

Size Contrast Interest can be captured by placing an oversized object in the display. It then overshadows the other elements in the presentation, making it the focal point.

Lights and Darks By including a single light object in a generally dark display or vice versa, an immediate visual force is created. White bridal gowns against a much darker background or men's black formalwear against a light background are good examples of this type of contrast, as is the display of a bride in a white dress with a groom in a black tuxedo. In a room setting, the interior designer often paints

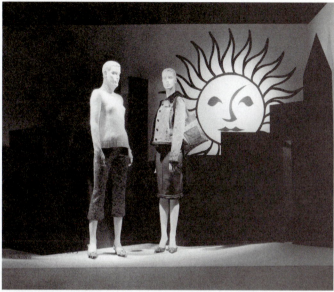

Figure 8–6 The oversized sun, in contrast to the mannequins, draws attention to the display.
(Courtesy of Lord & Taylor.)

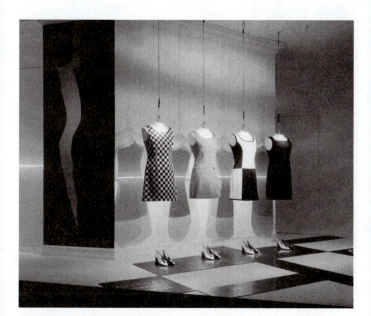

Figure 8–7 The lining up of four identical display forms and shoes exemplifies repetition.
(Courtesy of Lord & Taylor.)

Figure 8–8 The different shapes in the display provide visual interest.
(Courtesy of Lord & Taylor.)

three walls in a soft tint, and then colors the remaining wall in a very dark shade of the same hue. This gives the dramatic effect of light and dark contrast.

Shape Contrast A uniform presentation of the same shapes can be tedious. If a table display features only one shape, such as round dinner plates, the display lacks interest. Incorporating **shape contrast** by including various shapes, such as a rectangular or oval basket and folded napkins in rings, makes the display more artistic (Figure 8–8) and interesting.

Textural Contrast Introducing an unusual or unexpected **textural contrast** in a display is another way to capture interest (Figure 8–9). Wristwatches, for example, are usually shown in a luxurious setting of satin-lined gift containers or exquisite jewelry boxes. In one watch display, the trimmer decided to go after the rugged individualist with a display using rope and ragged packing cord. The fine timepieces set against textures that are rough and common produced an outstanding visual result.

Directional Contrast A display in which all of the elements face the same direction has its uses, but there are other possibilities. Including an element that seems to move in the opposite direction from all of the others provides an interesting **directional contrast.**

Unique Placement

Unexpected or unique placement of an item can immediately capture the customer's attention and make a point. Suspending mannequins in midair, for example, grabs the shopper's attention and focuses it on how attractive he or she can be in the clothes that are depicted (Figure 8–10). Put the same outfit on a conventionally posed mannequin and the result would not be as exciting.

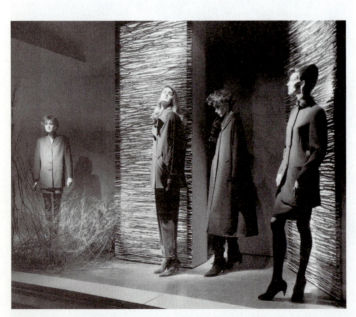

Figure 8–9 The textural screens perfectly contrast with the smooth fabrics of the ensembles featured on the mannequins.

(Courtesy of Lord & Taylor.)

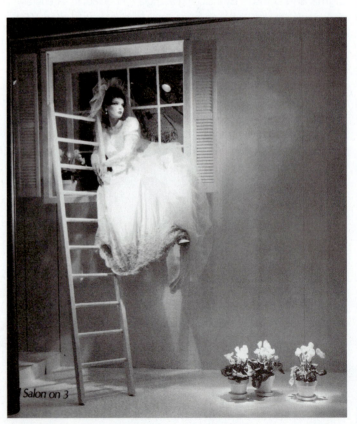

Salon on 3

Figure 8–10 The unique placement of the bride perched on the window ledge immediately captures the shopper's attention.

(Courtesy of Lord & Taylor.)

The concept of emphasis and how best to achieve it in each display situation comes with experience. Although the techniques mentioned are tried and true, the creative visual merchandiser is always trying to develop new approaches to capture the shopper's eye.

Proportion

The principle of **proportion** involves the comparative relationship of the design elements to each other (Figure 8–11). When each element of the design is properly proportioned, the whole will have a pleasing effect to the eye. That is not to say that each part is carefully measured to make certain that it is in perfect proportion, but it is our visual perception that tells us whether each of the parts is proportionate to the entire layout or design composition. Often the word **scale** is used in place of *proportion*. Interior designers speak of furnishings appropriately scaled to fit the available space.

To understand the importance of scale or proportion, consider an interior design situation. Professionals who design and decorate residences find that the average square footage of living space is shrinking. Cost and overcrowding in some areas have necessitated that individuals make do with less room than was once considered necessary. Therefore, furnishings for such quarters must be scaled to fit the shrinking living space. Not only would an overstuffed sofa not fit into the living room but even if it could, its size would make it visually disproportionate for the space. Numerous furniture manufacturers now offer home furnishings that are scaled for smaller residences to provide suitable proportions.

The visual merchandiser must also address the proportion principle in a number of situations. First, in planning a presentation, he or she considers the size of the space in the window, showcase, floor case, or interior display case. Not only must the merchandise fit well into the display space, but the mannequins, forms, and props must be properly proportioned for the presentation (Figure 8–12). Substituting a representational form that is properly scaled for the window makes the display more appropriately proportioned and more pleasing to the eye.

In the previous examples, the problem was space-oriented. Trimmers must also make certain when choosing the various elements of the display that each element is proportional to the others for an overall good design. In the lamp and table drawings in Figure 8–13, one is unacceptable, while the other is more pleasing. The lamp placed on the small table is an

Figure 8–11 The mannequin's size is out of proportion to the window.
(Photograph by Ellen Diamond.)

Figure 8–12 A smaller-scaled representational form better serves the space than the display in Figure 8–11.
(Illustration by Ellen Diamond.)

Figure 8–13 Proportional relationships among the elements can make or break a display.
(Illustration by Ellen Diamond.)

example of poor proportion or scale. When the same lamp is situated on a larger table, the total design is more pleasing.

In achieving designs of pleasing proportion, remember that it is not necessary to measure spaces and display elements. Exact mathematical ratios should be reserved for scientific endeavors, not design work. It is how the various elements interrelate to form the total image that is important.

Rhythm

When all of the elements of a design are properly located so that the eye travels smoothly from one part to another, then flow, movement, or **rhythm** has been achieved. This is an extremely important principle because it makes the eye take in every part of the display before it focuses and rests on a specific focal point or area of emphasis. It is the task of the presentation's designer to make the eye move in a specific pattern. As we examine the works of famous artists, we discover that rhythm is carefully executed through repetition, continuous line, progression, radiation, and **alternation**. These methods are also employed by visual merchandisers in their display arrangements.

Repetition

In a display using the principle of repetition of shapes, the eye is led in one direction by multiples of the same shape. The placement of identical forms in a row moves the eye across the display (Figure 8–14).

Continuous Line

Interior designers frequently use moldings or borders to achieve the principle of a **continuous line**. These linear devices lead the eye around an installation (Figure 8–15).

Progression

Rhythm can be accomplished by employing gradation of line, shape, size, or color. Textile designers sometimes provide interest in fabric coloration by offering a design in a range of the same color from the lightest to the darkest. Visual merchandisers borrow from this

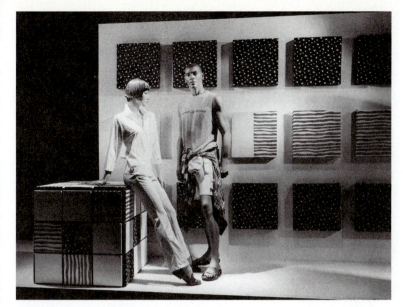

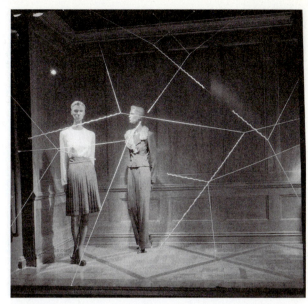

Figure 8–14 Repetition of the squares on the backdrop help to give the display a sense of rhythm.
(Photograph by Ellen Diamond.)

Figure 8–15 Continuous rhythm is generated in this visual presentation with the use of string to form a "web."
(Courtesy of Lord & Taylor.)

concept when trimming a window with a **progression** of tints and shades in one specific color. Another technique for incorporating progressive rhythm uses the same shape in increasing or decreasing sizes.

Radiation

Rhythmic movement may radiate from a central point, as in the rays of the sun or the spokes of a wheel. In fact, trimmers sometimes use circular props such as wagon wheels to move observers' eyes outward from a central point in a display. The merchandise itself may be arranged to radiate from a focal point without a special prop. In the drawing shown in Figure 8–16, depicting ties on a wheel, the trimmer has used rhythmic **radiation**.

Alternation

When certain shapes or colors are used alternately, they give a design rhythm. The alternating red and white stripes on the American flag are a powerful example of the rhythmic technique of alternation (Figure 8–17). The alternating light against dark colors or warm with cool colors can also give a design rhythm. Using awning-striped materials for display settings is one way trimmers employ the alternation technique.

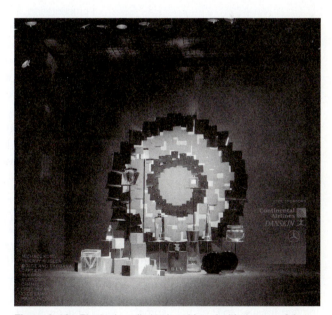

Figure 8–16 Rhythmic radiation is achieved with the use of the "circle" in the background.
(Courtesy of Saks Fifth Avenue.)

Harmony

When all of the elements in a design properly blend to form a unified picture, the principle of **harmony** has been achieved. It is analogous to a theatrical presentation. If the scenery, lighting, and characterizations are uniformly satisfying, the play is successful. When one of the actors demonstrates substandard ability, the play is not as effective. The unity of the various elements is necessary for a positive overall production.

Harmony of design seems to imply that all of the elements must be exactly the same—for example, using merchandise that is all red, in shapes that are all the same, and in textures that are similar. Such a display would be harmonious but not very interesting. In design, a

Figure 8–17 The stripes in the flag illustrate rhythm achieved through alternation.

(Courtesy of Saks Fifth Avenue.)

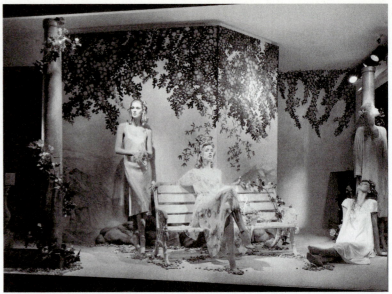

Figure 8–18 The perfect placement of all of the display's elements helps to create a harmonious effect.

(Courtesy of Lord & Taylor.)

display can include some variety and still be considered harmonious. In planning a visual presentation, if the central theme concentrates on a specific color, a variety of shapes and merchandise textures should be used to provide excitement. Using too many variables could cause confusion and could be just as improper as monotony. Experience teaches a designer how to use variety to create memorable, harmonious presentations (Figure 8–18).

Mastery of some of the design principles, such as balance, is easy to accomplish. Others take a little longer to use effectively in visual presentations because they are not scientific definitions—they are open to interpretation. We have introduced you to these basic principles, but experience is the best teacher when it comes to applying them in dynamic visual merchandising. In the following Profile of Williams-Sonoma, we learn how carefully executed design principles have helped the company to impact the world of home products.

PROFILE: A Contemporary Visual Merchandising and Environmental Design Profile: Williams-Sonoma

When Chuck Williams, a building contractor, first traveled to Paris with some friends, few, if any, knew that this adventure would be the genesis for the vast Williams-Sonoma empire that has become the premier retailer in the United States for cooking and food-serving products.

During that trip in 1952, Williams was introduced to French cooking equipment, and his fascination for fine equipment was about to point him in a new business direction. In 1954, he purchased a hardware store in which he set aside a small area to display a few items of cooking equipment. The response was so overwhelming that in 1956 he replaced the shovels, electrical tape, and other standard ware found in

hardware stores with a full collection of copper pans and chef's products from France.

The rest is history. With his eventual purchase and expansion of the Pottery Barn chain, Hold Everything, Pottery Barn Kids, Williams-Sonoma Home, PBTeen, and West Elm, the company stores now number more than several hundred. Including the website, catalogs, and *Taste Magazine* publication, sales are more than $1 billion.

While products of this type were available in other retail operations, few knew how to successfully present them to the customers in a manner that would motivate them to purchase and return again and again for more items. One of the keys to the success of Williams-Sonoma has been attributed to visual presentation. As soon

as a shopper enters the store, he or she is greeted with a vast array of products that are excitingly displayed. Each installation "calls" to the shopper to come and touch the merchandise. Using real dining tables, chairs, and other usable props, the items are displayed with every design principle carefully considered. Balance, emphasis, proportion, and rhythm each contribute to the harmonious results of the presentations, making them displays of distinction.

The Williams-Sonoma visual design philosophy and its overwhelming corporate success suggest that given the right methodology for displaying merchandise, customers will positively respond by returning over and over again to make other purchases.

review
chapter review
key points in the chapter

1. In order to construct a display that is technically correct, its plan should be evaluated in terms of principles of design.
2. Balance, the equal distribution of weight in a design, can be accomplished with a symmetrical (formal) or asymmetrical (informal) plan.
3. The term *emphasis* suggests that there should be a central or focal point to a display achieved through size variation, repetition of shapes, contrast, or unique placement of a key element.
4. Contrast can be achieved easily through the use of atypical sizes, variation of lights and darks, different shapes, different textures, or changing the direction of a key element.
5. Proportion must be considered carefully so that all elements of the design will relate in terms of size.
6. To achieve rhythm and move the observer's eye through the display, the trimmer should consider the use of repetition, continuous line, progression, radiation, or alternation.
7. Contrasting elements can bring rhythm to a display in addition to establishing emphasis.
8. Harmony suggests that unity of the elements is essential to an effective display.

terms of the trade

internet exercises

1. By logging on to the websites of such home furnishing stores as Pottery Barn at www.potterybarn.com or Crate & Barrel at www.crateandbarrel.com, you will be able to view many of the products that they offer for sale online. Select one of the product classifications for the purpose of preparing a window visual presentation that uses some of the featured products. The presentation should be handled as follows:
 - Using foamboard, a "window" should be constructed that measures approximately 20 inches across, 8 inches deep, and 12 inches high. The pieces should be assembled with the use of a hot glue gun that will ensure durability.
 - After viewing all of the featured products, select those that you would like to show in the display. After printing them out, they should be pasted to foamboard, and then cut out so that they will be used in the display. Each selected item should be made to stand, perhaps with the use of pins inserted at the bottom or by any other means that you might choose.
 - Once all of the products have been prepared, they should be arranged in the display window that has been painted in a color that will enhance the merchandise. In designing the installation, it is essential to make certain that all of the design principles have been carefully addressed.
2. Log on to a website of an apparel retailer such as The Gap (at *www.gap.com*) or any other of your choice. Once you have made a selection, create a display that uses an assortment of apparel, constructed with the same methodology as in Exercise 1.

Case Problems

Case 1

Boring and *monotonous* are perhaps the two most appropriate terms to describe the windows at Brown & Co., a children's specialty shop in southern Florida. The operation is a typical small store that grosses $250,000 annually, employs five people whose primary responsibility is sales, and is comanaged by John and Edith Brown, the proprietors.

In addition to the responsibilities of buying and merchandising, handling customer complaints, and arranging adjustments, the Browns have tried trimming their store windows. The company formerly employed a freelancer who accomplished the task satisfactorily but didn't achieve outstanding results. When the trimmer decided to retire, the partners investigated other freelancers but could not find anyone to fit their budget. They felt the costs simply outweighed the benefits they would derive from professional window displays. The only route left was to do the windows themselves.

Edith, originally a fine arts major in college, felt that her early training would be applicable to visual merchandising. She was familiar with color selection, as well as some of the rules of balance, proportion, and harmony. Armed with this knowledge she trimmed her first window, a back-to-school installation. She purchased the display accessories usually associated with this theme from the area's display house and perfectly balanced them in the window, so perfectly that one side was a mirror image of the other. The result was a dull presentation that didn't seem to catch her customers' attention.

Not yet willing to cry "help" to a freelancer, the Browns want to try again. They just aren't sure how to make the new effort a traffic-stopper.

QUESTIONS

1. What principles were neglected that could improve the first display's appearance?
2. What props could you suggest that the Brown's use instead of traditional back-to-school banners, rulers, and so on?
3. Aside from formal instruction, how might they improve their ability to achieve exciting displays?

Case 2

The Sweater Emporium, as its name implies, is a retail operation that deals exclusively with sweaters, specifically for women. The company's two stores are almost identical, with interiors and windows that are virtually the same size. Thus their visual merchandising efforts are alike.

The stores have been in operation for one year and, considering that they started on a shoestring budget, their accomplishments have been noteworthy. Except for their visual presentations, the rest of their efforts can be considered professional. As is the case with many smaller retailers, display is a sorely neglected area. The costs are often prohibitive. Their efforts in terms of window presentation are mildly satisfactory, but the partners, Marc and Mitch, want to improve their efforts.

After reading a few books on the principles of design and observing other stores for ideas, they concluded that their problem is not one of inability but one of limited merchandise. Everything they read about or observed indicated that a variety of shapes and sizes is necessary to give a window a more artistic appearance. However, sweaters are sweaters. They are soft, similar in shape, and possess the same basic characteristics. Accessories retailers have an assortment of merchandise types that allow for better design. Sportswear, menswear, home furnishings, and children's wear, too, offer an assortment of merchandise. Without changing their merchandise mix, Marc and Mitch believe they are unable to achieve what they want in terms of visual presentation.

QUESTIONS

1. How would you suggest that Marc and Mitch improve their windows with the merchandise they now feature?
2. What design principles could help them alter their lackluster displays?

discussion questions

1. What are the five principles of design that should be considered in the development of a display?
2. Is it necessary for each side of a display to be perfectly or formally balanced by the other side? Why or why not?
3. How can a display be easily balanced yet safeguarded against the monotony of a symmetrically balanced window?
4. Define the term *emphasis,* and describe its importance to a visual design.
5. What elements can be used repetitively to create interest in a display?
6. Describe the concept of proportion and why it must be considered in any visual presentation.
7. The term *rhythm* usually applies to music. How does it apply to three-dimensional design?
8. In what way can a trimmer use repetition as a rhythmic principle to catch the shopper's eye?
9. Why is continuous line usage effective in a display installation?
10. Describe how progression can be used to create rhythm.
11. What display props are appropriate for rhythmic radiation?
12. Select a synonym for *harmony* and discuss its importance to design.
13. How can contrast be employed successfully in a design while not interfering with the concept of harmony?
14. In what way can the excitement of an all-red window be heightened through the use of the contrast principle?
15. What is the difference between textural and directional contrast?

exercises and projects

1. Photograph four window displays, each on a different theme. Attach photographs to the forms provided on page 140. Beside the space for the photograph on each form is a space for analysis. As you have seen with some of the photographs in the text, do a companion drawing for each of your photos to illustrate how the principle of balance was employed in the window.

2. Prepare drawings on the form provided on page 141 demonstrate each of the subdivisions of rhythmic design. Do not use any of the illustrative drawings from the text.

EXERCISE 1 PRINCIPLES OF BALANCE

NAME: _____ DATE: _____

EXERCISE 2 DRAWINGS OF RHYTHMIC DESIGN

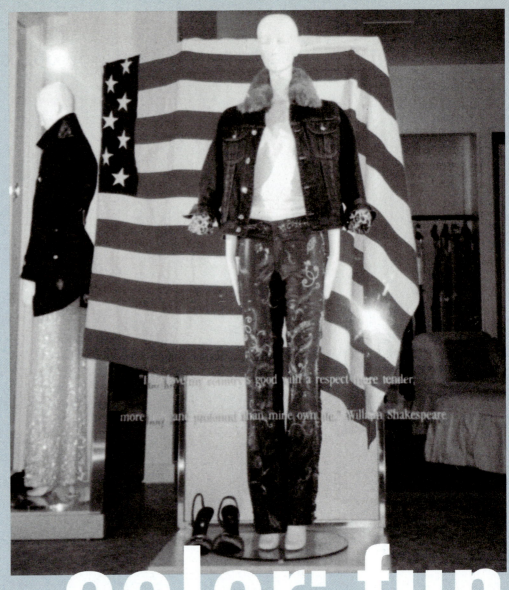

"This loving countries good will a respect figure tender,
more loving and veidoud than mine own life." William Shakespeare

color: fun
concepts and

Objectives After completing this chapter, the student should be able to:

... Discuss the importance of color in industries such as visual merchandising.

... Define the terms *hue, value,* and *intensity.*

... Choose color schemes based on the color wheel that are technically correct.

... Prepare a color presentation that is monochromatic yet has contrasting elements to avoid monotony.

... Design a color scheme using accepted theory that provides the greatest amount of color contrast.

... Identify the neutrals used in color combinations and discuss their importance to color schemes.

... Describe the effects of warm and cool colors on individuals.

... Explain the emotional concept of advancing and receding color.

... List the six primary and secondary colors and the emotional moods generated by each.

... Discuss the visual merchandiser's limitations in personal color preference when planning a presentation.

damental applications

Introduction

Using color is the best way to add excitement to a visual presentation without increasing the cost of the installation. It has often been stated by professionals in the field that color is 80 percent of the presentation. Our most famous art treasures abound with color, and it is that element that captures the immediate attention of the viewer. Avant garde artists, in particular, use the vibrancy of color to make strong initial statements. The movie industry, television, and the theater depend on color to give otherwise bland productions enormous visual appeal. Fashion and design periodicals seldom use black-and-white photographs; most are in color. Even some movie classics, originally black-and-white productions, have been colorized by computer. Some professionals dislike this trend; those who understand today's marketplace recognize that color can revive interest in old movies.

It is obvious that the use of color is essential in attracting attention to a subject. Fine artists must be skilled at mixing their own pigments to achieve a variety of colors; visual merchandisers rarely do the actual mixing of paints, with the possible exception of trying to achieve a specific color for a background or props. Their mixing of colors refers to arranging colored items tastefully. However, the display person must have the same understanding of color and its concepts and applications as a fine artist in order to capitalize on color's advantages. The visual practitioner in retailing and related fields needs to know the correct combinations of color for achieving special effects, how to best use color in a window or interior presentation, and the psychological impact of various colors. This chapter presents a foundation in color principles, terminology, and themes.

Dimensions of Color

The layperson's vocabulary of color usually extends as far as knowing the names of general colors. A customer will ask to see the blue shirt, red dress, or yellow scarf. If you closely examine a stack of red sweaters in a store, however, you realize that the word *red* by itself doesn't totally describe the color. Some reds look orange-red, while others seem to be purple-red or blue-red (which we often refer to as *maroon*). Two reds may look like the same basic color, but one may be lighter than the other. It is necessary, therefore, to explore the variations in color so you will be prepared to use them in visual merchandising.

Hue

In simple terms, **hue** is the name of the color. Yellow, green, blue, and purple are some of the hues or names of colors. Pure colors, or hues, by themselves tend to become monotonous in a visual presentation.

Value

When describing the lightness or darkness of a hue, we are speaking of its **value**. By adding white to a hue, we lighten it and achieve a tint. With the addition of black, a darker variation is produced, known as a **shade**. With each addition of white or black to a color, its hue doesn't change, only its value. In creating a window in which red is dominant, the installer adds interest by including different values of red, such as pale pinks or dark reds.

Intensity

The saturation or purity of a color is referred to as its **intensity**. A color's intensity is actually its brightness or dullness. Artists vary intensity by adding middle gray to the pigment or adding the complement of the color, which is discussed later in the chapter, for duller

intensity. The color is most alive and brilliant in its purest form. Although the mixing of colors to alter their intensity is usually the work of a painter, the visual merchandiser needs to know all about them in order to plan presentations.

The visual merchandising staff of a store and their freelance counterparts must know how hues are used to achieve harmonious as well as exciting effects and how values and intensities of colors can be arranged most effectively. It is this color comprehension that enables trimmers to maximize the effectiveness of their displays just by adding color, rather than adding props, materials, and other, more costly display elements.

The Color Wheel

The system of color that is most often referred to makes use of the **color wheel**. By understanding the relationships of the colors and applying them in terms of their location on the wheel, the visual merchandiser is more likely to come up with color schemes or themes that achieve the goal of attracting customer attention. The color wheel is based on three primary or basic colors—yellow, red, and blue—from which all other colors are produced (see color plates 9–19). The appropriate mixing of these primaries produces secondary colors. For example, if red and yellow are mixed, the result is orange. The blending of an adjacent primary and secondary results in a tertiary color. If equal parts of yellow, the primary color, and green, the secondary color, are mixed, the result is yellow-green. The wheel shows the continuous transition of color and is the foundation upon which most color schemes are based. In close proximity to the color wheel, the insert includes examples of the three most common color schemes based on the wheel, a value scale, and an intensity scale. In the remainder of the color insert, you will find examples that underscore the importance of color to several aspects of visual presentation.

Color Harmonies

A **color harmony** scheme, or arrangement, is easily accomplished by following specific rules based on the color wheel. Colors may be used together harmoniously in a design, depending on their locations on the color wheel and the value and intensity of each. In order to have a better understanding of the various color harmonies, it is advisable to refer back to the wheel and the value and intensity scales. The arrangements used most often by visual merchandisers and others wishing to maximize the effects of color are examined here.

Monochromatic

The **monochromatic** color arrangement uses only one hue (Figure 9–1). Initially, this might not seem very stimulating, but its proper use has the potential for visual elegance. Using tints and shades of one hue, then highlighting with the neutrals of black and white, one can achieve a showstopper. Additional interest can be provided if the materials of the merchandise and background vary in texture and pattern.

Analogous

Colors that are next to each other on the color wheel may be used in combination to form the **analogous color** scheme (Figure 9–2). This arrangement gives the trimmer greater freedom to use differently colored merchandise, unbound by the limitations of a monochromatic scheme. Since the merchandise in most stores is varied in color, the analogous design enables a variety to be featured in one presentation. Many retailers of clothing and home furnishings create in-store color combinations that are analogous and add to the excitement by following the same scheme in the store's windows. As with the monochromatic scheme, neutrals, tints and shades, textures, and patterns can also be used for greater artistic results.

Figure 9–1 The monochromatic arrangement. The shaded area is the specific color used in the monochromatic scheme. Tints and shades of the color add depth to the display.

Figure 9–2 The analogous arrangement. The shaded areas of yellow, yellow-orange, and orange provide a range of tints and shades to be used with neutrals for an analogous color scheme.

Figure 9–3 The complementary arrangement. The use of pure blues and oranges with neutral black or white provides color intensity that is unmatched by other schemes.

Complementary

When color selection builds on two colors that are opposite each other on the wheel, the result is **complementary colors** (Figure 9–3). When these colors are held side by side, the intensity of each is heightened. A Christmas display is a good example—bright red packages against a green Christmas tree provide high-intensity color that demands attention. This type of impact is often desirable, but quieter effects can also be achieved with complementary colors. Tints or shades of complementary colors are more subtle but still offer the excitement of each playing against the other—for example, the soft pinks and pale greens of spring.

Split Complementary

An interesting effect can be achieved by using one basic color with two colors that are on either side of that color's complement. In doing so, the trimmer has more colors to work with and can create a design that is infinitely more exciting than the monochromatic, analogous, or complementary schemes. **Split complementary colors**, in a variety of values and intensities and underscored by neutrals, can be the basis for a very creative visual installation (Figure 9–4).

Double Complementary

Expanding on the complementary arrangement that features two colors at directly opposite positions on the wheel, the **double complementary colors** use two sets of colors, or four basic colors, for the presentation (Figure 9–5). The use of four hues can cause visual confusion unless they are applied with great care. One way of avoiding a problem is to predetermine which of the four will be highlighted and which will play subordinate roles. Using one or two of the colors as dominant forces and the others as accents can have magnetic results.

Figure 9–4 The split complementary arrangement. Yellow as the basic hue, in combination with red-violet and blue-violet, results in a harmonious split complementary scheme.

Figure 9–5 The double complementary arrangement. The shaded areas indicate that yellow-green, yellow-orange, blue-violet, and red-violet are used in this double complementary color scheme.

Triad

The harmony of a **triadic color** arrangement is produced with the use of three colors on the wheel that are equidistant from each other (Figure 9–6). If you superimpose a triangle on the wheel, it will help you discern which colors fit this arrangement. As in other cases where several colors are used, it is best to vary the use of these hues by toning down their intensities and values or by using only one in a dominant role.

The six color harmonies discussed are presented graphically to show their arrangements.

Figure 9–6 The triadic arrangement. A superimposed triangle shows the equidistant location of the primary triad colors: yellow, blue, and red.

The Neutral Ingredients

Through the discussion of color harmonies, we have learned that hues are **primary colors** or **secondary colors**, with other colors achieved through their combinations. While black and white are often called colors, technically they are not. Along with gray and tan, they are **neutrals** that may be used in conjunction with colors or by themselves to create presentations of interest. A very elegant image is produced in a formal display featuring female mannequins dressed in white gowns escorted by male mannequins in black-tie dress. No matter how they are perceived technically, the neutrals play a vital role in window displays, interior presentations, and department colorization.

Choosing a Color Scheme

In our personal, everyday lives we make color choices that are generally based on taste and preference, not on a season, a theme, the time of year, or anything else. While we might want to learn about **restful colors** or colors that provide excitement, the bottom line in making a color selection is strictly personal.

In visual merchandising, however, choices are somewhat dictated by the merchandise to be displayed or the statement to be made. You might personally favor red, but if the designers concentrate on blue this season, you must decide how best to enhance blue. By employing the color wheel and the schemes that have just been explored, you will be able to fulfill the requirements of the project and capture shoppers' interest. This is not to say that arrangements of color must be adhered to as strictly as the schemes imply. Professional designers, whether their forte is clothing, home furnishings, interiors, or general display, often use their creative abilities to go against the conventional rules for visual impact. The rules of color are intended to be guidelines, not limits, to creativity.

In developing color combinations, many visual merchandisers use an interesting fabric as a starting point. A print or stripe that has considerable eye appeal might lead the trimmer to pull out a particular tone and use it for the background or prop color. Vendor-produced

graphics (discussed in Chapter 13) might feature a color scheme upon which a presentation could be based.

Paintings are often inspirational sources of interesting color harmonies. The bold geometries and strong color combination of Mondrian's works, for example, have provided many visual merchandisers with color schemes. Just as clothing designers explore costume collections for inspiration, like the famous one at New York City's Metropolitan Museum of Art, so might visual merchandisers make the rounds of art museums. Nowhere is it written that any set of rules must always be followed in selecting color schemes. Given the wealth of resources available, visual merchandisers who operate within a rules framework are shortchanging the companies for which they work. It is important to stay on the lookout for interesting color combinations. In addition to the resources mentioned, designers can (1) scan fashion and home furnishings magazines, (2) examine color presentations at color forecasting services such as Color Association of the United States (CAUS), and (3) use the color libraries at such forecasting services as Promostyl and Cotton Incorporated to enhance their ability to bring life to presentations through color. In addition, with the advent of the Internet, visual merchandisers and others who use color in their professional lives can log on to websites that give them the latest information about color schemes and other color news of interest. One such site is www.colormatters.com, where a wide range of color topics is offered. The Profile above summarizes the website's offerings.

Psychology of Color

The role that color plays in a window or interior store setting is much more than providing something pleasant for the shopper to see. While everyone has a favorite color, few understand the rationale behind their choices. Color has a significant effect on our emotions, and the skillful use of color in displays can motivate us to buy. In order to capitalize on the psychological effects of color, it is important to understand some of the ways that color can be applied to create the best emotional environment to encourage purchasing.

Warm and Cool Colors

Scientifically speaking, colors don't actually provide warmth or coolness. They do not have physical properties that dispense heat or cold. Instead, the temperatures that we associate with specific hues are a result of physical sensations we experience from certain colors.

Blue and green are considered **cool colors**, with purple sitting on the fence. If the purple is predominantly blue, it is considered cool. Red, orange, and yellow are **warm colors**. In designing a color scheme for a fur salon, the dominant color might be blue. With its cool and icy characteristics, it is almost certain to create an environment in which the shopper might experience an emotional chill and want to bundle up in the warmth of fur. Conversely, the use of yellows and oranges in a resort shop could quickly evoke the warmth of the sun and tempt the shopper to try on a swimsuit. If an experiment were done in which the colors were reversed in the preceding examples, it is likely that the shoppers' reactions to the merchandise would be quite different.

Advancing and Receding Colors

Although colors do not actually move, there is a feeling that some colors advance while others recede. When observed from a distance, the warm colors such as red and orange (**advancing colors**) seem to appear nearer to us than do their cool counterparts, greens and blues (**receding colors**). Bearing this in mind, the visual merchandiser who wishes to employ color to enlarge or shorten a display area should be aware of the tricks that colors play on our minds. If a display area or a department is small and the merchandiser wants to make it seem more open and spacious, a pale, less intense blue would be in order. If, on the other hand, a warm, cozy feeling were the desired result, a bright red would be an appropriate choice to bring the walls in.

The Emotional Effects of Color

The right color choice can immediately create a mood. Most of us have either felt mood changes due to specific color use or have heard others speak about mood swings they have experienced as a result of a particular color. Although blue is generally the color preferred by most people, with red second, no color will have the same effect on all people. The interior designer's task of color selection for a home is easy—the designer discusses it with the client. However, the selection of a color for retail departments, interior presentations, or window displays is a shot in the dark. In trying to predict the customer's response to certain colors, the visual merchandiser counts on the following typical **emotional effects of color**.

When trying to achieve excitement and a scene that will arouse the senses, red is an excellent choice. When used monochromatically in its pure form and contrasted with tints of pink and shades of maroon, it has an impact unattainable by most other combinations.

Orange is a warm color that when darkened to rust gives an earthy feeling. If the customer is to be reminded of the upcoming autumn season, there is no better color to use. Fall leaves, resplendent with oranges and yellows, immediately give us the emotional feeling of warmth.

Blue, the favorite color of most people, suggests coolness and serenity. The peacefulness of the color might be the reason it is a favorite. What better color than that of the sky to evoke a calming emotional experience?

Green is an excellent choice for a restful setting. For spring presentations, the greens of the grass and budding plants give the viewer a feeling of emotional comfort. By itself in a visual presentation, however, green doesn't have the properties sufficient to create a positive picture. It is best combined with yellows and oranges to create a spring-like feeling or contrasted with red, its complement, for pure excitement, as in the case of Christmas decorations.

Purple, the symbol of royalty, is a color to be used for dramatic purposes. In its pure or shaded forms it emits a feeling of drama or mystery. As a **tint**, its effect is generally cooling.

Yellow is a warm color that produces a cheerful effect. When it is used alone, however, it may be monotonous. It is best used in combinations with other colors or perhaps, if a monochromatic scheme is the goal, with white.

The neutrals—black, white, tan, and gray—while not technically considered colors, are still transmitters of emotion. Black might imply depression, but when featured in an elegant setting of eveningwear it imparts a message of richness and sophistication. White can generate a cold feeling but can add a striking balance to any color scheme. The elegance of the white bridal gown, when contrasted with any color or black, immediately heightens the emotions. Tans and grays add other dimensions to colors. Tans contribute to the earthiness of a visual presentation, while gray embellishes a display with an air of sophistication.

Although each color has a different emotional impact, visual merchandisers soon learn that the choice of color to feature in an installation is not theirs alone. The designers of clothing, accessories, and home furnishings dictate what colors are in vogue, and you must be sufficiently knowledgeable to enhance their offerings. Unlike the fine artist whose paintings reflect a personal preference and whose color palette is his or her own creation, visual merchandisers create with much less freedom of choice.

9 chapter review

key points in the chapter

1. Color plays a vital role in visual merchandising; its appropriate use is of utmost importance in the success of the store's interior and windows.
2. Without creative use of color in installations, it is unlikely that shoppers will stop to examine the merchandise offered for sale.
3. Color is discussed in three terms: hue, the name of the color; value, the color's lightness or darkness; and intensity, the saturation or purity of the color.
4. A color wheel is a system of color location and relationships.
5. There are three primary colors: red, yellow, and blue; three secondary colors: orange, green, and purple; along with the neutrals of black, white, gray, and tan.
6. Monochromatic schemes use one central color; analogous and complementary schemes use two main colors.
7. By adding white to a color, a tint is achieved; with the addition of black, the result is a shade of the color.

8. A complementary scheme enhances the strengths of two colors.
9. Neutrals are used to add interest to color schemes or may be used by themselves in specific situations.
10. Visual merchandisers must set personal color preference aside and enhance, through appropriate means, the colors of the merchandise to be displayed.
11. In addition to the color wheel, visual merchandisers can take inspiration from unusual coloration in a painting or from the prints and patterns of materials.
12. Color plays an interesting part in our moods. There are warm and cool colors that create specific feelings in us and colors that appear to advance and recede.
13. Different colors cause different emotional reactions in individuals. Blue, the favorite of most, is peaceful; red provides excitement; and purple gives a feeling of royalty or drama.

terms of the trade

advancing colors 151
analogous color 145
color harmony 145
color wheel 145
complementary colors 147
cool colors 151
double complementary colors 147
emotional effects of color 151

hue 144
intensity 144
monochromatic 145
neutrals 149
primary colors 149
receding colors 151
restful colors 149
secondary colors 149

shade 144
split complementary colors 147
tint 152
triadic colors 148
value 144
warm colors 151

internet exercises

1. With color being such an important element in almost every visual presentation, it is imperative that those who prepare display installations be aware of the latest in color trends so that their presentations will be timely. In order to keep abreast of these trends, visual merchandisers often use the services of experts to provide them with the latest color information. Two of the major color forecasting organizations are The Committee for Colour and Trends and The Color Association of the United States (CAUS). By logging on to their respective websites at www.colour-trends.com and www.colorassociation.com, you will be able to learn about the services they provide. Using the form provided on page 155, list five of the services each association provides and, in the comments section, which one is more appropriate to visual merchandisers and the reasons for your choice.

2. Log on to www.colormatters.com to explore the many different areas of research that exclusively address color. Such topics as Color & the Brain, Color & the World, Color & Design, and numerous others are examined in terms of how colors affect people and businesses. Select one of the areas listed under Explore, and prepare a two-page typed paper on the subject.

Case Problems

Case 1

The Landing is a department store organization based in the Northeast. It has a downtown flagship operation and six full-size branches in the surrounding suburbs. In business for thirty-five years, the store's sales have continued to increase each year. As with most other department stores, The Landing carries a wide assortment of hard goods and soft goods, with emphasis on clothing and accessories for its female clientele.

After a successful five-year attempt to trade up, the company is now ready to experiment with the addition of a fur salon to cater to the upscale female customer. But where? The stores are already bursting at the seams, and there is no possibility of acquiring additional selling space at either the flagship or its branches. The solution seems to be reallocation of floor space to accommodate the new furs.

The general merchandise manager believes that restructuring the space assigned to hard goods is the answer. Since this merchandise brings less than the markup achieved by fashion items, it is natural, she says, to use some of the space for the new fur department. The hard goods buyers believe that a decrease in their selling space would severely hamper sales and would give the impression that The Landing is no longer a full-scale department store. The latter conclusion has been voiced by others in top management.

Last week, the divisional merchandise managers presented a plan that has been favorably received by the store's executive team. They believe that if swimsuits (a seasonal offering except for a little resortwear during the winter) were alternated with furs (also seasonal), they could both use the same space, at different time periods. It was decided that swimsuits would take possession of the selling area from April until mid-August, with furs taking over from late August until the beginning of April. Two small areas would always be functioning to cater to those customers who desire out-of-season merchandise.

The visual merchandising department has been approached for suggestions on a new color scheme that would quickly and smoothly accommodate the transition from one type of merchandise to the other without requiring a major overhaul each time the merchandise offering is changed.

QUESTIONS

1. Is it feasible for such diverse merchandise groups to use the same selling area?
2. What approach would you suggest in terms of color to accomplish the store's goals?

Case 2

Ever since it opened, the Fashion Closet has concentrated on bringing its customers the best merchandise at affordable prices. The attraction has been a regular discount of 20 percent off department store prices. Situated in an off-the-beaten-path location, its success is due to word-of-mouth advertising. With the profits realized, the owners sought a place in which to open a second unit. They recently found a vacant shop in a small center inhabited by fashion retailers who specialize in shoes, accessories, menswear, and children's wear, as well as another store that specializes in merchandise similar to the stock carried by the Fashion Closet.

Both partners believe the time is right for expansion and that the new center would be perfect. Their present operation is lackluster in terms of visual presentation, but this new location, amid stores that consider visual impression important, will require changes. A quick look at the other stores shows that care and attention are focused on window display. Although they are not ready to invest in professional trimming, the partners want to spruce up their windows. They want to achieve impact with color and have decided to do it with a monochromatic display signature against neutral backgrounds of white, tan, gray, or black. The neutral backgrounds will allow them to make frequent display changes without great cost. With carefully timed changes in the monochromatic schemes, their windows will signal to customers that new merchandise has arrived in the store.

The problem that confronts them is the monotony of monochromatic color schemes. They need advice on how to avoid the pitfalls of using a single color to attract attention.

QUESTIONS

1. Does the monochromatic approach seem appropriate?
2. Should the Fashion Closet use only this color scheme?
3. How could monotony be avoided with such a color scheme?

discussion questions

1. What fields, other than visual merchandising, use color as one of their most vital ingredients to capture attention?
2. Since the visual merchandiser doesn't mix paints to achieve different colors, what color mix must he or she use?
3. Define the term *hue*.
4. How does one change a hue?
5. Differentiate between *value* and *intensity*.
6. Why is it important to understand the concept of the color wheel?
7. Distinguish primary colors from secondary colors, and list the names given to the colors that fall between the two on the color wheel.
8. In what way can monotony be avoided in a monochromatic color scheme?
9. Select an analogous color scheme and one that is complementary. Which scheme results in greater color intensity?
10. How does the split complementary scheme differ from the regular complementary configuration?
11. Which color scheme employs three colors that are equidistant from each other on the wheel?
12. Name four neutrals and describe the roles they play in color presentations.
13. Besides the color wheel, what other sources of color inspiration are available to the visual merchandiser?
14. Define the terms *advancing* and *receding* in color selection.
15. What are the cool colors and the warm colors?
16. Of what significance are cool and warm colors to visual merchandising?
17. Which is the favorite color of most people? Why?
18. What emotional effect is generated by red?

exercises and projects

1. Photograph two window displays that feature any of the color harmonies derived from the color wheel. Mount the photographs on the form provided on page 156. In addition to mounting the photographs, fill in the requested information.
2. Prepare a color wheel on page 157 that includes the primary, secondary, and tertiary colors. Apply the color with felt-tipped markers, with paint, by cutting up strips of Coloraid paper (available at any art store), or with chips of colored magazine paper.
3. Visit a paint shop or a department in a large home supplies store that sells housepaint, such as Home Depot. It should have an extensive assortment of color chips from which customers may select any tint or shade of a particular hue. Select one primary color and one secondary color and a wide range of tints or shades of each and prepare a value scale ranging from the darkest shade or lightest tint. Cut the color chips and paste them on the form provided on page 158.
4. Photograph two window displays that use only neutrals. On the form provided on page 159, mount the photographs and evaluate each in terms of color effectiveness.

NAME: _____ **DATE:** _____

COLOR ASSOCIATION COMPARISON

Committee for Colour and Trends Services	Color Association of the United States Services

Comments _____

EXERCISE 1 DISPLAY WINDOWS WITH DIFFERENT COLOR HARMONIES

Color harmony _____

Featured color(s) _____

Neutral(s) _____

Evaluation _____

Color harmony _____

Featured color(s) _____

Neutral(s) _____

Evaluation _____

EXERCISE 2 COLOR WHEEL PREPARATION

NAME: _____ DATE: _____

EXERCISE 3 PRIMARY AND SECONDARY VALUE SCALES

Primary Value Scale

Secondary Value Scale

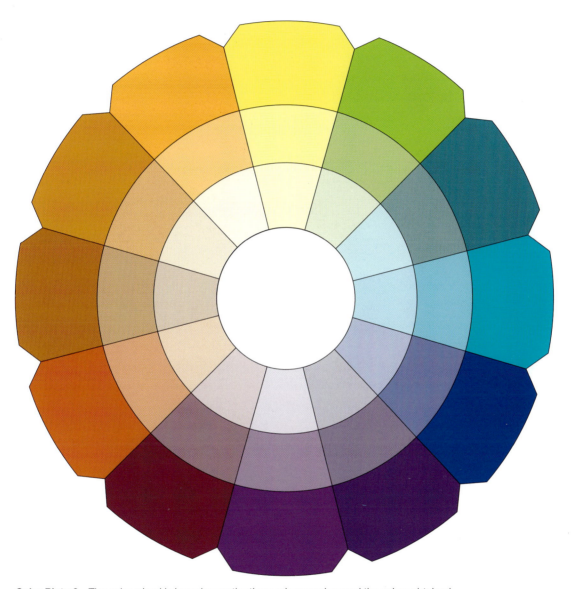

Color Plate 9 The color wheel is based upon the three primary colors and the colors obtained from mixing them.

Monochromatic

Color Plate 11 The value scale.

Analogous

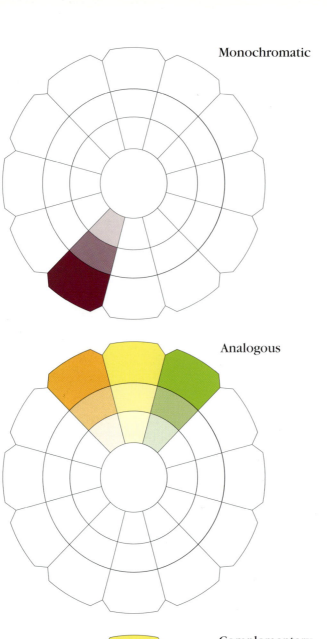

Complementary

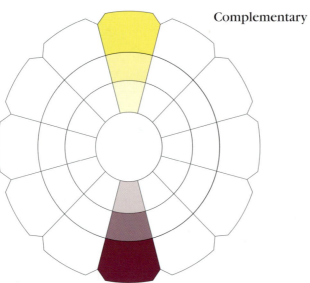

Color Plate 10 Common color combinations based on the color wheel.

Color Plate 12 The intensity scale.

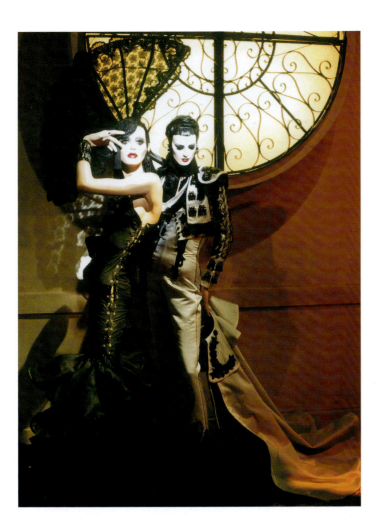

Color Plate 13 The starkness of the mannequins' skin tones adds drama to the setting.

(Courtesy of Adel Rootstein.)

Color Plate 14 Mannequins that represent men, women, and children, in the same manner, offer a uniqueness to the display.

(Courtesy of Adel Rootstein.)

Color Plate 15 In-store display of muppet characters.

Color Plate 16 Muppet characters, in a balance, make for an exciting presentation.

Color Plate 17 Stylized oversized constructions add pizazz to interior displays.

(Courtesy of Marshall Field's, now a Macy's store.)

Color Plate 18 The circus theme provides excitement for this institutional display.
(Courtesy of Marshall Field's, now a Macy's store.)

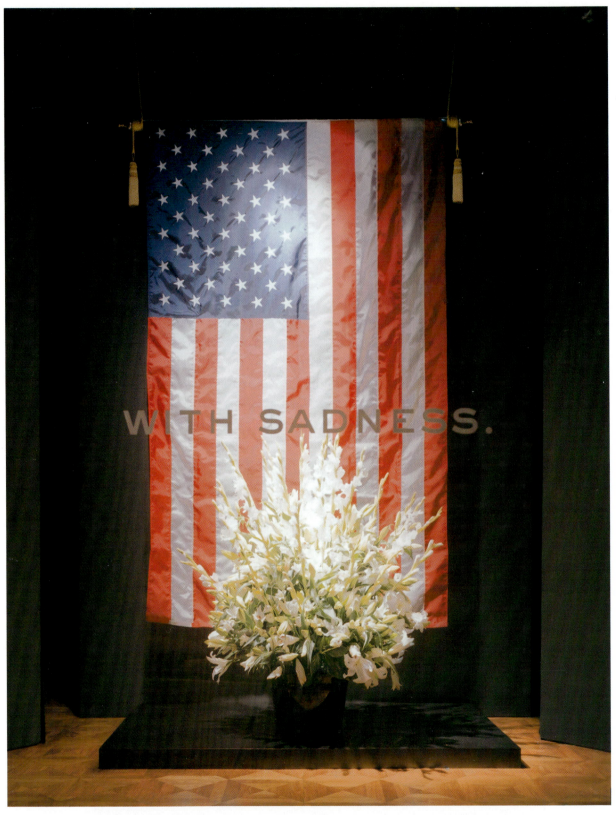

Color Plate 19 The emotions following the tragic events of September 11, 2001, were most powerfully expressed in this simple institutional display that features the American flag and a bouquet of flowers.

EXERCISE 4 NEUTRAL COLORED WINDOW DISPLAYS

Neutrals used _____

How interest is achieved _____

Evaluation _____

Neutrals used _____

How interest is achieved _____

Evaluation _____

lighting:
the selling
display

(Photo by Ellen Diamond.)

Objectives

After completing this chapter, the student should be able to:

... Discuss the importance of lighting to the selling floor and visual presentations.

... Identify the five areas of planning that are necessary before any lighting decisions can be made.

... Differentiate between general and accent lighting.

... Prepare a table that features the different amounts of general illumination required by retailer classification.

... Describe the various sources of light used by retailers and visual merchandisers in particular, and the advantage of each type.

... Differentiate between incandescent floodlights and spotlights.

... Define the term *fiber-optic lighting,* and explain the purposes it serves.

... Explain why many retailers have added halogen or quartz lamps to their interiors and windows.

... Give the reasons for the popularity of track lighting.

... Contrast the results of using a PAR spotlight and a blown glass spotlight.

... Describe two methods by which color can be achieved with lighting.

dramatizing floor and areas

Introduction

The movie director's shout of "lights, camera, action" is the signal that the film is about to be recorded. Imagine the result if the first of the three commands is eliminated. While the camera rolls and the actors go through their paces, inappropriate lighting could result in poor films. By changing nothing more than the intensity, direction, or color of the lights, shadows are altered, moods can be created, and the commonplace is transformed into the dramatic. Clever lighting can minimize unimportant areas and emphasize others.

Borrowing from the movie industry and the stage, visual merchandisers have turned lighting into a tool that does more than just illuminate a window or interior. No longer is lighting just a functional effort left to the whims of an architectural designer. After all, display is akin to theater in that it, too, requires dramatization to maximize the efforts of the director, or in the case of retailing, the visual merchandiser. In most companies, visual merchandisers play a significant role in the selection of lighting. The decision is not theirs alone; they work in conjunction with the people in operations and with architects and lighting specialists to make certain that the chosen fixtures and systems will satisfy the needs of effective window presentation as well as interior illumination.

Smaller retail organizations that operate without an in-house visual merchandiser must rely on the expertise of an architect, interior designer, or lighting expert. In these situations, lighting decisions may fall short of what is necessary to provide distinctive display effects because of the absence of a visual merchandiser. In such cases, the freelance trimmer is called upon to augment the existing lighting by providing additional temporary lighting, such as floor spotlights, to enhance the store's visual presentations. Whatever the situation, a knowledge of lighting is necessary to highlight the store's merchandise, on the selling floor or in display windows, and of course, the store's environment.

It should be noted that lighting a store's entire premises is sometimes a challenge that requires a significant amount of research so that the right systems will be selected for overall and focused illumination (Figure 10–1). The following Profile on the Benetton Flagship shows how a premises that was built for another purpose can be perfectly illuminated to house a fashion retailer.

Figure 10–1 General recessed fluorescent lighting is accented with spots that are suspended from a flexible track system.
(Reprinted with permission of Juno Lighting.)

In this chapter, attention is focused on the principal lighting requirements of the retail environment, the different types of light sources available, lighting fixtures and systems, and the use of colored lighting.

Retailing's Principal Lighting Requirements

Before choosing the lighting that will become part of the retail environment, any merchant must first assess the principal needs for successfully illuminating the premises. In general, every bricks-and-mortar lighting system must serve the following purposes:

- *Attract attention.* The merchandise that is featured in the windows or interior spaces must stand out against the competitor's offerings. With the wealth of stores in malls and downtown shopping centers, each merchant's product lines must be distinguishable from every other merchant's.
- *Generate interest.* The lighting must be sufficiently striking to motivate potential customers to stop and take a closer look at what is being offered. This is true of the display windows that greet the shoppers outside of the store as well as the departments inside.
- *Create a comfortable ambience.* The general atmosphere of a store helps to influence the mind-set of the consumer. A subdued, yet properly enhanced lighting system will help to put the buyer in the proper mood for shopping.
- *Provide compatibility with its identity.* Whatever strategy has been earmarked for the company, the lighting should be perfectly suited to enhance it. Discounters and off-pricers, for example, generally rely upon bright, overall illumination to underscore the entire premises, whereas upscale fashion emporiums use a more

PROFILE: A Contemporary Visual Merchandising and Environmental Design Profile: The Benetton Flagship

During the 1970s and 1980s, the Benetton Company, headquartered in Italy, made a splash in American retailing that caught many fashion-oriented merchants by surprise. It took the country by storm and soon became a regular shopping stop for teenagers and young adults. When all of the initial fanfare finally died down, and sales began to wane, the company retrenched its operation and ultimately developed a strategy to reposition itself.

In 1998, Benetton began its return to leadership in fashion merchandise with the acquisition of the historic Charles Scribner's and Sons Bookstore on New York City's Fifth Avenue. The challenge was to create a venue for its complete United Colors of Benetton collection while restoring the original architectural design of this preservation landmark building. In its makeover, lighting was the key to both presenting the merchandise and preserving the history of the 5,900-square-foot space, with its 46-foot vaulted ceilings, floor to

ceiling façade windows, and three floors of selling space. The challenge was a formidable one because of the extraordinary amount of negative space. According to Benetton's director of stores, "It was like being in a cathedral."

The lighting system had to effectively illuminate the premises with different shades of light during different times of the day, accounting for sunlight as it moved across the store through the enormous front windows. It also had to provide preset light levels, control heavy lighting loads among the various sources, and at the same time save lamp life and energy. Coupled with the need to have a user-friendly system that employees could easily operate, the lighting professionals had to solve some problems never before presented to them. To make matters even more difficult, the design team had to cope with the many distractions that directly faced the store, such as the fanfare created by Rockefeller Center's enormous Christmas tree. Its system had to have the lighting

capability to draw attention to itself from the outside "competition" and attract customers into the store.

To accomplish their goal, designers with Hillmann DeBernardo chose the Lutron Electronics' GRAFIK Eye 4000 Series system of preset multiscene lighting controls to achieve the effects they wanted. It effectively balanced the look of the store's day-to-day operation whether the light shone brightly through the windows or at night when different levels of illumination were needed. The system can be automatically set for an entire year, automatically turning on in the morning and changing throughout the day based on calendar days and times, winter or summer.

Replete with dimmers that enabled the highlighting or softening of an area as needed, the versatility of the lighting installation provided the premises with every nuance necessary to create a setting that would enhance the products and the entire environment.

subtle light approach that incorporates accent lighting for more intimate and dramatic effects.

- *Offer flexibility.* Retail trends and strategies often change rapidly; thus the lighting systems must be designed to address these needs whenever they arise.

Assessment of Lighting Needs

After a review of the principal lighting requirements, specificity is the next step. Different retail establishments pursue different marketing strategies and product mixes in their attempt to capture a particular segment of the market. Some, such as discount operations, need to feature a general illumination plan that sufficiently lights the entire shopping environment. Boutiques and other upscale fashion stores, on the other hand, need a visually quieter atmosphere to create the perfect ambience for their offerings. Supermarkets, home centers, mass merchandisers, and cosmetic shops need other types of lighting to properly illuminate their premises. Such factors as price points, sales assistance, store layout, competitor environments, and location each must be considered before the final lighting decision is made. Once these assessments have been made, the next stage is to develop a lighting plan.

Lighting Plans

The effective lighting of bricks-and-mortar operations requires a combination of general and accent lighting. Each plays an important role as part of the overall design plan of the store.

General Lighting

Every store's lighting plan should begin with the development of a general lighting scheme. In some cases, the focus is exclusively on general overall lighting. Discounters and mass merchandisers, for example, concentrate on this type of lighting to illuminate their premises. Those in the middle range of the retail spectrum use general lighting as a means of overall illumination and add accent lighting to highlight specific areas inside the store and display windows. The high end of the industry, which includes upscale, fashion-oriented retailers, uses some overall lighting with accent illumination in broad usage.

Table 10–1 outlines the level of general lighting according to retail classification. It should be noted that this overall illumination may be achieved through a variety of sources, such as fluorescents, incandescents, and fiber optics. These and other light sources will be explored later in the chapter.

Accent Lighting

The vast majority of retail operations must provide a balance between their general and accent lighting. As we mentioned, each retail classification requires a different amount of

table 10-1 General Lighting According to Retail Classification

General Lighting Levels	Retail Classifications
Very low	Boutiques, art galleries
Low	Restaurants, exclusive specialty shops
Average	Department stores, specialty chains
Fairly high	Supermarkets, discount stores
High	Warehouse operations

general lighting. Those that emphasize overall illumination require very little in accent lighting. Conversely, the lower the use of general lighting, the greater the need for accenting.

There are many different types of accent lighting, such as incandescent spotlights, halogens, and HIDs, each of which will be discussed in the "Light Sources" section of this chapter. Before a particular source or sources are chosen, however, it is necessary to assess the daylight that enters the store, lighting from nearby elements, and the amount of general lighting that is used for overall illumination. In the Benetton Profile, the problems from daylight and outside "light competition" required a great deal of expertise to solve.

Daylight has generally been a problem for lighting designers. Its presence can be a hindrance, especially when dramatic accent lighting is the goal. Daylight fluctuates in color and intensity and cannot be controlled. When, however, some daylight is warranted, skylights have been strategically placed to provide it. Lighting experts warn, however, that the intentional use of skylights will almost always compromise the accent factor.

It is important to consider two factors in the use of accent lighting.

- *Distance.* The greater the distance from the area to be illuminated, the smaller the effect. The closer to the lighting source, the greater the effect.
- *Beams.* Concentrated light is achieved through the use of beams (Figure 10–2). Their effective use causes a separation between accented illumination and the surrounding areas. Beams differ from one another in intensity (the amount of light emitted from a source in a particular direction) and width. They include very narrow spots, regular spotlights, narrow floods, and wide floods, each of which will be explored later on in the chapter.

When general lighting is controlled and adjusted area-by-area in a store, accent lighting will provide the drama so often necessary to underscore particular merchandise.

Light Sources

Other than natural daylight, which plays practically no part in store interior or window illumination, there are several sources of light employed by visual merchandisers. Knowledge of each will help you to make the appropriate choice in terms of both visual effect and economy of operation. Each different type—fluorescent, incandescent, high-intensity, neon, and halogen or quartz—is used for specific purposes.

Fluorescents

For cost-efficient, cool, general lighting, **fluorescents** are the choice of many retailers. The bulbs come in many shapes, but the long, narrow, cylindrical tubes that come in several lengths are used most frequently. A newer type is housed in fixtures that easily install on track systems (Figure 10–3). They are used by retailers for **wall washing** and display illumination. The advantage of this type of lighting is that it is visually appealing and smaller than the typical fluorescent. Other advantages of using fluorescents in general are dramatic energy savings (as much as 75 percent when compared to incandescent lamps), long lamp life, and high light output.

The early fluorescent lights gave off a harsh, bluish color that tended to wash out the shopper's complexion as well as the color of the merchandise. However, today's bulbs offer excellent color rendition and come in a variety of colors that can project coolness, warmth, or other desired effects. If color is needed for a particular temporary presentation, filters to encase the standard white tubes are available (Figure 10–4).

The fluorescent bulb is most often used in interior ceiling, floor, and wall cases, in valances that frame windows and shadow boxes, and on lighting tracks. Although the bulbs are comparably inexpensive and long-lasting, the fixtures, especially those with pleasing surfaces, are expensive and, in all cases except the track variety, are stationary, so they cannot be directed at specific targets. If fluorescents are not mixed with incandescents or other

Figure 10–2 Beams are used as accents and may be adjusted when placed at different distances. *(Courtesy of Phillips Lighting Company.)*

types of lamps, the store's appearance will be stark, evenly illuminated, and devoid of any interesting or dramatic effects. But many trimmers are using fluorescents over entire walls to create a dramatic effect. The fluorescent fixtures are recessed into a wall that is completely covered with a Plexiglas surface. In this way, general lighting is achieved as well as a dramatic focal point for the department.

Incandescents

Although a general wash of light can be achieved with the standard **incandescent** bulbs, their maintenance was so costly that new breeds of this bulb, known as low-voltage lamps,

Figure 10–3 Fluorescent fixtures that rotate on tracks are more useful for visual merchandisers.

(Reprinted with permission of Juno Lighting.)

Figure 10–4 Color tubes for fluorescent bulbs come in 48-inch lengths and can be cut to fit any size bulb.

are now being used by retailers. They provide more lumens per watt than standard incandescent bulbs and come in spotlight or floodlight form, known as PAR bulbs and R bulbs, respectively. The low-voltage lamps bring out the true colors of the merchandise, enhance textures, and create spectacular lighting effects. Whether highlighting a large area or spotlighting an object, the precise beam pattern of low-voltage lighting creates drama. There are many variations available in this type of lamp, ranging from those that accent items to those that throw very long beams (Figure 10–5). Another advantage of the low-voltage incandescents is heat reduction. The heat thrown off is actually two-thirds less than that of standard sources, which results in considerable savings in ventilation for the store. Finally, the lamps burn longer, which significantly reduces replacement and fixture relamping costs.

Figure 10–5 The beams of incandescents are either wide to highlight an area or narrow to spotlight or focus on a particular item.

Fiber-Optic Lighting

Technically, **fiber-optic lighting** is comprised of a remote light source incorporating glass optical fibers. More important to the visual merchandiser are the benefits of the product. They include the elimination of ultraviolet and infrared wave lengths, directional spotlighting or floodlighting, simple maintenance, ease of concealment, and reduced power consumption. Because they give off a cold light, heat-sensitive objects such as jewelry benefit from their use.

High-Intensity Discharge Bulbs

Commonly known as **HIDs**, high-intensity discharge bulbs are very small, produce more light per watt than either the incandescents or fluorescents, and are energy savers. While they are readily available, for the most part visual merchandisers still ignore them in favor of fluorescents for general, overall lighting and halogens and low-voltage incandescents for accenting purposes. HIDs are making their mark in the home, however, where they are housed in unusual lighting fixtures.

Neon

Once reserved for outdoor signs to identify the name of a store, **neon** lights are being used extensively in store interiors. A great advantage of neon, or cold cathode as it is technically known, is that it can easily be shaped to any form. These lights are relatively maintenance-free and cost little to operate. Available in a wide range of vivid colors, neon is used by visual merchandisers to build excitement. Neon quickly transforms a ho-hum junior department into a dance-floor environment with the flick of a light switch. Today's neon sculptors have broadened their scope of design to the creation of total environments that add immediate excitement to a department or window (Figure 10–6). Although neon is a source of light, it is relied on more for special effects than for total illumination.

Halogen

In their search for ways to improve the lighting of their wares, many retailers have turned to the halogen lamp for dramatic, intense lighting. The bulbs, which are housed in special fixtures, give off light that is unlike the light generated by the other bulb sources (Figure 10–7). Basically a whiter, brighter bulb, approximately one-quarter the size of a standard incandescent, it is ideal for enhancing a visual image and totally washes a wall. Not only does it afford more light control, more efficiency, and a more intense light per watt, but the lamp has a longer life, about double that of incandescent bulbs.

Low-Voltage Lighting

Low-voltage lighting can provide the visual merchandiser illumination that accents the form and texture of displays without having to sacrifice true colors. The benefits of low-voltage lighting can be realized in both track configurations as well as recessed installations—specifically, heat reduction and energy/maintenance savings.

 The heat produced by conventional lamps is significant and often causes the displayed merchandise to fade. The *dichroic reflectors* in low-voltage lighting redirect infrared light through the back of the reflector, resulting in two-thirds less heat than standard light sources. This not only alleviates the potential for fading but also solves the problem of

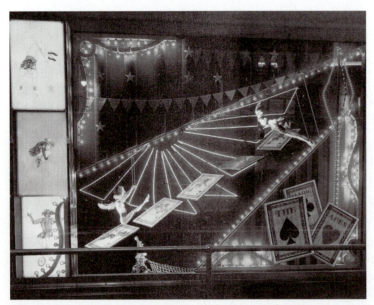

Figure 10–6 The neon lighting adds interest to this display window.
(Courtesy of Lord & Taylor.)

Figure 10–7 Halogen lights brilliantly illuminate any display area.
(Reprinted with permission of Juno Lighting.)

damage to any heat-sensitive or perishable items. **Low-voltage lamps** also provide more lumens per watt than standard incandescent sources, making it possible to do the same accent lighting job of much higher-wattage lamps at reduced energy costs. Additionally, the longer lamp life of the low-voltage entries significantly reduces lamp replacement and fixture relamping costs. In today's business environment, where operating costs continue to spiral upward, the savings derived from the use of these lamps has led the vast majority of retailers to use them.

Lighting Fixtures and Systems

The past several decades have seen a drastic change in the lighting fixtures and systems available to retailers. The variety enables retailers to acquire distinctive lighting and decorative fixtures to complement any decor. So attractive are many lighting appliances that they become the focal points of some store interiors. Although the innovative lighting fixtures and systems are readily available, retailers don't constantly change their designs when a new one appears on the market. The investment is just too costly. These newer systems and fixtures are generally reserved for new branches and units of department stores and chain organizations. For stores that have been in operation, visual merchandisers must be able to use what is available, adding fixtures and bulbs to existing systems.

Recessed Lighting

Many stores have **recessed lighting** systems that are housed in the ceiling (Figure 10–8). A can or container holds floodlights that illuminate broad areas and spotlights for narrow illumination or highlighting. Fluorescents are also often recessed and are used for overall, general lighting. It should be noted that numerous incandescent floodlights are necessary to do the job. A few recessed fluorescents could serve the same purpose, but most retailers prefer both the visual effect projected by the continuous circles of lights and the shadows these bulbs play on the surrounding walls. In the premises of value-oriented retailers, however, fluorescents are generally the choice for overall illumination (Figures 10–9 and 10–10).

Incandescent spotlights can also be used in recessed fixtures. These fixtures swivel to enable the visual merchandiser to pinpoint a specific area. For even more flexibility, extension swivel rods can be attached to the cans, lowering the bulb below the ceiling surface and

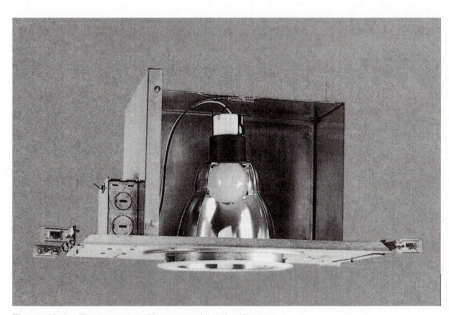

Figure 10–8 The anatomy of a recessed lighting fixture.

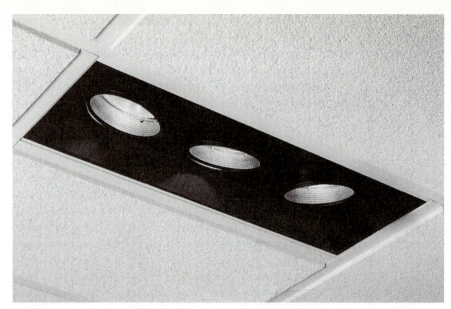

Figure 10–9 Recessed multispot lighting fixtures provide flexibility for interior and window illumination.
(Reprinted with permission of Juno Lighting.)

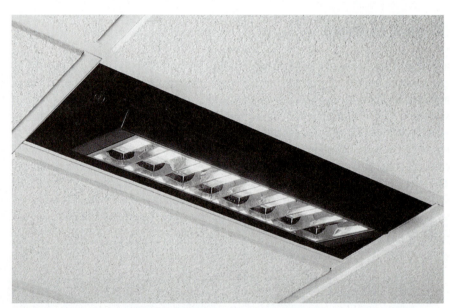

Figure 10–10 This recessed fluorescent fixture may be rotated to light a specific targeted area.
(Reprinted with permission of Juno Lighting.)

Figure 10–11 The extension rod adapter brings the light closer to the area of illumination.
(Reprinted with permission of Juno Lighting.)

allowing light to be focused in any direction. Figure 10–11 shows an incandescent bulb that is recessed into a ceiling can and a swivel extension rod adapter that not only lowers the light but permits it to be directed to another area.

In earlier recessed fluorescent fixtures, the bulbs were exposed, presenting a very unattractive appearance. Egg crate casings were soon developed to conceal the bulbs and later, Plexiglas panels. Today, many casings are available to conceal the bare fluorescent bulbs. It should be noted that while an aesthetic improvement is achieved with these coverings, there is some reduction in the amount of projected light.

Track Lighting

While recessed lighting is often considered an attractive as well as a functional method of lighting, its placement is stationary. In order to be able to adjust lights to the exact

positions in which they are needed, many retailers use **track lighting** systems. Track lighting is easy to install, does not involve complicated wiring, and can quickly transform an area into one that is attractive and perfectly illuminated. **Tracks** come in many lengths and can be arranged in many ways with the use of L, T, or flexible connectors.

To accent objects on a wall or to wash a wall with light, the track should be placed 3 feet from a wall that is 8 or 9 feet high and 4 feet from walls that are 10 to 12 feet high (Figure 10–12). The proper positioning maximizes the effectiveness of the light thrown. The ability to swivel the containers allows items in a window or on shelves to be perfectly highlighted. The proper choice of fixtures as well as bulbs will give the effect desired by the store.

Today's offerings are very extensive, ranging from the simplest contemporary cans to those that fit any design decor. The majority of retailers, however, choose decorative types. When fluorescent lighting is the choice and flexibility is needed, compact fixtures that fit easily on tracks are available.

Figure 10–12 Tracks may be used to feature a wide range of container designs.
(Reprinted with permission of Juno Lighting.)

Decorative Lighting

Tracks and recessed fixtures provide the lighting necessary to generally light an area or spotlight a particular mannequin or item in a display. Often, stores also use additional lighting to create a dramatic effect. This lighting by itself will not generally be sufficient to illuminate an area but will help set a mood or create an impression or image to capture the shopper's attention (Figure 10–13).

Lighting with Color

The application of colored lighting in a department or a window is risky business. The vast majority of visual merchandisers and store planners shy away from the use of colored lights because improper use can result in color change. If you have ever looked into a store window that is protected from the sun with amber transparent shades, you probably noticed that the color of the merchandise changed. The light streaming through the protective material has the same effect as a colored light. Colored lighting should be used only for special effects or when it is necessary to

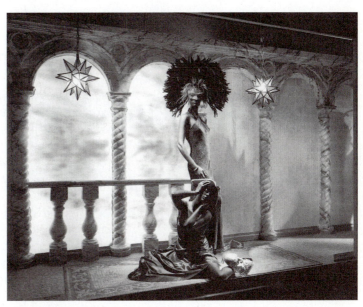

Figure 10–13 Decorative fixtures add interest to visual presentations.
(Courtesy of Lord & Taylor.)

intensify the color of the merchandise. The rule is to use the same color of light as the merchandise to be highlighted. Thus, a red light on a red dress is appropriate to intensify the color. A blue light on the same dress will drastically alter the color of the displayed dress and will confuse the shopper about the actual color of the dress.

If colored lighting is desired, it can be done in two ways. For short-term projects, colored **acetate gels** can be applied to the fixtures that house the bulbs. The gels come in a wide array of colors, are inexpensive, and are easy to use. However, extended use will result in cracking of the gels due to the heat from the light source. For periods of more than one week, it is best to use round **colored filters** that are made of glass. They are long-lasting, fit easily into many spotlight cans, and are available in numerous colors. Unless special lighting is necessary, white light should be the rule.

Lighting Accessories

In addition to light fixtures and light sources, a number of accessories assist in providing special effects for the trimmer. They include dimmers, flashers, fresnels, framing projectors, strobes, swivel sockets, and gels.

When a light is turned on, it automatically throws a specific amount of light according to the wattage of the bulb. In certain situations, the trimmer wants less illumination without changing the bulbs. This is easily achieved with the use of a **dimmer**, which can be rotated until the desired amount of light is achieved. A **flasher** is an attachment that fits into bulb sockets or onto electrical cords that causes lights to turn on and off. The end result is a twinkling, dramatic effect. At Christmastime, many visual installers use flashers. The **fresnel** is a focusing lens that is used in front of a light to change the size of the beam from general lighting to spotlighting. A pattern and **framing projector** is a light projector with built-in framing shutters for beam shaping; it also accepts **patterned templates** for image projection. They are used to simulate scenery, to create atmosphere, or to apply additional depth to any setting. **Strobes** are bulbs that turn on and off; they are used to achieve dramatic effects. A **swivel socket** is a versatile accessory item that fits into a light receptacle and swivels or rotates 360 degrees. It is used to direct the light bulb up or down or in any direction. Gels, as discussed earlier, are colored acetate films that can be placed over a bulb. They provide short-term colored effects for the trimmer.

Table 10–2 lists and describes lighting terminology.

Light System Acquisition

Lighting is a very technical aspect of visual merchandising and store design. Properly used, it illuminates selling areas effectively and provides sufficient accenting for display installations. Today's offerings are so diverse in terms of systems and light sources that care must be taken to achieve the best results. Although many visual merchandisers, as well as interior designers, are well versed in visual installations and fixture placement, some do not have the technical knowledge necessary to choose the most appropriate systems for their stores.

By visiting lighting professionals, one may learn about the benefits and disadvantages of what is available today. If visits to these professionals are difficult, many offer complete brochure packages that feature a host of products and describe their usage and costs. The names of these companies are available in the Yellow Pages directory, on the Internet, or from organizations such as the National Association of Display Industry (NADI) in New York City, Illuminating Engineering Society of North America (IESNA), and International Association of Lighting Designers (IALD), each of whose addresses may be obtained from *Visual Merchandising and Store Design* magazine. There are also many lighting trade expos across the country that feature a wealth of different lighting producers. Any of these resources will help to familiarize the retailer with what's new and how a system can be best utilized. Since lighting installations are long-lasting, caution should be exercised before any purchases are made.

table 10-2 Common Lighting Terminology

COMMON LIGHTING TERMS		
Term	**Definition**	**Usage**
Ballast	An electrical device that supplies the proper currency to the electric fixture	Starts and operates a discharge lamp
Chase lights	10-watt cosmetic bulbs, set in a bar or flexible cord, that flash on and off	For dramatic, theatrical effect
Cove lighting	Indirect lighting that is recessed in a cove or cornice and is reflected on the ceiling or a wall	To softly light a wall or an area
Dimmer	Mechanical device that changes the intensity of light	For mood or dim lighting
Filters	Colored, round, glass discs that attach to spotlight fixtures	To intensify a color present in a display
Flashers	Attachments that fit into bulb sockets or onto electrical cords that cause lights to turn on and off	For a twinkling, dramatic effect
Floodlight	Type of incandescent bulb available as PAR lamps or reflectors	To throw a wide beam of light on an area
Fresnel	Focusing lens placed in front of a light to change the size of the beam	To adjust from general floodlighting to spotlighting
Gels	Colored acetate that may be placed over a bulb	For short-term colored effect
General lighting	The basic or primary lighting of an area achieved with fluorescents or incandescent floodlights	For an overall lighting effect that is to be supplemented with spotlights
Halogen	A type of quartz lamp that offers longer-lasting, brighter, whiter light	For more efficient and precise light control; for enhancing the visual image
HID lamp	High-intensity discharge bulbs; smaller in size and more light per watt than fluorescents and incandescents	For achieving concentrated lighting and shadows
Indirect lighting	Light that is directed to the ceiling or walls and is concealed in cornices, corners, and valances	For the lighting of general areas or for dramatic effect
Neon	Cold cathode lighting that can be shaped easily to form designs	For electric signs and decorative effects
PAR lamp	Hard surface floods or spots that throw bright, intense light and may be used indoors or outside	For brighter, intense lighting
Pattern and framing projector	Light projector with built-in framing shutters for beam shaping; it accepts pattern templates for image projection	To project specific images, simulate scenery, create atmosphere, or supply additional depth to any setting
Spotlight	Incandescent bulb that throws a narrow beam of light	To highlight a particular object
Strobes	Lights that flash on and off	For dramatic effects
Swivel socket	A socket that fits into light receptacle and swivels or rotates 360°	To direct light up or down or in any direction
Track lighting	A 4', 6', or 8' channel that attaches to a ceiling or any flat surface and is electrically wired. A variety of cans or containers, which house bulbs, can be easily fitted to track to achieve desired lighting	For ease in adjusting lighting requirements as well as adding a decorative dimension to the setting

chapter review

key points in the chapter

1. Effective lighting in store interiors and windows is a result of what has been learned from lighting directors in the theater and movie industry.

2. Numerous sources of light other than daylight are employed by visual merchandisers.

3. Fluorescents provide good general lighting at a comparatively low cost.

4. Fluorescent fixtures can be purchased that fit on tracks for more flexibility.

5. Incandescent bulbs come in a variety of shapes, sizes, and wattages and provide the retailer with good overall or general lighting as well as highlighting.

6. Low-voltage lamps bring out the true color of merchandise, enhance textures, and have the advantage of heat reduction.

7. Fiber-optic lighting benefits the visual merchandiser by eliminating ultraviolet and infrared wavelengths and reducing power consumption.

8. HIDs are very small bulbs that produce more light per bulb and are energy savers.

9. Track lighting enables the visual merchandiser to adjust the store's lighting easily by changing containers and bulbs to achieve the desired effect.

10. To add color, fluorescents can be encased with colored cylinders and gels and filters can be placed over spotlights and floodlights.

11. Numerous lighting accessories, such as dimmers, flashers, fresnels, strobes, and swivel sockets, enable the visual merchandiser to achieve better results.

12. When setting out to acquire lighting systems, the visual merchandiser and store designer should learn about the advantages and disadvantages of the products available by visiting lighting manufacturers, attending trade expositions, and calling upon NADI and lighting associations for information.

13. Low-voltage lighting results in heat reduction and energy/maintenance savings without sacrificing proper illumination.

14. There must be a perfect balance between general and accent lighting to provide the shopper with the appropriate retail environment in which to shop.

15. The distance from the light source and the type of beam must be considered to ensure effective accent lighting.

terms of the trade

acetate gels 171
colored filters 171
dimmers 172
fiber-optic lighting 167
flashers 172
fluorescents 165
framing projectors 172

fresnels 172
HIDs 167
incandescents 166
low-voltage lamps 169
neon 168
patterned templates 172
recessed lighting 169

strobes 172
swivel sockets 172
track lighting 171
tracks 171
wall washing 165

internet exercises

1. Pretend that you have just been hired as the Director of Visual Merchandising for a department store group that is presently planning to open three branch stores in the next five years. Part of your responsibility is the purchase of lighting systems for the new stores. In order to initiate the process, you have decided to use the Internet to discover which vendors might be appropriate for showroom visits. Using any of a number of search engines such as www.askjeeves.com, examine all of the companies listed, choosing five of those that you believe will satisfy your company's need, and complete the chart on page 177 for each. When you have finished your research, write a few sentences in the "Comments" section naming the vendor that you think merits further consideration, and why.

2. LSI Industries, Inc. is one of the largest manufacturers of high-quality lighting systems. Its lighting systems are extremely diverse and feature everything needed for perfect illumination for professional uses. After logging on to the company's website, www.lsi-industries.com, examine its lighting product line, and prepare an oral report on the products you think best serve the needs of visual merchandisers and the stores they work for. Download any of the systems and "lamps" that illustrate the presentation that you will make. Each of the pictures should be affixed to foamboard and used during your talk.

discussion questions

1. Which light source do most large retailers use to generally illuminate their store interiors?
2. What are the advantages of using fluorescent lighting?
3. How can standard fluorescent bulbs be adapted temporarily for presentations that require colored lighting?
4. What types of systems have made the use of fluorescents more versatile?
5. Why have the standard incandescents declined in popularity for general illumination?
6. Although floodlights and spotlights are both incandescents, what different purposes do they serve?
7. What advantage does the low-voltage incandescent have over the older, traditional models?
8. How advantageous is the use of HIDs and halogens?
9. What purpose does fiber-optic lighting serve in retail environments?
10. Is neon a good general illuminator in visual presentations?
11. Discuss the advantage of track systems over recessed lighting systems.
12. How can spotlights be easily adapted for color usage?
13. Describe how improper use of color on merchandise can cause problems for the retailer.
14. In what simple way can the visual installer reduce the amount of light being projected from a bulb?
15. What is the purpose of framing projectors?
16. What are strobe lights?
17. Describe the advantage of a swivel socket.
18. How should the visual merchandiser and interior designer prepare for the purchase of a lighting system?
19. Why do most retailers opt for low-voltage lighting systems?
20. What are the principal needs for proper in-store illumination?

Case Problems

Case 1

Lackluster is perhaps the best way to describe the premises just vacated by a store in Dayton, Ohio, and leased by a new retailer, Helen's Fashion Depot. The new tenant could change the layout by totally gutting the interior and windows and starting anew. Given the new company's limited budget, however, such an approach is out of the question.

The partners believe that a fresh coat of paint and shampooing the existing carpet would be a good beginning. The fixtures that will house the merchandise will be the inexpensive modular type that can be rearranged into a variety of configurations. The 950-square-foot space, with a 20-foot frontage, doesn't really require an abundance of new, costly fixtures.

Except for the lighting, all of the problems seem to be solvable at modest expense. The previous tenant illuminated the store with two strips of fluorescent lighting down the center and sparsely spaced incandescent containers recessed into the ceiling. The two windows, parallel-to-sidewalk-enclosed structures and located on either side of a center doorway, are outfitted with recessed fixtures.

To say the least, the lighting leaves much to be desired.

Again, faced with limited capital, Helen's Fashion Depot would like to make as much lighting change as possible without totally changing the lighting arrangement. Complete renovation would cost much more than the new company could expend.

QUESTIONS

1. How would you enhance the existing interior lighting to accent the store and dramatize the featured merchandise without significant expense?
2. In what way can the two windows be outfitted with lighting that could simply, yet inexpensively, highlight the displays?

Case 2

Throughout the United States, shopping areas are being developed unlike the typical enclosed malls. For instance, the Boston area has its Quincy Market, a collection of sophisticated and unique shops in an area that had been nearly abandoned. Other cities across the country are also revitalizing downtrodden areas, transforming them into the likes of New York City's South Street Seaport, Baltimore's Inner Harbor, and St. Louis's Union Station.

Unlike the suburban malls, these shopping facilities are anything but conventional. In keeping with the notion of innovation, the shopkeepers have generally chosen unique designs for their stores. The latest in fixturing, signage, and lighting is quickly apparent.

Peter and Paul have just leased a small unit, 600 square feet, with an open-back window that is 9 feet wide. The store interior is actually what the shoppers will see, because space is at a premium and nothing could really be used for a conventional window. In trying to devise a unique design to enhance their avant garde, unisex merchandise, the partners are willing to forgo investing a great sum in merchandise fixtures to spend more on lighting.

They have visited many stores and lighting showrooms to develop a concept. They are interested in a designed lighting format that will not only illuminate the premises but also establish a visual focal point.

QUESTION

1. What lighting approach should Peter and Paul take in achieving their goal?

exercises and projects

1. Visit a major department store in a mall or downtown area and evaluate any department's lighting using the form provided on page 178.

2. Write or visit a lighting business that specializes in the illumination of retail interiors and windows. Get information on the following topics and prepare a report, complete with pictures and illustrations that they have supplied to you, to describe the state of the field.

 a. Trends in lighting
 b. Types of fixtures available
 c. Bulb classifications
 d. Use of colored light
 e. General illumination
 f. Highlighting
 g. Costs of lighting fixtures
 h. Low-voltage lighting
 i. Dramatic lighting effects
 j. Innovative lighting

NAME: _____ DATE: _____

EXERCISE 1 LIGHTING COMPANY RESEARCH

Company	Website	Services Offered	Lighting Systems Used

Comments _____

NAME: _____ DATE: _____

EXERCISE AND PROJECTS 1 STORE LIGHTING EVALUATION

Store Name: _____ Department: _____

Type of Light Fixtures Type of Bulb Effectiveness

General Lighting:

Highlighting:

General Comments:

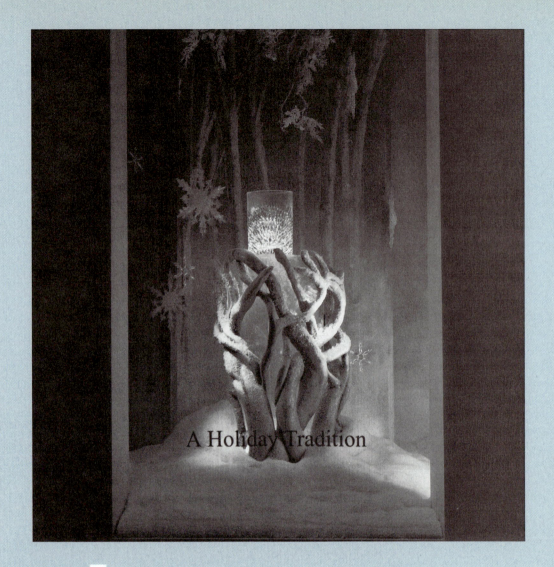

A Holiday Tradition

themes and windows

After completing this chapter, the student should be able to:

... Discuss the permanent total environment concept as it relates to visual merchandising.

... Explain the fundamental principles associated with the introduction of each season's visual presentations.

... Describe appropriate settings for the windows and interiors for each of the four seasons of the year.

... List five holiday periods for which visual merchandisers must prepare and the types of installations they might produce for each.

... Differentiate between presentations that are merchandise-oriented and those that are institutional.

... Explain the role of the visual merchandising team in a store's special event.

... Distinguish between unit and ensemble displays and discuss the emphasis of each type.

... Give the rationale for using an abundance of one item in a presentation.

settings for and interiors

Introduction

When the curtain goes up in the theater or the opening scene flashes on the movie screen, the design of the set immediately creates a mood. Emotional responses to the mood begin to flow in the observers. This impact is largely the work of the director.

Windows and store interiors, too, can project a mood that can turn the shopper's head. Like the director of a theatrical endeavor, the visual merchandiser can create environments that are exciting and stimulating and significantly improve the appeal of the merchandise. Whether it is a permanent setting or one that changes entirely with the seasons or special holidays, the visual presentation is of the utmost importance.

Each company has a personality that can be enhanced by the manner in which the products are presented. A single mannequin in a window, elegantly presented, sends the message that exclusive merchandise is within, while a display of many items together puts the emphasis on price and appeals to the more cost-conscious shopper. Whatever the message, it can be conveyed easily by the windows and interior settings.

A major factor in the complexity of the presentations is the store's budget. Some companies rely heavily on visual installations to tempt the shopper and expend large sums throughout the year to achieve this goal. Others spend sparingly throughout the year and make the major expenditure at Christmas, when most retailers achieve their greatest profits. Still others make one major investment in visual presentation at the time of the company's opening and use that setting as the attention-getter.

Whatever the situation, the visual effect can increase sales. Businesses that understand this fact are reaping the benefits from the visual merchandiser's expertise.

The Total Environment Philosophy

Theme parks such as Disney World, Universal Studios, and Epcot have captured the hearts and minds of visitors for many years. Borrowing from this concept, some retailers and restaurateurs have built premises based on a theme. These environments do not change with the seasons but remain constant. One of the early adherents of this philosophy was Banana Republic. Although its visual format has changed, it is worth mentioning because Banana Republic initiated the **total environment philosophy** that was eventually imitated by others. The company's original merchandising concept centered on safari-type clothing. In order to enhance the items displayed for sale, the visual merchandisers created an environment that immediately put the shopper in a setting that shouted safari. Every conceivable item, most of which were khaki-colored, was shown in wooden crates surrounded by bamboo poles, netting, jungle vegetation, and other safari elements. No matter what the time of year, the setting never changed. No special Christmas or Mother's Day displays were found at Banana Republic. Today, the company has reversed its merchandise philosophy and has totally refurbished its environments to complement the new styles. Again, no seasonal changes are made to depict a special time of the year, just a permanent setting that enhances the merchandise.

Tommy Bahama, a clothing manufacturer who markets its merchandise in department stores as well as in its own shops, has used some of the early Banana Republic environmental concepts in its company stores. With the use of "Bahama-like" furnishings, it has created permanent interiors that vividly enhance the merchandise offerings.

Another company that subscribes to the total environment philosophy is Rain Forest Cafe, A Wild Place to Shop and Eat, discussed in Chapter 4. Few companies today have captivated adults and children with their visual appearance as much as Rain Forest Cafe. A shopper who approaches the facility is greeted by a junglelike atmosphere in which a bird trainer is sporting a colorful, live parrot. This is but one attention-getter that brings the crowds in to see more. Inside, a vast assortment of T-shirts, sweatshirts, shorts, and so on, depicting animals and environmental settings, are featured in a reproduced setting of a rain forest

complete with realistic, life-size, and oversized animals. The result is magical. The eating area has the same environmental feeling, offering the patrons a startling visual experience.

Other stores that subscribe to the total environment philosophy include (1) the Disney Stores, where a large screen plays Disney animated movies and various famous characters such as Mickey Mouse and Donald Duck encircle the overhead of the store's display cases; (2) Warner Bros., where the characters made famous by the company's movies are featured throughout; (3) Niketown, where sports environments are the theme; and (4) the NBA store in New York City, where the selling floor is replete with basketball hoops and graphics of the game.

Among those restaurants with successfully developed themes that give their environments pizzazz is the Hard Rock Cafe. Its noteworthy approach that features dining as well as merchandise makes it an excellent subject for the following Profile.

Although the total environment philosophy is the rule for many businesses, the vast majority of retailers still believe in changing their atmosphere seasonally. At Christmas, their windows and interior spaces are transformed into arenas of tinsel, glitter, snow, animated figures, and Santa Claus; when the leaves are about to turn from green to russet, the stores take on the colors and textures of fall. The shot in the arm that is needed to meet and hopefully beat last year's sales figures is supplied by the visual merchandiser. This holds true not only for the major department and specialty stores but also for the independent retailer who employs the itinerant or freelance trimmer to adjust the store's message to whatever is appropriate for the time of year.

Types of Themes

The natural time to change an installation is when a new season is about to make its entrance, before a major holiday such as Christmas, and for special events such as the store's promotion of a particular designer. Whenever these seasons and events are about to show up on the store's calendar, the visual merchandisers are called upon to perform their special magic. There are also institutional themes such as a salute to the opening of the opera season in a major city or the recognition of a special week or month to alert citizens to the fight against a particular disease. No matter what the occasion, the task of the visual merchandiser is to produce inspiring displays.

Seasonal

Each season brings with it particular merchandise to feature, and nature suggests general settings in which to show it. The cold of winter, the budding and blooming of flowers in the spring, the warmth of summer, and the chill of fall each provide a unique opportunity to encourage customers to start thinking about what they need for the next season and to buy it now. Although the approach for introducing new seasons and the design of actual displays are up to the visual merchandiser, the length of time the **seasonal display** will occupy the windows and the specific merchandise to be featured are calculated by management to maximize sales.

Remember, too, that the total environment does not change with the same frequency as the windows in most retail operations. While the interior reflects the season or perhaps a major special storewide promotion, the windows may be changed as often as once a week to make timely statements about store image, special events, holidays, or other themes.

Summer

A splash of color or a display of merchandise such as swimsuits typifies the visual merchandiser's way of introducing this season. Summer is a time for fun, that long-awaited vacation, beach parties, summer camp, or just plain relaxation. Merchants introduce summer items as

PROFILE: A Contemporary Visual Merchandising and Environmental Design Profile: Hard Rock Cafe

When the first Hard Rock Cafe opened its doors to the public on June 14, 1971, in London, the world was treated to a new concept in dining environments. It would soon become a worldwide phenomenon with branches in many regions in the United States, Paris, Berlin, Canada, Tokyo, Kuala Lumpur, and more than thirty other global locales.

It became an instant classic as a venue that featured moderately priced food that was enhanced with a great deal of rock'n roll memorabilia and music. In fact, today the company boasts a memorabilia collection of more than 60,000 pieces that rotate throughout all of the units in the chain. The environments provide a visual history of rock'n roll that is unparalleled by any other music company. The treasures in the collection include classic guitars, posters, costumes, music and lyric sheets, album art, platinum and gold LPs, and photos of great performers. Other treasures in the Hard Rock's collection include Jimi Hendrix's Flying V guitar, John Lennon's handwritten lyrics to "Help," and one of Madonna's classic bustiers. It is truly

a living museum that company management considers a "work in progress." It continually expands and deepens as new music history is being made. The immediate excitement that it generates to those who come to each of the cafes comes from the unique "props." Enhanced by a continuous flow of rock'n roll music, it is, at once, seen as the epitome of themed restaurants.

In addition to its dining areas, each Hard Rock Cafe features a separate retail area in which signature T-shirts, sweatshirts, and accessories fill the counters. Few music enthusiasts leave the premises without stopping to purchase a remembrance. With the success of these relatively small shops within each restaurant, the music and entertainment giant extended its reach beyond the restaurant business. The first of what is expected to be a new avenue for the company was the 2,670-square-foot retail establishment at the new Hard Rock Hotel at Universal Studios in Orlando, Florida. What is its flagship store is expected to set the tone for other worldwide retail projects. It is a

child-friendly environment but "hip" enough for young adults.

Inside, it is the most innovative technology that holds center stage. There are interactive kiosks where families can log on to Hard Rock's website and an array of flat video screens that show the live action of Hard Rock Cafes from around the world. In addition, the interior design of the retail store includes colorful fiber optics, dramatically illuminated guitars and photographs of performers, and larger-than-life supergraphics of legendary rock stars.

With the merchandise as the focus of attention in the company's new format, it is displayed on self-service fixtures that may be reached by adults and children alike. An extended line of products, significantly greater than the merchandise offerings at the Cafes, include T-shirts, sweatshirts, dresses, jackets, shorts, pants, robes, and so forth, each sporting the Hard Rock label. This first venture into retail stores has been so successful that it has become a top performer among the company's holdings.

early as the day after Easter and usually not later than May 1. If a store is fashion forward, the earlier time frame is best suited to its needs; if it is more promotionally oriented, the middle of May might be more appropriate (Figure 11–1). Each store must decide upon the pace that fits its merchandising concept and image. It should be understood that summer presentations do not exclusively center on fashion apparel and accessories. Stores like Crate & Barrel, for example, do a wealth of business in summertime items such as outdoor furniture, colorful picnicware, and striking candle containers.

Fall

With the winding down of summer sales, August is the month when retailers prepare for what is usually a big season. Prices in the fall are generally higher than those charged for summer goods, and the selling period is a long one. In order to capture the mood and motivate shoppers to spend, visual merchandisers often transform the store into one that looks like fall. Autumn leaves abound, as do the fruits of the season, such as pumpkins and gourds (Figure 11–2). No matter what time zone one is in, even as far south as Florida, an autumn look prevails in stores. Summer merchandising is limited to fewer departments, but fall transcends all lines of merchandise. Back-to-school fashions, business clothing, activewear, accessories for apparel, and home furnishings all share the spotlight in fall themes. It is during this period that management of large and small stores alike spend major sums on visual merchandising in their windows and interiors.

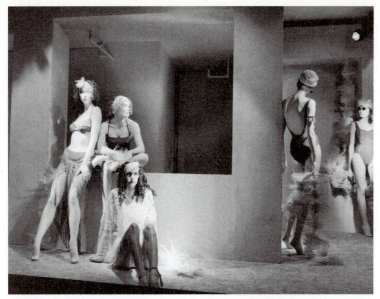

Figure 11–1 Swimsuits are among the most dominant merchandise classifications in summer windows.

(Courtesy of Lord & Taylor.)

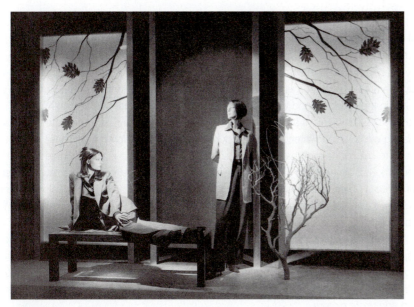

Figure 11–2 The sparse use of autumn leaves is a simple way to signal that summer has passed and fall shopping is to begin.

(Courtesy of Lord & Taylor.)

Once an interior decor or motif has been chosen, the windows are targeted. The opening of the season might depict a back-to-school theme if children's clothing is sold or, if the store is fashion-oriented, an installation that features the latest in women's fashion. In stores that feature linens for the home, a fresh look for fall might include darker-colored or printed bedding. Whatever the emphasis, it is time to freshen up the display areas and make them produce as much business as possible.

Winter

Although this calendar period includes the Christmas season, our discussion will intentionally exclude Christmas installations for separate examination in the next section on holidays.

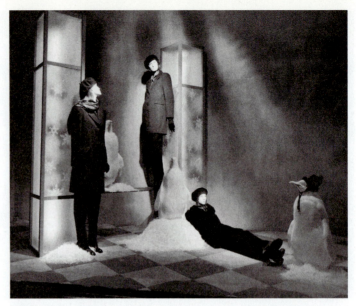

Figure 11–3 The use of stylized penguins, mounds of snow, and columns bearing snowflakes is an elegant setting for this winter display. *(Courtesy of Lord & Taylor.)*

It should be obvious by now that the store's seasonal displays do not coincide with the official calendar dates for the seasons. A store's season begins before the actual season. For example, although winter officially begins on December 21, winter merchandise displays usually overlap the fall ones. Some stores, in fact, do not differentiate between fall and winter, treating them as one season until Thanksgiving, the official beginning of the Christmas period.

It is in the windows and with specific merchandise that winter is best announced (Figure 11–3). Coat displays are a mainstay of the period in many major department stores, dominating windows and interior displays during October and November. These months are also used to sell off the merchandise that did not meet the customer's expectations in the fall. With enormous shipments of Christmas merchandise arriving daily, the store must rid itself of older inventory. Sales windows abound. Merchants invest little money on visual merchandising at this time, saving their resources for Christmas. It is generally the interior displays that feature the marked-down items, with some retailers announcing sales in their windows.

Although Christmas intersects the winter period and takes complete charge for six weeks, the second half of winter is still to be reckoned with. As in October and early November, sales dominate again in January and February. During this time, most companies aim to get rid of the season's slow movers or special purchases that were mixed to bolster the store's markup and profit picture.

Throughout the country many retailers feature cruise- or resortwear (Figure 11–4). It is not usually a big part of their business, but offers them the chance to accomplish several things: (1) to evaluate customer reaction to fashions earmarked for the summer season, (2) to chase away the winter doldrums with fresh merchandise, and (3) to serve the market of customers who vacation in the winter. During this period, some merchants build separate resortwear departments in areas that had housed other merchandise. Since stock levels are down, the store can afford to set aside space for this temporary sales area. Retailers call on the visual merchandisers to trot out fish netting, bright sunshine, seashells, and the like to complement the merchandise. If a store has several windows, some are usually earmarked for resort merchandise.

Spring

Following on the heels of the President's Day sales comes spring—a breath of fresh air for both retailers and customers (Figure 11–5). This season is typically short and low in sales volume but serves as a transition into summer. Stores introduce merchandise that is lighter in

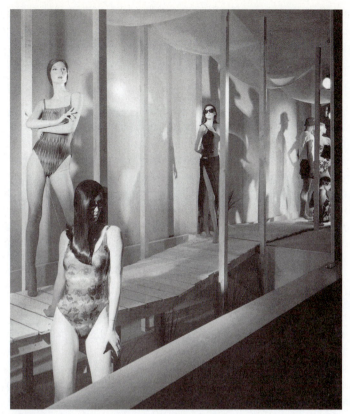

Figure 11–4 This two-level resortwear window installation attempts to motivate shoppers to buy swimwear.

(Courtesy of Lord & Taylor.)

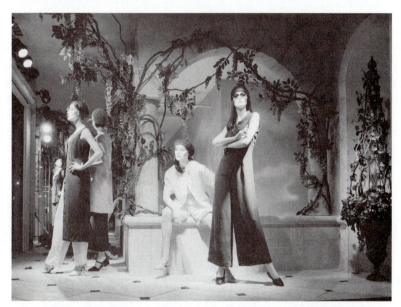

Figure 11–5 Grape vining is a traditional way in which to signal the arrival of spring.

(Courtesy of Lord & Taylor.)

both color and fabric and feature it in springlike settings. They hope customers are so tired of the winter look and heavy fabrics that they will be enticed to purchase spring goods at regular prices. Stores that subscribe to a total interior change usually overflow with trees and flowers in large baskets or brightly painted pots. It is a time when live plants of all types are found throughout the store. Windows tend to display the same decor as the interiors, with emphasis on airy, environmental settings. Macy's, in the New York City flagship store, ushers

in spring with its annual Flower Show. It is a multimillion-dollar extravaganza that signals the coming of spring. The store is filled with exotic plantings of every type and attracts scores of customers.

Holidays

Christmas is unquestionably the major holiday of the year for the majority of the retailing world, but other holidays play a vital role in the achievement of the year's total volume. Visit any fragrance department the week before Mother's Day and you will witness a special frenzy and an abundance of merchandise available. The selling period for each holiday varies, as does the number of departments served by the **holiday displays.** Valentine's Day promotions require just a few days before the actual event, while the Christmas season lasts at least a full six weeks (Figure 11–6). Whatever the holiday, the visual merchandising team gives creative support to make it the most successful Valentine's Day or Father's Day ever.

Christmas There is no better time of the year than Christmas for those involved in visual merchandising to strut their stuff. Thanksgiving Day has come to signal the beginning of the Christmas shopping period, igniting a spark in many people's minds that the purchase of gifts should begin. If you've ever worked in retailing on the Friday after Thanksgiving or merely entered a store as a shopper on that day, you are aware that this is a time when serious purchasing is under way.

In order to maximize the sales volume for this time of the year, visual merchandisers begin planning months before Christmas. It is not the mere changing of one department's decor or the trimming of a particular window that is involved. This is the time for transformation of the store's interiors and windows into a magical wonderland that will capture the shopper's fancy. Many visual merchandisers begin their plans for Christmas by attending trade shows (Figure 11–7). In these expositions, every important producer of display-oriented materials is represented. Those responsible for the visual installations in their stores come away with a good foundation for their Christmas plans that are still months off.

The actual displays for Christmas are generally installed just prior to Thanksgiving, with some companies getting an even earlier start. While the interior Christmas decorations remain intact for the entire holiday season, the windows will be changed frequently in most stores to give all of the departments a shot at the increased traffic. Each store's philosophy

Figure 11–6 This holiday display is underscored by the message that has been "etched" on the window.

(Courtesy of Lord & Taylor.)

Figure 11–7 Elaborate props used in Christmas displays are shown at many of the visual merchandising trade shows.
(Courtesy of Lord & Taylor.)

concerning Christmas windows is as different as its merchandising philosophy. Some believe merchandise is what retailing is all about, so that is what should be featured, while an ever-growing number invest in the institutional format, which will be explored in a later section. Whatever the approach, planning is essential for success.

President's Week Retailers at one time celebrated both Washington's and Lincoln's birthdays by closing their stores. To commemorate these special days, visual merchandisers often used patriotic themes featuring likenesses of the presidents. It was a time of sentiment and pride, not a sales event. However, in the early 1960s, a few retailers opened their doors on these two days for final cleanup sales of winter merchandise. The practice has become universal, giving visual merchandisers a new theme on which to build. The week between Lincoln's and Washington's birthdays, President's Week, has become a remarkable sales period. Visual merchandisers must be terribly creative, however, because usually little money is earmarked for display during this period. The visual department usually prepares posters and signs and perhaps windows that combine both sales and institutional themes. The emphasis, however, is on the cleanup sales message.

Easter Unlike Christmas with its extravagant presentations, in most stores Easter is not a major merchandising thrust. Some companies do not even bother to make a distinction between Easter finery and general spring finery, except in a few departments. Children's wear, if anything, gets the major share of the visual merchandising budget at Easter to buy the bunnies, baskets, and eggs that complement the bonnets and bows of the season. Some displays in women's wear feature the Easter theme, but more often than not there is just a freshening of the spring decor. Many shopping malls feature Easter settings with characters such as the Easter Bunny.

Parents' Days Mother's Day and Father's Day boost sales in some departments such as fragrances, clothing, and housewares, with Mother's Day the bigger retailing event (Figures 11–8 and 11–9). Merchants usually set aside about one week for windows devoted to these holidays. Interior presentations may last longer. The displays are not usually complex, often relying on an abundance of gift boxes piled high to set the theme.

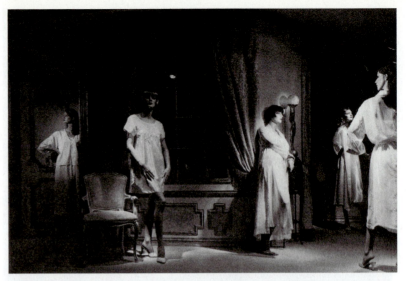

Figure 11–8 Mother's Day windows are important to many retailers.
(Courtesy of Lord & Taylor.)

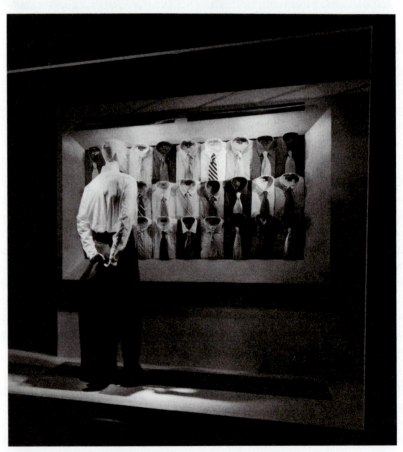

Figure 11–9 Father's Day is a major shopping period for shorts.
(Courtesy of Lord & Taylor.)

Valentine's Day Hearts, hearts, and more hearts are the mainstay for Valentine's Day installations. Although an abundance of traffic occurs in the candy shop or department, many retailers successfully promote other items, such as jewelry and accessories for sweethearts to purchase. Purchasing usually peaks two or three days before Valentine's Day, although many retailers report a major thrust on the day itself. The holiday falls during a period in which most stores are more concerned with disposing of the merchandise from the previous season and looking forward to spring business (Figure 11–10).

Figure 11–10 The simplicity of the merchandise forms contrasted against oversized "lips" represents a departure from the typical Valentine's displays. *(Courtesy of Lord & Taylor.)*

Columbus Day Much like President's Day, this holiday is an opportunity for stores to run special sales. The emphasis this time is usually on coats. Columbus Day has become the traditional day to purchase a winter coat at a reduced price. Some stores do use the institutional theme honoring Columbus and call on the visual department to create themes and execute displays that encourage fashion discovery. The emphasis, however, is on the sale and not just on coats. The sign shop people keep busy creating the copy and producing the signs that motivate people to snap up the bargains.

Creative Themes

The four seasons and major holidays provide a framework for planning merchandise presentations, but much of the work visual merchandisers produce does not fall in either of these categories. **Creative themes** for visual presentations result from the ingenuity of the display persons and their inherent creativity (Figures 11–11 and 11–12).

Oftentimes fantasy plays an important role in these creative endeavors. Visual merchandisers are often at their very best when the task is to create something out of the ordinary. It is not the retailer's merchandise that is in the forefront, but any visual theme that will stop passersby in their tracks. Fantasy themes range from topics that deal with the circus to underwater simulations and extravagant grand ballroom festivities. There are no real guidelines, except that they must have the pizzazz to gain attention.

Creative themes are not limited to fantasy. If it is a merchandise-oriented display, it is the featured items that must take center stage. A theatrically oriented window may be appropriate to merchandise installations, but the magnificent visual impact alone will not be sufficient. The shopper must not be puzzled about what the store is trying to sell. Displays of this nature should be easy to understand. The props may be clever and eye-appealing, but the merchandise should be the feature of the installation.

Institutional Themes

A store may develop display themes based on the organization's interests, activities, and image rather than built around certain merchandise. The concept of **institutional display** is subtler than other concepts, concentrating on building an image for the store in the minds of

Figure 11–11 The model tied to railroad tracks is a way to introduce fantasy in the window.
(Courtesy of Lord & Taylor.)

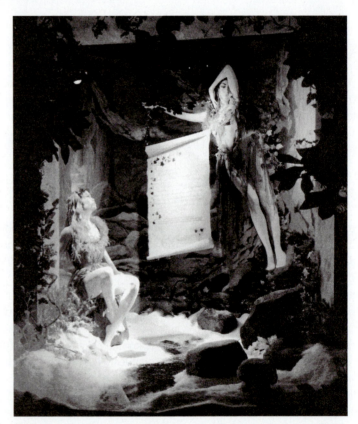

Figure 11–12 This underwater fantasy installation is one way in which to motivate the passersby to stop.
(Courtesy of Lord & Taylor.)

the customers (Figures 11–13 and 11–14). Displays might tie in with celebrating the beginning of the next millennium or saluting a particular charity. A specific example of the institutional concept centered on the tragedy of the terrorist attacks on the World Trade Center in New York City and the Pentagon on September 11, 2001. There was hardly a store that did not feature a patriotic window display, with the American flag as its centerpiece. Whatever the event, the store wants to say that here is a retailer with pride in its country and community, with interests beyond just making sales.

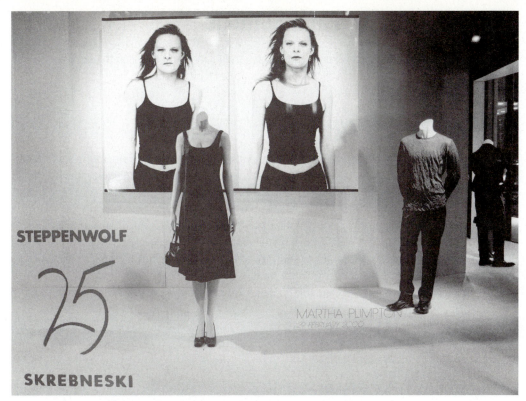

Figure 11–13 Life-size graphics shown in this institutional display commemorating Chicago's Steppenwolf Theater's twenty-fifth anniversary are attention-getters.

(Courtesy of Marshall Field's, now a Macy's store.)

Figure 11–14 Photographs and signage mounted on dowels are excellent props to underscore the United Nation's fiftieth anniversary.

(Courtesy of Saks Fifth Avenue.)

Other Themes and Settings

In addition to the themes already discussed, retailers might have reason to use other themes, such as ensemble displays and unit displays, to sell their products.

Ensemble Displays

When the store wants to deliver a message that says, "I'm a complete outfit, buy me," it often chooses to feature the outfit or ensemble in a setting by itself (Figure 11–15). The intention of an **ensemble display** is to entice the customer to buy a total package rather than one or two items. Most retailers direct their sales associates to suggestion sell, that is, to suggest other merchandise that complements the main item in the purchase. For example, a window or interior presentation might feature a tuxedo complete with shirt, bow tie, shoes, and socks. If properly presented, the shopper might easily be tempted to buy all of the accessories, not just the tuxedo. Ensemble displays are not restricted to apparel. In home furnishings departments, for example, ensemble displays consisting of dinnerware, glassware, and flatware are often featured to tempt shoppers to buy the entire offering.

Unit Displays

Some featured items, particularly small ones, may get lost in an installation. In order to boost their impact, the visual merchandiser may feature several items as a **unit display** in either a window or an interior presentation (Figure 11–16).

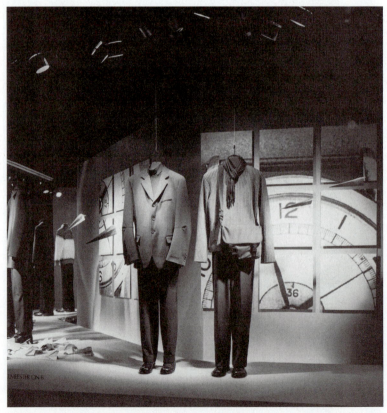

Figure 11–15 The showing of a complete outfit often leads to bigger sales. *(Courtesy of Lord & Taylor.)*

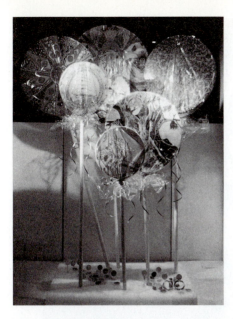

Figure 11–16 Scarves are brilliantly displayed over Styrofoam circles to give impact to this unit display.

(Photograph by Ellen Diamond.)

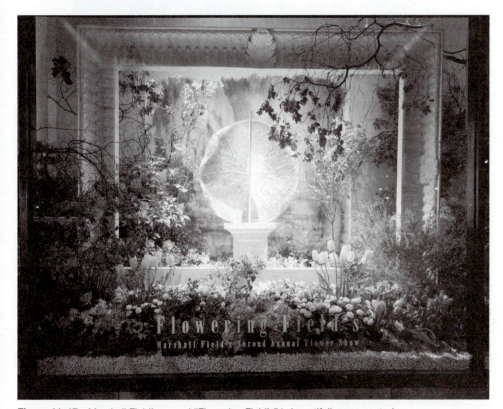

Figure 11–17 Marshall Field's annual "Flowering Field's" is beautifully represented in this window display.

(Courtesy of Marshall Field's, now a Macy's store.)

Special Events and Promotions

One of the ways in which retailers increase traffic and boost sales volume is through the development of special events and promotions. Some are storewide presentations, such as Marshall Field's annual "Flowering Field's" in its downtown Chicago flagship store, while others are departmental endeavors (Figure 11–17). The visual merchandising team plays a vital role in these promotions. It is their task to install windows and create interior displays that bring significant exposure to the events. A window or two may be devoted to the promotion's

Figure 11–18 This oversized cover of *Harper's Bazaar* is an excellent attention-getter in this special event window.
(Courtesy of Saks Fifth Avenue.)

theme, or a major part of the store might get transformed (Figure 11–18). When the visual merchandising efforts are tied to the special events, the retailer is better able to convey the message that something extraordinary is happening.

11 chapter review
key points in the chapter

1. It is the role of the visual merchandising department in many stores to develop themes and settings that best present the store's merchandise to the shopper.

2. Some stores subscribe to a permanent total environment philosophy and build their premises around a particular theme. Banana Republic was an originator of this concept.

3. Today, many restaurants also subscribe to the permanent total environment philosophy. Most who use this concept, such as Rain Forest Cafe, carry an assortment of apparel to augment their dining facilities.

4. Each season is a natural unit of time around which to plan interior and window presentations.

5. The Christmas period generally requires more planning and development from the visual merchandising team than any other period.

6. In addition to Christmas, other holidays that provide themes for displays are Mother's Day, Father's Day, Easter, and Valentine's Day.

7. Much of the work done by visual merchandisers falls outside of seasonal themes and traditional holiday settings. The store depends on the creativity of the visual staff to come up with timely, motivating themes.

8. The institutional display route is taken by many stores to promote their image or to convey to the customer that they, the retailers, are aware of the many events that affect their customers.

9. More and more special events and promotions are dominating stores' interiors and windows in an attempt to increase customer interest in the company.

10. Many stores use ensemble displays to help motivate the customer to buy related items.

11. Unit displays feature an abundance of single items to magnify their importance.

terms of the trade

internet exercises

1. Using the websites of any of the merchants that subscribe to permanent themes for their environments, locate the nearest store or restaurant so that you can make a visit to it. Such websites as www.rainforestcafe.com, www.hardrockcafe.com, and www.tommybahama.com are some that you might explore. Once you have located a branch that is convenient to where you live, visit it and use a camera to record its environment. The pictures should be secured to a large piece of foamboard for use in an oral presentation about the company that you will deliver to the class.

2. One of the most exciting manufacturers of theme displays is Spaeth Design in New York City. It is an award-winning company that services the needs of the major department stores in the United States. By logging on to its website, www.spaethdesign.com, you will be able to learn about the types of displays it produces, its client base, and the awards it has received for its work. Once you have visited the website, you should examine each of the sections carefully and use the information to write a complete report about the company, its major clients, and awards for its work. The report should be typed and at least two pages in length.

discussion questions

1. In what way may the visual merchandiser be compared to the theatrical director?

2. What name is given to the visual concept initiated by Banana Republic and now used by such companies as Rain Forest Cafe and the Disney stores? What purpose does it serve?

3. Discuss three factors to consider when planning a visual presentation for a window.

4. When is it generally advisable for the retailer to install the first summer display in a window?

5. Why do stores present their merchandise displays prior to the actual season for which the goods have been intended?

6. Is it appropriate to have a resortwear theme in a store's windows in the middle of the winter season? Why?

7. Which holiday provides the greatest opportunity for visual merchandisers to show their talents? Why?

8. At what types of industrial events can the visual merchandiser become familiar with the field's latest and most innovative products?

9. Which holiday signals the opening of the major purchasing period of the year for most retailers?

10. How has the visual staff's role changed since the early 1960s in regard to displays for presidents' birthdays?

11. In addition to using the four seasons and major holidays for window settings, what other motifs can the visual merchandiser use to enhance the store's display presentations?

12. Sometimes window backgrounds are so overpowering that the merchandise is overlooked. Does this type of display serve a purpose?

13. For what reasons do the major stores use institutional visual merchandising?

14. How might a display be designed to promote the purchase of a total package rather than single items?

15. When is it appropriate to feature an abundance of a single item in a visual presentation?

Case Problems

Case 1

Peter Flynn was an employee of the T. J. Sanders store when it opened thirty-five years ago. Originally hired as an apprentice in the visual merchandising department, Peter's responsibilities increased with the company's growth into an organization with a flagship store and eight branches. He achieved the plum position of vice president of visual merchandising before retiring last year.

His thirty-five years with the company coupled with its substantial success made Peter somewhat of a legend. Many believed his strongly held visual concepts played a major part in the store's emergence as a retailing leader. Now the search is on to find his replacement. Some of the more traditionally oriented members of management think Peter's successor should come from the ranks, specifically Peter's assistant for the past fifteen years. Others believe that the time is ripe for new blood and that a departure from the store's typical displays would be most welcome. This group feels that creative themes, more dramatically oriented, would enhance the store's quest to capture segments of the market that weren't significantly served before. Although T. J. Sanders stocks its shelves and racks with fashion-forward designs, this group thinks the visual presentations haven't matched the merchandiser's image.

QUESTIONS

1. Should the company continue the conceptual philosophy of Peter Flynn or embark on a more innovative course?
2. Would you promote the heir to the throne to the position of vice president of visual merchandising? Why?
3. What are the dangers of developing a new visual concept?
4. How would you safeguard against possible erosion of customer satisfaction while trying to appeal visually to another market segment?

Case 2

The institutional concept of visual merchandising has been a mainstay for Rockford's Department Store since it opened. While most of its competitors have favored purely promotional displays, Rockford's always believed in a format that also included institutional presentations. Rockford's has its share of windows built around merchandise, but certain holidays are still thought worthy of an institutional approach. Little by little, as the store became more price- and promotion-oriented, the notion of institutional display became less important. The Columbus Day and President's Day windows once featured patriotic themes, but the emphasis has now been placed on special sales. There are just a few obligatory signs to tie in the two historic events. Since the sale themes have helped to increase sales volume, there is little support for a return to the more traditional institutional approach for these holidays.

With these successes, however, top management feels it is time to dispense with nostalgic Christmas themes and use the windows exclusively to show off gift merchandise. The visual merchandising department feels that this approach will not only take the glamour and excitement out of the windows but will cause customers to feel the store's philosophy has become totally commercial. Management counters that customers have less time to spend shopping and would find it easier to make their purchases if more items were featured in the windows.

It is now four months before the Christmas season and plans must be made for visual presentations in the store's six main windows. Since the season traditionally runs from the day after Thanksgiving until Christmas Eve, it is time to formalize plans.

QUESTIONS

1. With whom do you agree? Defend your position with sound reasoning.
2. Present a plan that would accommodate both points of view.

exercises and projects

1. At a downtown retail area or shopping mall, photograph four different window or interior displays to illustrate themes and settings discussed in this chapter. Be sure to get permission to photograph from store management. Mount each photograph neatly on the form provided on page 199, and complete the information on the form.
2. Plan a three-dimensional display using an institutional theme of your choice. Construct a window out of foamboard or any other material, making certain to follow the fundamentals of design.
3. Write or call a member of a major store's visual merchandising department and make an appointment to interview the individual. Prepare a list of questions to be asked so that you will be able to present an oral report to the class on the following:
 a. Store's visual merchandising philosophy
 b. Theme sources
 c. Major display themes
 d. Special events
 e. Use of institutional displays

NAME: _____ DATE: _____

EXERCISE 1 PHOTOGRAPHS OF WINDOW OR INTERIOR DISPLAYS

Store Name _____ Theme _____

Overall Impression _____

Store Name _____ Theme _____

Overall Impression _____

Store Name _____ Theme _____

Overall Impression _____

Store Name _____ Theme _____

Overall Impression _____

energizing
bou

After completing this chapter, the student should be able to:

... Discuss the reasons why small specialty boutiques cannot spend the sums necessary to present their merchandise in windows and interiors traditionally.

... Explain the ways in which costly mannequins may be replaced with mannequin alternatives.

... Describe how color plays an important role in boutique environments.

... Discuss the different ways that visual installations may be energized without requiring large sums of money.

... Discuss how signage can be effectively created in-house without the need to employ professional sign makers.

... Explain the use of point-of-purchase materials that can be obtained, free of charge, from vendors.

... Name some inexpensive, eye-appealing display props that can be simply created by the small entrepreneur.

... Describe the types of lighting systems that provide perfect illumination as well as adaptability.

the specialty tique

Introduction

Lavish displays and interiors of distinction have long been associated with the major retailers in the United States. With large sums of money budgeted initially for the design of their environments and the visual presentation props that enhance these arenas, it is a relatively simple task to create selling floors and building facades that are both visually striking and functional. The wealth of design teams available to those who have the money to spend on unique and exciting interiors is significant. A retailer simply examines all of the available options, researches and studies the works that these industry professionals have created for other brick-and-mortar operations, and ultimately selects the company that seems to be able to carry out the mission.

However, funds are generally limited for the small entrepreneur who envisions the American dream of opening a business of any kind, let alone retailing, where the first impression of the shopper entering the store is important to motivate purchasing. Many of these retailing hopefuls enter business "on a shoestring." They have the necessary ingredients for success, such as drive, knowledge of their market, merchandise expertise, commitment to hard and challenging work, and the desire to succeed. The initial investment is earmarked for the creation of the environment in which they will sell their goods and for the proper assortment of merchandise needed to motivate shoppers to become customers. Of course, once they have established themselves with their vendors, they are able to receive lines of credit that enable them to purchase goods and pay for them later, leaving some monies for other necessities, such as advertising, promotion, and visual merchandising. Although their "purses" are initially limited, some do find success and sometimes are able to expand their businesses into chains of distinction.

One of the ways in which they can gain an edge over the competition is through the use of creative visual merchandising that will not strain their already limited budgets. With expensive fixturing and exotic mannequins often out of the question, it is their ability to visually enhance their merchandise offerings as well as their premises inexpensively that makes them an important player rather than a "me-to" merchant.

In this chapter, attention will focus on six areas, including:

1. How color, which comes without cost, can create excitement.
2. The way in which lighting can be used without extreme investments.
3. The numerous types of props that can be refinished or borrowed by the small retailer instead of purchasing the more expensive offerings from display houses.
4. How traditional mannequins may be replaced with alternative forms.
5. How point-of-purchase materials can be obtained without cost.
6. The way in which signage may be inexpensively produced in-house.

Color: The "Free" Visual Element

As we stroll past store windows, oftentimes we are attracted to stop and take a closer look at the displays because of the impact that the colors in the presentation have made on us. A monochromatic installation of red merchandise, for example, often delivers the "punch" that creates excitement. Since color has such an ability to stimulate our visual senses, many visual merchandisers, large and small, make extravagant use of it as the presentation's focal point.

For the small **specialty boutique**, the proper use of color is of paramount importance, particularly when monies for visual presentation are in short supply. Being "free" and at the same time having the ability to "stop traffic" is a benefit that doesn't often come with other elements of display. Everything else, such as lighting and props, costs money. Hence, those entrepreneurs who wish to rise to the challenge of creating displays of distinction without significant cost must plan color harmonies for their stores long before the windows and interiors must be trimmed.

Whether it is a shop that concentrates on wearable fashions or home furnishings, the first move should come when the buyer visits the market to purchase for the next season. In planning these purchases, every seasoned buyer prepares by learning about the trends, in

which color often plays a dominant role. Trade papers, reporting services, and **fashion forecasters** offer their professional advice on what's new and which colors should become the season's winners. Using this information, the buyer then concentrates on these color predictions. By doing so, he or she limits the inventory to just some hues instead of buying the smorgasbord that is seen in every collection. This is particularly important for specialty boutiques that have limited space and limited merchandise funds. It also enables them to look down the road and plan visual installations that use these colors as their central point. Once the merchandise arrives in the store, it is relatively easy to create an atmosphere, both inside and in the windows, that has the potential to have an impact on the shopper.

The easiest approach is to dress the windows with merchandise of one of the colors or with a scheme that uses two or three. For example, in the apparel boutique, a contrasting of royal blue and white items gives immediate impact. It might be further enhanced if stripes or prints of the same combinations are available in the inventory. Perhaps, if red is one of the colors of the season, its use with the two others could provide a nautical theme that is often eye-catching. To continue the impact, the interiors should also feature the same color harmonies as the windows. Wherever merchandise may be displayed, such as at the front of the merchandise racks, on countertops, or in shadow boxes, colors identical to those in the windows will underscore their importance as this season's fashion statement and will attract attention.

In home furnishing boutiques, where a variety of tableware, small accent furniture, and other household accessories are sold, the **color scheme** approach to giving visual life to the display areas, windows, and selling floor is also used as a motivational device. There, too, merchandise colors may be limited to those that are expected to be "hot," providing an atmosphere of excitement and distinctiveness. If shoppers are looking to purchase other colors of the display items, tags that indicate other color availabilities can be attached and offered as special orders. In this way, the merchant can concentrate on a particular color scheme in the store and still satisfy the needs of those who want other hues. In fact, many stores that specialize in upholstered pieces often attach material swatches to the items from which other selections may be made.

No matter what the merchandise assortment, color is a practical way in which to energize the store's appearance without incurring any additional visual merchandising expense.

Low-Cost Lighting

Any formal display or casual placement of merchandise in a retail environment must, in order to be effective, be appropriately illuminated. Not only is this a practical matter so that the merchandise may be clearly seen but an aesthetic one where specific focal points may be separated from everything else. It might accent an exciting item in a store window or areas inside the shop that feature merchandise that is especially appealing. If everything displayed is illuminated using overall lighting, the drama and excitement that is expected to deliver a fashion message, for example, will be lost. By "punching up" selected offerings with spotlights, the desired effect can be quickly, easily, and inexpensively achieved (Figure 12–1).

The key to achieving illuminated highlighting for the specialty boutique, without the costly expenditures often made by its large-store counterparts, is creating **low-cost lighting** through the selection of (1) a lighting system that is easily adaptable and (2) bulbs that are cost-effective, while at the same time delivering the necessary light. The system that generally fits the bill is track lighting. The fixtures are relatively inexpensive, available in a wealth of different styles to fit any environment, and modest in terms of installation requirements. Best of all, each "can" can be easily directed to spotlight any product or display area. Handy do-it-yourselfers can easily install the systems, saving the monies required to hire professional installers. The bulbs that fit the "housings" are energy efficient and may be either *incandescent* spotlights for accenting, *floodlights* for general illumination, or *halogen lamps* for more intensity. Each of these were discussed in Chapter 10 "Lighting: Dramatizing the Selling Floor and Display Areas," which should be reread to see how they may be effectively used in specialty boutiques without adding unnecessary expense.

Figure 12–1 Key accent lighting can be used to highlight the focal points of the specialty boutique.
(Reprinted with permission of Juno Lighting.)

Display Props

Just as the other necessary components of a visual presentation may cost significant sums, so can the props that are used. Whether they are used for displaying the merchandise or merely as visual enhancements, props that are bought from commercial prop houses can severely tax the display budgets of the vast majority of specialty boutiques. There are a number of ways in which creativity and ingenuity may help to defray these costs and still produce displays of distinction. These include using merchandise as props, borrowing attractive accent pieces from other merchants, and refurbishing shopworn items that were headed for the junk heap (Figure 12–2).

Merchandise as Props

An armoire, antique table, writing desk, or any other piece of furniture often doubles as a prop used to display other items being marketed to the retailer's customers. A few boutiques merchandise diverse assortments that include some accent furniture along with lines of apparel. Those fortunate to have these hard goods on the selling floor are often able to feature them not only as salable items but also as display platforms on which other goods may be featured. One such retailer is April Cornell, a successful chain that had humble beginnings as a single boutique, whose imagination and good merchandising sense catapulted it into a winning organization. This chapter's Profile shows the path the company followed from its first, small boutique to its now larger presence as a retailer in the United States and Canada.

Borrowed Props

Merchandise that is sold in one retail establishment may often be used as window props in other bricks-and-mortar operations. It may be a musical instrument; sheet music and stands; an antique chest, table, or chair; a ladder; or anything else that could either hold the

Figure 12–2 This umbrella serves as an excellent, inexpensive way to perfectly display ties.

(Photograph by Ellen Diamond.)

What began with two "flower children" pedaling the wares they gleaned from their travels to the Far East has grown into a company that not only has more than one hundred stores in the United States and Canada, and a major online division, but also a design and manufacturing operation that creates its own distinctive line of linens, apparel, housewares, and gifts.

Both Canadians, Chris and April Cornell met at Dawson College in Montreal in the late 1960s—he a budding entrepreneur and she an artist. They started their dream by traveling to the Orient in search of unique items to sell to fellow Canadians in flea markets. After some success, they were able to open a small boutique tucked away in a second story on fashionable Greene Avenue in Montreal. This tiny shop was the first of what would become a chain of LaCache boutiques in Canada. With that success they opened their first American unit in New York City and aptly named it April Cornell. With each additional opening, their success became greater.

Traveling through India, the favorite of their global resources, as well as Hong Kong, China, and Indonesia, they were able to purchase a great deal of the goods needed for their shops. With a desire to design and produce their own products, they opened a small factory in Delhi and began what has turned out to be an international company. All of these achievements, it should be remembered, came from very humble beginnings devoid of much money but with great ideas and confidence.

By examining their boutiques, other retail hopefuls can learn how success may be achieved on a virtual shoestring. The props they use, both inside the store and in their small show windows that feature the merchandise displays, are pieces of accent furniture that they also sell. By doing so, the company has a twofold benefit. First, it tastefully displays apparel and linens on the furniture that is also available for sale, and second, it saves them the expense of purchasing costly display props.

To make the environments attractive to the visitor, the chain features a merchandise mix that concentrates on a limited international theme and, when displayed, gives the feeling of a foreign bazaar. Simple inexpensive lighting, color enhancing that is taken from the patterns of the materials in the collection, and unique positioning of the soft goods they sell make April Cornell stores not only distinctive, but inexpensive to operate.

merchandise or enhance it (Figure 12–3). The advantage to the store in which the display is going to be installed is that there is no cost for the use of the item. The retailer uses the item, and in some area of the display window gives **loaner prop credit** to the loaner. Those who provide the props get recognition for their items with **show cards** and often as a result get interested parties to visit their premises and perhaps purchase the displayed items or other products.

Discarded Props

Many creative visual merchandisers recognize the uniqueness of items that were once useful but now have been discarded because of their shabby condition. With a new coat of paint,

Figure 12–3 Borrowed beach chairs and aluminum pails serve as excellent props without any expense to the merchant.
(Photograph by Ellen Diamond.)

the reassembling of an item, the application of a fresh finish, or, perhaps, its potential "as is," these would-be discards often become a display's focal point (Figure 12–4).

By examining the junk piles that abound in garbage dumps, scouting discarded products that are often left at a consumer's curbside ready for pickup by the refuse collector, or examining the contents taken from demolished houses, "treasures" are there for the taking. A case in point was an award-winning display that utilized an old box spring that was disassembled into individual coils. The springs were sprayed a color to match the presentation's Spring collection, and cleverly arranged to create a construction tower. Accompanying the display was a sign that read, "Spring into Spring," an excellent play on words. Another display of distinction that made use of discards was one that featured old paint cans. The creative trimmer gathered a bunch of these cans and sprayed "dripped" paint from them that was the same as the key colors of the merchandise. Small items were draped from the paint cans and immediately, without any real cost, provided an exciting environment. Old planting containers, garden hoses, and raffia may also be spruced up to make for interesting props.

Figure 12–4 These discarded plant containers are perfect props for a spring display.

(Photograph by Ellen Diamond.)

Alternatives to Traditional Mannequins

When passersby gaze into display windows of the major retail department stores, they generally are treated to mannequins that are exquisite reproductions of the human form. With price tags ranging upwards of $1,000 to $2,000 for state-of-the-art mannequins, these are most often out of the reach of the specialty boutique. The major retailers also have the advantage of warehousing many different types, ranging from the traditional forms to those that are brilliantly stylized. With a wealth of different styles of mannequins, the visual merchandisers are able to choose the ones that best suit the merchandise that is going to be displayed. Not only is this an extravagance for the specialty entrepreneur but, even if the higher-priced forms were within their budgets, they simply do not have the space necessary to warehouse them when not in use.

In-House Creations

Recognizing that mannequins are essential to apparel displays, inventive visual merchandisers sometimes create their forms from little more than a few pieces of wood, a hanger, and a device that serves as the head (Figure 12–5). As we learned in Chapter 6, "Mannequins and

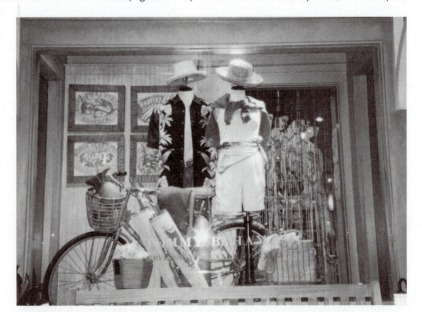

Figure 12–5 When accented with straw hats, these mannequin alternatives serve the needs of the retailer without incurring considerable expense.

(Photograph by Ellen Diamond.)

Other Human Forms," the task is quite simple, and modest in terms of cost. The outcome is often a mannequin that serves as an excellent "base" for apparel.

Basic Forms

If some money is available to purchase ready-made forms, it might be spent on headless varieties that are constructed from Styrofoam, an inexpensive material that is long-lasting. It is the merchandise that is featured on them that draws attention, and not the mannequins themselves, as is the case with some of the more exotic entries.

No-Cost Point-of-Purchase Props

Vendors wishing to make certain their products are appropriately displayed are often likely to provide retailers with **no-cost point-of-purchase props**. In this way, they don't have to worry about the size of the retailer's visual budget and whether or not there will be sufficient funds to promote their products. The breadth and depth of these offerings vary from company to company and from one merchandise segment to another. For specialty boutiques, the principle suppliers of point-of-purchase materials are cosmetic producers. Leading the way are the marquee companies such as Estee Lauder, Clinique, and Bobbi Brown. Their promotional materials include fabric banners that herald a special offering and graphics that feature their logos. As we will learn later in Chapter 15, "Point-of-Purchase Display," there are many different types of these tools, ranging from the inexpensive, temporary types to the more inventive, interactive fixturing components.

The vast majority of these promotional tools are earmarked for use by the major full-line and specialized department stores such as Macy's, Saks Fifth Avenue, and Lord & Taylor. The reasons for this are twofold. First, these merchants produce enormous revenue for the vendors and, second, these departments in the stores are typically merchandised and managed, in part, by the vendors themselves. Smaller fashion boutiques, where sales volume pales by comparison to the specialized department stores aforementioned, still have a chance to obtain these no-cost display props by arranging for them when the order is placed. Oftentimes, fashion producers of a myriad of products provide countertop replicas of ads that appear in fashion magazines and other point-of-purchase materials that help to underscore their importance to the fashion consumer. To dress up their interiors, franchisees of Merle Norman Cosmetic Studios, for example, are supplied with a wealth of photography. The pictures, which are provided free by the franchiser, are of attractive models who are elegantly made-up. Spread throughout the boutiques, these photographs turn what might be a mundane setting into one that has an immediate fashion orientation. Since these franchisees are individual entrepreneurs, generally with limited funds, provision of these no-cost graphics by the franchiser enables them to make their premises come alive without causing strain on their budgets (Figure 12–6).

These promotional tools are not solely for use by fashion boutiques, however. Other specialty operations that market different product mixes can use them. For example, a wave of exciting food boutiques is making headway in today's retail arena. In many of these shops, wines have become an important part of the product mix. To help separate their items from the competition, many wine vendors supply not only point-of-purchase graphics and signage but also unique "racks" in which their prize vintages may be featured. Specialty candy vendors such as Godiva also provide excellent point-of-purchase tools for their specialty boutiques, free of charge, in the form of self-service fixtures that serve two purposes: one is to promote the brand, and the other is to make self-selection quick and easy.

When initiating a product purchase agreement with any vendor, the specialty boutique entrepreneur should always investigate what is available without cost and write orders indicating that the goods must be accompanied by the point-of-purchase products.

Figure 12–6 Many vendors supply interesting graphic blowups that quickly lend excitement to the store's interior.

(Photograph by Ellen Diamond.)

In-House Signage Production

In the days before the computer was commonplace at every level of retailing, a great deal of promotionally oriented materials were purchased from outside sources. Oftentimes, these acquisitions were costly and generally outside the realm of possibility for the specialty boutique. Major merchants often had in-house artists who either hand-created limited-edition signage through such techniques as serigraphy or, for purposes of display price tags and show cards, hand-lettering. Today, the computer has given equal opportunity for sign production to merchants of all sizes. Using PC or Mac programs, such as Adobe and Print Shop, and printers that cost as little as a couple hundred dollars, both color and black-and-white signage is within easy reach of anyone. Signs that augment merchandise displays, announce special savings, and highlight specific products can transform the typical selling environment of the small specialty boutique into one that may rival its large-store counterparts.

Planning the Purchase for Visual Effectiveness

Having discussed the essential elements that can energize any retail specialty boutique with modest cost, or no outlay of money at all, it is imperative for the entrepreneur with limited space, which is generally the case, to plan merchandise acquisition carefully. If the monies that have been allocated to buy goods have been carefully apportioned into subclassifications that complement each other, then the boutique's environment will be easier to energize.

When one preplans the product assortment, whether it is for a fashion-oriented boutique, an accessories shop, a specialty food establishment, or any specialized retail environment, cohesiveness of merchandise often guarantees the effectiveness of the visual presentations. Thus, there are several areas the fashion buyer could concentrate on in order to develop and mount an appropriate visual program—for example, a particular color or color combination that is expected to be the season highlight, a silhouette that seems certain to capture the attention of the shopper, a group of name designers that are in the fashion forefront, or a trend that has significant sales potential. On the other hand, if a smorgasbord approach is followed, it is more difficult to design visual presentations that have the ability to have an impact on the consumer. Of course, if the upcoming season has no color direction, or is void of a specific merchandising theme, the visual project is more difficult to achieve.

Sound product planning is not only essential to help with visual merchandising plans that energize the specialty boutique but also gives the buyer a framework within which to work and results in a merchandise mix that will more often than not satisfy the customer's needs. Any purchasing professional recognizes the need for planning; sometimes, their small boutique counterparts approach their buying needs with less structured plans. In the latter case, it is often impossible to dovetail a merchandise plan with a cohesive visual presentation.

Having understood the need for such planning, it is not very difficult to enact a plan that has been based upon professional market indicators coupled with past company sales records. The following approach would almost assure that the right merchandise has been planned for:

- *Reading the trade papers.* Every industry has at least one periodical that provides an overview of a specific field. For women's apparel and accessories it might be *Women's Wear Daily (WWD),* for men's clothing it could be *Daily News Record (DNR),* and for home fashions it would be *Home Furnishings Daily.* Each issue concentrates on specific products and offers insights into color and silhouette trends, style directions, and so forth.
- *Reading the consumer periodicals.* By reading what the consumer reads, the buyer is able to learn exactly what his or her potential customer is going to look for in terms of merchandise. These magazines cover everything from fabrications and color forecasts to price points.
- *Fashion forecaster affiliation.* These forecasting experts predict, as much as eighteen months in advance of a season, everything needed to make sound purchasing decisions. It might be the skirt length, the theme that will expected to attract shoppers, and so forth.
- *Past sales record examination.* Nothing else is as important or inexpensive as learning from one's past merchandising experiences. With the computer allowing for the keeping of every type of sales record, the buyer is able to quickly and accurately determine the likes and dislikes of the clientele and approach new purchases with them in mind.
- *Market consultant affiliation.* No matter how small a specialty boutique might be, there are market consulting firms in business to help them feel the pulse of the market so that they can make good buying decisions. Many of these companies also advise on promotion and visual merchandising approaches so that purchases may be suitably promoted.

When these internal and external sources are carefully scrutinized, the buying plan will be professionally built, and the visual presentation of the acquired merchandise will help to energize the selling floor and windows.

chapter review
key points in the chapter

1. The funds needed by small specialty boutiques for display purposes are generally limited, and therefore, in order to bring excitement to their presentations, a good deal of careful planning is needed by these merchants.

2. Color is the one "free" visual element that can transform an otherwise mundane visual presentation into one that is exciting.

3. The selection of a lighting system that is easily adaptable, and the use of low-cost bulbs, enables the specialty boutique to be attractively illuminated without incurring significant expense.

4. When merchandise such as writing desks or armoires are used to display merchandise, the cost of professionally built props is eliminated.

5. Borrowing props such as ladders, music stands, and tables from other merchants, for display purposes, immediately reduces the need to spend money on costly display props.

6. Oftentimes, an item that is headed for the junk pile can be resurrected and used in window and interior visual presentations.

7. With the cost of traditional mannequins often out of the reach of the independent specialty boutique, alternative forms that are created in-house often serve the retailer's purpose.

8. Many vendors provide point-of-purchase materials to their customers without cost to them. By using them, it completely eliminates the expense of purchasing costly materials.

9. By using such programs as Adobe and Print Shop, specialty boutique owners may produce signage in-house, avoiding the cost of expensive, professionally produced signage.

10. With proper purchase planning, such as concentrating on a particular color or color combination for the season, creating effective visual presentations is less complicated.

terms of the trade

internet exercises

1. Using any of the search engines, such as www.askjeeves.com, that are readily available on the Internet, examine the wealth of lighting companies that specialize in illumination systems and products for the retail industry. Once you have logged on to many of them, select five that seem to have the necessary equipment for retailers. Enter your findings on the chart on page 213.

 Once you have finished with your Internet investigation, write to each of the companies you have selected in order to obtain brochures and photographs of their product line. When you receive the information, use the materials that would best serve the purposes of any type of retail operation of your choice, and explain why these would be the perfect products.

 The chart, and a few pages from each vendor, along with your explanations should be mounted in a booklet and used for an oral presentation on lighting resources and systems.

2. As stressed in the chapter, it is imperative for the merchandise assortment to be carefully selected in terms of color so that visual presentations will make an impact. In order to make certain that the best merchandise is selected, many merchants—especially those in specialty boutiques who do not have in-house fashion consultants to help with color forecasting—use the services of outside fashion consultants. The fashion forecasting of some companies is available on the Internet. One major player's website is www.doneger.com, where its services may be viewed and evaluated. By using any of the popular search engines, you can locate the websites of others in the field.

 Select any website and write a paper, for oral presentation to the class, that discusses the different fashion services offered and how they can help the buyer in the proper selection of merchandise that will best lend itself to exciting visual presentations.

discussion questions

1. Why are small specialty boutique entrepreneurs generally unable to make uses of display props and materials that have been professionally produced?

2. What is the major visual element that a merchant can use that is immediately eye-appealing but costs nothing?

3. How can the operator of a specialty boutique ensure that color will be easy to employ in display presentations?

4. What type of lighting may be used to add "punch" to the overall general lighting of a store?

5. Instead of purchasing display counters and props for merchandise presentation, what can the merchant use in their place that is without cost?

6. What is meant by the term *loaner props*?

7. How can the retailer resurrect discarded props and make them new again?

8. What is the alternative to high-cost mannequins for the independent specialty boutique merchant who has a limited visual budget?

9. What is meant by the term *no-cost point-of-purchase props*?

10. In what way can effective signage be produced in-house at modest cost by even the smallest boutique shops?

11. Why is it important for the buyer of a specialty boutique to carefully plan purchases and limit the assortment to particular color schemes?

12. How can a buyer make certain that the right merchandise assortment has been carefully planned before venturing into the wholesale market?

Case Problems

Case 1

Linda and Amy have finally realized their dreams with their decision to open a small specialty boutique. With both of them thoroughly experienced in the area of high-fashion apparel for women, as a result of previous employment as buyers, they thought they had the necessary backgrounds to begin a successful retailing venture.

After a great deal of research to find the right venue for the newly formed business, they decided upon a store that seemed perfect for them. With 2,800 square feet of selling space, and show windows on either side of the store's entrance that measure 6 feet deep and 10 feet wide, it would give them the right amount of space to sell their merchandise and amply display the hottest items.

Like many new entrepreneurs, Linda and Amy have limited financial resources. You might say the venture is being started "on a shoestring." They have enough capital to buy some merchandise on a cash basis, and to establish a line of credit for other purchases, and just about enough to afford the fixturing, lighting, and flooring that will provide the store with a functional as well as an eye-appealing appearance. The only area for which they haven't sufficient funding is visual merchandising expenses.

Although they recognize that attractive windows are the way in which to attract the attention of passersby, at this point they haven't the funds needed to purchase costly mannequins, display materials, and supplies. They learned about these costs by attending a national visual merchandising trade show and came away frustrated by the amount of money it took for even modest displays. They are frustrated, but they say that this will not prevent them from moving forward.

Some of the ways they are considering overcoming their absence of funds to purchase what they call essential display props include:

- Borrowing from a lending institution.
- Reducing the size of their merchandise inventories.
- Eliminating sales help and making the store more self-service-oriented.

Recognizing that outstanding visual presentation is a necessary ingredient for the newly formed company, they are still uncertain as to how they should proceed given their limited dollars for this expenditure.

QUESTIONS

1. Evaluate the three considerations that would allow them to purchase display props. Which, if any, would you advise them to pursue?
2. What suggestions would you make to Linda and Amy that would be cost-effective yet provide them with displays of distinction?

Case 2

Two years ago, Designing Children, a specialty boutique, opened its doors to the public with a unique line of children's clothing and accessories. Although the business immediately captured the attention of its trading area, and sales reached the anticipated levels, the owners were disturbed that the costs of doing business were greater than they thought and profits were less than expected.

Amanda and Matthew, the company principals, were not earning as much money as they thought they would, and they are becoming increasingly frustrated every day. They regularly examine the bills of the operation to try to determine where they could reduce expenses and at the same time not interfere with the visual appearance of the premises. Some of the bills that seem to be more than the anticipated costs, and the rationales for their continued use, include:

- *Lighting expenses.* Although they make certain that their lights are used in a most cautious manner, they recognize that lighting is essential to overall in-store illumination and that spotlights are necessary to highlight both interior and window focal points. Eliminating any lighting would hamper visual effectiveness and could cause lower sales.
- *Signage.* They use the services of a professional sign maker to prepare any signage that they need to announce sales, special events, and so on. They have checked with other sources of supply and have determined that the company they use offers prices in line with others in the industry.
- *Professionally developed point-of-purchase materials.* Although these materials are costly, they do bring the customer's attention to specific products that the store carries. By doing away with these materials, they would save some money, but sales might be hampered.

After carefully assessing these considerations, the partners are not certain of how they could reduce the costs of each one.

QUESTIONS

1. Have Matthew and Amanda really considered every way in which to cut costs in each of the areas they have analyzed?
2. What suggestions would you make to bring down the amount of each targeted expense?

exercises and projects

1. Using the pages of fashion magazines will give the specialty boutique entrepreneur an insight into the style and color trends for the upcoming seasons. Magazines such as *Elle, Harper's Bazaar, Glamour,* and *Vogue* should be examined for this information. For this project, choose a specific product classification, such as women's apparel, junior sportswear, or men's clothing, to determine which styles should be considered for purchase by a merchant. Once a classification has been decided upon, remove photographs of the items that best exemplify the merchandise from the magazines and affix them to foamboards in specific color combinations. For example, you might concentrate on just red or, perhaps, red, white, and blue. The final choice will be determined by the different pictures in the periodicals and from the information in the editorial material in the various magazines. Along with the pictures, prepare a one-page report indicating the rationale for your selections.

2. Plan a trip to a mall or any shopping area that is within your area and photograph windows that seem to be in need of "energizing." Three windows should be chosen and then photographed. The pictures of the selected windows and the ways in which you would energize them should be affixed in the spaces provided in the accompanying form on page 214. (*Note:* A separate sheet should be used for each store window.)

Name of the Company	Website	Product Offerings

ENERGIZING A WINDOW

Name of Retail Operation _____

Photograph of Display	Methods of Energizing

signage:
that tells

Objectives

After completing this chapter, the student should be able to:

... List eight types of signs that are being used by today's retailers to motivate consumer purchasing.

... Discuss how standing display fixtures are coordinated with signage to attract the customer's attention.

... Explain the importance of manufacturer and designer logos in store signage.

... Relate the importance of track signage in the retail environment.

... Compile a list of the various materials used for the construction of signage, the characteristics of each, and their uses and advantages.

... List the many materials used for sign lettering and discuss the applications for each type.

... Compare conventional sign-making machines with computer sign printers.

... Create a sign layout according to the principles of design.

... Discuss the various sources of commercially made signs for use in visual merchandising.

the tool

a story

Introduction

At no time in retailing history has the use of the written word been more important than it is today. Thirty years ago, retailers were satisfied with identifying their stores by placing their names in a prominent space over the entrance to their premises. Neon signs were common for many merchants, while assorted materials and letter styles, illuminated or not, were chosen by others to tell shoppers which store they were about to enter. The major retailers, in their multilevel units, used limited signage to identify their departments—nothing exceptionally artistic or inspirational, just simple words signifying Menswear, Juniors, or Home Furnishings.

In any major store today, one's eye is drawn to a variety of sign messages, each competing for the customer's attention. Not only are they informative but they are often eye-catching formats, the work of graphic artists. No longer are the messages mere paper signs, but decorative, creative constructions that employ brass, wood, felt, Lucite, and other materials. Signage may be three-dimensional, screen-printed, illuminated light boxes, neon-oriented, or enhanced by geometric shapes and forms to deliver a powerful message that will motivate customer spending.

Retailers are enjoying vendor cooperation and involvement in their merchandising efforts. Recognizing the power of signage, many manufacturers participate in joint signage ventures with stores. By sharing the expense of creative signage, many suppliers guarantee that their names and logos will be evident inside the store and will direct the shopper to their own merchandise. In some instances, particularly in the case of cosmetics, the suppliers provide the signage at no expense to the store. Taking the signage provided by vendors one step further, many manufacturers provide stores with total selling fixtures, complete with signs and logos, known as point-of-purchase displays. This concept is fully explored in Chapter 15.

With each passing day, the importance of signage becomes more apparent to the visual merchandiser and the retailer being served. Signs are the communicators of messages that move the shopper through the merchandise selection and purchasing stages. The Small Business Administration summarizes the importance of signage in "Compelling Reasons to Consider an On-Premise Sign" (see p. 217), which underscores the need for signage.

This chapter examines the types of signage, materials, and sign layout dominant in retailing today.

Types of Signs

The influence of signage has become so powerful that most visual merchandisers are constantly searching for new signs to make merchandise presentations more exciting and provide better direction for the shopper. Stores might use a particular signage theme throughout the store, or they might choose types that are specifically appropriate for one department or type of merchandise.

Banners

Made of fabric, plastic, or paper, **banners** are used extensively by retailers to spell out a theme, deliver a message, define a department, or just provide visual excitement and color in the store (Figure 13–1). They are particularly popular since their production and installation are comparatively inexpensive. Some banners come from the vendor and cost the retailer virtually nothing.

Banners can be used in a number of ways, but the overhead variety—suspended from the ceiling by wire or chain—is the most popular. In order to keep the banner taut, it is often designed with top and bottom pockets or openings into which steel or wooden dowels are inserted.

Figure 13–1 Banners are excellent signs to alert shoppers to particular merchandise.
(Photograph by Ellen Diamond.)

Figure 13–2 Fixture-contained signage combines the brand name and displayed merchandise.
(Photograph by Ellen Diamond.)

Wall Signs

The logical place to locate a sign is on a wall or a column. The message may denote a department, its entrance, a theme, or a specific informative message. The materials used depend on the expected permanency of the sign and its role in the visual presentation.

Fixture-Contained Signage

Combining a permanent sign with a merchandise fixture is a method often used to publicize the name of the vendor whose merchandise is featured. The trend toward departments specialized by vendor or designer name necessitates that appropriate signage accompany the installations. **Fixture-contained signage** is becoming increasingly popular and is being designed and manufactured by point-of-purchase suppliers; it is explored in Chapter 15 (Figure 13–2).

Valance Signs

Most often, signs give the name of the collection or name of the vendor's merchandise found in a specific area. Particularly successful signage is often found adorning a valance. The **valance,** a structural piece used primarily to connect the upright panels of a case and to conceal light fixtures, is an excellent place to install a permanent sign (Figure 13–3). With so much emphasis on designer or manufacturer labels or logos, many visual merchandisers use a replica of their logos on the valances.

Signs on Glass

Some visual merchandisers feature a message installed directly on the glass of the store's windows (Figure 13–4). **Adhesive letters** can be applied easily to the glass and removed effortlessly when the presentation has outlived its usefulness. Designer names, catchy phrases, and timely themes are some possibilities.

Figure 13–3 Valance signs are used to conceal lighting fixtures and announce a particular department.
(Photograph by Ellen Diamond.)

Figure 13–4 Signage on glass lends extra pizzazz to windows.
(Courtesy of Lord & Taylor.)

Figure 13–5 Pennants may be displayed as part of a display.
(Photograph by Ellen Diamond.)

Pennants

Used to adorn merchandise or used by themselves, **pennants** are quickly and inexpensively created (Figure 13–5). Paper is least expensive and best suited to pennants because it may be curled or draped, but felt, vinyl, and other materials also work well for a pennant message.

Moving Message Signs

A device that is ideal for attracting attention inside stores and windows is the electronic **moving message sign.** The messages can be programmed easily and quickly with a variety of letter styles and symbols. The speed at which the words move can be adjusted to suit the

store's needs. The units are generally used to notify shoppers of special sales or promotions and can be strategically placed at points of purchase for maximum exposure.

Track Signage

Track signage is an excellent system that uses a carrier beam attached to the ceiling into which strips for signs are fitted (Figure 13–6). Each strip has a channel or track providing for the addition of another sign or panel. The system is perfect as a directory that can be seen from a great distance to tell the customer where specific merchandise may be found. If special sales or promotions are being featured, as is the case in most supermarkets and discount operations, the information can be attached quickly and conveniently to the system and just as easily removed when the events have been concluded.

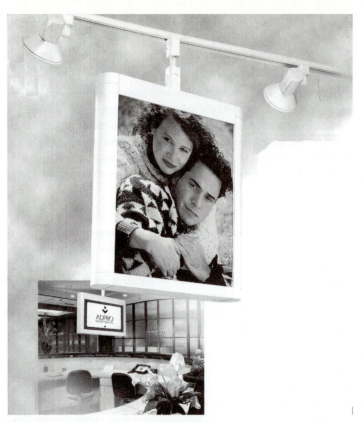

Figure 13–6 Tracks enable the retailer to mix signage, graphics, and lighting.
(Reprinted with permission of Juno Lighting.)

Neon Signage

Once relegated to announcing the name of the retailer on storefronts, **neon signage** is making a great impact on visual merchandising. Its availability in a variety of shapes and designs makes it a perfect adjunct to brighten and highlight a department, product, or area. For many years, beer producers have been manufacturing such signage to promote their products. Borrowing from the beer industry, other vendors are jumping on the bandwagon. Many of the vendors supply these signs to their retail customers without charge. In this way, they can guarantee that the illuminated message is exactly what is needed to best make the shopper aware of their merchandise. In keeping with the trend of other sign media, manufacturer and designer logos are being produced in neon, making them stand out even more to the shopper. For example, Nine West regularly places neon signs at the entrances to its in-store vendor shops. The motif it uses is the one found on its shoe boxes and labels.

Simulated Neon Signs

An alternative to traditional neon is simulated neon. By comparison with neon, the simulated type offers numerous advantages, such as a bolder appearance, lower operating costs, lighter weight, complete freedom of graphic design, easy installation, interchangeable panels, interchangeable colors of illumination, and generally overall economy. The basic lighting is comprised of fluorescent lamps backed by highly efficient concave reflectors. In order to simulate neon, an opaque background (typically black) surrounds the illuminated graphic elements, which are left clear on the panel, allowing the brilliantly colored illumination to shine through.

In making the most out of a store's signage program, it is important to visit every possible informational resource. One of the better places to learn about the industry and what it has to offer is the International Sign Association, whose Profile appears below.

Founded in 1944, the National Electric Sign Association, an organization that represents manufacturers, users, and suppliers of on-premise signs and sign products, is now known as the International Sign Association (ISA), for its membership represents the industry at all levels across the globe. The ISA's charge is to support, promote, and improve every component of the sign industry. Some of the membership services offered by the association include:

- Online courses that cover a variety of signage areas.

- Discovery seminars to help to bring recent changes in the field to the participant.
- An up-to-date listing of the different events being held throughout the world.
- A listing of current publications that offer specific information on signage.
- Sites at which the members may advertise their products.

The organization maintains a website, www.signs.org, on which a wealth of information is provided for its membership. The website also provides links to other websites, such as the Small Business Administration, which offers a section on signage and its role for today's retailers. By regularly logging on to the ISA's website, retailers and their visual merchandising teams can learn about membership requirements, educational materials, events of interest, and legislative considerations concerning the use of signage.

Finally, an electronic newsletter is provided that addresses the latest concerns of members as well as the most recent signage innovations.

Sign Materials

In all types of signs, various materials are used to achieve the specific appearance desired by the retailer. Aside from aesthetics, other factors such as durability, flexibility, and the cost of materials must be considered before the signage task is undertaken. If a sign is to be short-lived, it is economically unsound to construct it of costly materials. If it will be used for a long time, its construction must take into account factors that might cause the sign to lose its visual effectiveness. For example, paper might initially be an effective material, but over time it could be damaged by the store's lighting or heating systems. The list of materials used by today's signmakers continues to grow. Those that are used most frequently are described in Table 13–1.

table 13-1 Materials Often Used to Make Signs

Material	Characteristics	Uses
Paper	Inexpensive; good color reproduction; quickly produced by sign machines, computers, transfer letters, and hand lettering	Temporary or short-term for sales, special promotions, etc.
Cardboard	Relatively inexpensive; longer life than paper; may be produced quickly, in-house, by printing machines and hand lettering	For insertion in freestanding fixtures or holders that attach to merchandise racks; for short-term usage
Fabric	Long-lasting; available in many colors; may be draped; easily silk-screened, hemmed for use in banners; modest cost	Excellent for banners, long-lasting presentations; may be stretched on frames
Lucite	Durable; available in transparent or translucent forms; retains shape; easily cut into variety of shapes; accepts paint easily	For permanent signage on walls and columns or suspended from ceiling
Wood	Very durable; may be stained or painted; easily cut into any shape	For permanent or long-lasting displays, to add to a "natural" feeling
Masonite	Excellent painting surface; thinness may cause warping or buckling; inexpensive	In frames to prevent buckling; in semipermanent situations
Brass	Expensive; luxurious look; difficult to cut	For permanent installations depicting luxury

Letter Materials

The preceding section focused on the types of materials employed in the construction of signs. A wealth of materials is available today, for temporary or permanent installations, that enables the retailer to do more than just deliver a written message. The letter materials themselves, whether used to identify a department's name, highlight a designer collection, or announce special events in the store, help to make an impression on the shopper.

One of the most popular choices in dimensional signage letters is foam. Lightweight and inexpensive, it creates an illusion that belies its economy. It is available painted or unpainted and can be finished to resemble other materials such as wood or marble, both of which would be extremely costly. Application is simple, as foam generally comes with a self-stick backing of **Velcro** or **pressure-sensitive tape** or can be hung as part of the display design.

More and more visual merchandisers are using metal letters for their presentations, mainly brass and aluminum. Each adds richness to the message. Brass is heavy and expensive and thus has limited use; aluminum is relatively inexpensive and lightweight and is used in many situations. Aluminum is often laminated to foam, in a variety of thicknesses, and mounted with double-face tape or Velcro.

Mirror is a material that is also being used extensively in visual merchandising. It is available in a variety of thicknesses and may be purchased in a form that is attached to foam, which gives extra dimension to the letter and makes it easy to mount with special tape or Velcro.

Wood and woodgrain laminates offer the retailer a look of richness and enhance a natural display. The letters come in a variety of styles and thicknesses and are easy to mount on any surface.

Plastic letters also are used extensively. Made of injection-molded Plexiglas®, plastic letters have a smooth surface and shiny appearance that is easy to maintain. They are readily available with adhesive backing for quick, simple mounting.

Vinyl, self-stick letters are excellent for quickly producing an informative sign or poster. They are available in a variety of **typefaces** (also known as **fonts**) and sizes and can be applied with little effort. The letters are adhesive-backed and the backing must be peeled off before they can be affixed to the sign's surface. Once in place, they cannot be adjusted or removed. Therefore, it is important for the sign creator to make certain that the layout is carefully planned and the individual letters are pressed into place correctly. If just one or two signs are required, this is an excellent, inexpensive method to achieve professional results. The letters come in numerous colors as well as black and white and are available in most desired sizes.

For special presentations, when standard letters will not fit the bill, many visual merchandisers create their own. Using materials such as Fome-Core and Sintra, letters are drawn and simply cut with the use of an X-acto knife. Of course, in order to create perfect letters, the visual merchandiser must be professionally trained. Once these letters are completed, they are often adhered to surfaces with a hot-glue gun. This adhesive material provides excellent durability.

In-House Sign Production

Having the right sign materials and letters is just one aspect of developing appropriate store signage. Knowing how to use these materials most effectively to motivate consumer purchasing is the real challenge. In order to create signs that have customer appeal and carry out the store's visual merchandising message, most major retailers maintain an in-house team to make certain that their signage has the desired impact.

Some signage is permanent and requires nothing more than the placement of purchased letters over department entrances. Other signs are temporary, such as those constructed for sales and special promotions. Usually these are made of paper or cardboard, and the in-house staff must prepare copy and layouts to best fit the needs of the event.

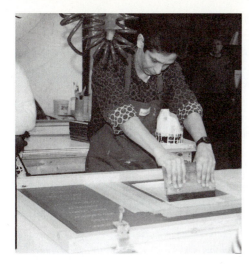

Figure 13–7 A silk-screen artist preparing a sign that will be used for limited purposes.
(Photograph by Ellen Diamond.)

When a special short run of signs is needed, the in-house signmaker sometimes uses the **silk-screening process** (Figure 13–7).

Signmaking machines were once the standard technique of sign production by in-house staffs, but the vast majority of large retail organizations have turned to computers to produce their signs. A wide assortment of computer programs is available to fit every signmaker's needs. With the wealth of available typefaces or fonts and the user's creative abilities, it is possible to turn out signs of distinction. Since **computer-designed signage** is produced in large quantities to serve the needs of all the organization's units, the cost per sign is modest. While in-house computer signage has become commonplace in large organization retailing, some companies use computer sign services; the retailer initiates the process and, by means of a computer terminal that is tied into the service organization's mainframe, the sign is produced. Additional copies can be printed by the computer specialty company or on the retailer's own printer. Laser printers and color copiers have made in-house production a simple task.

Sign Layout

Whatever the choice of materials, the sign layout must conform to all the principles of good design. These are the same principles of balance, emphasis, harmony, proportion, and rhythm that were discussed in Chapter 8. The message to be presented is not the decision of the signmaker but of those who planned the visual presentation in which the sign will play a part. The hand-rendered thumbnail sketches that were typically used in the creation of signs have literally disappeared in favor of computer-generated sketches, which require less time than the freehand technique to achieve the results desired. Graphic artists may choose from a wealth of *clip art* available from programs such as Adobe or render designs of their own, and select the most appropriate fonts available with programs such as Microsoft Word to complete the design. Oftentimes, several versions of the same sign are produced for comparison purposes. The one that seems to best present the message is then reproduced in the needed quantity.

Key Points in Creating Signs

Among other roles, EROGERO is a company that acts as a visual design problem solver. It offers a number of suggestions to designers of signage that, if followed, should make a retailer's sign offerings more effective. They are:

- Signs are often designed by people who don't use them. This is the surest way to error and the biggest mistake in the creation of information displays.
- Signs are always seen in a context and must be designed with that in mind. Consider the background against which the information will be seen. A sign that is

highly visible in the designer's office may become invisible in the store. Signs must be tested in an actual store.

- Always test signs with target customers who don't know your store or business and don't already know what the sign says.
- Signs and packaging must be meaningful, so understand your customers. What are they thinking about when they enter your place of business? Remember, meaningfulness is an important factor in attracting attention.
- Signs that command an immediacy of action are remembered better and are more effective.
- Signs should be located where the customers will be looking. Study customers to see where their eyes are pointed most of the time. Put signs and important displays there.
- Since customers scan only a portion of the store, it will be necessary to place some signs where they will be seen only out of the corner of the eye. Use conspicuity methods to draw attention.
- People typically turn right when entering a store. Put important signs there.
- Determine whether the customer will be moving fast or slow. The faster the movement, the briefer the sign should be. Waiting areas are a good place for long signs because people are stationary. If customers move too fast, find a way to slow them down, for example, mirrors or free samples.
- Legibility is critical, since you can't act on what you can't read. Use high contrasts, large letters, simple fonts, and brief messages.
- Educated, wealthier customers tend to gather more information and read packaging more. Ensure that packaging is legible and understandable. It is not an afterthought.
- If many of your customers are older, then be sure to use especially large print and limit colors. Design for older people requires a special set of design rules.

Commercial Sign Sources

The discussion so far has been about sign preparation by retail in-house staffs and the signage that is available from vendors at little or no cost. Many vendors opt to offer this signage in order to provide a uniform message in all of the retail outlets they serve. However, not every store organization has these options. The large retailer might be bombarded with vendor-produced materials and be able to produce special signs in-house, but a small store lacks these resources.

Inspection of a small retailer's premises shows that although signs are not used abundantly, there are situations that warrant their use. Short on the dollars needed to advertise a sale in the print or broadcast media, small retailers generally notify shoppers with a sign in the window. The signs are relatively inexpensive and may be obtained from a signmaker who will produce the message via computer. An attractive piece can be obtained quickly and efficiently.

13 **chapter review**

key points in the chapter

1. Signage and graphics are making a greater impact today on customers than ever before in retailing history.
2. The list of signage types continues to grow as retailers discover new ways to motivate consumer purchasing.
3. Electric signage is becoming increasingly popular, with backlit transparencies a favorite of retailers.
4. Signs are no longer simple and routine but are now the creations of professional graphic artists.
5. Neon signs, once reserved for store identification, are now being used significantly in visual presentations.
6. Numerous materials are being used for signage, each offering a distinct advantage to the retailer.
7. An abundance of letter types enables the visual merchandiser to create signage that stimulates purchasing.
8. Many letters come with Velcro or pressure-sensitive tape backings for easy sign installation.

9. Most major retailers maintain in-house staffs to produce signs specifically for their stores' needs.

10. Signs can be quickly produced in-house and by outside sources using computers.

11. Although free signage is often available from vendors and some sign production may be done on a store's premises, commercial sign houses are often used to produce computer and specialty signage, such as silk-screened or lithographic signs.

terms of the trade

internet exercises

1. The International Sign Association, whose website www.signs.org offers a great deal of information, is the major organization dedicated to bringing signage information to the trade. Its website offers, for example, educational features, upcoming industrial events, and the latest publications about signs. Investigate one of these or any other section of its website and prepare a report for oral presentation that fully explores the topic of your choice.

2. The Small Business Administration is a governmental agency that is responsible for assisting small businesses in a variety of areas. One such area deals with signage. By logging on to www.sba.gov/starting/signage/index.html, those interested in signage can gain a significant amount of knowledge. The website provides a wealth of information on a variety of topics, including the legal considerations for the use of signage, how signage may be obtained, the types of signage available, understanding the value of signage, and so forth. For this assignment, visit the website and examine each area. Then select a topic that you would like to explore further. Once you have studied that segment of the site, prepare a two-page, typed report that thoroughly addresses every aspect of your topic.

discussion questions

1. What materials used for signs provide more permanency than paper?

2. What form of signage offers the greatest level of color and vibrancy?

3. Describe fixture-contained signage.

4. Discuss the different types of letter backings that enable the visual merchandiser to install a sign quickly.

5. For what major purpose is the moving message sign used by retailers?

6. Discuss the advantages of track signage.

7. Which industry led the way in neon signage?

8. How is computer technology being used in sign production?

9. What is the advantage of self-stick letters?

10. What are the uses of lithography and silk-screening in display?

Case Problems

Case 1

David Neil is the trimmer for the Designing Woman, a small chain of ten specialty stores. The stores, all located within a radius of 150 miles, specialize in fashion-forward dresses and sportswear. Recently, David was invited by management to participate in a planning session on the company's visual merchandising approach.

For its thirty years of operation, the company has followed the traditional route of merchandise presentation. Dresses and other hanging merchandise have been housed on racks, with folded merchandise stacked in wall cases and on floor counters. The sales staff showed the items to the customers, rather than letting customers browse by themselves. Although this format had worked well in the past, the company is noticing a new customer independence. The younger clientele seems to prefer the self-selection approach over the show-and-tell method. More and more, shoppers seem to be saying, "I'd rather look by myself."

Management is considering several changes to accommodate a more relaxed merchandising concept. Mr. Neil and the company have decided on some fixture updating, with show-and-sell counters replacing the older variety so that shoppers can handle the merchandise and serve themselves. Hanging merchandise will also be displayed to invite self-inspection by shoppers. The fixturing change should lend a new, relaxed environment to shopping.

While the stores' windows will remain intact and continue to feature the types of presentations that always motivated pedestrians to come into the store, something should be done to make the interior more exciting. The new fixturing isn't enough. David Neil suggested that a signage program would liven up an otherwise low-key interior. Although management members think the suggestion is a good one, they want to make certain that the costs of exciting signage won't severely tax the store's visual merchandising budget.

QUESTIONS

1. What types of signage would be best suited for the Designing Woman?
2. How could you accomplish the goal with little money?

Case 2

As the proprietor of a small boutique, Caryn Kelly has always had to deal with the challenge of visual merchandising on a shoestring. She trims her own windows and has generally received admiration for her efforts. Since the business was profitable, she felt that her visual presentations were on target.

In her store, as in any other retail business, there has been a continuous need for signage to announce sales and relate other messages to her customers. This was the one area that Caryn felt uncomfortable handling, but professionally produced signs were too expensive or the finished products were not to her liking. The typical paper sale sign affixed to the window just wasn't right. Still, she needed something to help her dispose of slow-selling merchandise. She even tried her hand at lettering. The result was similar to the home-baked cake that might taste fine but leaves much to be desired in terms of professionalism. Not only were her signs poorly executed, but her self-made price tickets looked equally dismal.

Caryn finally visited some professional signmakers who were a step above the typical paper sign producer. They offered many suggestions but each required a bigger investment than she could afford. The fabric banners and lightboxes that were suggested did not seem right for her limited usage. What she really wants is a system to produce professional-looking sales signage at minimum expense and on short notice.

QUESTION

1. What approaches to sign preparation would you suggest for Caryn?

exercises and projects

1. Use the following information to produce four computer layouts of a sign. Then produce a finished, full-size sign of the best sketch, using colored markers or press-on letters.

 Sale
 Imported Glassware
 Reductions 20–50%
 For President's Week Only

2. Visit a major department store or specialty store in your area to observe its signage. Complete the form provided on page 230, listing the types of signage, and comment on their effectiveness.

EXERCISE 1 SIGNAGE ANALYSIS

Store Name _____

Type of Store _____

Type of Signage	Department	Effectiveness
1.		
2.		
3.		
4.		
5.		

EXERCISE 2 SIGNAGE AND GRAPHICS ANALYSIS

Store Name _____

Type of Store _____

Type of Signage	Department	Effectiveness

1.

2.

3.

4.

5.

graphics in environ

Objectives
After completing this chapter, the student should be able to:

... Discuss the different types of graphics that retailers and other businesses are using
to promote their products.

... Name the two primary sources of photographs used for graphic presentations.

... Explain the reason why some retailers prefer to customize their graphic presentations
rather than use stock photography.

... Describe the concept of backlit transparencies and explain why many companies
choose them for promotional purposes.

... Discuss why prismatic displays are being used more and more by retailers
and other businesses.

... Describe how light walls are being used to attract shoppers into stores.

... List the different venues where retailers can learn about the graphics being offered.

... Explain why exclusivity is important to retailers in terms of graphic usage.

the retail

ment

Introduction

As retailers entered the new millennium, the cost of doing business continued to spiral upward. At the same time, the competitive nature of the game demanded that they make considerable effort to attract consumer attention to their businesses, albeit with lower expenditures, wherever possible. One area that many merchants looked to for savings was in visual presentations. They knew the value of such endeavors, but they wanted to curtail spending large sums for their preparation and installation and at the same time make certain they would still get the benefits afforded by visual merchandising efforts. Although the often fabulous window and interior display designs generated a good deal of business, the costs were sometimes more than companies could really afford. Belt-tightening led to a heavy concentration on **graphics** in both interior and exterior presentations.

At the early stage of this new century, retailers are solving some of their budgetary problems by making significant use of a variety of graphics. They are becoming mainstays for many retailers, especially the chain organizations. A look at the windows and interiors of such companies as The Gap and its divisions Banana Republic and Old Navy, The Limited with its division Express, and Abercrombie & Fitch immediately reveals that graphics have come to play a central role in their visual merchandising efforts. In sizes that range from traditional poster dimensions to enormous "show-stoppers," these and other merchants seem to have found a solution to their budgetary problems. Not only is their cost relatively modest when compared to the costs of the more traditional display installations of yesteryear but they seem to be attracting as much shopper attention as any other form of visual presentation.

This chapter will focus on the different approaches available to retailers in their quest for creative graphics, the expenses involved in their production, and the different types that are being used in today's visual presentations.

Graphics Development and Procurement

Each retailer determines the approach needed to come up with the graphics that are appropriate to the operation. The initial factor that generally dictates the route to take is the size of the organization. Small businesses have no other choice than to go to outside sources for the pieces needed for their installations. Larger retail organizations, however, can purchase the pieces needed or use an in-house staff to develop their own pieces. The decision is generally based upon the number of retail units in the organization and the company's dedication to this form of visual merchandising. Sometimes, the approach used is a combination of both methods. Retailers might have people on their staffs who design the various types of posters and other graphics for their visual presentations but leave the actual production to outside sources. In this way, they maintain the integrity of the visual pieces and make certain that they carry a *signature* that delivers their message in a format that is exclusive to their company. The *artwork* is then sent to a production organization that faithfully translates the in-house design into a product that is exactly what the retailer wants.

The vast majority of intricate graphic designs and production comes from outside sources. Some of the major companies that serve the retail industry are:

- *Colorx,* which digitally prints graphics on a variety of substrates, such as wood, metal, tile, carpet, and fabrics.
- *Sungraf,* which uses the "Spectramax Ultra" process to produce digital images ranging from saturated, full-color graphics to subtle, muted tones and black-and-white prints on vinyl, film, canvas paper, or mesh.
- *Alusuisse Composites Inc.,* which creates oversized graphics using Sintra rigid PVC material in a range of colors and thicknesses.
- *Clearr Corporation,* a leader in a host of different graphic formats including backlit transparencies, edgelit display systems, and three-message poster displays.

Almost every day a new technique is being developed by these and other companies to take graphics production to newer levels.

Graphic Images

The key to any successful graphic presentation is the use of images that will attract attention. They are either custom creations or are pieces selected from **stock houses.**

Original Photography

When a retailer wants to make certain that the company will be represented exclusively by the images in graphic presentations, it achieves this goal through custom assignments. That is, photographers—either working exclusively for the company or as freelancers—are assigned to shoot a series of photographs that represent the theme of the upcoming visual presentation. Of course, this process may be time-consuming since it might require hundreds of *shots* before a satisfactory selection is available. It is also an expensive undertaking, especially if freelancers are used. Keeping a photographer on staff is also very costly and may only be suitable for retailers who do a lot of in-house photography for other needs such as catalog advertising. Thus original photography is reserved to the giants in the retail industry who can afford the often prohibitive expenses associated with custom photography (Figure 14–1).

Stock Photography

As the name implies, thousands of images featuring a wide range of subjects are on hand at *stock houses* (Figure 14–2). Some of these companies feature libraries of images that focus primarily on one class of image; others offer just about any type of image needed for reproduction by merchants. The use of **stock photography** has several advantages to customized images, including the following:

- The price is generally considerably less than the costs involved in custom assignments because photo buyers are only required to pay a use fee based on the size of the image and the exclusivity required.
- The photographs in the libraries can be quickly viewed and made ready in a matter of minutes. The user is able to see exactly what he or she is buying and how it will look in print.

Figure 14–1 A blowup of an original photograph gives exclusive use to the retailer.
(Courtesy of Saks Fifth Avenue.)

Figure 14–2 Stock photography can be obtained quickly and inexpensively from stock houses.
(Photograph by Ellen Diamond.)

- Oftentimes, the quality of stock imagery is better than custom assignment photography because, most often, the shots are created under ideal conditions.
- The wealth of images already available might give the visual merchandiser an idea for a specific display theme.

Stock Agencies

Just as there are many advertising agencies for retailers to choose from for their print and broadcast needs, there are also a great number of stock photography agencies from which to choose images. Each company, as in every business classification, offers different products and services to its clients. One way to learn about the various stock photography agencies is through the Picture Agency Council of America Membership Directory. Potential users can learn about agency offerings, the photographers whose images are represented by them, costs, and so forth. The organization may be contacted through its Internet website, www.pacaoffice.org, or by e-mailing, at info@pacaoffice.org.

Classifications of Graphics

As discussed, there are many different types of graphics that visual merchandisers and facilities designers use to attract attention and motivate shoppers to take a closer look. Some of these are merely enlargements of photographs; others are illuminated varieties that add yet another dimension to visual presentations.

Backlit Transparencies

Without question, the **backlit transparency** is one of the more important types of graphics used today by retailers, shopping venues, and the like (Figure 14–3). It not only serves as a motivational device but its relatively modest cost makes it affordable to most businesses wishing to quickly capture consumer attention. Basically, the units that house the transparencies are lightboxes fitted with two panels in which a transparency is inserted. Some lightboxes have a hinged door that can be easily opened to change the picture. The lamps that illuminate the device may be easily replaced in a matter of moments if they burn out. Most

Figure 14–3 Backlit transparencies add impact to any graphics. *(Courtesy of Clearr Corporation.)*

manufacturers suggest, however, that users do not wait for the lamps to burn out but replace them when they grow noticeably dimmer. The lightboxes may be "wall" mounted, suspended with the use of hanging loops that are attached to cables, mounted on freestanding pedestals, or recessed into a wall.

Today, backlit transparency systems are available in a variety of styles and prices. Clearr Corporation, the subject of this chapter's Profile, features a wide assortment of state-of-the-art backlit transparencies:

- the basic Luminaire plastic model, which is the most economical
- Luminaire Ultra, a permanent construction

PROFILE: A Contemporary Visual Merchandising and Environmental Design Profile: The Clearr Corporation

Established in 1959, the Clearr Corporation has developed into one of the industry's leading manufacturer of graphic formats and presentations. Without question, it has helped to bring the use of graphics in retail operations—and other environments where visual installations are used—to new heights. Its products are found globally in department stores, specialty chains, banks, restaurants, airport terminals, shopping malls, stadiums, and trade show exhibits.

The industry's professional groups as well as its editorial press have recognized Clearr Corporation's expertise in illuminated graphics. Specifically, it has achieved acclaim for such products as static graphic displays, sequential images, programmable multi-image offerings, and scrolling units. Its forte has been with *backlit transparencies,* setting the industry standard for many years. The featured models may be customized to every purpose, whether they are needed for indoor or outdoor placement. Color-correct illumination is provided in just about any size the client requires. Its unique formats and "names," such as Luminaire® and Panorama®, are available to fit most visual presentation budgets. Clearr Corporation is also a leader in *prismatic displays,* in which three messages can be conveyed through timed changes, each providing a striking visual effect as well as a way in which to deliver important messages. Multi-image and motion displays have also helped it to achieve status in the field of graphics; these include *full-screen motion displays* as well as **multifaced backlit presentations** and **scrolling display productions**. Rounding out the offerings are **simulated neon displays** and **edgelit installations.**

The company's expertise and knowledge have made it the lead vendor of visual presentations for such companies as Macy's. The world-famous department store was looking for a visual presentation that would immediately stop traffic and display messages that would motivate shoppers in its Herald Square flagship children's department to seek out specific merchandise. The challenge was a formidable one and has resulted in a presentation that is the central focus of the department. Using a combination of three-message internally illuminated displays and scrolling backlit displays, the result is a "mesmerizing" motion show that has continuously captivated the viewer's attention.

Clearr Corporation continues to maintain its position as a leader in the field, always developing new ideas to bring its offerings to heights that haven't before been seen in graphics for visual presentations.

- Luminaire Ultra II, a narrower transparency configuration
- Luminaire Ultra Dp, the thinnest of all of the constructions

Once the decision has been made to use the system, any slide, transparency, or color negative may be converted to a large transparency for placement in the unit. The transparencies may have been produced by a staff photographer or purchased from a stock house. Oftentimes, a vendor who is anxious to spread a product message makes transparencies available without cost to the user. In some situations, vendors who have sold substantial quantities of their products to retailers provide lightboxes at little or no cost. Since many merchants report that sales increase by as much as 20 percent when they use backlit transparencies in their premises, vendors are often happy to supply the transparencies.

Digital Images

The exterior windows and facades and interior spaces of many retailers display large-format **digital images** (Figure 14–4). Brooks Brothers, for example, before it opened its doors to its new flagship on New York City's Fifth Avenue, used a superlarge graphic for its barricade. The 100-foot-wide by 25-foot-tall photorealistic billboard stopped traffic. The "picture" was produced on adhesive-backed vinyl, making it weather resistant, using 3M's Scotchprint Printer 2000. More conventional sizes as well as large-format graphics are now found in every type of retail operation in the United States and abroad. Digital printers have made them more accessible and cost-efficient, so most retailers can avail themselves of the new graphics. The graphic industry employs **standard inkjet printers** (by far the most versatile and accessible), **laser photo imagers,** electrostatic systems, thermal transfer printers, and **superwide inkjet printers.** Each format has different advantages and disadvantages to the producer. The standard inkjet, for example, which can cost as little as $6,000, produces good-to-excellent quality images in vivid colors in formats that range in size up to 72 inches (see "In the News" for more information on printers) and thus provides a finished product that is excellent, easily affordable, and usable for outdoor presentations that will last up to three years.

With the cost of production thus relatively low, retailers may refresh their themes seasonally or for special promotions. Some even have graphic programs that change more frequently. Rockport, the footwear company, changes graphics monthly in its "concept store" on Boston's Newbury Street to highlight its themes. The windows of the facility use 26-by-59-inch panels produced on photographic paper. The Gap, Abercrombie & Fitch, and The Limited also have made this type of visual presentation part of their regular window themes.

Figure 14–4 Oversized digital images literally stop passersby in their tracks.
(Photograph by Ellen Diamond.)

Prismatic Displays

Companies that wish to add "action" to their graphics, and at the same time present three different but compatible messages to their audiences, may opt for **prismatic displays**. By using a format that somewhat parallels the "venetian blinds" commonly found in homes, businesses are able to present automatically changing, rotating graphics (Figure 14–5). The display unit is made up of horizontal prisms or slats that feature a particular graphic. These prisms automatically change to feature different messages. Even more excitement is provided by units that house devices that internally illuminate the graphics. Clearr Corporation offers a state-of-the-art format that is a high-impact combination of vibrant backlighting and "mesmerizing" motion—its *Triad* product combined with its *Neon Plus* package. Typically found in malls and on billboards, these graphics can be produced in sizes that range from the traditional 48 by 72 inches to almost any giant size (Figure 14–6).

Motion Displays

When complete **motion displays** are warranted to offer a fuller story about a retailer, restaurant, shopping environment, or product line, graphic presentations that parallel motion pictures are sometimes used. These are full-screen programmable visual offerings that can be easily changed to fit the needs of the user. They are set up in high-traffic areas to attract attention and direct consumers to particular selling places.

Simulated Neon Graphics

Companies have used neon illumination systems to present graphics and signage in unusual colors for many years. Today, technology has made simulated neon graphics available at lower costs but with the same eye appeal as the original (Figure 14–7). The signs feature graphics of products and also offer written messages to attract attention. Wrangler, manufacturer of jeans and other rugged wear, has used the neon displays as part of its point-of-purchase programs. Wrangler provides merchants who carry its lines with these simulated neon displays for use in high-traffic areas in the stores and to direct traffic to the shop areas where the merchandise is being sold.

Figure 14–5 Prismatic graphics add action to any display. *(Courtesy of Clearr Corporation.)*

Figure 14–6 Graphic revolutions rivet viewers and draw them into retail spaces such as this one at the American Girl Place store in Chicago. *(Courtesy of Clearr Corporation.)*

Figure 14–7 The use of simulated neon lowers costs but still retains the visual impact of original neon.
(Courtesy of Clearr Corporation.)

Light Walls

Light walls provide great visual impact for attracting the attention of shoppers who are passing by (Figure 14–8). The walls are comprised of numerous "screens" that feature moving images. These **multi-image displays** can be easily reprogrammed, providing new messages and graphics whenever the need arises. In its stores throughout the major malls in the United States, Wet Seal has installed enormous light walls covering a large portion of the back walls and visible from the stores entrance. Those entering the store or merely glancing in are immediately greeted by these images, which are changed as needed to present the latest themes that will, it is hoped, appeal to the market.

Banners

One of the simplest forms of graphic presentations is the banner. The vast majority of **banners** are developed and produced by manufacturers, who provide them to retailers that carry their product lines. They are made of materials such as fabric, plastic, and paper and can be manufactured with relatively modest expense. They are either suspended from the ceiling or placed on poles and often have "pockets" into which dowels can be inserted to steady them.

One of the major industries making use of banners is cosmetics. The vast majority of the cosmetic companies maintain counters in major department stores under a *leasing arrangement*. They are responsible for visually merchandising their own counters and often use the banner as a means of calling attention to their product lines. Companies like Lancóme make regular use of the banners, which are changed to coincide with the newest offerings.

The importance of graphics as a component of visual merchandising has led to a tremendous increase in the number of resources available to retailers and other businesses. Some of these companies offer a wide assortment of graphic products; others specialize in narrower offerings. Potential users of graphic products are best served by referring to *Visual Merchandising and Store Design* magazine, which features a host of different products and the companies that offer them, or accessing its website, www.visualstore.com, to learn about up-to-the-minute happenings in the field of graphics. More specifically, its annual Buyers' Guide editions, published every January, feature a wealth of different companies that specialize in graphics and other visual resources.

Figure 14–8 Light walls provide excitement to any retail environment.
(Courtesy of Clearr Corporation.)

First-Hand Evaluation of Graphic Technology and Products

Many retail operations, restaurants, and other businesses rely on trade magazines or direct-mail pieces to purchase graphics, but it is better to call on the companies that specialize in graphic technology and products so that the actual offerings may be seen and evaluated. Just as buyers for retail organizations call on vendors at their showrooms or visit trade shows to compare the available merchandise, so do the visual merchandisers.

Vendor Headquarters

One way to get a first-hand look at a graphics vendor's offerings is to visit or call the facility where the ideas are formulated and the products are produced. By making this in-person call, graphics users are able to get a better idea of the entire product line and how some of the elements might serve them. Of course, these producers are spread all across the country, and even abroad, making visits sometimes impractical. If, however, a particular company is located near the visual merchandiser, then the visit would be worthwhile. Visual teams employed by major retail organizations that make considerable use of graphics often make special trips to particular vendors to evaluate their lines.

Trade Shows

Attendance at trade shows is a very popular way to get an overall view of what the market has to offer in a relatively brief time period. Trade shows also can provide visual merchandisers with a means of comparing similar products of two different suppliers and allow them to make better decisions on purchases. The trade-show circuit covers major regions of the United States and numerous foreign countries. In the United States, New York City, Chicago, and Las Vegas are the cities most frequented by these expositions. Table 14–1 features the major American visual merchandising shows that attract numerous vendors of graphics and graphic technology.

In-Store Visits

Many retailers and other businesses have little time to visit manufacturers' showrooms or to attend the trade shows. In this case, if the offerings in the trade periodicals or by direct mailers are not sufficient to satisfy the potential user's needs, then an in-store visit might be in

table 14-1 Major Trade Shows in the United States

Trade Show	Location
Exhibitor Show	Las Vegas, Nevada
Global Shop	Chicago, Illinois
ISA Expo	Las Vegas, Nevada
Visual New York	New York City, New York
POP Show Chicago	Chicago, Illinois
POP Show New York	New York City, New York
NACS	Las Vegas, Nevada

order. Suppliers often have sales staffs that call on merchants to sell their products or help develop **custom graphics** that might be used for a visual presentation. While this is an alternative to the other two approaches, it generally doesn't provide as much product information. Sellers are limited as to the samples they can carry and will only transport a representation of the available line. Two other disadvantages to an in-store visit are the inability (1) to see possible production techniques and (2) to comparison shop. Of course, when this is the only means of getting an in-person look at the offerings, it is the only way to go.

Maximizing the Effectiveness of Graphic Displays

Once the visual team has decided to use graphics in the display concepts, the investment should be a sound one. With all of the innovative processes and output available with new graphic technology, a wealth of graphics is readily available. Before making any final selections, and once having made them, it is necessary to ensure that their effectiveness will be maximized. The following are some of the areas that should be addressed to achieve the goals expected from graphic presentations:

- *Coverage of the marketplace.* Just about every day, or so it seems, a new producer, technique, or graphic concept comes onto the graphic scene. With all that is available, it is essential that users educate themselves about graphic products from stock houses or the numerous photographers who will "shoot" custom images. In this way, it is more likely that the right decisions will be made.
- *Exclusivity.* Just as merchants want to ensure some degree of exclusivity in their merchandise assortments, so too must their visual merchandisers provide uniqueness. In-house development and production of the graphic concept is akin to private labels and brands that guarantee exclusivity. If, however, stock photography is used, care must be exercised to make certain that the images will be for that company's exclusive use within a specified trading area. If this is not carefully spelled out in a written **exclusivity contract,** the graphic provider is not bound to limit the use of the photographs. In these very competitive times, retailers must create an image to continue in business. The use of unique graphics will help achieve this goal.
- *Product longevity.* The time that a specific graphic is needed to carry out a theme or concept may be as little as a few weeks or as long as a few years. In the case of interior graphic usage, the time is generally brief, perhaps for a few weeks to a month or as long as a season. In these cases, long-lasting materials will not be necessary nor will special techniques for reproduction. For outdoor use, such as temporary facades, for example, for shielding a new, permanent structure from the elements and the eyes of passersby, the graphic may need to last for a year or more. In such situations, special care must be exercised to make certain that adverse weather conditions will not damage the graphic. It is also necessary to make certain that billboard graphics are carefully produced to deal with rain, sunlight, or anything else that will render them unattractive after a short period of time.
- *Placement.* It is important to make certain that graphics of a fragile nature are not within reach of shoppers. In the case of open-back windows, for example, it is likely that a child's hand will quickly damage the picture. There must be some form of window "backing" to prevent this from happening. Similarly, graphics suspended from ceilings on chains or dowels should not be within reach of passersby. Not only can they be mishandled but they could also be the cause of lawsuits if the handling loosens them and harms someone.
- *Graphic fixture maintenance.* In cases where illumination is imperative to the graphic display, as in the case of backlit transparencies, it is necessary to make certain that the lightbulbs encased in the fixture are changed when they begin to dim or burn out. Without illumination, the display will lose its effectiveness. Other

graphic displays that require regular maintenance are full-screen motion installations, prismatic displays, scrolling productions, simulated neon displays, light walls, and edgelit installations.

When all of these "checkpoints" are either carefully and faithfully investigated or regularly addressed, maximum use and effectiveness will most likely be achieved.

chapter review

key points in the chapter

1. Many visual merchandisers are overcoming their budgetary restraints by using a multitude of digital and other graphics for their display presentations.

2. Some of the retail giants in the industry design and produce their own graphics so that they are specifically tailored to their needs.

3. The vast majority of merchants use stock graphics for their companies; by doing so they save the expense generally associated with custom projects.

4. Stock houses maintain libraries that include thousands of images of every description for immediate selection by visual merchandisers.

5. The use of stock photography has several advantages, including price, seeing exactly what the piece looks like, getting images in a matter of minutes, and securing quality products.

6. Backlit transparencies are considered to be one of the more important types of graphics used since they provide a special impact through their illumination component.

7. Digital images are being produced in enormous sizes for both interior and exterior use and on materials that can withstand the problems associated with adverse weather conditions.

8. Prismatic displays and motion graphics add yet another dimension to graphic presentations. Their ability to "move" often motivates the shopper to stop, look, and, sometimes, listen.

9. First-hand evaluation of graphic technology and products can be accomplished at the various vendors' showrooms, at trade expositions, and sometimes at the user's own premises.

10. In order to maximize the effectiveness of graphic displays, potential users should carefully cover the marketplace, determine if product exclusivity is available, inquire about product longevity, and make certain that the graphic fixtures are properly maintained.

terms of the trade

backlit transparency 236
banners 240
custom graphics 242
digital images 238
edgelit installations 237
exclusivity contract 242
graphics 234

laser photo imagers 238
light walls 240
motion displays 239
multifaced backlit presentations 237
multi-image displays 240
prismatic displays 239

scrolling display productions 237
simulated neon displays 237
standard inkjet printers 238
stock houses 235
stock photography 235
superwide inkjet printers 238

internet exercises

1. The number of different professional photography resources continues to grow in the United States. All across the country, societies, associations, institutes, and other groups are addressing the needs of retailers in terms of graphics for their visual concepts. Pretend that you are director of visual merchandising for a major chain organization and would like to assess the different resources to determine which you should use for your displays. After logging on to the website www. stockphoto.net/Associations.html, select five associations to contact and determine which has the greatest potential to

serve your company's needs. Complete the accompanying chart on page 246 and discuss your findings in an oral presentation. To make your report even more informative, you should request samples of the vendors' work. Make certain that you tell the group that this is an educational project.

2. Much information is available about the various companies that specialize in the different types of graphics currently being used in retail environments. Many of these companies can be found by accessing such search engines as www.google.com. Companies like Clearr Corporation, EPS, and others have websites that give an overview of their operations and provide pertinent information that will help the potential user decide to pursue additional contact with the company. Select one of the websites for a company that specializes in graphic formats and prepare a report that addresses each of the following:

- the company history
- specializations
- technology employed
- clients
- published articles
- contacts

To make the report even more informational, request examples of their products and adhere them to foamboard.

discussion questions

1. Why are many visual merchandisers embracing the use of graphics for their displays rather than using the traditional props and background materials?

2. How can companies wishing to go the graphic route for display acquire products with a minimum of effort?

3. What approach to procurement of unique or more individualized graphics is available to retailers and other business enterprises?

4. What type of retail organization is more likely to maintain its own graphics development facility rather than make use of acquired graphics?

5. In what way can stock photography serve the visual merchandiser even better than the customized approach?

6. Why do backlit transparencies often attract more attention than the standard graphic presentations?

7. How can digital images used in billboard sizes for exterior purposes withstand the problems associated with inclement weather conditions?

8. What is a prismatic display and why is it generally advantageous to the standard formats?

9. Where are motion graphics generally used?

10. In what way does the "light wall" graphic presentation differ from the other graphics used by retailers?

11. What types of materials are used for banner graphics?

12. How can potential users of graphics learn about product availability without leaving their headquarters?

13. What types of venues are available to those who wish to get a first-hand look at available graphics?

14. Why would a trade show or exposition best serve the visual merchandiser who is seeking to purchase graphic products?

15. Can an in-store visit by graphic vendor representatives provide as much information and product examples as visits to vendor showrooms?

16. Why should retailers make certain that the graphics they purchase from stock houses come with the guarantee of exclusivity?

exercises and projects

1. Visit a mall or downtown central shopping district in your area for the purpose of observing and categorizing five different types of graphics. Each type should be photographed for use in an oral presentation to the class. The pictures should be mounted to a foamboard for use during the talk. Complete the chart on page 247 using the graphic examples that you discovered during the research project.

2. Contact a major retailer and arrange for an interview to learn more about its use of graphics for visual presentations. The interview can be an in-person visit, a telephone call, or an e-mail. The best person to speak to is a member of the company's visual merchandising team or someone in public relations or promotions who would be familiar with the company's graphics. With the information gathered, prepare a typed paper, double-spaced, that is no longer than three pages. (*Note:* Make certain that you identify yourself as a student and make clear that the information gathered is to be used only for classroom purposes.)

Case Problems

Case 1

For the past year, the Mandarin Male, a twenty-unit chain that caters to the eighteen- to thirty-year-old market, has trimmed operating expenses in many of its divisions. The size of the sales staff, for example, has been somewhat reduced in favor of a more relaxed approach to selling that allows for the shopper to look around without the assistance of a salesperson. Not only does this save the company money but it also presents the store as a nonpressure selling environment. The new selling approach has proven successful, with sales remaining at the same levels as before.

The next area that is to be affected by the cost-saving effort is visual merchandising. Heretofore, the company has maintained a centralized visual merchandising division in which all displays are developed at company headquarters and are used as the basis for window and interior displays in each of the chain's units. Cathy Underwood, director of visuals, and her staff would create the displays, photograph them, prepare instructions for those in the company that actually do the installations, and evaluate their effectiveness through periodic in-store visits. Ms. Underwood used the traditional approach to visual merchandising to display the merchandise. Props were purchased and used in all of the stores, an expense that has continued to spiral upward and has now become too costly for the company to use. With the cost-cutting imperative, the visual team has been directed to continue its centralized visual concept but to create a more cost-effective conceptual approach that would maintain its current level of timely display. Not only does upper management want savings in terms of props, it also plans to eliminate the visual teams that travel to the stores to install the displays. They have directed Ms. Underwood to devise a plan that would make the individual store managers responsible for all display work in their respective units.

After considerable discussion, Ms. Underwood and her team decided to join the graphics bandwagon. Gone would be the traditional display fixtures and props, and in their place would be digital graphics that could be used in the windows and store interiors. Since only the development of graphic themes would be required under this plan, the "touring" visual staff would be eliminated, saving the company money. Graphics, either custom designed or selected from stock houses, would be sent directly to the stores for installation. The only decision that needs attention before the change can be made is whether or not The Mandarin Male should install its own in-house graphics facility in which custom products could be designed or use stock graphics from agencies. At this point a decision has yet to be reached in terms of the approach the company should take.

QUESTIONS

1. Which approach would you recommend if you had the ultimate decision to make? Why?
2. What are the pros and cons of each consideration?
3. Do you think the company might embark on yet another visual merchandising approach in place of the graphic approach? What would it be? Would it be as cost-effective and would it be as likely to achieve the goals of the visual merchandising division?

Case 2

Raintree Center is a major mall that opened twenty years ago in a suburban midwestern community. It quickly became the centerpiece for shopping in that area, attracting consumers from a radius of seventy-five miles. Its success caused a decline in sales in the region's two downtown central shopping districts, eventually rendering them of little importance as viable shopping venues.

Last year, Raintree felt the effects of another shopping mall that was designed to serve the same market. Just as Raintree caused problems for the aforementioned shopping districts, the new retailing environment has started to affect sales in the stores that lease space in Raintree. The crowds seem to be growing smaller and smaller, with many beginning to patronize the newer mall. The Raintree management company is not ready to concede failure and is committed to do everything in its power to return to the place of importance it once held with area residents.

After numerous brainstorming meetings between the management company and the anchor tenants, a decision has been made to undergo a face-lift that would hopefully bring the mall "into the new millennium." The stores have all agreed to spruce up their exteriors and interior spaces to provide the shopper with more exciting shopping environments. In addition to the individual structural changes, each has pledged to revitalize its visual approaches to merchandise display.

The mall itself has pledged that it will also make a considerable effort to give the venue a face-lift. The mall plans to create new seating areas where the shoppers can take a break from shopping and a new food court that will feature the traditional as well as more health-conscious fare. In addition, an overall redevelopment of the lighting systems and a major effort in terms of unique graphics are planned for the mall's corridors. At the present time, a consulting firm has been employed to carry out the details of the graphics plan. It is responsible for choosing graphic technology that will give the mall a newer and exciting environment—one that will attract the lost customers back to the mall.

Many different approaches were considered during the preliminary discussions with the management team. These include the use of backlit transparencies (many of which are multifaced), simulated neon displays, billboard-size digital images that will hang in central areas, prismatic displays, motion displays, and light walls. Each will be designed for a specific purpose and should help to generate interest in shopping.

Using all of these formats could be too costly for the mall to endure, and only those with the greatest potential would be used. At this point, discussion is still centered on determining where the dollars should be spent.

QUESTIONS

1. If you were a member of the Raintree management team, which three of the suggested graphic approaches would you select for the mall? Why?
2. Would you proceed on a single thematic concept, or would you use different concepts for each of the formats? Why?
3. Would you suggest that the approach be used to promote the entire mall, or would certain graphic installations be assigned to individual stores for short periods of time? Defend your answer with sound reasoning.

NAME: _____ DATE: _____

Organization	Location	Specialization

NAME: _____ DATE: _____

SHOPPING VENUE	GRAPHIC CLASSIFICATION	THEME

Comments _____

point-of-dis

Objectives

After completing this chapter, the student should be able to:

... Define the term *point-of-purchase* as it relates to today's retail environments.

... Discuss the reason for the wide cost variations in point-of-purchase fixturing.

... Explain why vendors are anxious to provide retail clients with point-of-purchase units at little or no cost to the client.

... Describe the various types of point-of-purchase fixtures that are used in today's retail establishments.

... Discuss the various materials that go into the making of point-of-purchase units.

... List the various types of retailers who use point-of-purchase displays, and name the different displays each retailer might use.

purchase
play

Introduction

For many years, manufacturers of small items such as hosiery, sunglasses, and greeting cards were anxious for their products to make an impact on the selling floors of the retailers they sold to. Generally, most of these vendors found their merchandise mixed with offerings from other vendors, thus diminishing their presence in the overall merchandise mix. In an effort to separate and distinguish their items from the others, some of the vendors designed and produced inexpensive, self-contained stands and shelves that featured their lines exclusively. The units were generally constructed from corrugated materials and featured the brand's name, logo, or other identifying marks and space on which to feature the merchandise. A visit to any supermarket, for example, would reveal a point-of-purchase display unit filled with hosiery or sunglasses, located somewhere near the checkout counters. Thus, when consumers thought of point-of-purchase displays, they concluded that they were inexpensively created display units, designed and produced by the vendors of consumer goods for use in retail operations. Today, the concept has been considerably expanded. The early types of point-of-purchase units are still used successfully, but others have been developed that are more costly and permanent.

The success of this type of display can be measured in a number of ways. First, Washington, D.C.–based Point of Purchase Advertising International **(POPAI)** has reported that the use of such devices increases sales by as much as 30 percent. Second, what was once a minor part of the display industry has now become a $17 billion industry. The significant advance in this type of merchandising has been attributed to the enormous increase in the number of in-store shops.

The early concept of point-of-purchase that used temporary, inexpensive display racks has now taken on a new definition. Today, POPAI defines point-of-purchase as "displays, signs, structures, and devices that are used to identify, advertise, and/or merchandise an outlet, service, or product and which serve as an aid to retail selling." Those engaged in point-of-purchase production and usage are generally members of POPAI, the subject of the following Profile.

This chapter will focus on the stores that use point-of-purchase displays, the different types of displays that are in today's marketplace, and the materials used in their construction.

Retail Point-of-Purchase Users

It seems that no matter which store we enter today, there is some form of **point-of-purchase** display in evidence. Retailers such as **mass merchandisers,** supermarkets, warehouse clubs, pharmacies, greeting card stores, record shops, specialty organizations, and even department stores have embraced point-of-purchase. Each uses the type of fixturing combined with signage that is best suited for its environment and will best motivate shoppers to buy.

Mass Merchandisers

Companies such as Wal-Mart, Kmart, and Target that deal with a vast assortment of **value-priced merchandise** are significant users of point-of-purchase units. The merchandise that these units feature is often not carried by these stores in abundant quantities but stock to round out their product lines. In order to emphasize items such as reading glasses, paperback books, records, and tapes, they are stacked on the holders supplied by vendors and feature the vendors' name, logo, and a product assortment (Figure 15–1).

The newer entries are interactive units. For example, in Target stores an interactive display for music sales features a variety of tapes and CDs as well as a sound and sight monitor that, when started by the consumer, plays a sample of the tape or CD requested. Other interactive units enable the user to sample products. The remainder of the units in

PROFILE: A Contemporary Visual Merchandising and Environmental Design Profile: POPAI

The Point of Purchase Advertising International (POPAI) is the only trade association of the point-of-purchase (POP) advertising industry and is dedicated to serving 1,700 members internationally by promoting, protecting, and advancing the broader interests of POP advertising through research, education, trade forums, and legislative efforts. The organization aspires to enable the industry to influence consumers' buying decisions. It also seeks to advance the evolution of point-of-purchase advertising as a strategic medium integrated into the global marketing mix. It offers its members the tools they need to

be knowledgeable about POP advertising and to adhere to the standards of practice. The organization is headquartered in the United States, in Washington, D.C., with chapters in Europe, Australia, New Zealand, Brazil, and Argentina. Committees in Canada and Mexico are part of the North American membership.

A vitally important aspect of the association's role is to offer its membership information through numerous regular research studies. The research includes consumer buying studies, investigation of the size of the industry, and a color compendium of the best in point-of-purchase

advertising. To round out its services, it offers a lead referral program in which members are provided contact information in any location or area of expertise.

Extremely valuable to the members is the ability to learn about the most recent innovations in the field by logging on to its website, www.popai.com. There the viewer can quickly get any information needed. The websites calendar of events is available online to both members and nonmembers, which helps to deliver up-to-the-minute places, dates, and times when specific industry events are to take place.

these types of stores are the **corrugated cardboard fixtures** that are generally for temporary use, turning wire racks that can be quickly spun to see the entire offering, and wooden units that have more permanency. These point-of-purchase display units generate impulse purchases that would certainly be lost if the items were mixed in with the remainder of the stores' merchandise.

Figure 15–1 Self-service fixturing is a staple in most mass merchandise stores.
(Courtesy of The Elliott Group.)

Supermarkets

When supermarkets originally opened their doors, their product assortment was primarily food-oriented. Departments for produce, meats and poultry, canned goods, paper products, and so on were designed to satisfy the shopper's household needs and generate enough business to make the company profitable. As time went by, supermarkets became more and more price competitive, with markups and profits dwindling. One solution to this problem was the introduction of nonfood items. Merchants began to set aside shelf space for nontraditional supermarket items that carried higher markups than food and thus brought greater revenue to the store. Most supermarkets that want to feature unique or limited-quantity items they hope will appeal to the shoppers start by adding point-of-purchase units on their selling floors. Placed in high-traffic areas such as the checkout counters and **endcaps,** these units reap excellent rewards for the stores.

Warehouse Clubs

Throughout the country, many **warehouse clubs** have opened their doors to member shoppers. Major operators such as Sam's Club and Cosco appeal to huge numbers of people seeking to save on purchases ranging from food items to household goods. Since these operations are totally devoid of service, the way many of their suppliers attract attention is through the use of point-of-purchase displays. Whether they are freestanding structures (which are generally of the corrugated type) or endcaps, they help to get the message across and sell goods.

Pharmacies

At one time, pharmacies were primarily designed to provide customers with prescription drugs and over-the-counter medicines, as well as other related items. Today, this area of retailing has significantly expanded to include a variety of other products. Whether the stores are individual proprietorships or large chains such as Walgreens or Eckerd, they successfully merchandise items ranging from greeting cards to hosiery. In these operations, with medicine purchases the primary objective of patrons, the merchants must find ways to direct attention to the other products. For most, the key is to use point-of-purchase displays. The display units are strategically situated in such places as the prescription-filling areas, where people often wait for their prescriptions, and at checkout counters, although they can be placed anywhere in the store. The units used in pharmacies include (1) revolving metallic wire stands for items such as sunglasses, (2) permanent fixtures that feature greeting cards and cosmetics, (3) corrugated units that stock suntan lotion during the warm months, and (4) glass-enclosed freestanding shelves that feature giftware.

Because competitive pricing limits the profits on pharmaceutical items, operators of these stores are merchandising more and more items that are less competitively priced and are often bought on impulse. What better way is there to alert shoppers to these items than with point-of-purchase displays?

Greeting Card Stores

Primarily in business to sell greeting cards throughout the year, many greeting card stores are expanding their offerings to increase sales. As in the case of pharmacies, they use various point-of-purchase fixtures to feature their other merchandise. Products such as novelty toys, giftware, boxed chocolates, and paperback books are found on special display units throughout the store to tempt shoppers. Even special types of greeting cards that would be overlooked if merchandised along with the regular inventory are featured on point-of-purchase display units.

Specialty Organizations

Specialty shops—businesses that restrict their merchandise offerings to one major classification of goods—continue to grow in number. Whether the stores feature apparel, shoes, gourmet foods, recorded music, or anything else, the rate of expansion is significant. In most of these shops, extra complementary items are featured. An apparel shop, for example, might stock a particular vendor's hosiery that is merchandised on a revolving rack supplied by the vendor. Generally placed near the store's checkout register, the display might remind a shopper to purchase hosiery to complete the outfit just purchased. The gourmet food store might have a special fixture that features a grower's wine of the month and alerts the shopper to its availability. The shoe store often features a special rack that offers a full line of shoelaces or shoe ornaments. If they were not prominently displayed on special fixturing, these items would sell in much smaller quantities. Many of today's vendors are employing design firms to produce unique point-of-purchase fixturing that is replete with company brand names and places to stock merchandise (Figure 15–2). Point-of-purchase fixtures in specialty stores range from those that have a temporary purpose to sturdy, permanent fixtures.

Department Stores

A shopper entering a department store is not apt to find the point-of-purchase fixtures and displays that grace the premises of the mass merchandisers, supermarkets, warehouse clubs, and specialty stores. The department store is generally a service-oriented operation that is more upscale than most of these retailers. Thus, the point-of-purchase displays take on a different format and look, as in the case of the cosmetics area (Figure 15–3). These departments, by and large, are joint ventures of the stores and the cosmetic manufacturers. Each plays a role in its management and merchandising. In these departments, point-of-purchase displays are commonplace. The signage and graphics, provided by the manufacturer of the products, are ever changing to coincide with the new season's offerings.

One growing trend in department stores is the in-house vendor shop. **In-store vendor shops** have become increasingly important: Designers and well-known manufacturers such as Ralph Lauren, Donna Karan, Calvin Klein, and Chanel often arrange to have shops inside the department store that are separate from the regular departments. These vendors

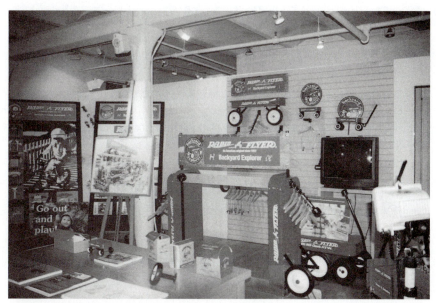

Figure 15–2 Point-of-purchase fixture in the design stage.
(Photograph by Ellen Diamond.)

Figure 15–3 Cosmetic manufacturers traditionally supply their own POP fixtures to department stores.
(Photograph by Ellen Diamond.)

often supply the fixturing, signage, special merchandise racks, logos, and anything else that is exclusive to their lines for the stores. In this way, the shopper is shown the merchandise in a new light. Unlike the temporary corrugated fixtures found in other types of retail institutions, these point-of-purchase display fixtures and presentations are of the highest quality. The concept is good for both the vendor and the store. The vendor gains by having a special section devoted to its collection, and the store gains because the fixtures are often supplied by the vendors at no cost. Another major income-producing point-of-purchase display in department stores is designed to sell hosiery. The fixtures that are vendor supplied generally feature the vendors' names and are exclusively created for use in department stores.

Major Reasons for Point-of-Purchase Use

POPAI notes in its research piece, *Size of the Industry Study,* the following reasons for the use of point-of-purchase advertising:

- *The effectiveness of POP advertising is clearly demonstrated by sales impact.* In a study undertaken with Kmart and Procter & Gamble, which used control store testing, triple-digit sales increases were demonstrated for products supported by POP displays compared to those without such support.
- *POP advertising is persuasive.* It is the only mass medium executed at the critical point of confluence for the three elements needed for any commercial transaction: the product, the consumer, and the dollars to purchase the product.
- *POP advertising serves as the silent salesperson.* POP displays, signage, and in-store media educate and inform consumers about a product's availability and attributes. Coming at a time when most consumers want more information, and retailers have reduced staffing levels, it performs a vital service and augments cost-reduction efforts.
- *POP advertising is flexible.* It is the only mass advertising medium that can convey the same overall strategic message in differing languages in the same village or city.

- *POP advertising is increasingly sophisticated in its construction and use.* It is more easily assembled and maintained, and at the same time, more powerful in entertaining and informing in the retail environment.
- *POP advertising is used increasingly by retailers to enhance the shopping experience.* It is used to help overhaul a store's image, redirect store traffic, and bolster merchandising plans.

Point-of-Purchase Fixtures

As mentioned in the preceding section, there are different types of point-of-purchase displays and fixturing available to retailers. They range from those designed to last for just a brief period of time to those that are more permanently installed.

Interactive Video

One of the newest formats for use in retail operations is known as **interactive video** (Figures 15–4 and 15–5). These screens entice the shopper to learn more about the specific products the display features. One major proponent of interactive video is Microsoft. In an area that is actually a **shop within a shop,** and that features unique signage and display racks, the interactive video has drawn significant attention. The prototype for this point-of-purchase display presentation is a 500-square-foot shop inside Nebraska Furniture Mart's Mega Mart. In this one area, an abundance of Microsoft's product line is featured. The interactive videos, encased in kiosks, allow customers to experiment with specific computer programs and learn about their benefits. Since the installation of this point-of-purchase store within a store, Microsoft sales have increased 50 percent. Another example is Dickson Cyber Express in Hong Kong. This store features an interactive point-of-purchase station where shoppers can examine the company's product offerings and order them without sales assistance.

Figure 15–4 Interactive point-of-purchase facilities allow customers to scan a company's product line and to order without assistance.

(Courtesy of JGA, Inc., Laszlo Regos Photography.)

Figure 15–5 Self-contained hosiery fixtures alert shoppers to specific brand names and enable shoppers to serve themselves.
(Photograph by Ellen Diamond.)

Figure 15–6 Gondolas on wheels allow for the fixture to be moved from place to place.
(Courtesy of The Elliott Group.)

Gondolas

Constructed of materials such as wood, metal, and pegboard, **gondolas** are permanent fixtures on wheels that can be moved from one location to another (Figure 15–6). They house a variety of items, including hosiery, computer software, foods, greeting cards, and so forth. They are equipped with signage featuring the vendor's name and sometimes its logo and providing immediate recognition for the products they house. They are found in all types of retail operations.

Closed-Circuit Video

Many apparel and women's accessories designers and manufacturers are developing **closed-circuit videos** for use at the point of purchase. Designers like Donna Karan, for example, provide retailers with videotapes of runway shows of their latest collections. In this way, shoppers can stop, look, and listen to learn about the clothing. If sufficiently motivated, the next step would be to examine the merchandise on the racks to find something appealing.

Another very successful in-store video presentation was developed by Vera, a scarf manufacturer. The presentation shows the various ways scarves can be used to create interesting effects. Shown close to the counters where the scarves are available for sale, the video acts as a motivational device to examine the inventory.

In the Disney stores, there is a continuous showing on a large screen of the movies available on video. Young and old watch these features and are often tempted to buy those that catch their fancy. Adjacent to the viewing screen are shelves filled with the videos for easy purchase.

Motion Creations

Moving objects at the point of purchase are excellent tools to capture the attention of the shopper. One of the biggest users of these devices is the Disney Store. In both the windows and store interiors, characters such as Mickey Mouse and Donald Duck can be seen in motion. They quickly capture the attention of the passersby, tempting them to come into the store, where they are greeted by other **motion creations,** often resulting in a purchase.

In-Store Shops

The in-store shop is helping many vendors and retailers increase sales. The fashion industry was the first to enter this market, and many other industries have jumped on the bandwagon. The Nickelodeon brand, for example, inhabits a separate part of each Blockbuster Video store intended to attract parents and children. As the kids enter the area, they are automatically filmed and the results are played back on a video monitor. Also featured are play benches set in front of a television set that features Nickelodeon programming. In addition, this point-of-purchase location has interactive terminals that allow the children to offer their opinions of Nickelodeon programming. Cutouts of the characters seen on the vendor's programs round out the presentation, making it visually exciting. Others subscribing to the in-store shop concept include Wrangler, Reebok International, and the Bank of America, which now operates in-store facilities in supermarkets.

Countertop Cases

In order to attract shoppers to seek merchandise on the shelves, some vendors supply their retail clients with countertop glass enclosures that attractively highlight some items. One such company is Lantis Corp., which uses the cases to spotlight its Killer Loop/Active Sunglasses in department stores. The glasses are featured on a contemporary steel construction that allows for viewing from different sides. The products are targeted at skiers, surfers, and snowboarders and are separated on this construction from the traditional products, making them stand out.

Cardboard Fixtures

When temporary point-of-purchase fixturing is the goal, an inexpensive material is generally the choice. Often, some form of cardboard or other corrugated material is used. Vendors have fixtures designed so that they can be shipped in a folded state and easily assembled by

the retailer. They might be a one-piece configuration that simply folds out along **scored lines,** with flaps quickly inserted into designated places for completion. Others involve several separate pieces that are quickly assembled. Greeting cards for specific occasions such as graduation, the latest best-seller paperback book, and seasonal decorations such as those used at Christmastime all make use of these temporary devices. When the period of selling has passed, the retailer generally disposes of these units and replaces them with others that are more timely.

Computer Stations

With the population becoming more and more computer literate, many vendors are now offering **computer stations** to their retail accounts that enable users to create their own products. One of the more popular is the station that lets customers create their own greeting cards. Following simple computer instructions, customers choose the color of the paper, the design, the message, and any other detail to create personalized greeting cards. Personalized T-shirts are also created using the same technique. Although stores generally stock traditional T-shirts and greeting cards, the point-of-purchase computer station allows for originality and also acts as a motivational tool for the department.

15 chapter review

key points in the chapter

1. The Point of Purchase Advertising Institute (POPAI) is the major organization that reports about the latest innovations in point-of-purchase displays.

2. Point-of-purchase is defined as "displays, signs, structures, and devices that are used to identify, advertise, and/or merchandise an outlet, service, or product and which serve as an aid to retail selling."

3. Point-of-purchase displays are used throughout retailing; the units used by the various retailers differ according to their needs.

4. Mass merchandisers often use point-of-purchase units to feature merchandise that they do not carry in very large quantities, but stock nevertheless to round out their merchandise assortments.

5. Supermarkets, while primarily in business to sell food items, often use point-of-purchase units to feature nonfood items that are generally more profitable than their food lines. They usually place these items at endcaps and checkout counters.

6. Many pharmacies are adding nonpharmaceutical lines to their inventories as a means of expanding sales. These products are often featured on point-of-purchase display units and, if sufficiently eye appealing, motivate shoppers to buy on impulse.

7. The department store was the first retailer to subscribe to the concept of in-store shops. Vendors such as designers and

manufacturers provide the retailers with the fixtures and signage that form these shops and help to distinguish the merchandise found in them from the store's regular assortment.

8. Interactive video is one of the newest formats in point-of-purchase displays. The structures use screens that entice the shoppers to learn more about the products.

9. Gondolas are permanent fixtures on wheels that can be moved from one location to another. They hold merchandise as well as identifiable signage.

10. Closed-circuit video presents a vendor's complete line of merchandise, such as a designer's collection, and is intended to motivate the shopper to seek the merchandise on the selling floor.

11. Motion creations attract attention to specific products and are designed to convince the shopper to buy the store's items.

12. Cardboard fixtures are temporary and are used only for the period of time in which certain merchandise is salable. They are inexpensive, easy to assemble, and can be discarded after their usefulness has passed.

13. Computer stations enable shoppers to participate in the creation of their own products, such as personalized greeting cards and T-shirts.

terms of the trade

internet exercises

1. Using the search section on AOL and entering "point-of-purchase advertising," you will be led to a number of different websites that are POP-oriented. Scroll down to the one that reads: **Point of Purchase—Department of Advertising, The University of Texas at Austin.** By clicking on it, you will be shown a number of links that are related to point-of-purchase advertising. Select five of the links and use the information given to complete the chart on page 261.

2. *Point of Purchase* is a magazine that serves the needs of those in the industry. Its pages are full of articles that provide pertinent information to its readers. By logging on to its website, www.popmag.com, you will be taken to its home page, where a number of different areas are available. On the left side of the home page there is section called Reports and Analysis that lists in-depth articles. Choose the one that interests you most, read it in its entirety, and prepare an oral report, to be delivered to the class, concentrating on its main points.

discussion questions

1. Define the term *point-of-purchase* according to the Point of Purchase Advertising Institute.

2. How do today's point-of-purchase displays differ from those that were popular when the concept was in its infancy?

3. By how much does POPAI report that point-of-purchase displays increase sales?

4. How large, in terms of dollars, is the point-of-purchase industry?

5. Which types of merchandise do the mass merchandisers such as Kmart generally sell through point-of-purchase units?

6. Why do supermarkets use point-of-purchase display fixtures to feature items other than food products?

7. Where do most supermarkets feature their point-of-purchase displays?

8. What types of products do pharmacies locate on point-of-purchase display units, and why do they choose to sell this merchandise?

9. What point-of-purchase concept has the department store embraced in which the vendors supply the fixturing?

10. What is meant by a *shop within a shop?*

11. How does interactive video work on the retail selling floor?

12. Describe the gondola fixture and the purpose that it serves for the retailer.

13. In what way do fashion designers utilize the retail operation's closed-circuit video installation?

14. Which major retailer employs motion creations as point-of-purchase motivators?

15. Why do some vendors supply their retail clients with cardboard fixturing instead of the more permanent varieties?

16. Why have point-of-purchase computer stations become popular?

Case Problems

Case 1

The Gourmet Emporium is a specialty food chain that has been in business for fifteen years. There are twenty units in the organization, each carrying fresh produce, meats and poultry, imported and domestic cheeses, baked goods, and fully prepared meals that require no preparation before consumption. The company has been profitable since it opened its first store, always enjoying a steady clientele.

At the regular semiannual management meeting at company headquarters, the discussion turned to increasing volume and profits. Suggestions included expanding those stores that had available space adjacent to their existing premises so that new lines might be added, carrying greater depth in the products now featured, and perhaps reducing prices to gain an even greater market share.

Each of the suggestions met with both positive and negative reactions. For example, while expansion might be appropriate, not every unit had sufficient adjacent space to do so. Carrying greater inventories in the lines now featured might result in a lower stock turnover, which would hamper profits. Price reductions, while favored by some, would cut into profit margins if sales didn't increase appreciably. At this point, management is still groping for a solution to bolster sales and profits.

QUESTIONS

1. What type of program could the Gourmet Emporium embark upon to carry out its desire to increase sales without undergoing major alterations?
2. Which products could it add to its existing lines, using the new format?

Case 2

Lansing's Department Store has been in business for twenty years and operates eight branches in addition to its flagship store. Business has generally been good, with steady gains in profit a regular trend.

The company is a full-service operation with sales associates and personal shoppers available to satisfy the customers' needs. The departments it offers include every aspect of clothing and accessories for men, women, and children, as well as home furnishings. The manner in which it merchandises the departments is to mix each category of merchandise together without any special attention to vendor names. Ladies' Handbags, for example, features Coach, Gucci, Donna Karan, Liz Claiborne, and so on in one area. The other departments are similarly merchandised.

With more and more focus on designer labels, those carried at Lansing's often get lost among everything else offered for sale. A customer who is looking for a Calvin Klein suit, for example, must browse all of the suit racks to find the desired label.

Pat Lane, senior vice president of merchandising, would like to see something new in terms of how special lines are featured. Other management people feel the same but are reluctant to attempt any new approach because it would probably require a large outlay of capital to do so.

At this time, the company would like to find a way to differentiate among collections without having to expend significant dollars.

QUESTIONS

1. How could Lansing's solve its problem?
2. What approach should it take in order to make the change without incurring significant expense?

exercises and projects

1. Write to the Point of Purchase Advertising Institute in Washington, D.C., and ask for a list of the pamphlets, brochures, and publications it offers. Choose one topic from the literature received and report to the class about its use in point-of-purchase displays.

2. Visit three supermarkets in your area for the purpose of reporting about their point-of-purchase display units. Using the form on page 262 for your note-taking, prepare a report on the one that you believe makes the most significant use of point-of-purchase displays.

NAME: _____ DATE: _____

EXERCISE 1 UNIVERSITY OF TEXAS POP LINKS

Organization	Website	Products and Services

EXERCISE 2 SUPERMARKET POINT-OF-PURCHASE DISPLAYS

Name of Store _____

Types of Point-of-Purchase Units

Point-of-Purchase Merchandise _____

Name of Store _____

Types of Point-of-Purchase Units

Point-of-Purchase Merchandise _____

Name of Store _____

Types of Point-of-Purchase Units

Point-of-Purchase Merchandise _____

display as set "consumer

(Courtesy of Marshall Field's, now a Macy's store.)
*Written by Amy Meadows, Visual Marketing Manager, Macy's, Chicago.

Objectives

After completing this chapter, the student should be able to:

... Compare the art of visual presentation to "consumer theater."

... Discuss the threefold mission of windows.

... Explain the basics that must be addressed before any window installation may take place.

... Describe the four display dilemmas that regularly confront the visual merchandiser in planning window installations.

... Explain why a "color" story is an excellent way to visually merchandise a window.

... Discuss how a budgetary shortage can be easily addressed for a window installation.

... Describe the three planes that should be approached in the design of a window.

... Contrast the benefits of a career in visual merchandising with one in the theater.

windows

tings for

theater"*

Introduction

It begins with a pane of glass, a floor of some sort, a back wall (maybe), and, if you're lucky, a **grid** or ceiling for hanging. The rudimentary elements of a display window become the setting for **"consumer theater."** You provide the scenery and lights and your merchandise takes the starring role. Windows can provide a glimpse into the store itself or, more important, allow a carefully edited view of your merchandise and your brand. If a picture is worth a thousand words, then a compelling window is worth a thousand advertisements (Figure 16–1)!

While there are a handful of retailers—Macy's, Saks Fifth Avenue, and Lord & Taylor—for whom windows have been business icons for generations, you will also encounter windows in smaller stores that possess just as much potential and can drive just as much business for that retailer. The individual retailer will not likely have the payroll and supply budget to provide staffing and propping exclusively for the windows, but effective, well-executed windows can be installed within even the most limited circumstances.

Windows possess a threefold mission: they must ENTERTAIN, EDUCATE, and ENTICE (Figure 16–2). With real estate at a premium for a store, why devote valuable space to an edited arrangement of product when that same square footage could hold capacity fixtures? Why block the customer's view inside the store—doesn't that defeat the purpose of an "enticing" display? But how often have you glimpsed inside an open window only to see the back of a register base and a purse or shoes stashed nearby? Hardly enticing!

Too often, the smaller, independent stores feel that the resources or ideas for effective windows are the exclusive domain of the big department stores or the costly consultants. What they must remember is that they are in competition for the same shopping dollar and can use their window as their most effective marketing tool—provided that they are willing to make a small investment of time and money to ensure success.

In this chapter, we will explore many long-held truisms of window display design and execution. While there are several similarities between the skill sets required for both in-store and window strategies, the design disciplines shared by window display and set design/construction for the theater are just as important. In all of those disciplines, the essential first step is the least fun—housekeeping.

Figure 16–1 The use of strategically placed mannequins shown with a simple merchandise rack results in a well-executed window with limited expense. *(Courtesy of Adel Rootstein.)*

Display windows as settings for "consumer theater"

Figure 16–2 The elegance of this display entices passersby to come into the store.
(Courtesy of Marshall Field's, now a Macy's store.)

Housekeeping Basics of Visual Merchandising

Before one begins an installation, start with the basics. The very, very *basic* basics—**housekeeping!** The window must be clean. Not just part of the window, but the entire pane, inside and out, the ceiling cleared of any remnants of past displays (hooks, cable or fishline, staples, etc.).

Step back across the street or across the aisle and take a critical look at both the window and its surroundings. Many business owners enter and exit the store each day through a door in the rear. That's convenient, but not terribly enriching. You must learn to see your business as your customers see you. Appearances and first impressions count—not simply the cleanliness of the window and the surrounding facade but a demonstration of standards in signing, merchandise presentation, and overall philosophy. Is this a retailer that strives to be all things to all customers, or is the business a bit more exclusive or specialized? How would the customer discern the distinction? What level of customer service can you expect to receive from that shop? If it can't take care of its windows or signing or basic housekeeping, chances are that they cannot take care of *you.*

Window Display Dilemmas

In most cases, window display dilemmas fall into four categories:

I DON'T HAVE ENOUGH ROOM!
I DON'T HAVE ENOUGH MERCHANDISE!
I DON'T HAVE ANY WAY TO SHOW IT!

and, everyone's favorite . . .

I DON'T HAVE ANY MONEY!

Space Considerations

Let's begin with the notion that the space isn't large enough. Frankly, it's more likely that the space is more than adequate, but for some reason, the owner or visual merchandiser feels compelled to show one of everything in the window (Figure 16–3)—a veritable smorgasbord of product, all under glass for easy viewing. Well, that's just the problem—it's *too* easy—too easy to see what the store has, too easy to make your decisions from the sidewalk without losing too much time. One can simply sum it up and move on. While it may appear that this situation actually benefits the guest and displays sensitivity to the guest's busy schedule, the retailer has lost key opportunities to both entertain and educate the customer.

In another respect, the overfull window makes it too difficult—too difficult to find the focus, to sift through the signing, to determine what is being sold and why.

When you begin to feel squeezed for space, take a deep breath and **edit.** Edit and then edit again. Pare your merchandise assortment to its most valuable message and start over if need be. This part of the process is an especially scary one for owners of smaller stores—they are probably worried about revealing a lack of artistic skills, but they also tremble at the thought of losing a sale simply because an item wasn't shown. Relax. If one creates a color story and dresses the mannequins in all red, the guest will *not* assume that only red dresses are for sale and, too bad, she wanted black! It will, in fact, convey the idea that one simply must come inside because if there are these many *red* dresses on display, imagine the depth of the merchandise assortment within!

The simplest way to begin is, as suggested, to create a **color story** (Figure 16–4). It can be monochromatic or a combination of colors, for example, black and white. If your merchandise assortment doesn't easily fall within that category, can you build a display around an event—wedding gift registry? Mother's or Father's Day? Christmas?

Merchandise Insufficiency

For the second hurdle, not having enough merchandise, it is more often the case that the merchandise in question is quite small (cosmetics, giftware) and/or the space allocated for the display is left over from a previous retailer. Try "romancing" fragrances in a space created

Figure 16–3 Too much merchandise in limited space detracts from the display.
(Courtesy of Marshall Field's, now a Macy's store.)

Figure 16–4 Creating a color story, by limiting merchandise to one or two colors, is a simple way to use limited space effectively.
(Courtesy of Adel Rootstein.)

for mountain bikes! There might be any number of undesirable or inappropriate elements such as a slat wall or carpeted risers that will hinder skillful execution. Just as one edits the amount of merchandise in order to not overwhelm the display, one must look for ways to edit the viewing area in order to not overwhelm the merchandise.

In order to begin, consider the structure of your window. Does it have a back wall into which you mount shelves or shadow boxes? Do you have a proscenium that can be re-shaped to create a smaller opening? The prevailing rule of thumb states that the customer will spend twenty seconds sizing up a display and making a decision to act: walk on or walk in. The visual merchandiser must be proactive in creating a **vignette** or setting that can be easily "read" for message and merchandise (Figures 16–5 and 16–6). Much of this is simply common sense. Place items at eye level, centered in the space. For some reason, many of the decisions that seem to be second nature in our own homes regarding artwork, furniture placement, and so on elude us when we step inside a store.

Another method for easily reducing your viewing area is to paint your window. Latex wall paint is both affordable and effective as a framing device. It can be rolled, brushed, or stenciled onto the inside of the glass and then easily removed later with a scraper. Please allow enough time and material to apply two to three coats so that light from *inside* the store does not "leak" through the paint application at night. In a pinch, seamless paper that has been torn or cut open to reveal the scene will work also.

Considerations for Effectively Showing the Merchandise

When tackling issues that involve a lack of display vehicles, things can become a bit trickier. After all, this involves a bit of creativity! Words to live by for the small business owner: "If in doubt, hire it out!" It is not realistic to assume that the same individual who is running the business, covering payroll, and handling the buying can also undertake the artistic end of the job. This is where a **freelancer** or consultant can make a difference that more than justifies the cost. If you have run out of ways to show it, you can be sure that an artist, designer, or even another retailer might have some ideas.

Figure 16–5 For limited merchandise displays, the use of an elaborate picture frame can help adjust the setting to the goods.
(Courtesy of Marshall Field's, now a Macy's store.)

Figure 16–6 Draperies quickly reduce space to accommodate a limited merchandise assortment.
(Courtesy of Marshall Field's, now a Macy's store.)

For displaying fashion, the mannequin would appear to be the most logical choice. All mannequins are not created equal, however. The same **dressmaker form** that shows activewear will not be able to shift easily to after-five wear, nor can mannequins intended for designer fashion look good in casual weekend wear. In the world of men's forms, the options become even more complex, with a variety of bust forms versus suit forms versus sweater forms—all intended for specific silhouettes and specific clothing categories. For children, just because they're half the size doesn't mean they're half the cost. They still require a sculpt, paint, hardware, and makeup. Some alternatives to consider include dressmaker forms, folded presentations, hangers, and dowels (Figures 16–7, 16–8, and 16–9).

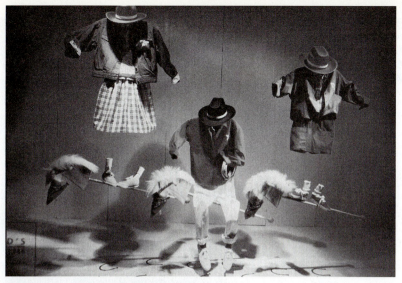

Figure 16–7 Mannequin alternatives are excellent choices for showing merchandise at little expense.

(Courtesy of Marshall Field's, now a Macy's store.)

Figure 16–8 Alternatives to a standard bed are cost-saving and inventive.

(Courtesy of Marshall Field's, now a Macy's store.)

For hardlines merchandise, the number of options increases. A table presentation for china and crystal can also be shown on a series of pedestals, or hay bales, or crates, provided that the format is appropriate to the style and price point for the merchandise.

Creating Effective Displays with Budgetary Restraints

And what about those who declare that THEY HAVE NO MONEY? Honestly, no one ever has quite enough to do everything they would like to do. No money, no problem. The window will require *some* cash—housekeeping supplies, lettering for the windows, and so on, but a large number of effective props and display devices can be obtained for little or no money (Figures 16–9 and 16–10). In a business district, this is a perfect opportunity to negotiate a loan of display props from another store's merchandise—a win-win situation—the store receives credit in the window for the item(s) on loan (a bicycle, artwork, furniture) and you find a low-cost way to enhance your vignette. In addition, look for a tie-in to special events in your community or neighborhood: a summer festival, an upcoming concert, or a theatrical production. You can be sure that the prop master or costume designer of that same theatrical

Figure 16–9 Office supplies are inexpensive products that help overcome budgetary restraints.
(Courtesy of Marshall Field's, now a Macy's store.)

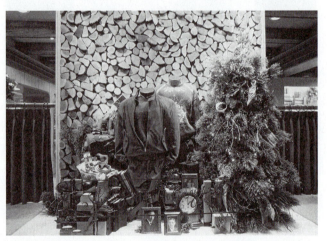

Figure 16–10 Stacking of firewood facings creates an inexpensive backdrop.
(Courtesy of Marshall Field's, now a Macy's store.)

production is interested in making a trade that would benefit both parties! Your cocktail dress for the lead actress in exchange for some extra scenery or props for use in the window? Of course!

Many theatrical set designers find themselves exploring visual merchandising, especially window display, as a career alternative. The jobs share much of the same training, and an emphasis on working under deadline (whether it's an ad break or opening night, one must be able to work with a sense of urgency and prioritization). Crossing from one field to another will find you comfortable on a ladder, handy with a glue gun or drill, and, when you move to responsibility for *design* and not simply execution, you will be adept at implementing important design disciplines.

Considerations for Effective Visual Presentation

Both **legitimate theater** and "consumer" theater require sets that show either the actors or the merchandise to the best advantage. In order to do so, the designer must address three important considerations:

1. *Cleaning the space.* It must be CLEAN, not strictly in a housekeeping sense but in a visual sense. No clutter, no confusion. Even settings that are "over the top" are carefully planned to resemble chaos and excess when, in fact, there is nothing random about them! Closer examination will reveal some very detailed visual organization.
2. *Consistency.* The set must be CONSISTENT—consistent within the propping itself and propping that is consistent within the theme. The window designer might also be challenged to determine whether the scene or display approach is consistent *within the business.* Is the window going to appear out of place within the façade or in proximity to the store's interior?
3. *Creativity.* Finally, the set must be CREATIVE. What is your thematic/**creative focus?** Is it the novelty and newness of the product or is it reinforcing the traditional and familiar aspects of the merchandise?

A benefit of a career in visual merchandising is that mannequins, unlike actresses, cannot storm off the stage (although mannequins have their own prickly dispositions!) and the hours tend to be a bit more regular so that you are available for merchandise calls and so on. In addition, you will enjoy all of the opportunities to design for the stage without the attenuated production timetable (with the exception of Christmas windows, which can take months—even years—of planning).

The "Planes" of Visual Presentation

When approaching the design for the window, be certain to think in three planes: **foreground** (proscenium), middle ground (the traditional "zone" for the merchandise), and background.

The Proscenium The **proscenium** is literally the frame through which you will view the scene. It can be planned to disappear and be as neutral as possible or it can be laden with visual information for your eyes to "collect" as they take in the appearance of that scenery and move further into the set. The foremost plane, or **downstage plane,** is also most likely to be the area for placing the title and location information (in a larger store, this component will call out the brand and department and direct you to the proper place in the building).

Middle Ground The **middle ground** is the "meat" of the display, the traditional placement for mannequins, tables, and so on. Please remember that you can be guided by, but not *bound* by, tradition. The mannequin placed quite close to the glass or pressed against the backdrop will create a different visual energy for your viewer and, in the proper circumstances, can have a very powerful effect.

Background The **background** is less likely to be used as the prime spot for merchandising, unless the space is extremely shallow and/or the design is intended to use the product in that fashion. Depending on the configuration of your space, you may wish to create a back wall with fabric or seamless paper. Ideally, the back wall is plasterboard installed over 1-inch plywood so that you have a surface that can be drilled, painted, screened, and so on for years and years of heavy use. A little spackle, a fresh coat of paint, and the window is refreshed and ready for a new trend or theme.

chapter review

key points in the chapter

1. Windows possess a threefold mission that involves entertainment, education, and enticement.
2. Windows are effective marketing tools that help increase sales.
3. The absolute housekeeping basic is to make certain that the window is cleaned before any display work is initiated.
4. The window display dilemmas that constantly plague visual merchandisers are inadequate space, insufficient merchandise, inability to properly show the merchandise, and lack of money.
5. Color stories are excellent ways to create interesting displays.
6. The appropriate mannequins should be used to show merchandise effectively.
7. An excellent way to overcome budgetary shortages is by borrowing items that can be used as props, such as bicycles, artwork, and furniture.

terms of the trade

background 273
color story 268
consumer theater 266
creative focus 273
downstage plane 273
dressmaker form 270

edit 268
foreground 273
freelancer 269
grid 266
housekeeping 267

legitimate theater 273
loan of display props 271
middle ground 273
proscenium 273
vignette 269

internet exercises

1. As we learned in the chapter, mannequins are an excellent choice for showing merchandise. It is important, however, to choose the appropriate types for the particular merchandise to be featured on them. Using a search engine such as www.google.com with the search words mannequin manufacturers, investigate the various mannequin producer's websites to learn about their mannequins and study the pictures of them. Using one or more of these sites, choose several mannequins that would be best suited for a particular merchandise classification, such as evening wear, active sportswear, and so on, download them, and tell why they are suited to that particular type of merchandise. The photos should be mounted on a foamboard for a presentation to the class.
2. Creating a color story is one way in which to handle small window space. In order to design a color scheme that is appropriate, an understanding of color is essential. Using any search engine with the search word *color,* you will arrive at many sites that explore color. Select one and, using the information offered, write a paper on one aspect of color, such as combinations, psychological aspects, and so on. The paper should be two pages in length, typed, and double-spaced.

Case Problems

Case 1

Twixt and Tween is a relatively small retail operation that is about to open its doors on a busy, downtown main shopping street in suburban Chicago. It is the brainchild of Sara Marshall and Andrea Mitchell. The merchandise concept will focus on upscale, fashion-forward styles for preteen girls.

Both Sara and Andrea are fulfilling lifelong dreams of owning a business. Each has worked for several years in major department stores, Sara as a buyer and Andrea as a divisional merchandise manager. Their expertise focused on buying and merchandising several different product classifications, from women's apparel to fashion accessories.

They made the decision to open a preteen shop after studying the different areas of retailing and discovering that this market was severely underserved. In addition to the formal research they conducted, they learned, firsthand, from friends and acquaintances, there was never enough merchandise in this classification to serve the need.

With a solid monetary investment they were able to establish significant lines of credit and successfully purchase from well-known manufacturers. Their backgrounds in merchandising afforded them the knowledge necessary to determine inventory levels, product mixes, price points, and so forth.

They even had enough design creativity to tackle the chores of visual merchandising.

The storefront featured two windows that would suitably feature their merchandise. The only challenge that they now faced was to design an opening visual presentation that would be attractive, but not eat up unnecessary funds. How to create an eye-appealing display was the challenge. They thought about a freelancer to handle the display chores but found that at this stage of their business development the fees were a little more than they could afford.

QUESTIONS

1. Should they overextend their expenses and employ a freelance display person?
2. How might they create attractive window settings without the expense of costly props?

Case 2

Jack Peters is the visual merchandising vice president of Barclay Ltd., a specialty chain with thirty-five units. The merchandise assortment is primarily focused on serving a female middle-income market with apparel and accessories. The company has been in business for twenty-six years and has enjoyed significant success.

With expenses ever spiraling upward, the profit margin is beginning to disappoint the company's executive team. Property rents and other expenses have adversely affected the bottom line. Although the business in general has maintained a positive monetary position, management is starting to look at some ways in which expenses can be reduced. One area that is being asked to cut back expenses is Jack Peters's visual merchandising.

Ever since the company began its operation, the visual tasks were performed by three professional teams, in three regions, that went from store to store to trim windows and set up interior displays. The system has worked effectively, but the anticipated budget cuts would no longer fund the salaries of these visual teams.

Management proposed that a new concept should be put in place, with store managers and assistants being responsible for the display tasks. In order to carry out such a change, Peters was asked to develop a display manual that each store would have to help with the concepts, designs, and installations.

QUESTIONS

1. Do you think that such an approach is feasible? Why?
2. What topics should such a manual feature to make certain that the level of visual presentation is appropriate to the company's image?

discussion questions

1. What is the threefold mission of windows?
2. Before one begins a window installation, what is the very basic consideration that must be addressed?
3. What are some of the space considerations that must be addressed by the window installers?
4. Is a color story a good way to design a display? Why?
5. How might a trimmer "edit" a window's viewing area so as not to overwhelm the merchandise?
6. Why should most small retailers use a freelancer for their visual presentations?
7. In what way can a shortage of money be overcome when planning a display?
8. Do the theatrical designer and visual merchandiser share much of the same training? Explain.
9. What is meant by the word *proscenium*?
10. Which part of the window is the "meat" of the display?

exercises and projects

1. Visit several retail brick-and-mortar operations for the purpose of evaluating their window displays. Using a digital camera, photograph five windows and judge each one in terms of the following:
 a. The proper use of the space
 b. The merchandise and its appropriateness for the size of the window
 c. Proper mannequin choices, if applicable
 d. Attention to housekeeping basics
 e. Creativity

The photos should be mounted on a foamboard panel for use when presenting your findings to the class.

2. Visit as many retail establishments as necessary in order to locate displays that seem to cost little to create. Take pictures of these windows for a presentation showing how they have been designed without considerable expense. (*Hint:* The reasons might be borrowed props, reused or discarded items, and so on.)

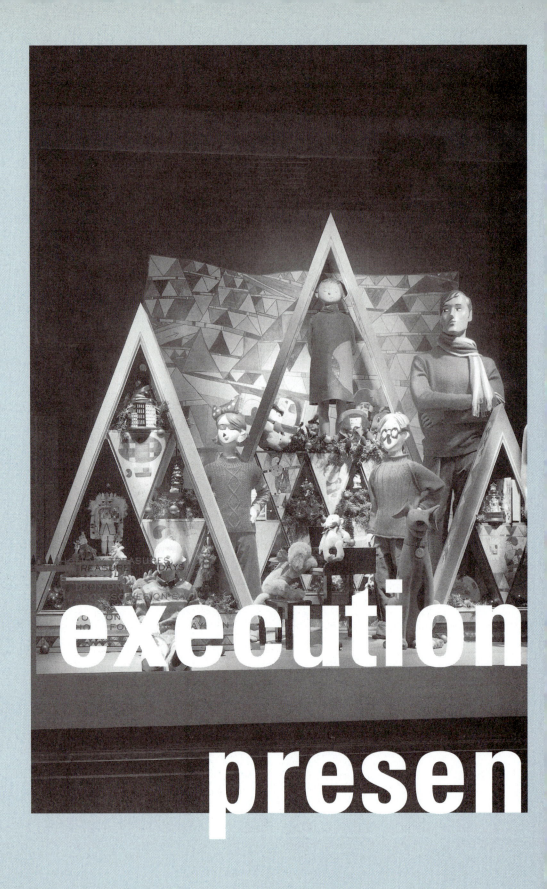

execution

presen

Objectives

After completing this chapter, the student should be able to:

... Describe the stages in the execution of a visual merchandise presentation.

... Discuss the relationship of background materials and props to the merchandise featured in the display.

... List five ordinary props that are inexpensive, are easy to find, and make eye-catching installations.

... Prepare a window space that is to house a new display theme.

... From a variety of available mannequins, choose those that fit a specific theme or setting.

... Explain the major steps involved in the installation of a window display.

... Compare display sketches and graphic plans.

... Draw a preliminary sketch for a window display.

... Produce creative props and install them as exciting displays.

of a visual

tation

Introduction

Mastery of visual merchandising theory in such areas as design fundamentals, mannequin use, color comprehension, and copy preparation is vital to the execution of a presentation that has visual appeal and also motivates the shopper to purchase. However, an individual may know the concepts but lack the competence to actually assemble all of the elements into a good presentation. Compare this person with someone who is knowledgeable in the terminology and schools of thought in the arts, but cannot produce his or her own artistic creations.

The installation of a display requires an approach that is carefully planned and executed with attention to every detail. A written outline or format is often helpful. This outline is similar to the sketch an artist does before beginning a painting. Although this preparation is important to a novice, the seasoned professional in visual merchandising might not need to put every detail down on paper before executing the design. As more confidence is developed, some details will evolve naturally from a basic thumbnail sketch of a display. Of course, in companies that utilize the centralized approach to visual merchandising, as we explored in Chapter 3, detailed blueprints are prepared so that reproduction of the display is easily accomplished.

This chapter explores the various stages in preparing a visual presentation, which include (1) selecting the merchandise, (2) preparing the merchandise for the installation, (3) developing exciting and creative props for use in the displays, (4) assembling props and materials, (5) selecting mannequins and other forms, (6) preparing the space that will be used, (7) lighting preparation, and (8) installing the actual display.

Selecting the Merchandise

Several times throughout the text, the following fundamental concept has been repeated: Unless an institutional concept is being developed, such as a store's commemoration of Columbus Day or a tie-in with National Health Week, *the emphasis for the presentation must be on the merchandise.* The background materials and props are merely enhancers. Selection of the merchandise for the display is the domain of the divisional merchandise manager or the buyer. If two departments' items are to be featured in one window, for example, both buyers should make selections that complement each other's merchandise. In branch stores, if directions do not come from the buyer in the flagship store, the department managers are called upon to select what's new.

Usually, and especially in department stores, only one classification of goods holds the spotlight. However, it is often necessary for the featured items to be properly accessorized. This not only enhances the main items but also helps to presell other items—the end result being a larger purchase. When accessory items such as shoes, handbags, and jewelry are required, the fashion director or coordinator is called upon to select the appropriate items.

In stores that specialize in furnishings and accessories for the home, such as Crate & Barrel and Williams-Sonoma, the merchandise to be featured is selected at the central visual merchandising facilities by merchandisers. Since the displays generally include a variety of items, the decisions are made by several people. In this way, all of the stores in the respective chains will have a similar type of merchandise display running at the same time.

In some presentations, a main group of items is displayed along with accessories to motivate shoppers to purchase more than just the main items. In addition to having the extras boost sales, the impact of the entire display is more effective than if only the main item were featured.

In order to make the greatest impact and increase sales, the merchandise chosen should be timely, have positive eye appeal, and make a statement. The message might be about a current popular style, a particular fabric, a trend that is developing, dinnerware and table accessories for the perfect Christmas dining table, or any theme that the store is trying to convey to its clientele.

It is imperative to have all of the merchandise and props ready when the trimmer is ready for the installation. Care should be taken to arrange the accessories so they will be

featured with the appropriate outfit if the project is one featuring apparel. If items are not carefully organized, the wrong combinations might appear in the display.

Preparing the Merchandise

Responsibility for preparing the merchandise varies, depending on the size of the store and whether it has its own visual merchandiser or retains a freelancer. When merchandise is on loan from a selling department in a large store for use in visual presentations, a specific procedure must be followed to make certain that the items are returned to the department from which they came. The visual merchandising department is responsible for preparing a **merchandise loan form** shown below. The procedure for the form's use is as follows:

1. The form is completed and signed by the borrower and the department manager, or in some situations by the assistant buyer of the lending department. Dates, quantities, merchandise descriptions, prices, and so on must be entered.
2. The department manager of the lending department keeps the original copy of the form and the borrower keeps a copy.

MERCHANDISE LOAN FORM

DATE _____

DATE OF INSTALLATION _____

DEPARTMENT _____ DEPARTMENT NUMBER _____

DISPLAY LOCATION_____

TOTAL DAYS OF THE INSTALLATION _____

DESCRIPTION OF BORROWED MERCHANDISE _____

MERCHANDISE STYLE NUMBERS _____

MERCHANDISE PRICES _____

BUYER'S SIGNATURE _____

DEPARTMENT MANAGER'S SIGNATURE _____

VISUAL DEPARTMENT REP SIGNATURE _____

Note! Department Manager signs and keeps original copy. Visual department signs the original and duplicate copies when the merchandise has been returned. Items not returned by visual department should be noted in the space below.

3. When the display has been dismantled and the merchandise is returned to the selling department, the lending manager completes the bottom of the form.
4. If some items are not returned, this is noted on the form.

Since each department is accountable for its inventory, it is very important that managers make certain that borrowed items are returned.

In large retail organizations, the trimmers handle the final touching up of the merchandise before the installation takes place. Clothing and soft accessories must be carefully ironed to eliminate wrinkles. Shoes should be polished, jewelry must be free of fingerprints, and all hangtags should be removed from garments. In smaller stores, where the freelancer's time is limited and the installation might take place during normal shopping hours, it is imperative that the merchandise be out of the customer's reach until it is needed by the trimmer.

Product placement on the selling floor, along with some instructions, is also the duty of the buyer. He or she prepares a floor plan that is followed by the department manager, and if there are props to be used in the presentation, a member of the visual team completes the installation.

Assembling Props and Materials

Once the merchandise leaves the hands of the assistant buyer or department manager and others responsible for its delivery to the place of installation, the visual merchandisers run the show. By this time the appropriate theme or setting has been established to best show off the merchandise. Unless the promotion is part of a major campaign, generally a great deal of money is not invested in new props for interior displays. Background equipment for such presentations is often chosen from the display storage area and freshened to fit the trimmer's needs. A new coat of paint, rearrangement of props into a new configuration, or using them exactly as they once were used are generally the routes taken for these installations. Pads, if used, are sometimes covered with new fabric to give the display a fresh look. Boxes, covered with colorful or seasonal papers, are redone to create new excitement.

Many stores use a variety of plants such as **asparagus ferns** to complement their interior presentations. This is an effective way to cut costs. Care must be exercised with plants, however, to make certain that low-light varieties are used and that they are watered regularly to maintain their appearance. Dried flowers and artificial leaves are also excellent adjuncts to displays because they have eye appeal and are maintenance-free (Figure 17–1).

Figure 17–1 Inexpensive props such as stuffed animals and toy instruments are effective in display installations.
(Courtesy of Marshall Field's, now a Macy's store.)

Although more and more attention is paid to interior installations, windows are still the major attractions for the larger retailers, especially the flagships of the large department stores. Stores that indulge in these presentations usually spend the bulk of their visual merchandising budgets on eye-catching windows that they hope will entice the shopper to enter the store. As we saw in Chapter 7, multitudes of props are available from many sources. Using creative ability, the visual merchandiser selects just the right props and materials. Unless the presentation is institutionally oriented, inspiration must come from the merchandise. Does the item warrant a theatrical setting or does it stand on its own merits, shown against a simple background? These are but two of the questions that cross the display person's mind when deciding on materials and props. Another question deals with the specifications and shape of the window structure. Some windows allow little in the way of props and materials because of size or design.

When it comes to props, few companies can compete with the imaginative creations of Spaeth Design, whose Profile follows.

Preparing the Display Space

Too often, the space in which the design is to be presented is sorely neglected. Stains or cracks in the walls, fingerprints on the glass, stray pins on the floor, and burned-out lights can seriously mar the presentation's overall effectiveness. In order to produce a high-quality display, the trimmer must pay attention to environmental details as well as to the selection of merchandise. A retail organization that puts up with blemishes in the display areas may soon find its image suffering. A **window and display case checklist** should include the following:

1. Make certain that the walls are freshly painted, all holes are filled in, and staples are removed. If pads that were used before are to be used again, check them for possible damage.
2. Examine valances and frames for blemishes. They might have to be repainted or covered with new material.
3. Vacuum the floor to remove fallen pins or staples.
4. Clean window or display case glass to remove fingerprints and the film that often develops on enclosed windows.

PROFILE: A Contemporary Visual Merchandising and Environmental Design Profile: Spaeth Design

When shoppers gather in front of the Christmas windows of retailers such as Lord & Taylor and Macy's, it is to view the imaginative creations of Spaeth Design. With a worldwide reputation for designing, fabricating, and installing custom displays with mechanical effects, they have become the epitome of imaginative visual presentations. From concept to installation, the design staff—replete with carpenters, artisans, mannequin designers, costume creators, and painters—has been heralded as the best in the field. The *Today Show*'s review, "When it comes to the construction of holiday displays, Spaeth Design is state of the art," sums it up.

With more than 27,000 square feet of space in its New York City facility, Spaeth tackles projects of all sizes. These include "animatronic" and electromechanical displays; theme and environmental ambience for retail and corporate locations; custom props for motion picture, video, commercial, and theatrical productions; museum and exhibit environments; seasonal trim and décor; mall exhibits; showroom design and installation; décor for special events; trade show exhibits; and custom creations for amusement parks and attractions.

A sampling of its client base for the past fifty-five years gives an idea of Spaeth's worldwide acclaim: HarborCircus Mall in Kobe, Japan; Saks Fifth Avenue in New York City, Chicago, New Orleans, and other locations; Lord & Taylor in New York City; Selfridges & Company in London; Macy's in New York City; and Nordstrom in Seattle. Some of the awards Spaeth has received in recognition of its artistic endeavors include:

- *The New York Post's,* "$\frac{1}{2}$ stars" for Christmas displays at Saks Fifth Avenue and Lord & Taylor
- Best of Show, *VM + SD,* for trade show booth and execution
- First Place, *VM + SD,* for international display competition, Lord & Taylor's "Enchanted Christmas"

5. Test all lights and replace burned-out bulbs.
6. Cut wires that were used to hold props and suspend merchandise from ceiling grills or other supports.
7. Clean the ventilation frame surrounding the glass.

Selecting Mannequins and Forms

In most situations, a mannequin is the best way to feature apparel realistically. It enables the shopper to immediately appreciate the garment's silhouette and determine if it is appropriate for his or her needs. In Chapter 6, we learned about the enormous variety of mannequin types and materials and for what purposes each was best suited. Larger stores often have a storage area stacked with many types of mannequins ready to serve the purpose of the particular display. Smaller companies, with a limited budget and space, are less likely to have the opportunity to use different types of mannequins.

If a choice is available, study all of the mannequin styles and choose the ones most suited for the merchandise and the setting in which they will be featured. For example, if the design needs an air of sophistication, a good choice would be fashion-forward, elegant mannequins. Not only are style and image important to mannequin selection, but so are the mannequins' positions and the direction they face. A sitting model might be used to achieve interest and balance. Most visual merchandisers, however, learn early about the pitfalls and limitations of seated forms. They take up more space than standing mannequins and are more difficult to dress. Once the mannequins have been selected, each one must be prepared to properly enhance the garments that they will wear. This generally requires a fresh application of makeup and creation of a hair design (Figures 17–2 and 17–3).

Some windows don't lend themselves to full figures. Visual merchandisers are fortunate to have many other forms from which to choose. As with mannequins, some stores stock a variety of merchandise forms. These, too, should be chosen with care to display goods to their best advantage.

Figure 17–2 In large retail organizations, the visual merchandiser has numerous mannequins from which to choose.

(Photograph by Ellen Diamond.)

Figure 17–3 Fresh makeup applications and new hair designs must be created to properly enhance the featured merchandise.

(Photograph by Ellen Diamond.)

Preparing the Lighting

The last step before the actual installation of a display concerns lighting. Not only must each permanent light fixture be examined and tested for burned-out bulbs, but portable spotlights should be assembled in the right number. The bulbs for all of the fixtures should be examined to determine if they are spotlights or floodlights and changed if the required type is not present. Today's light offerings are so plentiful and diverse, as discussed in Chapter 10, that the trimmer has a wealth of products to choose from to make the installation most effective.

If colored lighting is essential to enhance the display, it will be necessary to prepare the right color of bulbs or gels to achieve the desired effect. Often, trimmers who leave lighting requirements to chance find it difficult to come up with specific needs at the last moment. Without proper lighting, the presentation's effectiveness will suffer.

A final note on lighting concerns the use of **display time clocks** to turn the lights on and off automatically in window displays. Most retailers recognize the fact that shoppers frequently examine their windows when the store is closed. The lights should remain on until they no longer serve a purpose. If lights are left on all day and night, power costs will increase and the bulbs will quickly burn out.

Installing the Display

When all of the preliminaries have been attended to, it is time to assemble and install the display's components. Since the windows play a vital role in motivating shoppers to purchase, it is best for them to be refurbished, if possible, early in the morning before the store opens for

business or after closing time. Another consideration is the amount of disruption that may take place in trimming a window during regular hours. Some stores, especially the smaller independents, experience havoc if the installation occurs at a busy selling time. If an installation cannot be done when the store is closed, precision is of the utmost consideration. The less time for disruption, the better (Figure 17–4)!

The Lord & Taylor flagship store on Fifth Avenue in New York City uses display windows that may be lowered to the basement when a major presentation is being prepared. The windows are lowered in a manner similar to elevators and are dressed out of the sight of the passersby. The entire presentation is raised to street level when it has been completed. The famous Christmas windows are installed in this manner.

The following step-by-step procedure is generally used to install a display:

1. After the entire display area has been prepared as previously described, the background walls should be dressed. If the walls are permanently decorated for use in all displays, there is no further work in this step. Most visual merchandisers, however, rely on background walls to project a certain color, texture, or theme. Pads covered with fabric can adequately serve the needs of the display person. Although paper initially costs less than fabric, it has a short life and damages easily. Draped fabric walls can also serve as background cover. Apply the background material quickly, making certain that neither staples nor other fasteners are visible to the viewer. Note that pads can be prepared in advance in the store's visual merchandising facility, which can eliminate the time and fussing often associated with paper usage.

2. Position the props and fasten them securely. If they are installed carelessly in a window, vibration could cause the props to fall. This is particularly important when trimmers choose **flying props** that hang from the ceiling. Falling props could not

Figure 17–4 The seasoned window trimmer quickly installs displays in a minimum amount of time to avoid disruption of the store's selling activities.
(Photograph by Ellen Diamond.)

only ruin the presentation but could damage the mannequins, forms, and glass panels. In some cases, if window glass is broken, pedestrians could be hurt, causing legal problems for the store.

3. Mannequins, if used, are handled next. There are two schools of thought on dressing them. One group prefers to dress the mannequins in an area adjacent to the window and then place them, fully clothed, into the display. The other school chooses to fit the garments onto the mannequins inside the window. In the case of trimmer-made mannequins, the first choice is better since the operation could be time-consuming. Whatever the preference, place the mannequins without disturbing the flooring. Fabrics tend to shift, paper could tear, and wood could be scratched if care is not taken in the placement.

4. Apply the accessories to the mannequins next. Remove or conceal any merchandise tags.

5. Many windows, especially those of the case type, feature merchandise that is not shown on mannequins. Trimmers often fly some items or use various pedestals and props and a variety of stands for their presentation. These should be placed at this time. If both mannequins and merchandise on props are used, the mannequins should be placed first.

6. Direct the spotlights to the areas that are the highlights or focal points of the display.

7. Place showcards and price cards, if used, in the appropriate areas.

8. Examine the floors carefully for any marks left by the trimmer. Many installers remove their shoes during the installation or use **display socks** over their shoes to minimize marks. However, if there are some blemishes, a handheld vacuum cleaner will remove them as well as stray pins and staples. A small vacuum cleaner is better than a full-size model at this point because it can fit easily into tight spots.

9. Survey the entire display to make certain that its appearance is exactly as planned and that every detail has been considered. The final check often requires moving a mannequin slightly, adjusting a spotlight, or replacing a sign. The job should not be considered finished until this step is completed.

Display Sketches

Many visual merchandisers prefer to complete a preliminary **display sketch** of the upcoming display before it is actually executed (Figure 17–5). Not only does it graphically present the designer's thoughts but it acts as a guide to those who will actually install the presentation. In major companies such as Lord & Taylor and Saks Fifth Avenue, where there is a large visual merchandising team, the director is often the individual totally responsible for theme designs, but the staff carries out the installations. It is certainly easier to convey design concepts with sketches or finished drawings than with words. In companies with distant branches having one or a few trimmers, with the director of visual merchandising located in the flagship store, the sketch is an excellent way to relate the display's concept. As with their merchandise offerings, most retailers want uniformity in their visual presentations to give the total company a unified image. In some cases, these sketches are accompanied by fabrics, paper, signs, and so on to ensure not only that the design is accomplished correctly but that the materials best featuring the merchandise are used.

Graphic Floor Plans

Many chain organizations have hundreds of units across the country and do not employ professional trimmers to install their displays. In the preceding discussion, the sketches were meant for professional trimmers who could easily execute a quality display. Many companies, though, rely on a store manager or someone else whose principal duty is to dress a window or change an interior corner or niche. In order to make certain that the plan can be carried out easily, those companies might choose to set up a display in their home office or central

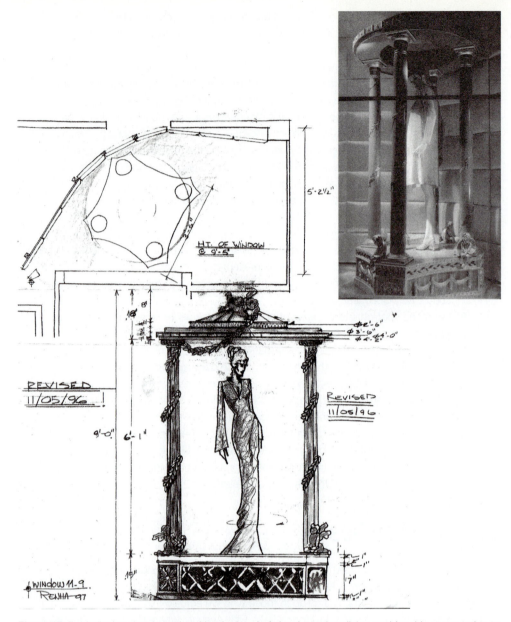

Figure 17–5 A display sketch rendered by the head of visual merchandising enables this presentation to be perfectly installed by the window trimming team.

(Courtesy of Lord & Taylor.)

headquarters, photograph it, and send the pictures along with a scaled **graphic floor plan** (Figures 17–6 and 17–7). These plans show the placement of mannequins, forms, props, floor lights, and signs. Nothing is left to the imagination of the installer, and even those less gifted in visual merchandising can carry out such a plan.

Developing Specific Displays

As we have learned in earlier chapters, Christmas is the time when retailers put their best foot forward to capture the consumer's attention and bring greater sales to their companies. The dollar amounts budgeted for visual presentations are significantly greater than for any other time of the year. Major department store organizations, such as Macy's, Saks Fifth Avenue, and Lord & Taylor, feature display windows in their downtown flagships that require as much as ten months of advance planning. The creations are from Spaeth Design, a New York City

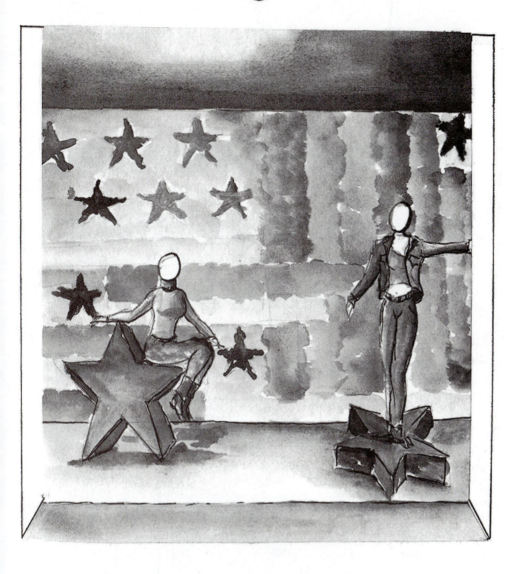

SAKS FIFTH AVENUE
611 FIFTH AVENUE NEW YORK, NY 10022 212 753 4000

Figure 17–6 A watercolor is sometimes created to show the trimmers the exact nature of the display window.
(Courtesy of Saks Fifth Avenue.)

company that specializes in state-of-the-art display installations featuring numerous miniature motorized mannequins in settings that range from storybook tales to historical depictions.

The Spaeth Design Approach

The stages in the development of such presentations generally involve the following steps:

1. Meetings are held between the store's visual director and staff and the Spaeth Design team. The purpose is to brainstorm and develop a concept that will ultimately be transformed into unique window presentations.
2. Sketches are provided by the Spaeth team that will give the retail operation an idea of what the finished product will look like.

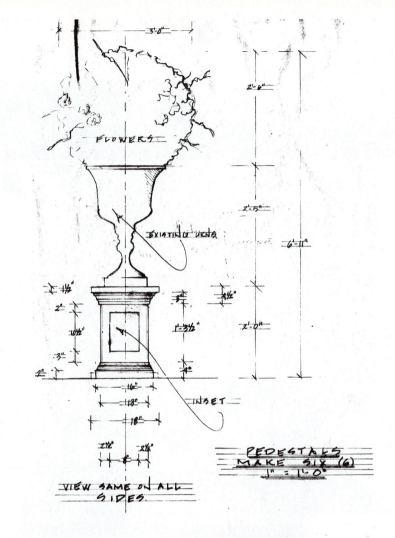

Figure 17–7 Pen-and-ink and pencil drawings, some with specific dimensions, are supplied so that the props can be accurately produced.

(Courtesy of Lord & Taylor.)

3. Once the theme has been approved, the Spaeth Design team prepares exact detailed drawings or blueprints for translating the concept into real sets.
4. The team members that will build the sets and create the display components for it are assembled and given their actual assignments.
5. Carpenters, painters, artists, signmakers, mannequin designers, costume makers, and others each begin to develop and produce the parts of the displays to which they have been assigned.
6. When each element of the design has been completed, they are assembled in the company's facility to make certain that they fit perfectly to produce a display of distinction.
7. The displays are disassembled for delivery to the retailer.
8. At the retailer's store, representatives of the Spaeth team, along with the store's visual merchandising team, install the displays in the windows.

The color insert pages show the collaborative efforts of outside design firms such as Spaeth Design and the Larson Company and the visual departments of Lord & Taylor, and Saks Fifth Avenue, who created these dramatic windows. The photographs in color plates 20–32 feature a behind-the-scenes effort of the Spaeth Design creative staff, with the remainder showing the actual installations.

chapter review

key points in the chapter

1. In the installation of a display, careful planning with attention to detail is a must to guarantee effectiveness.
2. The merchandise displayed in a visual presentation is the choice and responsibility of the store buyer, an assistant, or a department manager.
3. Before garments are positioned in the presentation, they must be carefully pressed, obvious merchandise tags must be removed, and the outfit should be accessorized for a total positive impact.
4. Accessorizing is generally the responsibility of the store's fashion director or coordinator.
5. All props and materials should be selected and made ready for a specific installation on time so as not to delay the presentation and leave display windows and cases undressed for longer than necessary.
6. To cut costs, most retailers require that props be reused as often as possible. Props can be freshly painted and reassembled to convey a new look.

7. Display areas should be prepared carefully before an installation. This includes cleaning glass and floors and checking the lighting.
8. If an assortment of mannequins is available, the trimmer should carefully choose the most appropriate ones for the display.
9. Lighting should be arranged to guarantee the best visual effect. Floor spotlights should be placed properly to create the best lighting accents.
10. A step-by-step procedure should be followed in the installation of a display so that it will be carefully executed in the least amount of time.
11. Display sketches are often used, as well as graphic layouts, to convey the visual merchandise director's message to the trimmers.
12. Many props can be created by trimmers once they have mastered the knack of doing so.

terms of the trade

asparagus ferns 282
display sketch 287
display socks 287

display time clocks 285
flying props 286
graphic floor plan 288

merchandise loan form 281
window and display case checklist 283

internet exercise

1. Log on to www.spaethdesign.com to learn about the different display services that Spaeth Design offers to the retail community. Prepare an oral presentation that describes these services and the different awards the company has received in recognition of its efforts.

discussion questions

1. Why do some visual merchandisers intentionally minimize background props in a window?
2. Who is responsible for selecting the merchandise to be featured in a display?
3. Besides being shown as merchandise for sale, what role do accessories play when used in windows that focus on dresses or outfits?
4. How might a tired display prop be revitalized and reused?
5. What concerns are associated with the use of live plants in a display?
6. List five points to be checked before merchandise is installed in a window.
7. Which mannequin position is most difficult for the trimmer to dress?
8. Define the term *display time clock*. What function does it serve in visual merchandising?
9. What is the best time of the day to trim a store's windows?
10. Why are fabric-covered pads favored by most trimmers over the use of paper?
11. Where is the best place to dress a mannequin that is to be featured in a window?
12. Describe the purpose of a display sketch.
13. For what reasons are graphic scale drawings used in visual presentations?

Case Problems

Case 1

Hartley's is a specialty chain that features junior sportswear and activewear. The company has been in business for twenty years and has experienced steady growth. Management operates from a centralized headquarters that is no more than 100 miles from any of the stores. The philosophy of the company has always been to keep its trading area confined to 150 miles so that the centralized staff can have personal contact with each unit. The twenty stores are close enough to headquarters that regular visits by top management and the merchandising team are possible.

Visual merchandising is accomplished with a manager and four trimmers who regularly visit each store to change the window and interior displays. Since the stores are within a manageable radius, the plan works perfectly. The presentations are professionally installed and seem to motivate shoppers to become customers.

Now Hartley's is embarking on an expansion program. It is in the process of acquiring a twelve-store chain that is 300 miles from its base of operations. This is just the beginning of a program that calls for the acquisition of other small chains, some of which are even farther away than this current acquisition.

The only problem yet to be resolved concerns the visual merchandising function. It is not feasible to have the display team, which so successfully served the company when it was a smaller organization, trim all of the stores owned by Hartley's. Expansion of the visual staff would not only be expensive but would require another preparation point from which to service those stores that are too far from the company's original headquarters. Although the company recognizes effective display presentation as a necessity, it believes another solution must be found to maintain costs at a reasonable level.

QUESTIONS

1. How can the company maintain the quality level of its visual presentations?
2. Suggest an alternate solution that would maintain its present staff or even reduce the number while still providing effective visual merchandising.

Case 2

In approximately three months, Avidon's will open as a high-fashion specialty shop catering to affluent men and women. In addition to the typical designer merchandise usually associated with this type of retail operation, the company will feature an assortment of private-label designs and accessories from all of the world's fashion centers.

The company plans a retail environment that is not typical of its contemporaries. The fixtures, lighting, and other interior elements will feature a decor oriented to antiques. No chrome, brass, or marble fittings will be used. The interior design will boast antique armoires, cupboards, tables, and so on to house the merchandise. Leaded glass will enhance the showcases.

In order to support this image of old-world elegance that the company wishes to project, it is formulating a new concept of visual merchandising and hiring a full-time visual merchandiser to handle all of the interior and window presentations. Although stores of this type often rely on freelancers, Avidon's is willing to hire a full-timer to keep the shop's visual presentations at a superior level. The individual will have overall responsibility for all visual merchandising, including installations in two windows and throughout the interior as well as the purchase of display equipment.

Since interviewing for the job is about to begin, management is preparing a list of questions to determine the candidates' eligibility for the job of visual merchandiser.

QUESTIONS

1. What type of experience should the successful candidate bring to the job?
2. How can management determine which individual holds the most promise?
3. Is there a test that can be used to determine the individual's ability to do a satisfactory job of visually merchandising Avidon's interior and windows?

exercises and projects

1. On the grid paper provided on page 294, prepare a graphic floor plan to scale for a closed-back window that measures 4 feet deep and 8 feet across. Each item, such as mannequins, forms, pedestals, and props, should be indicated by its shape and floor placement. Make certain that the scale is noted and each form is marked to show what it represents.

2. From the types of window structures shown in Chapter 4, select one for a display that you will design. On the form provided on page 295, prepare a detailed sketch to show all of the component parts of your window. Mark each part of the drawing with a number that corresponds to the list of items that will accompany the sketch. For example, 1 for mannequins, 2 for pedestals, 3 for floor spotlights, 4 for background screen, 5 for display props, and so on. Make certain that the information requested on the form is completed along with the sketch. Along with the directory of items, include color samples to be used for merchandise as well as the background materials and props.

EXERCISE 1 GRAPHIC FLOOR PLAN

NAME: _____ DATE: _____

EXERCISE 2 DISPLAY DESIGN SKETCH

Window Type: _____ Dimensions: _____

Display Theme: _____

Directory of Items

Items Number Color

creating
concept: from
to com

(Photograph by Ellen Diamond.)

Objectives

After completing this chapter, the student should be able to:

... Discuss how an overall concept is developed to promote a retail organization and gain the attention of the consumer.

... Explain the different types of ancillary design components of products.

... Discuss the importance played by design facilities in the enhancement of a retailer's merchandise.

... Describe the different types of promotional endeavors in which retailers are involved.

... Explain why retailers sometimes use institutional advertising as part of their promotional campaigns.

... Give the specifics of "the Timberland Story" and the pieces of the puzzle that successfully launched the new product line.

the overall conception pletion

Introduction

As we have learned in the preceding chapters, visual merchandising has numerous components that must dovetail to be effective and contribute to greater sales volumes. The different aspects of visual merchandising discussed thus far, however, are only a part of the total picture that retailers are using to get their fair share of the market. Along with eye-appealing visual presentations, advertising campaigns, special promotions, and attractive and functional merchandise displays, a number of other areas must be addressed (Figure 18–1). These include the product's packaging, **hangtags, logos, marketing campaigns,** and new-brand development or extension of an existing brand.

Visual merchandising once stood alone as a way to better sell the store's products, but today's competitive environment necessitates a more comprehensive concept. While in-house visual merchandisers are playing a greater role in these endeavors, they alone are not able to develop all of the "ingredients" necessary to make the company's project work. More often, outside specialists are called on to do their magic and present a total concept that will help elevate the stores merchandise to heights that will motivate shoppers to become customers. In this chapter, attention will focus on the remainder of the components that augment visual merchandising practices and facilities design.

The consulting firm of Graj + *Gustavsen* is one of the leaders in developing overall concepts for major retailers. A Profile of the company follows.

Ancillary Design Components

In today's retail environment, the major impetus is for merchants to develop and merchandise products of their own rather than to just rely upon nationally recognized vendors for their goods. The products range from apparel and home furnishings to foods and tools. With ever-increasing competition in every retail classification, the need to distinguish one's offerings and premises from the others in the field is becoming more and more necessary. Aside from product design, merchants are now using total programs that immediately give their offerings and environments images of their own and that enable shoppers to differentiate one store from another. The components that contribute to making their assortments unique include packaging, hangtags, labels, and logos.

Figure 18–1 The extension of the Radio Flyer brand, once applied only to a red wagon, required a great deal of product and environmental planning.
(Photograph by Ellen Diamond.)

Simon Graj and Eric *Gustavsen* founded their company in 1990 after they each spent many years in the retail and wholesale industries. Among his many notable achievements before he founded the company, Mr. Graj directed the repositioning of Banana Republic from its safari concept to its present-day sophisticated format. Mr. Gustavsen, former art director for The Gap, went on to play an instrumental role in helping Nordstrom develop the Evergreen private brand and Timberland's Pro and Mountain Athletics brands. Together, their expertise and talents have made them leaders in an industry that develops and designs every aspect of merchandising necessary to maximize retailers' and manufacturers' sales potential. Their client list is quite impressive and includes Sears, J. C. Penney, and Saks Fifth Avenue.

Graj + *Gustavsen* is recognized as creative industry pioneers because it does not fit into the traditional ad agency, graphic design, or marketing slots. Unlike many of its competitors, who do just a portion of the work for a company, G + G's approach is total packaging. It provides everything from a complete new-brand identity to the revamping of an existing one, from start to finish. It executes, in-house, all of the ingredients of a successful package, including **packaging,** environment design, advertising, promotion, and visual presentation concepts.

For Sears, G + G repositioned the Tool and Hardware Department, renaming it Tool Territory, using the **store-within-a-store** concept and developing a complete signage and graphics program. Sears has realized sales increases of 25 to 30 percent.

Carter's, the renowned children's wear specialists, has long been a major retailer of baby clothing and accessories. Hoping to capitalize on the market for older children who have outgrown the Carter's size range, Graj + *Gustavsen* has helped the company with an overall re-imaging and **repositioning** strategy that will help maintain its relationship with customers. In achieving this goal, G + G has created new retail and outlet store environments.

Other notable accomplishments of these specialists have been assistance with the repositioning of Banana Republic, development of a **positioning strategy** for the Bullocks & Jones label acquired by Saks Fifth Avenue, the creation of the 5/48 label brand for Saks, as well as the repositioning of Saks Real Clothes Brand.

Heralded by industry publications such as Fairchild's *Children's Business* and *DNR,* the company takes over where the typical marketing research organizations leave off. It has the in-house ability to execute all of the essential ingredients that ultimately become part of a retailer's visual program, such as identity systems, packaging, environmental design, advertising, and promotion. Its efforts have enabled businesses, both retail and manufacturing, to grow in a steady fashion and confront the challenges of competition.

Hangtags

The vast majority of apparel products today use two types of hangtags (Figure 18–2). One is designed to be purely informational and provides the shopper with such pertinent information as price and size. The other is one that features the brand's name and perhaps its logo.

5 | 48 HANG TAGS

DROPED OUT LOGO EMBOSSED LOGO

FRONT MIDDLE BACK MENS BACK WOMENS

Figure 18–2 The three-part hangtag is both informative and attention getting. *(Courtesy of Graj + Gustavsen.)*

While the first is an essential component, it is the second that helps to make an indelible impression on the customer in terms of brand recognition. If carefully designed, it can become an everlasting promotional device that can lead to future reminders of the brand. Ralph Lauren's Polo logo has become so well known that it helps to distinguish his merchandise from all others.

So important are these brand hangtags that some merchants have gone to extremes. In the development of its marketing strategy to promote one of its new private brands, Saks Fifth Avenue made use of a three-part hangtag. The tag features front, middle, and back portions that are held together by red string. The first is black and merely shows the brand logo 5/48, the second is red and features an embossed version of the first, and the back uses a photograph of New York City to impart the brand's "universal cosmopolitan spirit." A walk through most any retailer's premises immediately reveals that hangtags are taking on new looks and are helping to differentiate one product line from another.

Packaging

One of the ways in which shoppers are motivated to stop and take a closer look at a product is by the use of imaginative packaging (Figure 18–3). No industry does it better than the fragrance industry. Walking through any cosmetics and fragrance department in stores all across the globe, one is immediately struck by the creative bottle designs. While the fragrance itself tempts many people to purchase, the packaging often stops shoppers in their tracks. The value of this type of packaging may be best appreciated by the fact that the product inside the bottle—the fragrance—generally costs less to produce than the bottle itself.

Hosiery producers have also joined the unique packaging bandwagon with point-of-purchase displays that are used to attract shopper attention. The "eggshell" container for Legg's hosiery immediately separated that brand from the rest.

Figure 18–3 Unique packaging and innovative hangtags help to separate this product from the competition.
(Courtesy of Graj + Gustavsen.)

Candy is another product where packaging has made one brand stand out from the rest. Godiva, for example, has created a gold foil packaging design that immediately conveys the quality of the product. Mass displays of its chocolates and other products have significantly impacted sales. One quickly gets the impression that this is a quality product and bears sampling.

In the development of the new private SPA and Sport brand for Saks Fifth Avenue, Graj + *Gustavsen* designed an innovative cylindrical plastic package to house some of the products. Its unique design was not only attractive but also enabled the shopper to see the product inside. Coupled with a three-part tag, it set the product line apart from the competition.

Logos

Of course, the aforementioned Polo pony is the epitome of logos. It has helped Ralph Lauren to gain worldwide attention for his products. The use of a logo does not guarantee positive results, however. The product must stand on its own if repeat business is to be generated.

When Saks Fifth Avenue acquired the Bullock & Jones brand, a company that was first established in 1853, it immediately determined that brand recognition was necessary to ensure customer interest. In addition to other marketing strategies, Saks made significant use of the logo that Bullock & Jones had used for years (Figure 18–4). The "ram's heads" either in pairs or singly, along with the company's initial date of establishment, were used in every advertisement and on every product. It quickly made an indelible impact on the Sak's shopper.

In the Sears tools department repositioning, part of the project was finding the perfect logo. Several entries were considered before the right one was selected. It has been determined that the logo, along with the new environmental approach, helped Sears to achieve its sales increases.

In the creation of the Timberland Pro Brand, a product line that would concentrate on professional work-boots for the construction trade, a new logo was developed to differentiate this line from the traditional products Timberland was producing for regular consumer use. The logo it eventually chose capitalized on the words *Pro Series* and helped capture the attention of the marketplace. Its inclusion in the overall marketing approach has made the new product line a powerful and very successful division of the Timberland Company.

Figure 18–4 The use of logos on labels helps to bring greater identity to the product.
(Courtesy of Graj + Gustavsen.)

Labels

Labels have long been an important part of most products. Once relegated to the inside of garments, labels began to appear on the outside of garments during the heyday of designer brands. Beginning with Pierre Cardin in the 1970s, the French designer's labels adorned sweaters, jeans, and other apparel on the outside. The trend quickly gained favor, and other jeans designers, such as Calvin Klein, embraced the concept. Today, labels continue to adorn products, both on the inside and the outside. It has been said that as much care and creativity go into label design as into the product itself. Whether it is the retailer who wishes to make a lasting impression on the consumer about where the product was purchased or the designer and manufacturer who want to establish a brand, the use of creative labeling continues to convey a "visual" image.

Facilities Creation

As we have discussed earlier in the text, especially in Chapter 4, "Facilities Design: Exteriors, Interiors, and Fixturing," the facilities layout of any retail establishment is an invaluable component of visual presentation. Its uniqueness in terms of functionality and eye appeal helps to provide environments that enhance the merchandise offerings and motivate the shoppers to stop and take a closer look at the product offerings. For example, when Saks Fifth Avenue wanted to reposition its Real Clothes brand, it began with a new facilities design. It created the Walk-In Closet shop environment that gave the shopper the impression she was looking through her own closet for something to wear (Figure 18–5).

At Sears, repositioning of the Tool and Hardware Department involved the overall re-design of the floors that housed the store's tools. Featured in the new department layout were see-through tool islands that created a more open feeling and a centralized information center at which customers could have their questions answered. Coupled with "way-finding" signage that led the shoppers to the right locations for their needs, the new environment helped Sears to better display its products and increase sales.

The whole concept of visual merchandising no longer rests on "pretty window displays," but requires the proper in-store design to enhance the merchandise to be presented

Figure 18–5 In contrast to traditional fixturing, the "walk-in closet" provided a unique way to show the merchandise.
(Courtesy of Graj + Gustavsen.)

Color Plates 20–32 For the Christmas selling season, Marshall Field's regularly devotes all of its flagship windows on State Street in Chicago with an extravagant mechanically driven presentation. For 2005, the theme was Cinderella, complete with the evil stepmother, stepsisters, Prince Charming, and Cinderella herself.

(All Photos Courtesy of Marshall Field's, now a Macy's store.)

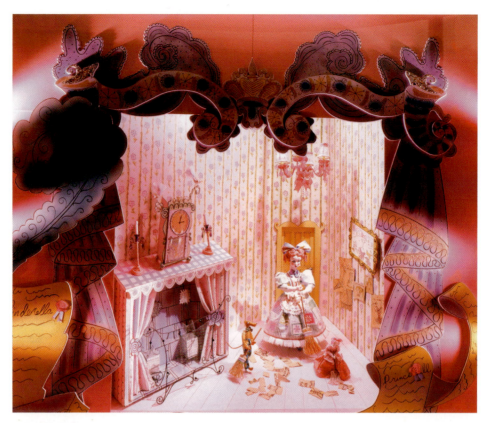

Color Plate 21

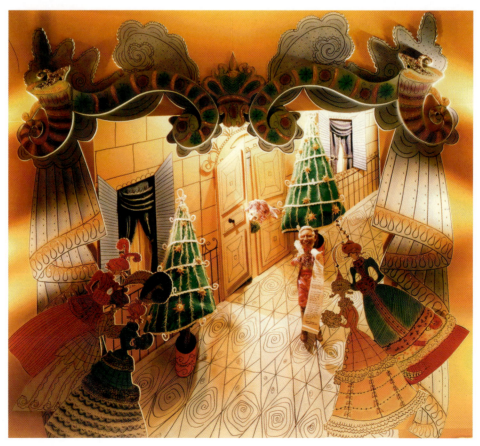

Color Plate 22

Color Plate 23

Color Plate 24

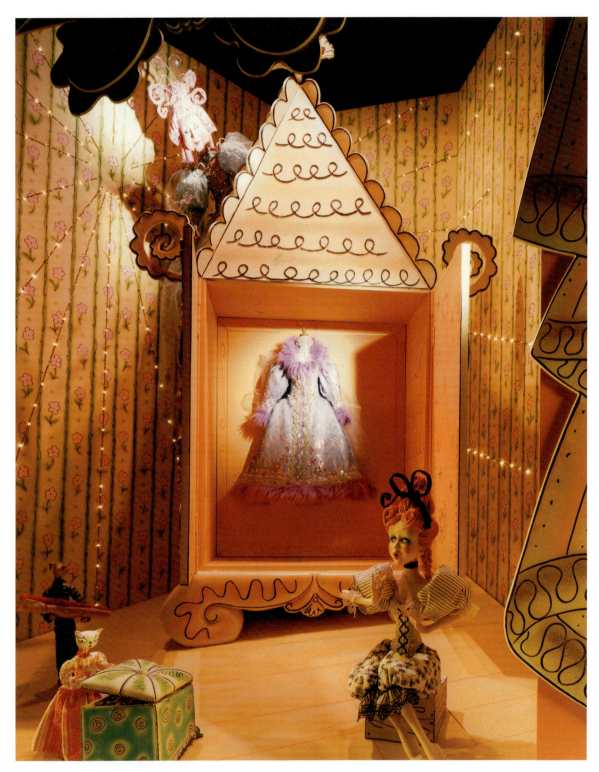

Color Plate 25

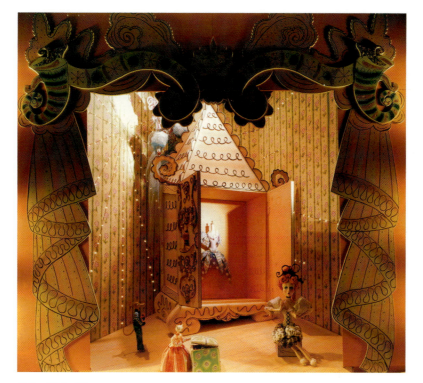

Color Plate 26

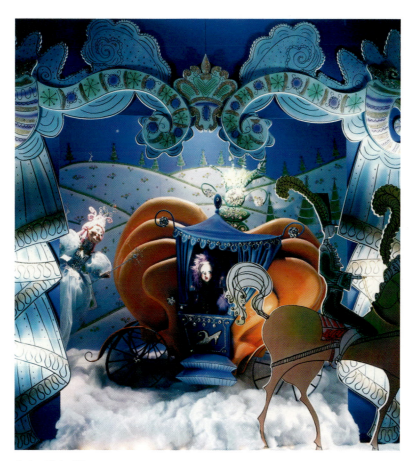

Color Plate 27

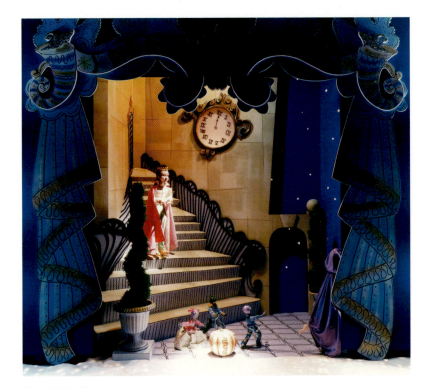

Color Plate 28

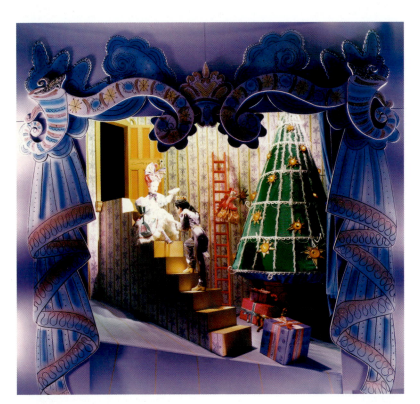

Color Plate 29

Color Plate 30

Color Plate 31

Color Plate 32

to the customer. Whether it is the thematic approach used by Disney and Rain Forest Cafe or the traditional approaches of most retailers and restaurants, it is essential that the creation of environmental facilities be undertaken carefully.

Promotional Endeavors

Once the premises have been designed and all of the other components discussed have been developed, it is essential that a promotional plan be put into place to publicize the operation and make it a place in which shoppers would like to have their needs satisfied. Included in these endeavors are marketing campaigns, **publicity vehicles,** visual presentations, and point-of-purchase displays.

Marketing Campaigns

Whether it is the introduction of a new retail operation or a restaurant, the promotion of an operation to increase consumer awareness, or the continued exposure of successful ventures, various marketing campaigns are in order. In most of these situations, it is advertising that helps to generate sales by informing the consumer about merchandise and services that are available at individual companies. In concert with such advertising are numerous special promotions that attempt to bring shoppers to the brick-and-mortar operations. Often, each of these endeavors is dovetailed with window and internal visual presentations (Figure 18–6).

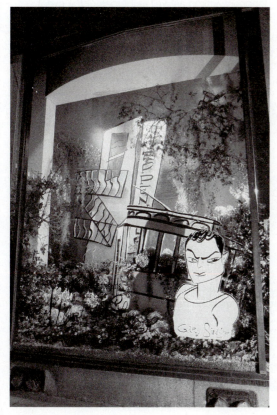

Figure 18–6 When store windows are extensions of special events advertisements, as in the case of Marshall Field's salute to Steppenwolf, shoppers often come inside to shop.
(Courtesy of Marshall Field's, now a Macy's store.)

Advertising Any daily or Sunday newspaper contains a wealth of advertisements alerting consumers to items that the merchandiser hopes will grab their interest. These ads might be for the latest fashion item that is expected to become a winner, a sale, special events that might generate in-store traffic, or a particular event with social connotations.

First and foremost, most retail operations use **product advertising** as their mainstay. That is, they might feature a few styles from a designer collection, products that are produced as private brands for the company, or items that have been touted by the editorial fashion press as important components to any wardrobe. All across the nation, companies such as Lord & Taylor, Saks Fifth Avenue, Bloomingdale's, and Macy's regularly feature such advertisements. The **media** used for these purposes include newspapers—the retailer's main communications outlet—magazines, television and radio, and direct-mail pieces.

Sales are extremely important to most merchants for pushing unwanted merchandise, and using media is an excellent method for this purpose. They might be end-of-season sales, promotional sales at times such as President's Week or Day, or sales anytime the retailer's inventory is too high. Newspaper advertising and the broadcast media are the primary tools for such programs.

Special events often distinguish one merchant from another. Macy's, for example, commands a lot of attention with its annual Flower Show. When its Herald Square flagship in New York City is literally transformed into a botanical garden, customers flock there to view the extravaganza. Of course, with such huge crowds in attendance, each department in the store benefits with increased sales. Following suit, Marshall Field's, now a Macy's store, in Chicago has used the garden concept based upon such themes as "Curious George" to generate in-store traffic with great success (Figure 18–7). Other special events might include fashion shows, trunk shows, celebrity personal appearances, and so forth.

In order to underscore an event of social significance in the retailer's trading area or, for that matter, other important events, merchants use advertising to inform their customer base as well as potential new customers of these happenings. One example of this type of advertising, better known as *institutional advertising,* dealt with the tragedy of the terrorist attacks on September 11, 2001, in New York City. Just about every major retailer created advertisements centered on patriotic themes and honoring victims as well as heroes of the event. Others emphasized the greatness of the country and the pride that Americans should feel as citizens. Of course, tragedies are not the usual focus of these advertisements. Typically, institutional advertising concentrates on charitable events, social occurrences such as the

Figure 18–7 Marshall Field's "Curious George" presentation helped increase in-store traffic.
(Courtesy of Marshall Field's, now a Macy's store.)

opening of the opera season in major cities, salutes to organizations such as the Boy and Girl Scouts of America, and anything that is timely.

Publicity Vehicles Another way most major retailers reach their consumer markets is through the use of publicity. Unlike advertising, which the retailer pays for, publicity is a no-fee promotional device that helps to spread the retailer's message. By issuing **press releases** to the media, merchants attempt to get coverage without cost. For example, most publicity users prepare informational sheets "for immediate release" and deliver them to any individual or group who might use them in their columns or broadcasts. If considered newsworthy, oftentimes such publicity will alert consumers to events of interest (Figure 18–8).

For Immediate Release

<div align="center">

Bloomingdale's and Moulin Rouge
Because You Can Can . . .

</div>

April 2001, New York, NY . . . Moulin Rouge, the musical sensation that will make the world do the can-can, starring Nicole Kidman and Ewan McGregor, can also be experienced at Bloomingdale's Moulin Rouge theme shops opening in New York and Los Angeles. The shops unveil on April 19th offering Only At Bloomingdale's ready-to-wear, intimate apparel, accessories, and Christian Dior cosmetics that are inspired by the mood and lifestyle of Paris 1900.

To kick off the festivities, Bloomingdale's 59th Street will unveil the Lexington Avenue windows with great fanfare on April 19th at 7:30 PM. With all the glamour and excitement one expects at a Hollywood premiere, Nicole Kidman will appear with a group of escorts in white tie and tails and a bevy of can-can dancers and much much more! The windows will emulate significant scenes from the movie while using several props sent directly from the movie set in Australia. Nicole will also be showing the exclusive Moulin Rouge t-shirt that benefits her chosen charity the UCLA Women's Reproductive Cancer Program.

"We asked a group of designers to be inspired by the film and to create modern interpretations for us. The merchandise will be housed in a very special shop that will be located in our New York and Century City stores. This beautiful collection of very special merchandise will include evening gowns, cocktail dress, bustiers, petticoats, camisoles, T-shirts, and accessories from gloves to boas. The CD of the film soundtrack will also be available in the shop upon its release date May 8th," said Kal Ruttenstein, Senior Vice President for Fashion Direction.

Vendors that have joined Bloomingdale's in this project for the creation of the Only At Bloomingdale's Moulin Rouge shops are: Anna Sui, BCBG Max Azria Collection, Victor Costa, Elie Tahari, ABS by Allen Schwartz, Yigal Azrouel, Jessica McClintock, Rebecca Taylor, Ady Gluck-Frankel for Necessary Objects, Kitty Boots, Laundry, Ticci Tonetto, Vivienne Tam, and Skinny Minnie. Accessory and intimate apparel vendors include Kenneth Jay Lane, Swarovski, Kokin, Corsetry by Versatile, and Shaneen Huxman.

The Moulin Rouge look would not be complete without the face to match. Christian Dior cosmetics has partnered with Bloomingdale's to create an exclusive Moulin Rouge makeup collection. The look, which will be available at all Bloomingdale's nationwide, features a porcelain complexion, dark smoky eyes, and a specially designed Moulin Rouge Red lipstick.

Moulin Rouge the musical is a celebration of love and creative inspiration set in the infamous, gaudy, and glamorous Parisian nightclub, at the cusp of the twentieth century. The famed Director, Baz Luhrman, brings together gorgeous period design and modern-era pop tunes to create a unique motion picture experience. Nicole Kidman plays the club's most notorious star, forced to choose between a young writer's inspiration and another man's obsession. Ewan McGregor is the writer who finds himself plunged into this decadent world where anything goes—except falling in love.

Bloomingdale's, a division of Federated Department Stores, was founded in 1872 and currently operates 23 stores in New York, New Jersey, Massachusetts, Pennsylvania, Maryland, Virginia, Illinois, Minnesota, Florida, and California. For website access, log onto *www.bloomingdales.com.*

Figure 18–8 Press releases generally bring special events to the attention of the editorial press.

Visual Presentations As we have learned throughout this text, visual presentations are extremely valuable tools to the retailer. Of special importance are the window displays designed to attract the attention of the passersby and tempt them to come into the store. Very often these displays are extensions of advertisements and special events. For example, the pages of fashion magazines featuring designer ads are augmented by window displays that feature the identical merchandise. At Christmas, retailers such as Saks Fifth Avenue use the media to announce to the public their window extravaganzas in the hope that customers will make a trip to the store to see them. Once inside the store, shoppers are often motivated to purchase because of the displays presented within the departments, which might be a continuation of a window theme or just another type of presentation.

Point-of-Purchase Displays Chapter 15 discussed the different types of point-of-purchase displays and their uses. As a promotional endeavor, these constructions often combine both visual and utilitarian components. Whether they are temporary corrugated configurations or more permanent installations, they often become the silent sellers of merchandise or services. When used as a part of the company's overall promotional efforts, POP displays are even more effective.

Putting It Together: The Timberland Story

Whether the goal of the merchant is to bring new awareness to an existing company, add a branch operation, introduce a new private label, energize an existing private brand, or merely reposition itself, an overall concept must be created. Each of the components presented here must be perfectly blended into one theme or idea to achieve success (Figure 18–9).

 MAIN IDENTITY

Figure 18–9 Way-finding signage helps to direct the shoppers to right places in the store.
(Courtesy of Graj + Gustavsen.*)*

Sometimes the retailer has specific parts of the plan in place and merely needs to refine them or to add others to make the plan complete. Whatever the challenge, careful planning must take place so that the dollars spent will reap the desired rewards.

For example, a number of components were used when Timberland added a new brand. The company wished to target the **market niche** of professional workboots for the construction trade. Long recognized as purveyors of consumer boots, the company felt that this new brand would be energizing and make it more profitable. Since the collection was entirely new to the company, it needed to develop brand identity, packaging, an in-store point-of-sale program, and a marketing campaign. Each component of the task was formulated based on extensive marketing research and numerous brainstorming sessions between the company and the outside marketing specialists, Graj + *Gustavsen*. The following pieces of the puzzle were designed and molded together to comprise the overall approach the company would use in its pursuit of a new market, identified as male, blue-collar vocational consumers between the ages of eighteen and forty-four (Figures 18–10 through 18–18).

1. *Main identity.* Once the product designers created the product line, the next step was to decide on an appropriate name that would separate the new brand from the existing one and to design a logo that would identify the new brand. The decision was to retain the Timberland name but differentiate the new line from the original with the use of "Pro Series" labels and signage.

2. *Main sign.* A principal sign was created, along with variations on the theme that would be used in interior retail spaces. The sign used the "Pro Series" label along with Timberland name and two slogans: "Workboots for the Professional" and "Suppliers to the Trade for Over 25 Years."

3. *Campaign statement.* Each ad and promotional campaign used a statement that included the same ingredients as the main sign, except in a different configuration.

4. *Woven labels.* A series of woven labels was designed that would be affixed to each workboot and help identify the product to the shopper.

5. *Boot embellishment.* Each pair of boots would feature embossed logos at the heel of the boot and the back. In this way, observers would have a constant reminder of which brand was being worn. In addition, the boot's tongue and upper-back portion would feature sewn-in woven labels. Each of these embellishments would become effective transmitters of the brand's name.

6. *In-store and image concepts.* A series of graphics was developed that featured workers who would be the users of the workboots in action. The slogans "Suppliers to the Trade for Over 25 Years" and "Workboots for the Professional" were evident in each graphic. The graphics varied in terms of the photographs of workers used and the specific messages they would convey.

7. *Hangtags.* Various hangtags were designed to affix to the boots. They featured the brand's logo as well as some information for the shopper.

8. *Box designs.* A corrugated box was created to not only house the boots but also feature the logo, a picture of workers in action, the size, and key features of the product.

9. *Shelving.* Slatwall wooden shelves were constructed that would hold the boxes and also feature the brand name, logo, and benefits of the product. Plexi slatwall shelves were also developed in which signage could be inserted to identify the products.

10. *Sign holders.* With signage so vital to today's retailers, Timberland created a variety of holders to house standing signs and graphics as well as models that could be suspended. The inserts are easily removed to make way for newer offerings. The holders are comprised of wood and steel—materials that indicate the ruggedness of the company's products.

When these components are installed in their physical surroundings, they create a suitable environment for bringing the new brand to the forefront. Featuring functionality and creativity, the venues for the Timberland Pro Series at once inspire shoppers to become customers.

MAIN SIGN

WORKBOOTS FOR THE PROFESIONAL

SUPPLIERS TO THE TRADE FOR OVER 25 YEARS

WOVEN LABELS

CAMPAIGN STATEMENTS

WORKBOOTS FOR THE PROFESSIONAL

SUPPLIERS TO THE TRADE FOR OVER 25 YEARS

BOOT EMBELLISHMENT

SUPPLIERS TO THE TRADE FOR OVER 25 YEARS

INDOOR WORKBOOTS

WORKBOOTS FOR THE PROFESSIONAL

HANGTAGS DEMONSTRATING GROUPING

BOX DESIGNS

STENCILED LUMBER SLATWALL SHELVES

WODDEN SIGN HOLDER FOR SUSPENDING GRAPHICS

Figures 18–10 to 18–18 The various components of Timberland's brand extension help to create an overall impact on future purchasers.

(Courtesy of Graj + Gustavsen.)

chapter review

key points in the chapter

1. Visual merchandising is only one method retailers use to motivate shoppers to become customers.
2. Advertising, special promotions, and functional facilities all contribute to the success of any retail operation.
3. Numerous ancillary design components help to further bring attention to the merchant's products.
4. Packaging plays a vital role in gaining customer recognition as is evident in such products as cosmetics and fragrances.
5. Logos are becoming more and more important to product lines. Ultimately, if successfully designed, they sometimes become the motivating factor for retail purchases, as in the case of Ralph Lauren's polo pony.
6. Labels, once found exclusively on the inside of an item, are now often used on the outside, giving the product immediate recognition.
7. Retailers, to better publicize their operations and make certain that they are differentiated from their competitors, use numerous promotional devices.
8. Most retail marketing campaigns use advertising, publicity vehicles, visual presentations, and point-of-purchase displays to reach potential customers.
9. Retailers issue press releases in the hope of reaching the editorial press, which might publicize their "news."
10. Product advertising is the mainstay of most retailers' promotional budgets.

terms of the trade

hangtags 298
logos 298
marketing campaign 298
market niche 307
media 304

packaging 299
positioning strategy 299
press releases 305
product advertising 304
publicity vehicles 303

repositioning 299
special events 304
store-within-a-store 299

internet exercises

1. One of the most important parts of a product is its packaging. Oftentimes the package is designed not only to be utilitarian but also aesthetically appealing. To avail themselves of the proper packaging, product designers conduct Internet searches to find packaging design companies. The Internet provides the individual or company with a wealth of package design companies to contact, and does it in a time-saving fashion.

 For this exercise, locate five companies that specialize in package design using an Internet search engine. You should log on to many of them to find those that specialize in a particular product package, such as tool containers, cosmetics, clothing, shoes, or any other product classification.

 First select the companies that appear to be packaging specialists for a particular product classification, and then complete the form on page 313. In the comments area, select one company and explain why you would choose it for your packaging needs.

2. Advertising is a key element in any retailer's promotional plan. Although many larger retailers have in-house staffs to perform these functions, outside agencies are traditionally used as adjunct resources. So many agencies are available to merchants that choosing just one is often a difficult task.

 Choosing from the number of different agencies available to retailers is often accomplished by using the Internet. For this exercise, use a search engine and enter "advertising agencies." Before you examine any agency website, however, select a specific type of retail operation—department stores, specialty stores, chain organizations, supermarkets, pharmacies, and so on. Once you have chosen a classification, log on to some of the websites that specialize in your selection.

 Select five agencies that fit your retailing classification and complete the chart on page 314. Choose the one that will probably best satisfy your needs and explain why in the comments section.

Case Problems

Case 1

Carron Cherrie is an upscale specialized department store that has been in business since 1965. The flagship store is in Chicago, Illinois, and there are fifteen branches in suburban Illinois and Michigan. The owners, David Neil and Amy Fain, have been able to earn a handsome profit ever since they opened their doors. While other stores of their size have become publicly owned, Carron Cherrie has remained a private venture.

The merchandising philosophy of the company has been centered on *marquee* labels. International designer collections, ranging from couture to *bridge* price points, have been the mainstays of the merchandise mix. While this concept continues to make the company profitable, the management team, headed by David and Amy, believes the time is ripe to pursue other avenues to make their operation even more successful. After numerous discussions with the general and divisional merchandise managers, buyers, visual merchandisers, and in-house facilities designers, it was decided that a private-label collection would be developed and marketed exclusively by Carron Cherrie.

The philosophy of the product design was a casual women's collection that would be priced at the *bridge level* (a price that is between couture and moderate) and would feature sportswear. The next stage would be to (1) create ancillary design components for the new merchandise collection, (2) design and install a facility in the store that would best enhance the new offerings, and (3) formulate a promotional approach that would bring the new line to the public's attention.

After three months of planning sessions, the company owners and management team have yet to finalize their plans and proceed with an overall concept that would bring the organization an increase in profits.

QUESTIONS

1. What kinds of ancillary components should the store create for each product?
2. Which marketing tools should it employ to publicize the new addition to the store?

Case 2

John Gallop and Marc Litt have been involved in the grocery industry for many years. They have worked for some of the major supermarket chains in the country and both enjoyed regular promotions to positions of importance wherever they worked. Their last employment was at Crystal Stores, a supermarket chain with 250 units. Working at the corporate offices in Houston, Texas, they developed a professional and personal relationship that has convinced them they would be the perfect team to open their own grocery business. John's expertise in merchandising and Marc's in promotion seemed the right mix to pursue this new venture. With their own dollar investment, funding from several vendors, and a promise of a loan from a major bank, they are ready to embark upon the American dream ownership of a business.

Recognizing that their backgrounds fall short in terms of opening a new company, they have employed the services of Atlas Marketing to develop a total concept from conception to installation of the premises.

After numerous discussions with the Atlas design team, they learned about the components that needed to be addressed before the actual venture could begin. They discussed facilities design, fixturing, the merchandise mix, and other areas of importance. Although many decisions were made, Gallop and Litt are not totally satisfied with the research firm's approach to promoting the new business. Atlas placed a great deal of emphasis on the typical newspaper inserts, a traditional means of calling attention to the store. The owners feel that the already overcrowded marketplace needs a newer promotional approach. They are still at a stalemate, hoping to find a solution to the problem that would satisfy their needs.

QUESTIONS

1. What might the owners use to promote the company in addition to traditional supermarket advertising?
2. What types of visual presentations would make the store come alive?

discussion questions

1. In addition to visual merchandising, what other types of promotion do retailers use in order to gain a fair share of the market?
2. Aside from the usual hangtag components such as price and size, what other "ingredients" are retailers using on tags to give the product greater recognition?
3. How important are the packaging designs of products found in retail environments?
4. What is a logo, and what purpose does it serve?
5. Why do some manufacturers use labels on the outside of garments instead of keeping them on the inside?
6. Who was the initiator of the label on the outside of an apparel product?
7. In addition to functionality, what other consideration should be addressed in the design of a retailer's environment?
8. What are the major components of a retailer's marketing campaign?
9. How does product advertising differ from institutional advertising?
10. Which media do retailers use to spread the word to the consumer about their products and image?
11. What types of special events do retailers use to bring shoppers to their brick-and-mortar operations?
12. Name a publicity tool used to bring a company to the attention of the editorial press.

exercises and projects

1. Pretend that you have been assigned to a product that has just come on the market. Your task is to create a logo to be affixed to the product itself and used on packaging, labels, and so forth.

 From a newspaper or magazine, choose one product that has no logo and design one for it. Attach the picture of the product in the space provided on page 315, and then design four logos in the space provided on page 316 so that your client may select one for ultimate use on the product.

2. Visit any department or specialty store to assess the different types of hangtags that are attached to the garments. Ask the manager if there are extras for you to use in a classroom project. When you have obtained five samples, attach each to a foamboard and evaluate their aesthetic design and usefulness to the consumer. Then select the one that you think best captures shopper attention and explain why.

NAME: _____ DATE: _____

Product Classification _____

Company	Website	Client Base

Comments _____

NAME: _____ DATE: _____

Retail Classification _____

Agency	Website	Advertising Specialty

Comments _____

Product Photograph

Logo Sketches

promotion's components: special events,

Objectives

After completing this chapter, the student should be able to:

... Discuss the relationship of visual presentation to promotion's other components.

... Evaluate the different types of advertising media used by retailers.

... Explain why most retailers use newspaper advertising as their main medium.

... Discuss the reasons why most retailers do not use magazines as an advertising medium for their companies.

... Explain demographic targeting.

... Discuss some of the advantages of website advertising as compared to the traditional forms of advertising.

... Describe the types of special events retailers use in their promotional programs.

... Explain the difference between a fashion show and a trunk show.

... Discuss why publicity is often not free.

other advertising, and publicity

Introduction

The considerations involved in the development and execution of displays in windows and showcases and the decisions concerning the approach to placing merchandise on the selling floor are numerous. As we have seen in each of the other chapters in this book, little is left to chance in terms of thematic approaches, mannequins and prop selection, harmonizing of color, lighting choices, and the use of signage and graphics. Each aspect of the visual presentation is carefully addressed and painstakingly coordinated to make certain that the ultimate impact will help motivate the shopper to take a closer look at the merchandise offered for sale. In the case of institutional visual merchandising, although merchandise isn't being featured but perhaps an image concept or a charitable event, the same care must be exercised to ensure that the theme is understood and acted upon by the passerby.

Visual merchandising is intended to capture the attention of those who frequent bricks-and-mortar operations with the hope of transforming their curiosity into a purchase, but visual presentation is only one part of the overall promotional endeavors of the retail organization. Often, the shopper comes to the store not by chance, but as a result of something that has sufficiently whetted his or her appetite. Time and time again, the catalyst is a particular newspaper advertisement that prompts the action, a special event that peaks interest, or a column written by someone from the editorial press describing the excitement being generated by a special promotion. Each of these stimuli might bring the shopper to the store, where the visual presentations, if carefully dovetailed with these outside events, take over and provide further prompting to examine the merchandise more closely (Figures 19–1 and 19–2).

This chapter focuses on the other promotional components that often pique the shopper's attention, including the different classifications of advertisements, special events, publicity arising from the retailer's actions, and **promotional campaigns.**

Figure 19–1 This final clearance ad whets the appetite of the bargain shopper.

(Courtesy of Lord & Taylor.)

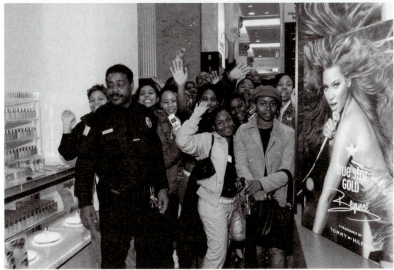

Figure 19–2 Superstar Beyonce draws huge crowds for the launch of the new fragrance Gold.

(Courtesy of Marshall Field's, now a Macy's store.)

Visual Presentation in Relation to Other Components of Promotion

The three-dimensionality of actual merchandise offers a lifelike view to the observer. In contrast to their appearance in print ads, which show products to the consumer in a "flat" format, products have a real quality when they are featured in windows, showcases, interior niches, vitrines, and other visual casings. Unlike the television commercial, which is used sparingly in retailing by comparison to the other advertising media, print and radio generate little excitement. Bridal gown ads, for example, although they alert the bride-to-be to one or more styles available for the big day, can only show the basics of the design. The dimensional quality of the fabric, laces, and other adornments, so important as enhancements to the actual silhouette, is generally lost in photographs or drawings. On the other hand, when gowns are shown in a window, the viewer can immediately see the luster of the silks and satins, the depth of the embellishments, and the detailing that makes the designs unique. If the window display is exciting, it will probably motivate the viewer to come into the store for closer inspection of the models displayed. At the point of purchase, an interior display of the

gowns on mannequins allows closer examination of the crispness of the fabric as well as all of the details of the design than is possible from window displays, which distances the observer from the merchandise. Although the initial print ad might have played an important role in bringing the excited future bride to the store, it is the creative talents of the visual merchandiser that have had an impact on her. She might try the gown on, buy it, or at least consider it as one of her options. Other promotional tools, such as a bridal extravaganza focusing on a particular designer, could also be used as part of the overall promotional effort. A personal appearance by the designer could be scheduled, or a runway show, or a discussion group on proper wedding etiquette.

Whether a major promotional campaign or merely a simple presentation is involved, using all of the promotional components helps to raise awareness and, if successful, make a profit for the company.

Advertising

Retailers bring attention to themselves and their merchandise offerings most often through the use of advertising. Whether a one-time ad or a full complement of ads constituting a major campaign, advertising is a powerful tool. It immediately tells the consumer, in a timely manner, that something that might be of interest is taking place—a clearance sale, the introduction of a new designer collection, the appearance of a celebrity to promote a line, the announcement of a special event such as a flower show, a charitable function, or just a new, exciting product. Whatever the case, advertising is the tool that generally commands the lion's share of the retailer's promotional budget.

The Media

Retailers must use their expertise when choosing among the different classifications or types of advertising **media** available to select the appropriate medium for particular situations. For a clearance sale, this medium might be the newspaper; for the announcement of a high-fashion designer collection, it could be the glossy pages of a magazine; or for a private offering to "customers only," it might be a direct-mail piece. Each of the advertising media has strengths and weaknesses that must be carefully considered before one is chosen for the event.

Newspapers Most retailers use the newspaper more than any other advertising medium (Figure 19–3). The newspaper has always been the lifeblood of their promotional programs, enabling them to reach their regular patrons as well as newcomers they wish to attract. There are many advantages to newspaper advertising, including the following:

- *Lead time.* Television has time-consuming technical complexities and magazines generally require considerable production time, but the newspaper is a daily publication in which space is available to the retailer with only a few days' notice. Ads can be quickly constructed and placed even at the last minute. If a snowstorm is predicted, the merchant can design an ad for fur-lined boots and have it reach the public in a very short time. The rest of the media cannot be accessed as quickly.
- *Cost.* Although the costs of newspaper advertising continue to increase, the expenses involved pale by comparison to magazine and television advertising (Figure 19–4).
- *Timeliness.* The seven-day publication schedule of newspapers enables retailers to reach their markets at the time most desirable for the merchandise to be advertised.
- *Market appeal.* Since the newspaper has many different sections that often have specific appeal for different family members, it therefore appeals to most of the household residents. In addition to its universality, more and more papers are being published to appeal to specific ethnic minorities. By advertising in these publications, the retailer is able to reach some of the faster-growing segments of the population.

Figure 19–3 The introduction of the new Coach Shop is announced to the public with newspaper advertising.

(Courtesy of Lord & Taylor.)

- *Geographic concentration.* Unlike television and most magazines, newspapers are concentrated, for the most part, in narrow geographic areas. This concentration allows an ad campaign to bring the greatest results.

Of course, the newspaper does have some limitations, which require the retailer to consider other media. Some of the negatives include:

- ***"Life" of the advertisement.*** Except for the Sunday editions, the life of a newspaper is generally twenty-four hours at most. Each day, when the next edition is delivered to the home or purchased at the newsstand, yesterday's paper becomes obsolete. Of course, it has a longer life in comparison to the broadcast media, where messages are shown for a minute or less, and now can be completely eliminated by users with TIVO and on-demand capability.
- *Low-quality stock.* **News "sheet"** is of a poor quality and does not lend itself to high-quality printing. Color is rarely used, and when it is, it doesn't have the quality of magazine four-color ads. Except in the Sunday supplements, which feature better color reproduction, there is little the advertiser can do to make the ad more eye appealing.

Magazines It is the magazine that brings high-quality print reproduction to the retailer. Whether black-and-white or produced in four-color format, ads in magazines generally provide a greater degree of clarity than in their print counterpart, the newspaper. Some of the pluses of this print medium are the following:

- *Life potential.* Unlike newspapers that are regularly discarded each day, magazines tend to remain in the household even after the next edition is published. Not only

Figure 19–4 Timeliness is of the essence when clearance sales are offered.

(Courtesy of Marshall Field's, now a Macy's store.)

do the purchasers sometimes save these periodicals for future reference but many pass them on to other readers, thus giving ads additional exposure.

- *Broad distribution.* Where newspapers are generally restricted in terms of their geographic distribution, magazines reach out as far as an entire nation and sometimes even internationally. In the case of fashion magazines, in particular, it is not unusual for foreign newsstands to feature publications from around the world. With the Internet websites of merchants regularly included in magazine ads, the potential for orders from numerous trading areas is growing (Figure 19–5).
- *Quality reproduction.* The excellent "stock" coupled with fine printing techniques enable the merchant to present a favorable image of the company and its merchandise.
- *Regional editions.* In cases where widespread geographical distribution is not the retailer's marketing plan, **regional editions** of most magazines are available for more restricted distribution. This limits the size of the market, but also generally results in lower costs.

Figure 19–5 The magazine offers broad distribution opportunities for retailers. *(Courtesy of Lord & Taylor.)*

As in the case of the newspaper, there are some disadvantages to magazines. Some of these are:

- *Cost.* The expense involved in the production of the ad and the cost of placement are significant. Often, therefore, only the largest retailers make use of magazines, and then on a very limited basis.
- *Timeliness.* Since most magazines are published once a month, or bimonthly, the medium is more likely to attract ads for nonperishable merchandise that has a significant life expectancy, such as automobiles. Clearance sales, often run as spontaneous events, would be inappropriate to advertise in magazines.

Direct Mail Rounding out the print media important to retailers is **direct mail.** The use of flyers, brochures, pamphlets, and other mailers continues to increase. Mailing lists are easily updated from credit card accounts and obtained from marketing research firms, so their depth and breadth in terms of regular shoppers and potential customers are significant. Some of the advantages of direct mail are:

- **Demographic targeting.** Specific groups with desirable characteristics can be categorized and become the basis for a mailing list. For example, if the optimal consumer group has a household income of approximately $50,000, two or three children, and occupations oriented to business management, the list can be tailored to include these characteristics and exclude others.
- *Undivided consumer attention.* Unlike the mass media of newspapers and magazines, where there is a great deal of competition from other ads in the same publication, mailers are individual pieces that get the viewer's undivided attention.
- *Lower distribution costs.* When direct-mail pieces are inserted in end-of-the-month credit card statements, the cost of postage is eliminated. Not only can the retailer be assured of the recipient's undivided attention, but can do so without the need to incur costly delivery expenses.

There are, however, some negatives when direct mail is used, including the following:

- *Junk mail image.* Often, busy consumers perceive some mailing pieces as junk mail and toss them into the trash without reading them.
- *Slow delivery.* In many instances, users of direct mail opt for the lowest delivery cost. In this case, the brochures or pamphlets may be delivered in an untimely manner, arriving after the offer has expired, making them worthless.

Broadcast media, specifically television and radio, also are important outlets for many retail operations. As in the case of the print media, they too offer pros and cons to their users.

Television
Although it is less frequently used by retailers than the print media, television nonetheless is the appropriate communication outlet in certain situations. Among the positive characteristics of television are:

- *Live action.* Seeing products in action gives them a special pizzazz not achievable in print media. Models dressed in the latest fashions walking on runways, automobiles traveling on scenic highways, and foods being eaten in glamorous settings raise the excitement level of the products. This cannot be duplicated with even the most exciting print ads.
- *Widespread market potential.* In just one airing, a television commercial may be seen by millions of viewers. No other medium can as quickly get the message across to the consumer.
- *Localized segmentation.* In cases where the merchant wishes to reach a more defined market, **spot commercials** may be utilized. For example, if a company's trading area is in the northeastern portion of the United States, the advertisement may be aired to the viewers only in that region. Not only does this target the desired group but it also saves the company money.

As with the other media, there are also disadvantages to television advertising. Among the negatives are the following:

- *Costs.* One need only examine the cost of a one-minute spot during the Super Bowl to realize the expense involved in advertising at a major event. Of course, this is an extreme example, but the costs are considerably higher than for any of the other media. These "air" costs are in addition to production expenses.
- *Lead time.* Unlike newspapers, which require as little as a few days before the ad can be placed, television production and placement time are considerable. Especially in cases where the commercial is part of a campaign, it is sometimes necessary to produce and place the ad months before it is set to air.
- *Bypassing the commercial.* The invention of such systems as TIVO and Comcast's On Demand has enabled viewers to bypass television commercials. With sales of these devices soaring, the likelihood of all viewers seeing the commercials is declining.

Radio
Less frequently used by merchants than television, radio is most suitable when there is need to announce a timely promotional event. For those who use the medium, it has the following advantages:

- *Cost.* Radio is relatively inexpensive, thus making it affordable for small retail operations that want to announce sales and other timely events.
- *Additional listening venues.* In addition to tuning in at home or the office, listeners are often also participating in other activities, such as exercising or driving in their cars. Retailers find that this "captive" audience is receptive to their ads.
- *Marketing to ethnic minorities.* Hispanic-speaking radio stations are becoming more common than ever before. There is enormous growth in this market segment, and with it radio retailers are able to reach those who do not speak English.

The disadvantages of radio are the following:

- *Absence of visuals.* The listener must visualize, with the absence of pictures, the products being advertised.
- **Message life.** The message is relatively brief and is often lost when the listener is distracted from the broadcast.

Retail operations are spending more and more money to advertise their products on the Internet. Websites are getting more sophisticated every day, and new inventive approaches are being used to attract more attention.

Websites Some of the advantages of website advertising include:

- **Website linkage.** When users log on to search engines, they invariably are shown different websites that might arouse their interest. By scrolling down to the ones that seem appropriate for their needs, they can immediately reach the retailer's own pages.
- **Website interactivity.** Unlike the other media, which are essentially impersonal, some websites feature an interactivity option where consumers can have questions about the merchandise answered.
- *Detailed information.* Both the print and broadcast media offer little in the way of extensive information about retail operations and the merchandise offered for sale. The Internet provides pages upon pages of illustrations as well as information about company services, which can help the shopper make a more informed purchase.
- *24/7 availability.* No matter what the time of day, or day of the week, shoppers are able to access the websites of their choice and order the products that best suit their needs.
- *Costs.* The expense involved in operating a website is minimal. With sales continuing to steadily increase from this source, merchants are able to advertise numerous products that they more than likely couldn't afford to do with traditional media.

To a lesser extent, retailers use *billboards, posters,* and *backlit transparencies* for their advertising needs. Collectively, these are inexpensive and provide the special advantage of having visibility to pedestrians and people in their automobiles and on buses.

Classifications of Advertisements

There are three major types of advertisements that retailers use to appeal to their markets. They are known as **promotional** or *product,* **institutional,** and **combination advertising.** Each serves a different purpose, with promotional advertisements concentrating on the sale of specific product, institutional ads focusing on company image, and combination ads featuring elements of both of the others.

Promotional Advertising The most widely used type of advertising is promotional. Its goal is to sell a particular item or items or announce closeout, special, or regular sales. The success of this type of ad can be immediately measured based upon the sale of the merchandise soon after it has appeared in print (Figure 19–6).

Institutional Advertising In contrast to the promotional ad, institutionally oriented ads are used as image enhancers. The themes range from the announcement of charitable events and recognition of outstanding community service to acknowledgment of social events such as the opening of the city's opera season. Unlike the promotional ad, the success of the institutional variety is difficult to measure. They are, however, expected to deliver future business to the company (Figure 19–7).

Figure 19–6 The promotional ad is often used to announce a closeout sale.

(Courtesy of Marshall Field's, now a Macy's store.)

Combination Advertising Sometimes merchants use a combination of promotional and institutional advertising. For example, a fashion retailer might want to highlight its dedication to American designers and also feature a particular creation of one such designer. The copy could be a brief story about American design, which is the institutional part of the ad and used to enhance the retailer's fashion image; the accompanying photograph depicting one American designer's style would be used to sell a particular ensemble (Figure 19–8).

Cooperative Advertising

The costs of advertising continue to increase and often cause the retailer's budget to be insufficient in terms of sales goals. One of the ways in which advertising dollars are "stretched" is through participation in **cooperative advertising.** The principle involves the sharing of the cost of the ad between the manufacturer and the retailer. The manufacturer generally commits to one-half of the cost of the ad, with the base amount determined by the retailer's purchase order, a percentage of which is used to pay for the ad. Thus, if a retailer spends $100,000 with a manufacturer and sets aside 10 percent for advertising purposes, the

Figure 19–7 Institutional ads are often used to announce special store events.
(Courtesy of Marshall Field's, now a Macy's store.)

allowance for advertising would be $10,000. Then, the cost of the ad must be considered in the equation. If the ad costs $20,000, the manufacturer would contribute one-half, or $10,000. If, on the other hand, the cost of the ad is $5,000, the manufacturer would be liable only for 50 percent, or $2,500. In some cases, manufacturers contribute set amounts to retailers for cooperative advertising. The benefit of cooperative advertising to the manufacturer is getting attention for the product; for the retailer, the benefit is informing the consumer about where the product can be purchased.

Special Events

Making the shopper aware of the retailer's offerings is most often done with individual advertisements or **campaigns,** but these are not the only methods used by the retailer. Many different types of promotions are developed to bring greater attention to the company. These include both one-time special events and ongoing activities. Some are relatively costly, as in the case of runway fashion shows and charitable dinners; others are modestly expensive, such as special sale days.

Fashion Shows

Many retailers use fashion shows to dramatically present their latest collections. These shows run the gamut from the costly full-scale formal production to inexpensive informal modeling.

- *Formal productions.* Although a formal show is very expensive for retailers, some do so for special occasions. The show might be part of a charitable fundraiser to which tickets are sold with the proceeds going to the charity or perhaps held to

Figure 19–8 This combination ad used the Valentine Day's theme with the retailers' dedication to American style. *(Courtesy of Lord & Taylor.)*

celebrate the opening of a new branch. These productions take a great deal of planning and generally involve the use of unusual props, live music, mood lighting, and so forth, in addition to the models, who often dance or even skate to give that extra pizzazz to the show. Generally, it is retailers like Neiman Marcus and Bloomingdale's who opt for these types of extravaganzas.

- ***Runway shows.*** Runway shows can be set up within special areas of the store or within the department that is featuring the fashions. Sometimes an area outside the

store, such as a mall walkway or perhaps a tent set up in the parking lot, is used for these types of shows. In some cases, if the show is focused on a particular collection, the designer or company representative is on hand to provide commentary. The music is most often "canned," and the models range from professionals to people selected from specific groups, such as college students or members of charitable organizations. The costs vary depending upon the professionalism required in the production. If prerecorded music and college students or store employees are used in place of paid models and live bands, the costs may be significantly reduced. The purpose of the function generally dictates how much will be budgeted for the event.

- *Informal modeling.* Some retailers use **informal modeling** to make shoppers aware of the latest fashions in the store. Most often, it is employees who are used to move throughout the store wearing the designs and carrying small show cards indicating where this and other merchandise from the group may be seen. Furs are often shown in this manner. The benefits of informal modeling include little expense and no significant planning other than to tell the models which areas of the store they are to cover.

Trunk Shows

When a retailer wishes to highlight a specific fashion collection and generate excitement among its customers, a **trunk show** is often the promotional choice. The format involves the delivery of a designer's collection to the store with the designer, or a representative, providing commentary about the individual styles. The trunk show is very popular for high-fashion, upscale merchandise. The arrangement gives the potential purchaser the opportunity to ask questions about the collection, to determine whether special colors or fabrics may be substituted for those that are shown, or to learn more about the company and its fashion focus.

Cosmetic Demonstrations

A walk through any department store's cosmetic area generally reveals a number of company representatives ready and willing to apply their products to shoppers without any obligation to purchase. The makeup artists apply a variety of their company's products, generally resulting in a purchase for future use. These events are intended not only to sell products to the individual in the demonstration but also to the many bystanders.

Designer and Celebrity Appearances

The appearance of a fashion designer or a theatrical personality generally attracts scores of people to the store. More and more people in the entertainment industry are "designing" apparel collections or merely lending their names to the products. In either case, their appearances generate a great deal of excitement in the store. The action takes place in the area in which the lines are merchandised so that when the presentation is completed, a captive audience is on hand to examine the goods and make purchases (Figure 19–9).

Holiday Parades

Initiated by Macy's, parades are now used by many major retailers, especially at Thanksgiving, to "kick off" the year's major shopping season. The Macy's parade has grown into an extravaganza that attracts enormous crowds to New York City and also to the television channels showing the event. Macy's aisles are often filled the day after the parade, by people motivated by the fanfare. Television viewers also add to sales volume by purchasing Macy's products online.

Figure 19–9 Sarah Jessica Parker's new fragrance launch drew throngs of people to the store. *(Courtesy of Marshall Field's, now a Macy's store.)*

Special Sales

When Harrods' department store in London holds its semiannual clearance sales, the crowds are so large that hundreds of uniformed police are on hand to maintain some semblance of order. The event begins with a parade of celebrities riding in coaches to the store's main entrance, where the waiting throngs are eager to seek out the merchandise of their dreams at deeply discounted prices. Each year the crowds grow larger and larger and the bargains better. Not only do the sales clean the shelves of the company's leftovers but they also provide a great deal of publicity on television and in the newspapers.

Sampling

The idea of giving away a small sample of a product is not new to the retail industry. Manufacturers provide these **product samplings** to introduce a new product in their line, a new color, or something that will motivate future purchasing. The cosmetics industry is one that uses samples to generate business. Especially at Christmastime, the major companies offer gifts ranging from a single item to attractively packaged sets either free of charge with a purchase or at a nominal fee. The intent is to make shoppers aware of the products and motivate them to make future purchases.

Cooking Demonstrations

Stores that sell cooking utensils often use chefs to create their special recipes in these departments. The intent is to entice the shopper to watch the demonstration, sample the food, and, it is hoped, purchase the pots and pans in which the food was prepared. Restaurants are often motivated to supply their chefs for these demonstrations since they not only help sell the products but also provide publicity for the restaurant.

Institutional Events

Many major retailers use special events that do not focus on particular merchandise assortments to draw crowds to their stores. The idea is to bring the crowds and motivate them sufficiently to purchase throughout the store. Annual flower shows, such as those held by Macy's, are an example of such an event. With a budget of more than $1 million, the main floor of the Herald Square, New York City flagship is transferred into a veritable botanical garden. Each spring the traffic it generates fills the entire store with shoppers. The following profile features Macy's and some of the special events that have helped make it the world's most recognized department store.

Publicity

Rounding out the promotional activities in which retailers engage is **publicity.** Often, publicity is described as **free publicity** because in and of itself, it technically doesn't cost anything. Of course, the majority of events attracting such publicity are themselves costly—special holiday parades or a personal appearance by a celebrity, for example. Publicity in the media is a result of something the merchant does that is sufficiently newsworthy to warrant exposure in the editorial press, for example in a magazine's fashion column, a newspaper's society page, or perhaps a news show on television. In contrast, advertising is an expense incurred by either the space it occupies in print formats or the airtime it takes up in the broadcast media; special events are also expenses, the amounts ranging from minimal to extremely large; and of course, visual presentations, or displays, also cost the retailer varying amounts of money.

Those responsible with disseminating information about special events or other items to the press that might be of interest to the retailer's clientele are generally members of the publicity or public relations department. They use a variety of techniques to whet the media's appetite and get them to refer to the information in their writings or on the air. Some of the ways in which information is distributed to the press include press kits in hard copy format or e-mail that include written materials, often accompanied by photographs; press conferences, to which the media are invited to hear about an event or happening; or telephone conversations.

In today's retailing scene, where the competition is at the highest level ever experienced by the industry, publicity is an essential tool. It helps to distinguish one merchant from another and bring that extra exposure that might just be enough to attract the shopper to the store.

In the world of retailing, no other store in the world has captured the attention of the consumer as Macy's. Not only has it maintained its high level of quality merchandise in unheralded assortments throughout the year but it has regularly excited people from all over the world with its extravagant special events. Although many of the events feature merchandise that is sold in the store and is presented in runway shows, demonstrations, sampling sessions, trunk shows, and other formats, it is the institutional genre that continues to capture the attention of the masses. Particularly special are the Thanksgiving Day Parade, Flower Show, and Fireworks Spectacular. Each has become a regular favorite and is eagerly awaited by consumers.

In 1924, Macy's began what is probably its most anticipated annual presentation. The number of people viewing this event filled with helium-filled character balloons, extraordinary floats featuring celebrities from the theater, screen, and television, marching bands, and many live performances, is staggering. More than 3 million people line the streets of the parade route in Manhattan, and another 44 million see it on NBC television! Designed as the official kickoff for the Christmas selling season, it is presented each year on Thanksgiving Day. Aside from the marching bands from all over the country and the celebrities, the majority of the people in the parade are Macy's employees, who handle the enormous balloons and work the floats.

The annually produced Flower Show is an event that is held inside Macy's New York City and San Francisco flagships. For a two-week period, from the beginning to the end of April, the show features millions of flowers from all over the world that transform the store interior into a magical botanical garden. Hundreds of thousands of people visit the stores during the Flower Show. In addition to the floral presentations, other events include celebrity chefs who create culinary masterpieces with flowers, floral designers who demonstrate their skills, and table settings that feature unusual floral centerpieces.

Rounding out the trio of the major Macy's institutional events is the annual Fourth of July fireworks. For more than a quarter of a century, the visually spectacular pyrotechnic display has been held in New York City. As a joint venture with the city of New York, it is the largest fireworks display in the country. More than 2 million people watch it live, and many millions more view it on television.

Each year, Macy's continues to benefit from these and other special events: Santa-land, a free presentation for children; Passport, a fundraising event benefiting such causes as HIV/AIDS research; and Puppet Theater, a presentation during Christmas.

The Promotional Campaign

As we read through the pages of the print media or turn on our television receivers or radios, the volume of advertising that greets us is enormous. Most often, it is one-time ads that attempt to capture our attention and motivate us to buy. Sometimes, it is a whole *campaign,* which takes on greater impact from repetition. In the case of a campaign, the merchant is attempting to expose the readership or listening audience to a major undertaking. Such campaigns are often used to highlight a retailer's special event. In order to maximize appeal, the retailer often uses different advertising formats, window and interior visual presentations, and publicity to capture attention.

The components of promotion are intended to work in the following manner:

- A **special event** is planned either as a promotion for specific merchandise or for an institutional concept—for example, a charity—that will bring prestige and build the image of the company. Whatever the format, the intention is to distinguish the store from its competition (Figure 19–10).
- Once the event is planned, *advertising* it is often the next step. Carefully written copy interspersed with appropriate photography or other artwork will be planned for either print or broadcast media, or sometimes both. These promotional devices are intended to bring shoppers to the store's premises.
- The *visual presentations,* both for the windows and inside the store, are then designed and executed to coincide with the special event and its advertising focus. The intention is that the windows will bring the shoppers inside the store to the

Figure 19–10 The Breast Cancer Research Fund is the beneficiary of the special appearance of actress Elizabeth Hurley and cosmetic dignitary Estee Lauder. *(Courtesy of Marshall Field's, now a Macy's store.)*

point of purchase and that the interior displays will sufficiently whet their appetites to buy.

- *Publicity* may occur at any time during the promotion. It may be planned to happen before the ads are run, at the same time as the advertising exposure, or when the event has already begun, or it may occur whenever the press thinks it appropriate to give the event editorial coverage.

When the promotional campaign is properly planned, developed, and executed, the merchant is likely to achieve positive results in terms of immediate sales, and the potential for an expanded customer base.

chapter review

key points in the chapter

1. The three-dimensionality of visual merchandising makes it an excellent tool for accurately presenting the merchandise to the consumer.

2. Visual merchandising has its advantages, but the amounts spent on it pale in comparison to the dollars expended for advertising.

3. The newspaper is the most important of the advertising media used by retailers.

4. Newspaper advertising offers to merchants such advantages as short production lead time, comparatively modest costs, and timeliness.

5. Magazines offer such advantages as long life potential, broad distribution, and quality reproduction.

6. Direct mail offers the retailer demographic targeting, which can help focus on specific groups with the desired characteristics.

7. Television offers the advertiser live action and wide market potential.

8. Radio provides the retailer low-cost advertising and an abundance of ethnic audiences.

9. Website advertising has such features as interactivity, 24/7 availability, and low cost.

10. Ads are classified as promotional, institutional, and combination. Each serves a different purpose for the retailer.

11. Cooperative advertising offers the retailer an opportunity to defray some of the expenses of advertising by splitting the costs between the retailer and the manufacturer.

12. A special event is a promotion that includes fashion shows, trunk shows, demonstrations, celebrity appearances, holiday parades, and special sales.

13. An institutional event is one that features promotions intended to focus on the company's name and image and bring shoppers to the store, catalog, or website.

14. Publicity is free, but it often comes at the expense of a costly promotion.

terms of the trade

campaign 329
combination advertising 327
cooperative advertising 328
demographic targeting 325
direct mail 325
free publicity 333
informal modeling 331
institutional advertising 327

lead time 322
"life" of the advertisement 323
media 322
message life 327
news "sheet" 323
product sampling 333
promotional advertising 327
promotional campaigns 320

publicity 333
regional editions 324
runway shows 330
special events 334
spot commercials 326
trunk show 331
website interactivity 327
website linkage 327

internet exercises

1. Go directly to three major retailer's websites, or use a search engine such as *www.google.com* to get the correct websites if they are not familiar to you, to see how they promote any special event such as a sale, holiday event, and so forth. Download descriptions of each of the events and compare the formats used. Rank then, in order, from the best to the poorest, and explain why you have ordered them this way.

2. Visit five retail websites for the purpose of evaluating their advertising approaches. Each ad should be analyzed in terms of type (promotional, institutional, combination) and whether or not you think it will motivate online purchasing.

Case Problems

Case 1

Ever since its inception in 1998, The Sportsman's Venue has been a proponent of advertising. Its ads generally feature products like sports equipment, clothing, camping products, and exercise equipment. The company has five units, each of which occupies about 10,000 square feet, located within a 100-mile radius.

In addition to the regular ads it runs in the city's major newspaper, The Sportsman's Venue sometimes uses radio spots to announce special sales, direct-mail pieces at Christmastime, and interactive advertising on its website. Through these promotional endeavors, the company has regularly reached its targeted sales goal.

Recently, with the retirement of its founder and CEO, Edward Olson, a new company head was brought on board to take his place. John Philips, president of a competing company, assumed the responsibility for directing The Sportsman's Venue. At the helm of the operation for six months, Philips has carefully studied the organization's past and potential for future sales and has come up with some new promotional ideas that would conceivably increase sales and profits.

One idea is to feature periodic special events to bring additional traffic to the store and increase the potential for additional revenues. The suggestions Philips has brought to the management team are as follows:

1. Plan one-day events that would feature in-store appearances of sports celebrities.
2. Offer one-day demonstrations of physical fitness equipment that would feature personal trainers.
3. Provide clinics that feature sporting equipment such as golf clubs.

At this time, the management team has yet to give the new company leader its impressions regarding the use of special events in the stores.

QUESTIONS

1. Do you think these events would help increase sales? Why?
2. What other types of events could be used to stimulate business?

Case 2

The Sophisticated Woman, an upscale specialty shop, opened its first store in 1992 with a small unit in downtown Chicago. It has since grown into a chain that operates twelve stores, each of which is located in a Chicago suburb. Success of the company has primarily been based upon word-of-mouth advertising instead of a regular promotional plan. On rare occasions, the company runs ads in the city's major newspapers as well as in some local publications.

The success of The Sophisticated Woman is generally credited to the service it provides. Individual personal shopping, special orders, and custom alterations are just some of the services provided to its clientele.

Although sales have been generally favorable, there seems to be a sense among the management team that more can be done to realize even more growth. Jackie Lane, vice president of the company, believes the hit-or-miss advertising approach needs some formal structuring. She has developed a plan to provide a promotional budget that would not only be used for advertising on a regular basis but also for special events and exciting visual presentations for windows and interiors. Although the plan has been favorably received by most of the company's management personnel, some have reservations about the costs involved and whether or not the promotional package would make the company more profitable.

At this point, no decision has been reached on Lane's proposal.

QUESTIONS

1. Do you think the new program is merited? Why?
2. How might the company introduce an expanded promotional concept without expending a substantial amount of money?
3. What types of events could be offered that would be cost-effective?

discussion questions

1. What does visual merchandising offer that advertising does not?
2. Which of the retailer's promotional efforts generally warrant the lion's share of the promotional budget?
3. Of all of the media available to retailers, which one is generally the most frequently used?
4. What are some of the advantages of newspaper advertising for retail businesses?
5. Why is "lead time" such an important factor in ad placement?
6. What are two negatives associated with newspaper advertising?
7. In what ways does magazine advertising better benefit the advertiser over newspaper advertising?
8. How can direct mail target specific groups of potential shoppers?
9. Why do retailers use television rather infrequently?
10. Which recent innovations have caused the effectiveness of television advertising to diminish?
11. Why is radio advertising being more aggressively used by many retailers?
12. Discuss some of the advantages of website advertising for retailers.

13. In what way does the focus of promotional advertising differ from institutional advertising?

14. What advantage does cooperative advertising afford the retailer?

15. What are the three major formats used in fashion show presentation?

16. How does a trunk show differ from a fashion show?

17. In addition to fashion shows and trunk shows, what are some other special events that retailers use to bring shoppers to their stores?

18. Why is publicity often referred to as *free* publicity?

exercises and projects

1. Visit a major retailer in your area for the purpose of discovering any special event it is promoting. Take photographs of the event and use them as tie-ins with newspaper ads. Assemble the photos and copies of the ads on a loomboard in order to lead a discussion in class regarding the effectiveness of the in-store event and the ads.

2. Using copies of recent fashion magazines such as *Elle* and *Harper's Bazaar,* select five advertisements that concentrate on one fashion segment, such as apparel, shoes, jewelry, and so on. Mount each ad on a loomboard for use in leading a class discussion on the effectiveness of the ad. Some of the areas of the discussion should focus on

 a. the classification of the ad.
 b. the artwork and its ability to capture the reader's attention.
 c. the ad's effectiveness in terms of motivating the reader to seek further information about the product.

index